# The Spirit of Surrealism

# The Spirit of Surrealism

## EDWARD B. HENNING

Published by
The Cleveland Museum of Art
in cooperation with
Indiana University Press

An exhibition held at The Cleveland Museum of Art
October 3 through November 25, 1979

The exhibition and catalog were made possible by grants from
the National Endowment for the Arts and the Ohio Arts Council

Design by Merald E. Wrolstad
Edited by Sally W. Goodfellow
Typesetting by Square Composition Company, Cleveland, Ohio 44113
Printing by Congress Printing Company, Chicago, Illinois 60610
Distributed by Indiana University Press, Bloomington, Indiana 47401

Copyright 1979 by The Cleveland Museum of Art
11150 East Boulevard, Cleveland, Ohio 44106
Library of Congress Catalog Card Number: 79-63387 √
ISBN: 0-910386-52-8

Library of Congress Cataloging in Publication Data is on page 185.

# Contents

# Foreword

Surrealism as a defined and recognized cultural attitude is slightly more than a half-century old. So why bother with an "antediluvian" movement? Because, like the physically deceased Marcel Duchamp, the spirit of Surrealism is not dead. As with any concept that reveals truth, people tend to suppress those elements they find disturbing. They consciously will those things to be not known, thus proving that Freud was right.

The ideas and instincts of Surrealism are, therefore, by no means exhausted — only mislaid. Like any art movement or style, Surrealism provided masters, followers, and incompetents. But the crucial point is that by its self-defined nature, Surrealism was meant to be suppressed. Consequently, its potential for a full cycle of humanistic development and artistic variation was unfulfilled — worse, aborted.

Harold Rosenberg felt that the art following the "action" painters was fundamentally sterile and anti-human, either unsanctioned play or cerebral self-indulgence. Whether he overreacted instinctively to the new avant-garde or not, the fundamental criticism seems telling. Perhaps life itself became so surreal that a Surrealist art seemed unnecessary. That was an error of judgment and of feeling on the part of the devotées of high art. Popular art and the new arts of cinema, photography, and even advertising adapted Surrealist techniques for only too practical ends. In doing this, the practitioners of science fiction, horror movies, fast cuts in television advertising, and many others may have diluted the power of Surrealist art but maintained the subconscious acceptance of unreal imagery.

The plastic creations of Giotto were not fully understood in his own city for more than a century after their invention. How can we be confident that a profound *and* intelligent theory barely more than fifty years of age has had its day? We need to be reminded of the potential within the spirit of Surrealism, and in recalling it, we should find it relevant to the existing human condition.

The images selected and the text provided by Edward B. Henning represent a serious effort at preserving and presenting a creative social and aesthetic theory peculiar to the twentieth century. We owe thanks to him and to all those — lenders, contributors, and staff — who made this exhibition and catalog possible.

Sherman E. Lee, *Director*
*The Cleveland Museum of Art*

# Preface and Acknowledgements

This is neither a comprehensive exhibition of Surrealist art nor a book specifically about Surrealism. There has been a plethora of such exhibitions as well as literature dealing with Surrealism. To add to either would be more than redundant; it would be boring. Instead, I am attempting to demonstrate that the major aim of Surrealism, as defined by André Breton — and the techniques it developed — could and did lead to the creation of works of art which were formally structured and aesthetically valuable. And further, that Surrealism affected many other artists who did not consider themselves part of the Surrealist movement. I am convinced that some major Surrealists (such as Max Ernst), some peripheral Surrealists (such as Joan Miró), and some non-Surrealists (such as Pablo Picasso and Robert Motherwell) were indeed influenced by Surrealist theories and techniques in their creation of major works of art.

On the other hand, some members of the Surrealist movement (such as Wolfgang Paalen, Hans Bellmer, and Victor Brauner) are important in the historical documentation of Surrealist art, but to my mind are not so interesting as artists. Furthermore, those who worship at Marcel Duchamp's shrine will surely feel that he is not well represented; yet, aside from the impossibility of borrowing most of his major works, Duchamp himself would probably agree that he should not be represented extensively in this kind of exhibition.

The attempt to define the Surrealist spirit involved brief reviews of some important ideas from philosophy, literature, political theory, and depth psychology, which undoubtedly will be considered inadequate by those familiar with these fields. However, it is only those elements that *influenced* Surrealism — as the Surrealists understood them — that matters here. The section on Immanuel Kant is a special case: although his influence on Surrealism was minimal at best, he defined certain key issues and proposed concepts that laid the groundwork for nineteenth-century German philosophers who followed and who greatly influenced the Surrealists.

Surrealism was first of all a literary movement. In order to capture its flavor, therefore, attention must be paid to the Surrealist poets and their acknowledged ancestors. Since space is a major factor in a catalog of an exhibition, I had to make choices. André Breton was an inevitable one among the Surrealists, as was Isidore Ducasse (Le Comte de Lautréamont) among the predecessors. From there on, it was largely a matter of selecting a few from many possibilities: I chose Rimbaud and Jarry ahead of de Sade, Blake, Lewis Carroll, Swift, Baudelaire, and Apollinaire; and Breton ahead of Aragon, Eluard, and others. Professors of literature might find my treatment of the earlier writers and poets inadequate. I can only say that I represented them in the way that I believe they influenced Surrealist writers and artists.

Among the artists considered here, some (like Picasso and Klee) were chosen because they created major works of art while utilizing — at least partially — methods similar to those devised by the Surrealists and because they participated in the Surrealists' attempts to reveal unconscious experience.

That Surrealism affected the American artists known as Abstract Expressionists — or The New York School — is beyond dispute. Yet I have elected to include just four members of this group, as well as Joseph Cornell. My main criteria were that they not only had direct contact with the Surrealists and exhibited in Peggy Guggenheim's and Julien Levy's galleries during the 1940s but their mature styles and creative methods as artists occurred during that time. It was difficult to omit such figures as Rothko, Gottlieb, Still, David Hare,

and David Smith; yet the determining criteria made that decision for me. I am well aware of the quarrels that could result. For those who would take issue, I offer: limited exhibition space, unavailability of important works, and my own subjective judgment.

A film program on Dada and Surrealist films, their precursors and their heritage, accompanies this exhibition. Originally I had intented to devote a section of this book-catalog to the spirit of Surrealism in films, but then I discovered that J. H. Matthews's excellent book, *Surrealism and the Film,* covered the same ground. Correspondence with Professor Matthews revealed that he is publishing another book, *Surrealism in the American Feature Film.* Indeed, a number of films that I had scheduled for the film series and had written about briefly in the announcement of the series were dealt with in Matthews's books in greater depth than would have been possible here. Since I am in essential agreement with Matthews, I shall simply recommend his books and content myself with a few perfunctory remarks.

The film series includes works by early precursors: the great French experimental pioneers Emile Cohl, Jean Durand, Louis Feuillade, and Georges Méliès. The feature film *Norsferatu* by F. W. Mureau, which was much admired by the Surrealists for its marvelous effects and fantastic theme, is included, as are Dada films by Man Ray, René Clair, Marcel Duchamp, and Hans Richter. Certain early American films with Charles Chaplin, Buster Keaton, Harry Langdon, and those directed by Mack Sennett, all reflecting the Dada spirit, are also included.

The first classic Surrealist films, *The Andalusian Dog* and *L'Age d'Or,* were made by Luis Buñuel — the first in collaboration with Salvador Dali, the second, discussed with him. Buñuel has been the most consistently Surrealist of all film directors. A number of his later

feature films lacking the obvious Surrealist symbols of his two early ones — *Los Olvidados, El, Robinson Crusoe, Viridiana, The Exterminating Angel,* and *Belle de Jour* — are attacks on bourgeois institutions and their devastating effects on human nature.

Other major films that in one way or another define some aspect of Surrealism are Jean Vigo's *L'Atalante* and *Zero for Conduct;* Marcel Carné and Jacques Prevert's *Quai des Brumes* and *Le Jour se Leve;* Henry Hathaway's *Peter Ibbetson;* Ernst Schoedsack and Merian Cooper's *King Kong;* Schoedsack and Irving Pickel's *The Most Dangerous Game;* Claude Autant-Lara's *Le Diable au Corps;* and many of the films with The Marx Brothers (Harpo is a comic manifestation of the Freudian id) and W. C. Fields (an almost perfect incarnation of Alfred Jarry's Ubu).

Buster Keaton's *Sherlock Jr.* and *Go West* illustrate his poetry of action and implied aim to transform the world. Chaplin, on the other hand, was more anarchistic in his attacks on the modern world, as are Laurel and Hardy in their best films (for example, *Two Tars, Big Business,* and *The Music Box*). Matthews points out, however, that their wild destruction of bourgeois property is purely gratuitous and relates only to the demands of comedy.

Two film directors often assumed to be Surrealists but who are, in fact, the antithesis of Surrealism are Jean Cocteau and Ingmar Bergman. Cocteau's fantasies are usually used to mock the methods and aims of his enemies, the Surrealists. Bergman, on the other hand, is a God-obsessed director who uses scenes of sexual acts to shock his audience into feeling ashamed of their human nature. What the Surrealists celebrated, these two directors censured.

It would be difficult, if not impossible, to list all of the people who helped with the preparation of this exhibition and book. Nineteen years ago I did an exhibition on abstract art which I intended to follow with one on Surrealism. Major exhibitions of Dada and Surrealism held elsewhere discouraged this enterprise until this year when Professor Jack Roth of the Department of History at Case Western Reserve University approached me with the idea of a Surrealist Festival involving a number of area institutions. I welcomed the opportunity to develop an exhibition demonstrating the broad, motivating spirit of Surrealism. Everything depended, however, on whether the owners of important Surrealist works would be willing to lend them. In several instances I was indeed disappointed, but the crucial collection at the Museum of Modern Art was made available with great generosity on the part of the Curator of Painting and Sculpture, William Rubin, as well as the Director, Richard Oldenberg, and the trustees. Other lenders who graciously lent works that were essential for the success of the exhibition are listed elsewhere. Two institutions with important holdings were unable to lend because of anniversary celebrations during which their major works would be on constant view; a third was opening a new extension and planned to exhibit all its major works.

Pontus Hulten of the Centre Georges Pompidou in Paris, Thomas T. Solley at the University of Indiana, Robert Motherwell, and the art dealers Klaus Perls, Eugene V. Thaw, Pierre Matisse, Mr. and Mrs. Daniel Saidenberg, and William Acquavella made special efforts to lend works that were important for the exhibition. To these and the many other lenders, my heartfelt thanks.

Although many of the artists and poets who were directly involved with Surrealism are no longer alive, memories of personal visits and conversations with Marcel Duchamp, Richard Huelsenbeck, Man Ray, Frederick Kiesler, and Joseph Cornell, among others, were enlightening. Even more so was the helpful information shared by mail and through either direct or telephone conversations with Julien Levy, Pierre Matisse, Rosamond Bernier, and Jimmy Ernst. Robert Motherwell was especially generous in sharing documents and recommending sources that proved most useful. It should be emphasized, however, that the author alone is responsible for any errors, shortcomings, and special interpretations in connection with the exhibition or in the text of this book.

An enterprise of this scope can only be achieved with the cooperation of a diligent and expert staff. I should first like to express my thanks to the Director of the Cleveland Museum, Sherman E. Lee, for his encouragement, advice, and for allowing me complete freedom in organizing the exhibition. I also would like to thank the Trustees, who have intervened only to offer encouragement.

However, it is the staff of the Museum that is ultimately responsible for mounting an exhibition and publishing its accompanying catalog. The Registrar and his staff are at the heart of the operation, organizing the packing, shipping, insurance, and many other details that continue long after the exhibition closes. The Utility Crew that hangs the exhibition, the Photography Studio, the Printing and Public Relations Departments, the General Manager, Museum Designer, Conservators, all these and more play critical roles in seeing to details that are an essential part of any exhibition. The Department of Art History and Education also planned lectures, made slide tapes, and offered a multifaceted educational program for the duration of the exhibition.

In the production of the catalog, the Associate Curator of Modern Art, Tom Hinson, was invaluable in supervising the numerous details of putting together the catalog section and the bibliography. The Library staff was most helpful and patient in obtaining source material. William Robinson, Roslynne Wilson, Ellen Breitman, and Suzanne Fisher contributed to the research and compiled information for the catalog and bibliography. In particular, the Editor of Publications, Merald E. Wrolstad, who designed the catalog and oversaw its production, deserves special thanks, as does the Assistant Editor for Catalogs, Sally W. Goodfellow, who put in long, hard hours of editing.

The entire project would have been impossible without the efforts of the Secretary of the Modern Art Department, Margaret Wilson, who kept track of hundreds of details and constantly reminded me of things to be done. And Leona S. Miller deserves my special gratitude for her rapid typing of my nearly illegible manuscript.

I should also like to thank my son Eric and his wife, Sylvie Debevec Henning, who reviewed the first drafts of the sections on literary and philosophical ancestors of Surrealism. Their suggestions were most valuable, and if these chapters are not all they should be, it is because lack of space and time prevented my following all of their advice. Finally, I thank my wife, Margaret, who did without my presence during much of the year and who made some suggestions which saved me from despair at crucial moments.

# Introduction

The spirit of Surrealism in the arts is a revolutionary spirit, a spirit that — along with that of Dada — aimed to eliminate traditional forms and subjects in the arts. It not only turned its weapons on the arts of the past but also attacked other kinds of contemporary art such as Cubism, Expressionism, and abstract art. It pointed out that such art only continued traditional art with modifications. Indeed, it hoped to eradicate all preconceived notions of form and, by exploring the unconscious wellsprings of the human personality, to bring forth entirely new forms and subjects. In short, the spirit of Surrealism was intended to be investigative rather than formulative or expressive.

André Breton defined the nature of Surrealism in his two Manifestoes of Surrealism. Yet the movement did not develop exactly as its founder expected. He depended on information gathered from past experience and established a system, projecting certain results based on that information. But Breton and his comrades became immersed in a wave of events that they had helped to stimulate. Once they became integral parts of a complex system in process of developing instead of objective theoreticians, they were affected by events beyond their control. Variations on Surrealism — such as Miró's tendency toward abstraction or Dali's deliberate employment of obvious Freudian symbols, as well as the Abstract Expressionists' use of certain Surrealist methods to arrive at works in which the form itself conveyed content — could not have been predicted.

Two notions not recognized by Breton when he insisted on the purely investigative nature of Surrealist art were: (1) the human tendency to construct and formulate experience, and (2) the human disposition to evaluate. Jacques Lacan, Jean Piaget, Morris Halle, and other structuralists assume that the forms produced by man reflect an innate structure of the human mind; and the Surrealist artists created works which established fresh norms for evaluation and which are now judged by the very standards they themselves created. History is filled with such paradoxes. Setting out to investigate the internal combustion principle as a means of power for carriages to transport human beings efficiently, for example, man created an aesthetic of automobile design which established its own criteria. Similarly, investigating ways to visually record photographic images in movement, the art of the film was born and evolved its own unique aesthetic standards. In addition, new strains of flowers, cats, or dogs are constantly being developed, defining the criteria by which others of their kind will be judged.

Thus, this exhibition and book-catalog consider the Surrealist spirit as formulative and inevitably aesthetic, as well as investigative.

The world of events has no obvious a priori structure. Form is an intellectual concept imposed on events and has little to do with the spontaneous vitality of life. Still, whenever attempts have been made to demonstrate the inadequacies of form, those efforts themselves have inevitably been made in formal terms — demonstrating man's impulse toward form. It seems obvious that Surrealism never really intended to do away with form, only with traditional forms which grew from — and referred to — concepts which it held to be no longer valid. The destruction of these forms and the return to the unconscious as a source for poetic experience was made

in the expectation that new, more poignant and valid forms would emerge. Meyer Schapiro has aptly remarked that "automatism in art meant the painter's confidence in the power of the organism to produce interesting unforeseen effects and in such a way that the chance results will constitute a family of forms."

I am persuaded that such forms signify content which approximates the subjective experience that the artist seeks to articulate. The work of art is — as Breton said — a window. However, Surrealism is concerned with what it looks *in* on rather than what it looks out on. Like the patient who attempts to communicate the nature of his pain to the physician, the artist uses every possible means to articulate his inner experience. And like the doctor, the intelligent perceiver of art makes every effort to comprehend, interpret, and appreciate the message. In neither case does the audience have the same experience as the articulator; rather, he gains insight into it. How then can we penetrate to the content of unfamiliar — even Surrealist — works of art?

In recent years a method of analysis called structuralism was developed in linguistics, anthropology, literature, psychoanalysis, and the arts. Marx and Freud were pioneers in defining structures beneath the surface events of history and the individual personality. In France, Ferdinand de Saussure led the way in establishing the foundations for studying linguistics structurally. Since then, Claude Levi-Strauss, Roland Barthes, Jacques Lacan, Roman Jakobson, and others have applied structuralist methods in various fields.

In the United States, Noam Chomsky is a major figure in linguistic analysis with his theories of deep structure and generative grammar. So far as I know, only Jack Burnham has attempted a strict application of structural methods of analysis to the study of visual arts.

Surrealist works of art offer fertile ground for such methods, since they have many levels of structure and content. While I have not made a concentrated effort to apply structural analysis in the discussions of paintings and sculptures in this book, I have attempted to discuss them in ways that might be termed "instinctively structuralist." The brief comments sometimes refer to the surface structure of images or form and their symbolic referents; in a few instances I have tried to probe more deeply into the organization of the elements of the works, hoping to arrive at logical inferences from the interrelationships of those elements. While the full import of a work of art can never be caught in a net of logical sentences, I am convinced that one can learn to read its "language." An elementary example of the kind of approach I am referring to might be demonstrated most efficaciously by using a familiar work by an old master.

Nicolas Poussin's painting of *The Burial of Phocion* narrates the death and burial of a distinguished and scrupulously honest Athenian statesman and general who, recognizing that resistance was hopeless, advised the citizens of Athens to accept Phillip's offer of privileged status for their city within the growing Macedonian empire. Opposed by Demosthenes, he was later put to death and buried in disgrace when Alexander the Great died. Poussin's painting seems to sympathize with the reasonable and honest conservatism of Phocion. It refers obliquely to the fickle nature of the demos, the success (in this case) of political opportunism over integrity, and the unfortunate triumph of human emotion over

reason. The formal elements that make up the landscape are carefully ordered, while the inconspicuous litter carrying Phocion's corpse suggests a contrast between the grand order of the natural world and the disorder of the human domain. In short, the formal structure of the painting carries its content (Poussin's world view) as poignantly as the images that illustrate the subject.

In the seventeenth century Poussin's audience was probably familiar with the story of Phocion and prepared to infer its import from the subject of the painting. The general art public in the twentieth century is less likely to know Phocion's history; yet, the content of the work may still be inferred from its formal structure.

Although Poussin's philosophical position was far from that of the Surrealists, the method suggested to "read" their works is the same. If we depend on the images of Chirico, Magritte, and Dali to decipher the import of their paintings, for example, we must refer to the deeper level of Freudian symbols and their interrelationships. In order to recognize the full import of Chirico's work, or Ernst's, Miró's, and especially the American Abstract Expressionists', it is crucial to be able to read its formal structures as well. Motherwell's series of black and white abstractions entitled *Elegy to the Spanish Republic,* for example, neither illustrate events from the Spanish Civil War nor provide symbols in the normal sense; rather, they refer to the artist's affective response to that event. A sense of conflict, repression, constriction, and other subjective events too subtle to be identified verbally can be revealed to the willing perceiver in these paintings.

Surrealism's primary roots were in French literature. Writers such as André Breton, Louis Aragon, Paul Eluard, René Crevel, and others sought to revolutionize language, to create new poetic images by allowing words to flow out freely without conscious control. This process — automatism — was adapted by Surrealist artists who sought to go beyond the perimeters of traditional art. In their efforts to explore the unconscious part of the human personality and to end the dominance of bourgeois values, the Surrealists turned for support to the work already done by Sigmund Freud and Karl Marx.

Marx held that man's ways of acting and thinking are determined largely by his relationships to the underlying social structures of society, particularly the means of producing goods for subsistence and for trade. However, he did not deal with individual consciousness; the question of *why* artists, writers, philosophers, theologians, and other intellectuals often produce works that reflect the interests of holders of social and economic power — even when they themselves come from other classes — was left unanswered.

Freud, on the other hand, was concerned with the individual. He looked beneath surface events for an underlying structure to help explain what appeared to be accidental or chance behavior. His work in uncovering the deep structure of the personality depended mainly on the technique of free association in order to reveal the meanings of dreams. Dreams, he believed, provided a window to the hidden workings of the unconscious part of the self. Freud's theories established the foundation for André Breton's definition of Surrealism.

Some Surrealist artists, such as Magritte, Tanguy, and Dali, developed illusionist Surrealism by building on Freud's concern with dreams. Their works focused on the content of dreams and their symbolism to provide a link between the inner and outer worlds.

The spirit of Surrealism as conceived in this exhibition and book refers to an attitude toward life and the world that can be manifested in all of man's actions. It is seen as a life-embracing force, a love of what is natural and a hatred of unnecessary restrictions on man's free and ebullient spirit. It stands for poetry, love, and humor in life and against cold logic and objectivity. Above all, it insists on the unity of perceptions of the external world and the experiences of the inner world.

# PART ONE
## The Dada Prelude

The liberation of the human mind has never been furthered by . . . dunderheads; it has been the gay fellows who heaved dead cats into sanctuaries and then went roistering down the highways of the world, proving to all men that doubt, after all, was safe. . . . One horse laugh is worth ten thousand syllogisms. It is not only more effective; it is also vastly more intelligent.
H. L. Mencken

# The Origin and Nature of Dada

Dada was the wrecking crew that preceded the Surrealists' attempt to suggest a new basis for human life. The Dadaists rejected the social order and values that produced the human slaughter and destruction of the First World War. The mindless fury with which the European nations attacked one another was too absurd to be simply criticized; it demanded satire, and Dada obliged with sardonic mockery aimed not only at the war itself but also at the traditions and values of Western bourgeois society that had produced it.

Many of the young avant-garde artists in France, Germany, Italy, and Russia served in the armed forces during World War I; some of the most gifted were killed or wounded. Franz Marc, August Macke, Raymond Duchamp-Villon, and Umberto Boccioni were among those who died, and Georges Braque and Guillaume Apollinaire were two of many who were seriously wounded (Apollinaire died of complications in 1918). Intellectuals from all over Europe, disgusted with the suicidal conflict, sought refuge in Switzerland during the war. In Zurich some of them formed an anarchistic movement that called itself Dada; included were artists, writers, philosophers, and intellectuals from many nations. They made the Cabaret Voltaire their headquarters, and they lived as neighbors of the Bolshevik leader V. I. Lenin and several of his comrades. A member of the Dada group, Jean (Hans) Arp, later wrote: "Revolted by the butchery of the 1914 World War, we . . . devoted ourselves to the arts. . . . We were seeking an art based on fundamentals, to cure the madness of the age, and a new order of things that would restore the balance between heaven and hell."[1]

Like the Bolsheviks, the Dadaists opposed the existing order, but while the Marxist revolutionaries welcomed the war as a step toward the destruction of capitalism and the birth of a new society, the Dadaists abhorred it. Although both disdained the bourgeoisie, the Bolsheviks regarded the Dadaists as frivolous dilettantes because they lacked a systematic revolutionary program. Even when Dada events and works portrayed anger and disgust with Western traditions, they appeared ineffectual to the dedicated Marxist revolutionaries who preferred polemics to poems, strategy to cafe programs, and tactics to discussions.

Another point of departure for the two groups involved human nature. The Dadaists believed that human nature was better left to find its own way; they were iconoclasts who believed in uninhibited freedom. The Bolsheviks, on the other hand, advocated social organization and political control. Far from subscribing to the dictum that freedom does not include the right to shout "Fire!" in a crowded theater, the Dadaists applauded Jacques Vaché's threat to fire random pistol shots into a theater audience. (Vaché had made such a threat during the intermission of a performance of Guillaume Apollinaire's *Les Mamelles de Tirésias* as a gesture to mock the absurdity of shooting at someone simply because he wore a certain uniform.) In short, Dada preferred anarchy to socialism.

Hugo Ball, a tall, somber German writer, was the first leader of the Zurich group. He was deposed, however, after a brief period of co-leadership with Tristan Tzara. A Rumanian writer, Tzara was slight, brilliant, waspish, and aggressive; he was certain to win his campaign for leadership against the thoughtful and sincere Ball. The uneasy dual leadership ended when Ball, disturbed by

the cynical negativism that Tzara imposed on the movement, disengaged himself with these words: "I have examined myself carefully, and I could never bid chaos welcome."[2]

In addition to Ball and Tzara, other major figures of the Zurich group were Jean (Hans) Arp, Alsatian sculptor, painter, and poet; Richard Huelsenbeck, German poet, physician, and later, Jungian psychoanalyst; the brothers Marcel and Georges Janco, Rumanian painters, sculptors, and poets; Hans Richter, German painter and film-maker; Emmy Hennings, singer, performer, and Ball's mistress; Sophie Tauber, dancer, painter, tapestry designer, sculptor (later Arp's wife); and Dr. Walter Serner, a cynical nihilist whose disgust for mankind derived from "the thing Brecht proclaimed all his life, that mankind is too weak to be really good and too good to be really bad . . . only weak and, in consequence, base."[3]

It was early in 1916 that the group founded the Cabaret Voltaire, where they held exhibitions, gave plays and performances of all kinds — including music and simultaneous abstract poetry readings — and held discussions that often became arguments and occasionally erupted into fights.

There are various explanations of how the word Dada was chosen to represent this group. The one most commonly accepted is that Richard Huelsenbeck and Hugo Ball discovered it by random selection in a German-French dictionary. It seemed appropriate: it is a child's word for hobbyhorse in French; to Germans it indicated idiot naivete and a preoccupation with procreation and the baby carriage. Hugo Ball's diary for April 18, 1916, states that his suggestion to call the group's magazine *Dada* was accepted. Later, he gave credit for its discovery to

Huelsenbeck in a letter addressed to the latter in November 1926. Another explanation suggests that it was indeed Ball's idea that the word be used and that it occurred to him while listening to Tzara and the Janco brothers punctuate their rapid-fire conversations in Rumanian with the affirmative "da, da." Finally, Arp was credited by André Breton and Francis Picabia with its discovery. When Tzara later pressed him to deny it and give the credit to himself, Arp produced a satirical account which appeared in *Dada Intirol Augrandair* (Open-Air Dada in Tyrol). Although it affirmed that Tzara had found the word, its absurd and humorous tone makes it obvious that Arp was poking fun at Tzara's unbecoming ambition: "I hereby declare that Tzara invented the word *Dada* on the 8th of February 1916, at 6 P.M." wrote Arp. "I was there with my twelve children when Tzara first uttered the word which filled us so justifiably with enthusiasm. It happened in the Café de la Terrasse in Zurich, and I was wearing a brioche in my left nostril." The true story of how the word Dada came to be adopted will probably never be known, which in itself is appropriate to Dada.[4]

While the Dadaists were united in their opposition to traditional Western values and by the quest for individual freedom, there were important differences among the members as well as the various Dada groups. Two extremes of personality already noted were represented by Tzara and Ball. The philosophical-political nihilism of Walter Serner, Jacques Vaché, and Arthur Craven was quite different from the later Communist leanings of Huelsenbeck and George Grosz. Further, these groups were opposed by the apolitical satire of Kurt Schwitters and Arp's warm, intuitive love of nature. In fact, paradox was the essence of Dada. If it embraced love, life, and laughter, it also encompassed black humor, nihilism, and suicide. Hans Richter called it "an

artistic revolt against art." In all its aspects, however, it was an attempt to discard the accumulated conventions of traditional culture and return to the wellsprings of life.

Dada was not a style in art. Earlier movements such as Fauvism and Cubism developed as painting styles and then, in one way or another, were named, whereas Dada began as an attitude toward life which sometimes led to actions and the production of objects. Although the ultimate objectives of Dadaism and Futurism were diametrically opposed — the Futurists glorified war and modern industrial society, while Dada came into being precisely to protest both — Futurism had an influence on Dadaist methods. The Italian group's emphasis on action and its provocation of the audiences at its performances, goading them to respond emotionally and thereby become an unwitting part of a performance, was a method adopted by the Dadaists.

Above all, Dada scorned reformation; it had no constructive plan for improving the human condition. Dadaists were seen as destructive clowns who fired bullets of irony and satire at society. At first they shocked and frightened the bourgeoisie who sensed that the Dadaists were serious about destroying middle-class institutions and ideals. Their cerebral bombs were later defused, however, by a jaded society looking for new thrills and amusements. Thus, the circle of irony completed itself: Dada's popular success marked its failure.

1. Jean Arp, *Dadaland,* quoted in Hans Richter, *Dada: Art and Anti-Art* (New York and Toronto: McGraw-Hill, 1965), p. 25.
2. Hugo Ball, quoted in Richter, p. 43.
3. Richter, p. 36.
4. These and other speculations on the origin of the term are found in Richter, pp. 31-32.

# The Spirit
# of Dada
# in New York

In 1913 the photographers Alfred Stieg-litz and Edward Steichen opened a gallery called Little Gallery of the Photo-Secession at 291 Fifth Avenue. Francis Picabia, who was in New York at this time, joined Man Ray and Morton Schamberg in forming the nucleus of a group that was in the spirit of Dada and made its headquarters at Stieglitz's gallery. When Marcel Duchamp joined them in 1915 — having come from Paris in 1913 — he became a major figure defining the negativism and anti-art character of Dada. Following the *succès de scandale* of his canvas *Nude Descending a Staircase* in New York's Armory Show of 1913, Duchamp pursued a rigorous line toward the elimination of aesthetic value as part of the definition of art. Two works exemplifying this evolution in Duchamp's attitude are *Chocolate Grinder No. 1,* (1913) [1], and *Chocolate Grinder No. 2* (1914) (Figure 1). The first version retained too much of the form and space associated with traditional art to satisfy Duchamp. In the second version the shapes are quite flat and are outlined in places with pieces of thread fixed to the canvas. Lengths of thread also played a major role in his series of "stoppages" (pieces of thread of a certain length let fall at random onto a flat surface and fixed). Satirical representations of imaginary machines symbolizing erotic human figures were the basis for his masterpiece, *The Bride Stripped Bare By Her Bachelors, Even* (called *Large Glass*), 1915-24 (Figure 2).

Duchamp also experimented with "readymades" such as *Bottle-Rack* (1914) and a urinal titled *Fountain* (1917). These were preceded by a bicycle wheel (1913) which he mounted upside down on a stool as a distraction to be enjoyed in his studio. In 1919 he

Figure 1. Marcel Duchamp. *The Chocolate Grinder No. 2,* 1914.

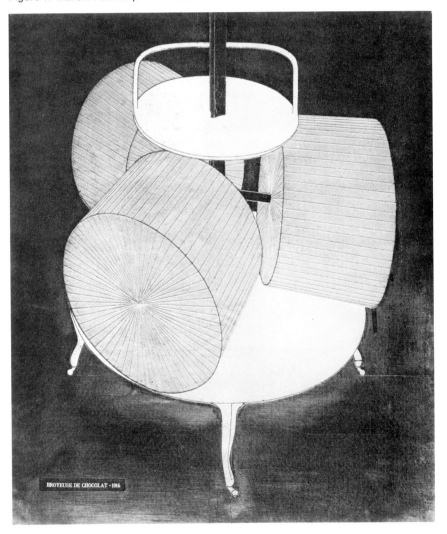

BROYEUSE DE CHOCOLAT - 1914

"improved" a reproduction of the *Mona Lisa* by adding a moustache and goatee. He gave it the title *L.H.O.O.Q.*, which, when pronounced rapidly, becomes *Elle a Chaude au Cul* ("She Has a Hot Bottom").

Duchamp's implacable logic led him to try to prevent his works from being publicly exhibited. He ceased work on the *Large Glass* in 1923, having brought it to a satisfactory "state of imcompletion"; in fact, word went out that he had stopped creating. However, he continued to work on many projects, including "roto-reliefs" (rotating disks

**1** Marcel Duchamp, *The Chocolate Grinder No. 1,* 1913

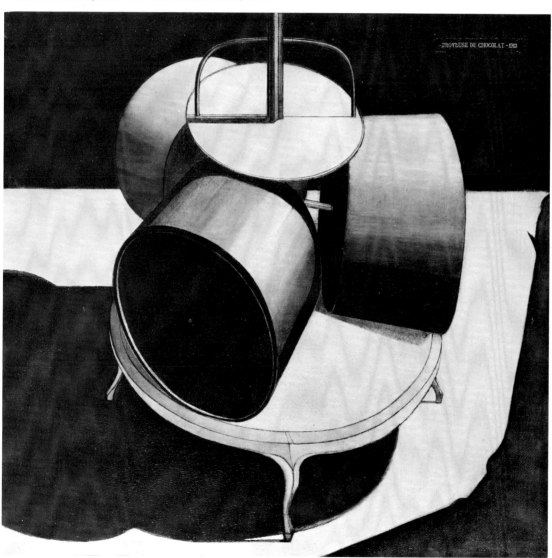

painted so as to cause the illusion of movement forward and back — a technique he had developed earlier), as well as on small reproductions of all his works for *Box in a Valise.* Other "Valises" were worked on over the years with assistants such as Joseph Cornell, Xenia Cage, and Jacqueline Matisse.

Duchamp later participated in some Surrealist films, designed installations and catalogs for Surrealist exhibitions, lectured, appeared on panels and wrote. He spent twenty years working on a tableau-assemblage, *Etant donnés: 1° la chute d'eau, 2° le gaz d'éclairage* ("To be given: first the waterfall, second the gaslight"). In 1959 (Era Pataphysique 86), on one of his return trips to Paris, he entered the Collège de Pataphysique, an organization that grew out of Alfred Jarry's invention. (See Part One section two for a definition of pataphysics; time was reckoned from 1873, the year of Jarry's birth.) Duchamp attained the rank of Transcendent Satrap — the highest obtainable in this life — and, in addition, was accorded the honor of *Maître de l'Ordre de la Grande Gidouille* (Master of the Order of the Great Gut).

Duchamp also devoted himself to the game of chess — with astonishing success. For several years he represented France in the International Chess Federation. As captain of the French team in the First International Chess by Correspondence Olympiade, he was undefeated. In 1932 he won the Paris Chess Tournament and, for a time, wrote a chess column for the Paris daily, *Le Soir.*

The paradox of Duchamp lies in the fact that this rigorously logical figure became a convincing champion of the anti-rationalist movement, Dada. Octavio Paz, the Mexican poet, has remarked: "Perhaps the two painters who have had the greatest influence on our century are Pablo Picasso and Marcel Duchamp. The former by his works; the latter by a single work that is nothing less than the negation of work in the modern sense of the word. The pictures of the former are images; those of the latter are a meditation on the image."[1] Duchamp's influence on younger contemporary artists is probably challenged only by that of Picasso and Matisse. With Pop Artists, Minimalists, and Conceptualists, his influence is unrivalled.

Devoting much of his life to sarcastic mockery of the romantic concept of the artist, Duchamp continually attempted to recall Surrealism to its original revolutionary basis. He never entirely surrendered the principles of Dada, however, particularly its insistence that one's mode of living took precedence over the creation of art objects. Evidence to support this conviction came toward the end of his life when he traveled about genially delivering a witty and satirical lecture entitled "Apropos of Myself."

Figure 2. Marcel Duchamp. *The Bride Stripped Bare by Her Bachelors, Even (The Large Glass),* 1915-23.

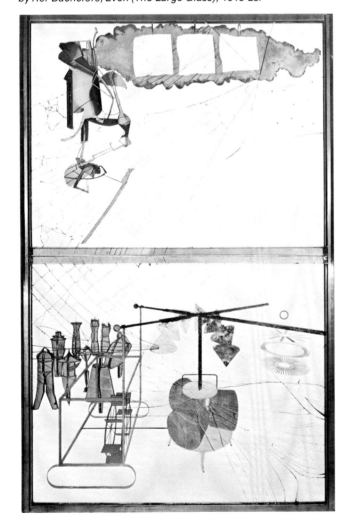

## FRANCIS PICABIA
## 1879-1953

Like Picasso, Joan Miró, Juan Gris,
Julio Gonzalez, Pablo Gargallo, Sal-
vador Dali, and Roberto Matta — among
other contemporary masters — Picabia
had Spanish blood: his father had been
a wealthy Cuban businessman. His
mother came from an upper middle-
class French family. He was born in
Paris in 1879 and, as a young man,
studied at the Ecole Nationale des
Beaux-Arts. In 1903 he gave up his
academic style and began to work in a
pseudo-Impressionist manner. He then
passed through various phases, includ-
ing Fauvism and a kind of Cubism re-
lated to Léger's and to Delaunay's
Orphism.

At the 1913 Armory Show in New
York, Picabia's *Dances at the Spring*
ranked second after Duchamp's *Nude
Descending a Staircase* as a *succès de
scandale.* After his return to Paris from
New York he was filled with enthusiasm
and energetically set about painting a
group of important canvases including
*Edtaonisl* and *Udnie.* Picabia never in-
terpreted those titles, but the American
painter Philip Pearlstein has proposed a
translation of *Edtaonisl* as an anagram
of *étoil(e)* and *dans(e)* as Star Dancer
and *Udnie* as Nudie.[2] The last of three
large canvases in this group was
painted in 1914 and is titled *I See Again
in Memory My Dear Udnie* [2]. This
composition uses hoses, spark plugs,
and other mechanical elements to refer
to human anatomical parts and to the
act of sexual intercourse.

During World War I, Picabia, although
not a French citizen, allowed himself to
be taken into the French army as chauf-
feur to a general who was a friend of his
family. In 1915, in a rare instance of
army logic, the half-Cuban was sent to
Cuba to obtain sugar for the French
army. He went by way of New York and
once there, joined Duchamp, Man Ray,

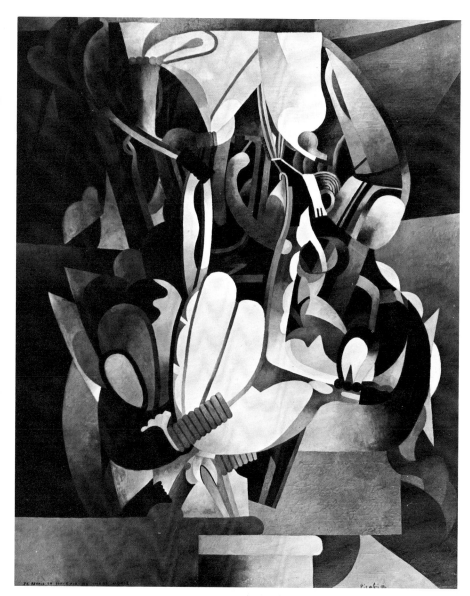

**2** Francis Picabia, *I See Again in Memory My Dear Udnie
(Je Revois en Souvenir Ma Chère Udnie),* 1914

and others in forming the circle of artists and writers around Alfred Stieglitz and the collectors the Walter Arensbergs. Somehow, Picabia was able to move about, even during the war — from Zurich to Barcelona and Paris — carrying ideas from group to group. While in Barcelona he founded a pamphlet titled *391,* based on Stieglitz's and Duchamp's publication *291* (named after the address of Stieglitz's gallery in New York). By 1918 he was serving as a link between the German Dadaists in Zurich and the French Dadaists in Paris.

In 1921 he followed André Breton's lead toward the development of Surrealism, but three years later when Breton defined Surrealism in his Manifesto, Picabia broke away. His erratic journeys and reversals of loyalties, beliefs, and styles suggest an enthusiastic but unstable personality. A self-styled dandy who loved automobiles, yachts, and women, he referred to his paintings as "shadows of my adventures." Periodically he destroyed those works which he though unsatisfactory; of those which remain, many are in delicate condition because of the unstable materials that he used.

3  Man Ray, *The Rope Dancer Accompanies Herself with Her Shadow,* 1916

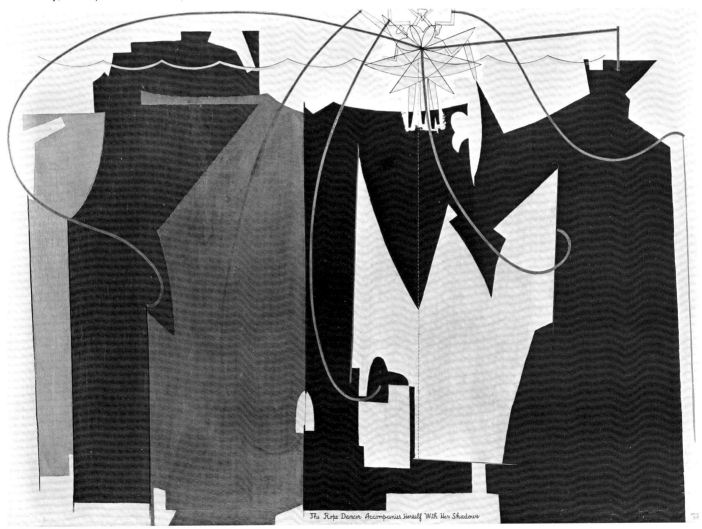

# MAN RAY
# 1890-1976

A third major figure manifesting the Dada spirit in New York was Man Ray, an American painter and photographer. He had helped to found an artists' colony (1913) in New Jersey, where in 1915 he met Duchamp; that same year he met Picabia. Man Ray was intellectually and psychologically prepared for the meeting by his association at the colony with anarchistic and socialistic writers such as Max Eastman, William Carlos Williams, and Alfred Kreymborg. He was close to a French girl, Adon Lacour, who later became his wife and who helped familiarize him with the work of poets such as Rimbaud and Mallarmé. Duchamp and Picabia were as happy to find an avant-garde group of intellectuals in the United States as Man Ray was delighted to meet these members of the European avant-garde.

Man Ray opposed the tradition of the "well-painted picture," finding collage and object-making more to his liking. His first major painting, *The Rope Dancer Accompanies Herself With Her Shadows* [3], done in 1916, uses flat shapes painted in clear, unmodulated colors, causing the painting to resemble a collage. In fact, the painting was preceded by a small collage of the same subject. The skirt and multiple legs of the mechanical image of the rope dancer in the upper part of the painting suggest machine-like movements. The shadows are large, irregular shapes painted with intense reds, blues, yellows, greens, and a brownish-purple. In the original collage they were made of the pieces that remained of the sheets of colored paper from which the figure of the dancer had been cut.

When Man Ray arrived in Paris in 1921 he was enthusiastically inducted into the French Dada group by Breton and his friends. In order to earn a living he photographed his new friends and made photographic records of their works. Meanwhile, his important Dada creations were what he called "aerographs" and "rayographs." The former were images made by using an air gun to spray paint over stencils and templates; the latter, by exposing photo negatives to strong light in various ways while developing them. Some of these were published under the title *Les Champs Délicieux* (The Delicious Fields).

Man Ray had long been involved with assembling found objects. In his first year in Paris he made *Cadeau,* a flatiron with nails protruding from its bottom. One of his most striking objects was a sewing machine and umbrella wrapped in sackcloth and bound with ropes (fifty years before Christo began wrapping objects), entitled *The Enigma of Isidore Ducasse.*

Among Man Ray's later works suggesting the precarious psychological situation of mankind is a sculpture, *L'Homme Nouveau* [4]. A naked mannequin carved out of wood sits with bowed head, cramped within a box. It

**4** Man Ray, *L'Homme Nouveau (The New Man),* 1964

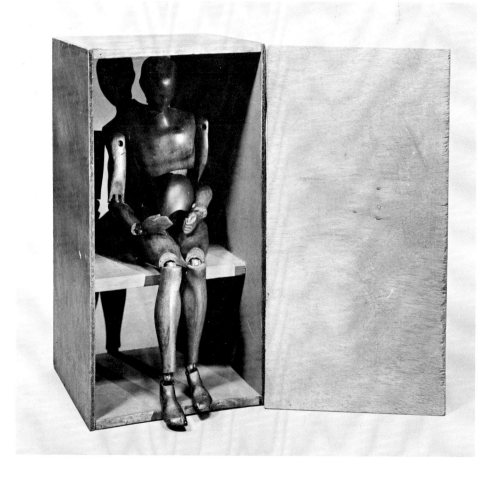

appears that Man Ray is commenting on man's inability to free himself from the structures that he has invented to protect himself. Hidden within his restrictive enclosure, the characterless figure presents a fearful image — like a child in a closet or a man in a fallout shelter.

Perhaps the most important of Man Ray's works are his films. Among these are *Retour à la Raison* (1923), *L'Etoile de Mer* (1928), and *Les Mystères du Château de Dé* (1929). He also appeared in René Claire's *Entr'acte* (1924) and collaborated on Hans Richter's *Dreams That Money Can Buy* (1946) and *8 X 8* (1952). (The last film was based on Duchamp's passion for chess.)

1. Octavio Paz, *Marcel Duchamp's Appearance Stripped Bare,* trans. Rachel Phillips and Donald Gardner (New York: Viking Press, 1978), pp. 1, 3.
2. Philip Pearlstein, "The Symbolic Language of Francis Picabia," *Arts* 30 (January 1956): 37-43.

# Dada in Europe

**5** Jean (Hans) Arp, *Collage,* 1938

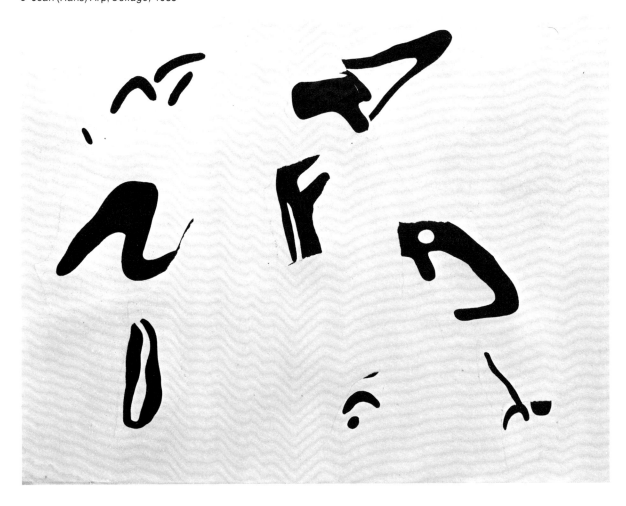

## JEAN (HANS) ARP
## 1887-1966

Arp joined his family in Weggis, Switzerland, in 1915 when his German citizenship (he had been born in Strasbourg in Alsace) made his presence in wartime Paris uncomfortable. That summer Hugo Ball invited him to join the group of artists, poets, and other intellectuals that was gathering in Zurich. Arp fitted easily into the group, and so participated in the formation of the Dada movement.

He began to make rectilinear papiers collés which continued a style he had used earlier in the decoration of a theosophical institute in Paris. He soon extended this technique to include compositions "according to the laws of chance." Hans Richter has described Arp's discovery of the significant role that the unconscious could play in the creative process: "Dissatisfied with a drawing he had been working on for some time, Arp finally tore it up, and let the pieces flutter to the floor of his studio in the Zeltung. Some time later, he happened to notice these same scraps of paper as they lay on the floor, and was struck by the pattern they formed. It had all the expressive power that he had tried in vain to achieve, namely *expression*."[1]

Although Arp himself believed that he allowed chance to play a major role in this process, he also recognized that the pieces of paper were consciously selected and dropped. He explained that he developed the collage automatically — by "arranging" the pieces without will[2] — even later works such as *Collage* [5].

At about the same time (1916), he transformed the process of collage into assemblage. He glued together biomorphic shapes which he had cut out of wood approximately an inch thick. He painted some of these assem-

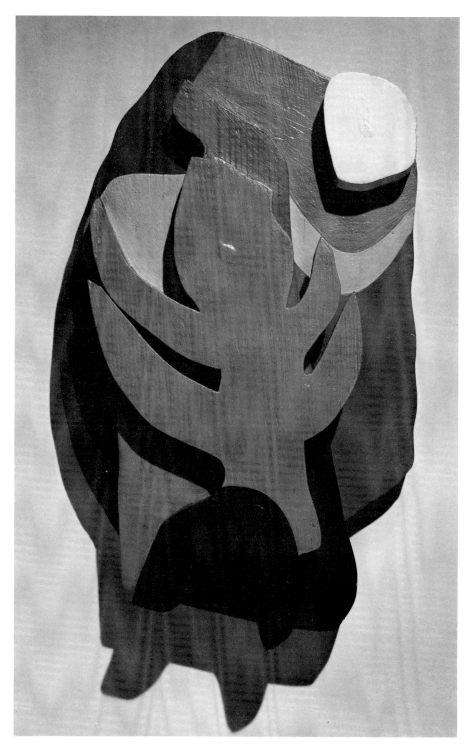

**6** Jean (Hans) Arp, *Forest,* 1916

15

bled reliefs, such as two works entitled *Forest* [6, 6A]; others he left with the raw wood exposed. Both these reliefs were inspired by the branches, pebbles, and foliage that Arp noted while sitting on the beach of Lago Maggiore in Ascona in 1916. The subject of the first — a tree, clouds, and sun — seems relatively clear; that of the second is not. Both, however, are richly colored with graceful, fluid shapes harmonized in light and vigorous compositions. The biomorphic character of these wooden works probably owes something to Kandinsky's early Non-Objective paintings and perhaps even to Art Nouveau, but Arp's attitude toward the creative act was closer to that of Schwitters and Paul Klee. Like them, he considered the work of art to be produced by the artist as gratuitously as "a fruit is by a tree."

When World War I ended, the Dada group in Zurich dispersed to various centers in Europe, especially Paris and Berlin. Arp spent most of 1919 and 1920 with Max Ernst and Johannes Baargeld

**6A** Jean (Hans) Arp, *Forest,* ca. 1916

(Alfred Grünewald) in Cologne, where they formed the Dada Conspiracy of the Rhineland with headquarters at W/3 West Stupidia. He contributed to *Die Schammade,* a journal whose title made no sense, and collaborated with Ernst on a series of collages that they called *Fatagaga.* (The name was created from the phrase *FA*brication de *TA*bleaux *GA*rantis *GA*zometriques — "Manufacture of Pictures Guaranteed to be Gasometric.") Also in 1920 Arp went to Berlin, where he met Kurt Schwitters who was visiting there; the two formed a close and lasting friendship.

When Breton published the first Manifesto of Surrealism in 1925, it had no effect on the work of artists such as Arp or Schwitters. Arp's stylistic evolution was undisturbed as he continued to develop his own poetic-plastic language. *Mountain, Table, Anchors, Navel* [7] differs from the painted wooden reliefs done nine years earlier only in that it is painted on cardboard with shapes cut out rather than piled on top of one another. *Homme-Oiseau* [8], a later painted wooden relief, is a metamorphic figure referring to man's ancient dreams of flying like a bird.

**8** Jean (Hans) Arp, *Homme-Oiseau (Man-Bird),* 1956

**7** Jean (Hans) Arp, *Mountain, Table, Anchors, Navel,* 1925

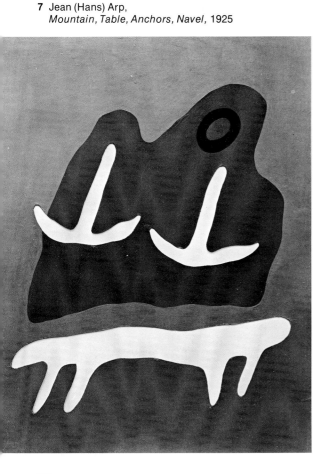

In 1930 Arp began to do sculpture in the round. *Shell Crystal* [9], done in 1938, continues his involvement with a plastic language based on organic forms. Arp wrote poetry and, as might be expected, was more spontaneous with words than with carved, modelled, or cast forms. Yet, he was surreal in his insistence upon the absolute oneness of mankind and nature. ''I love nature,'' he wrote, ''but not its substitutes. . . . [I] do not want to reproduce but to produce . . . like a plant that produces fruit.''[3]

**9** Jean (Hans) Arp, *Shell Crystal,* 1938

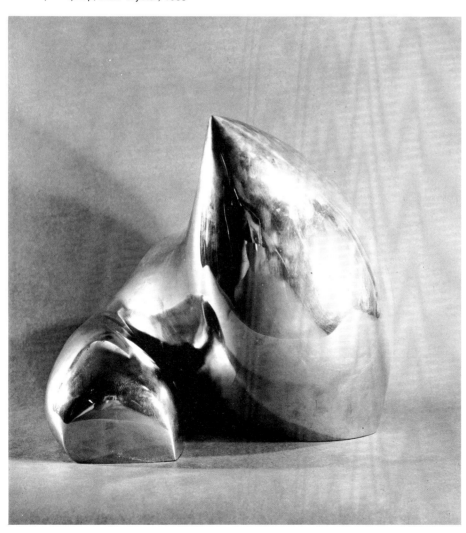

*Head on Claws* [9A], made by Arp in 1949, is a biomorphic form with tentacle-like appendages ending in claws. The horrors of World War II concentration camps, compounded by Hiroshima and Nagasaki, affected the images produced by many artists during this period.

In 1960 Arp produced *Tête Heaume* [9B], a motif that Henry Moore also used. The curved, indented section in the casque-like form with its deep shadows suggests an impersonal, robot image that refers not so much to the past as to the present and future.

**9A**  Jean (Hans) Arp, *Head on Claws (Tête sur Griffes),* 1949

**9B**  Jean (Hans) Arp, *Tête Heaume,* 1960

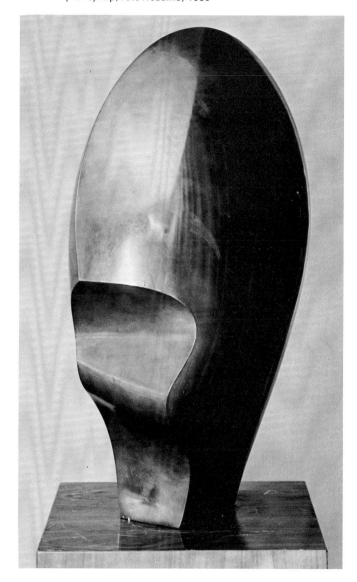

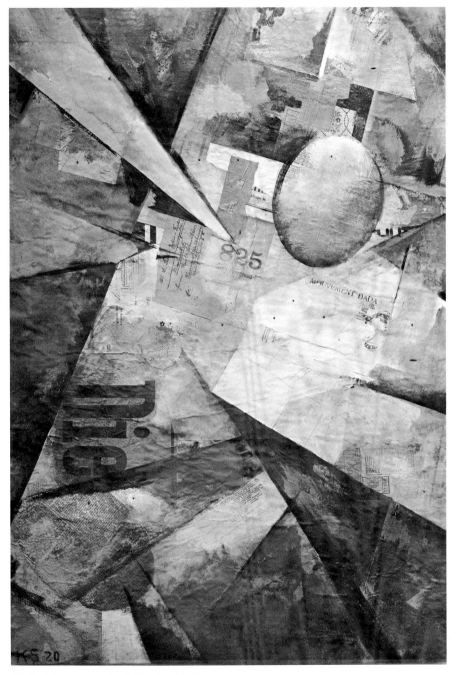

**10** Kurt Schwitters, *Radiating World,* 1920

# KURT SCHWITTERS
## 1887-1948

In Hanover, Schwitters, a gifted artist, established a unique branch of Dada which he called Merz. Like Arp, he adapted the Cubist collage technique for his own ends. He created papiers collés and collages out of bits of rubbish that he collected while wandering the city streets [10, 11, 12]. These pieces carried with them associations of their role in the world. One, a fragment of a pasteboard advertisement for a *Kommerz und Privatbank* (Commercial and Private Bank), still retained the letters "merz," and Schwitters adopted it to designate his own particular kind of Dada.

In 1919 he published *Anna Blume,* a poem formed by piecing together the words of sentimental bourgeois clichés, the first of a series of *Anna Blume* poems. In addition to the many small, elegant collages and some larger ones that he unceasingly created, he made three *Merzbau* (merz constructions). Two were *Schwitters-Säules* (Schwitters Columns), while the last was a constructed relief. They were made of plaster, pieces of wood, and rubbish of all kinds. The first, called *Kathedrale des erotischen Elends* (The Cathedral of Erotic Distress), was the most fully developed, although it was never completed. It began as an abstract construction in the middle of a room in a house in Hanover that Schwitters had inherited. It grew to a height of twelve feet and had a variety of parts, to which he gave names such as *Goethegrotte* (Goethe Grotto), *Nibelungenhort* (Nibelung's Treasure), *Lustmordhöhle* (Sex Murder Cavern), *10%-igen Kriegsbeschädigten* (The 10% War Injured), *Grosse Grotte der Liebe* (Great Grotto of Love), and *Klossetfrau des Lebens* (Lavatory Attendant of Life).

Schwitters said that he knew of "only three men who, I assume, will understand me completely when I speak through my pillar — H. Walden, Dr. S. Giedion, and Hans Arp." This column, with which he most completely identified, was destroyed by an air raid in 1943.

Beginning in 1929, Schwitters visited Norway repeatedly. In 1937 he moved permanently to the outskirts of Oslo where he began the second *Merzbau*, abandoned when the Germans invaded that country. In 1951 it was destroyed by a fire started accidentally by children. Finally, in his studio near Ambleside, England, where he settled in 1945, he began the third *Merzbau* in a barn. He received financial assistance from the Museum of Modern Art in New York and was partially supported by his friend, Edith Thomas. Unfortunately, before the work had progressed very far, Schwitters died of a heart ailment at the age of 61. Eventually, this *Merzbau* was moved to Newcastle-Upon-Tyne by the fine arts department of the university in that city.

According to Breton, the first *Merzbau* was made because: *"The model of yesterday, taken from the external world, no longer existed and could no longer exist. The model that was to succeed it, taken from the internal world, had not yet been discovered."*[4]

Huelsenbeck had refused to accept Schwitters as a member of the Berlin Dada group. He later said he could not bear Schwitters' bourgeois face, but probably the real reason was that Schwitters lacked interest in politics and was still concerned with the idea of art. Furthermore, Schwitters associated with the anti-Dadaist group, *Der Sturm*, in Berlin, and later joined the geometrical abstract *Cercle et Carré* movement in Paris.

Hans Richter recounts an incident which poignantly contrasts Schwitters' sly wit and resilient spirit with the vitriolic temper of some of the Berlin Dadaists. One day, while in Berlin, Schwitters decided he wanted to meet George Grosz. As Richter tells it:

George Grosz was decidedly surly; the hatred in his pictures often overflowed into his private life. But Schwitters was not one to be put off. He wanted to meet Grosz, so Mehring took him up to Grosz' flat. Schwitters rang the bell and Grosz opened the door.

"Good morning, Herr Grosz. My name is Schwitters."

**11** Kurt Schwitters, *Little Dance (Kleiner Tanz),* 1920

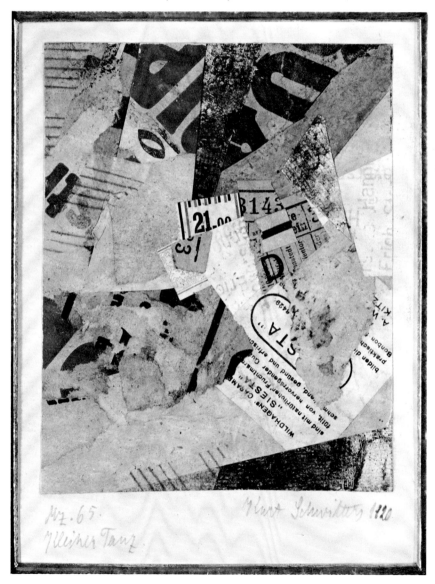

21

"I am not Grosz," answered the other and slammed the door. There was nothing to be done. Halfway down the stairs Schwitters stopped suddenly and said, "Just a moment." Up the stairs he went and once more rang Grosz' bell. Grosz, enraged by this continual jangling, opened the door, but before he could say a word, Schwitters said, "I am not Schwitters either," and went downstairs again. Finis.[5]

12  Kurt Schwitters, *Untitled,* 1923

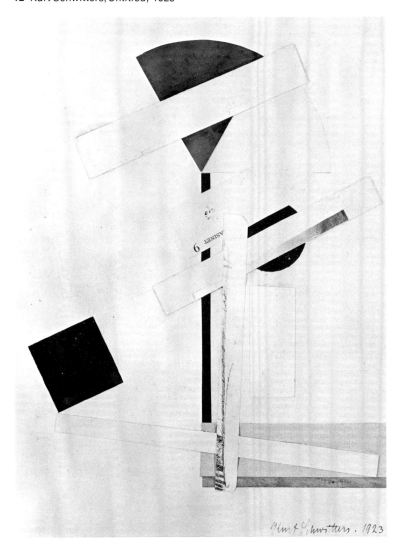

# MAX ERNST
# 1891-1976

In Cologne another branch sprouted from the Dada trunk. The painter, collagist, and writer Max Ernst was both its leader and most illustrious member. However, Johannes Baargeld, also a painter, was essential to the Cologne group since his father, an affluent banker, assisted financially in publishing the Dada journal *Die Schammade*.

(Thus the name Baargeld was given to Grünewald by his friends — *bargeld* meaning cash in German.) This publication had replaced *Der Ventilator* (The Electric Fan) which was banned by the British occupational authorities as subversive. When his son showed an inclination to collaborate with Ernst on the new publication that was more concerned with Dadaism than with Communism, Baargeld's father was so relieved that he helped finance the venture.

The Cologne group developed close ties with Paris which was becoming the new center of Dada activity; Paris was far removed from the political action of the Berlin group. The Communist revolution was trying to spead westward, and leading German Socialists such as Karl Liebnecht and Rosa Luxemburg were arrested, imprisoned, executed, or assassinated. In Berlin the Dadaists sided actively with the Bolsheviks. The Club Dada was formed there in 1918 by Huelsenbeck, who had returned from Zurich. George Grosz, Johnny Heartfield (Hans Herzfelde), his brother Wieland Herzfelde, and Walter Mehring, among others, were members. In Cologne, Hanover, and Paris, however, Dada was content to preserve its anarchistic character by opposing all traditions as well as any efforts to organize society.

Tzara had arrived triumphantly in Paris in 1920; Ernst came in 1921, and thereafter, except for the years spent in the United States during and after World War II, made the French capital his home.

Like Schwitters and Arp, Ernst adapted the collage technique to his own ends. On the surface, these three artists had much in common. They were sensitive, intelligent, gifted, and witty; yet the cast of their minds was quite different. Ernst's cultured intellect often produced images of demonic and erotic fantasy; Schwitters' bourgeois character led him to create collages and con-

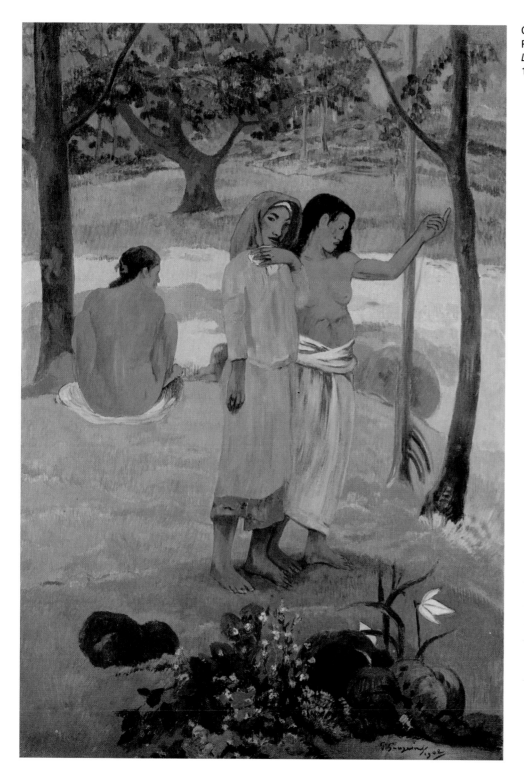

Color Plate I.
Paul Gauguin,
*L'Appel (The Call),*
1902 (Figure 5).

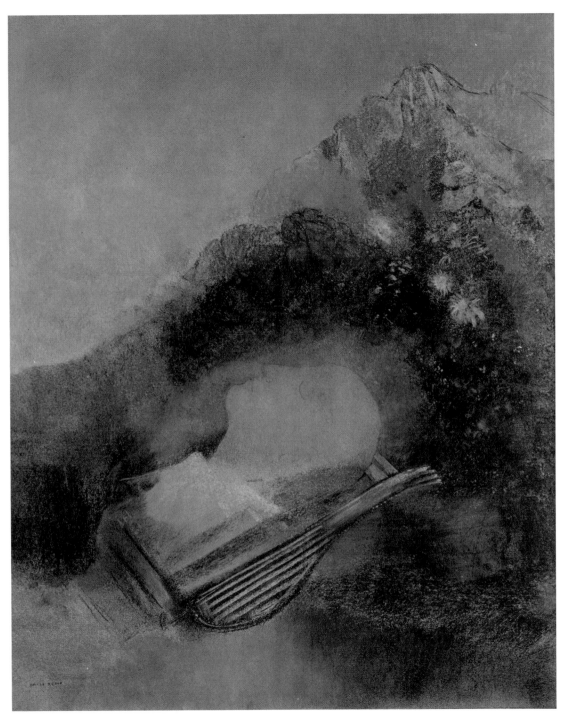

Color Plate II. Odilon Redon, *Orpheus,* painted after 1913  (Figure 4).

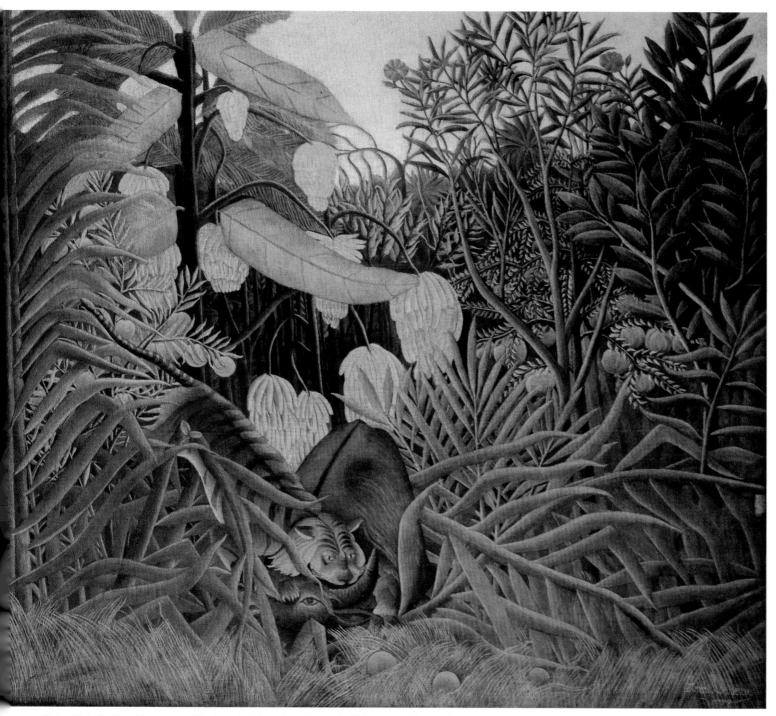

Color Plate III. Henri Rousseau, *The Jungle: Tiger Attacking a Buffalo*, 1908 (Figure 8).

Color Plate IV. Francis Picabia, *I See Again in Memory My Dear Udnie*
*(Je Revois en Souvenir Ma Chère Udnie)*, 1914 [2].

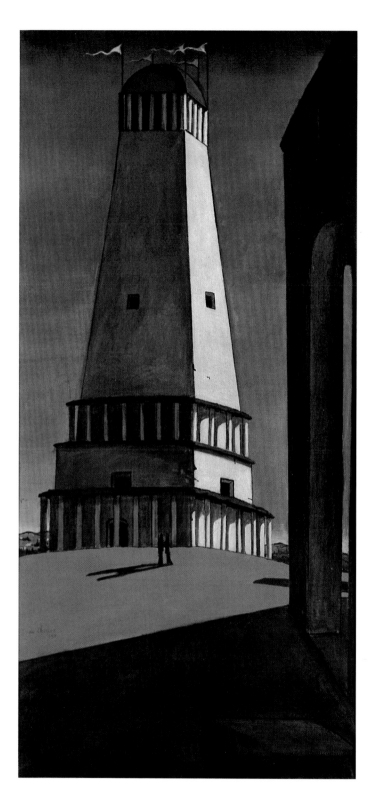

Color Plate V.
Giorgio de Chirico,
*The Nostalgia of the Infinite,*
1913-14  (?), dated on painting 1911   [13].

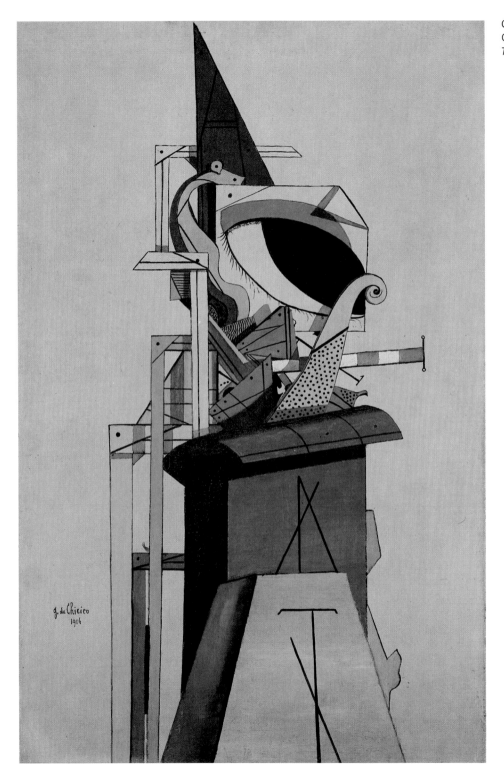

Color Plate VI.
Giorgio de Chirico,
*The Jewish Angel,* 1916  [17].

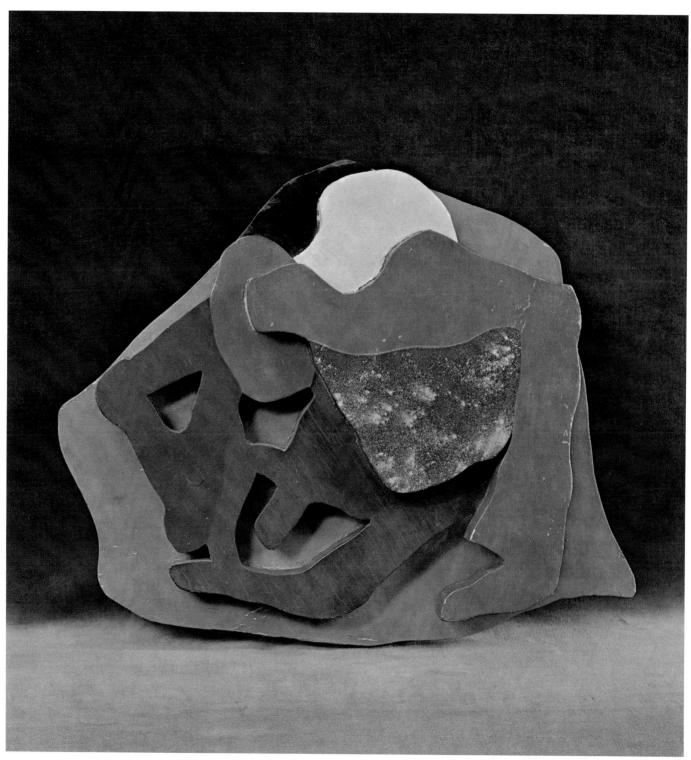

Color Plate VII. Jean (Hans) Arp, *Forest,* ca. 1916  [6A].

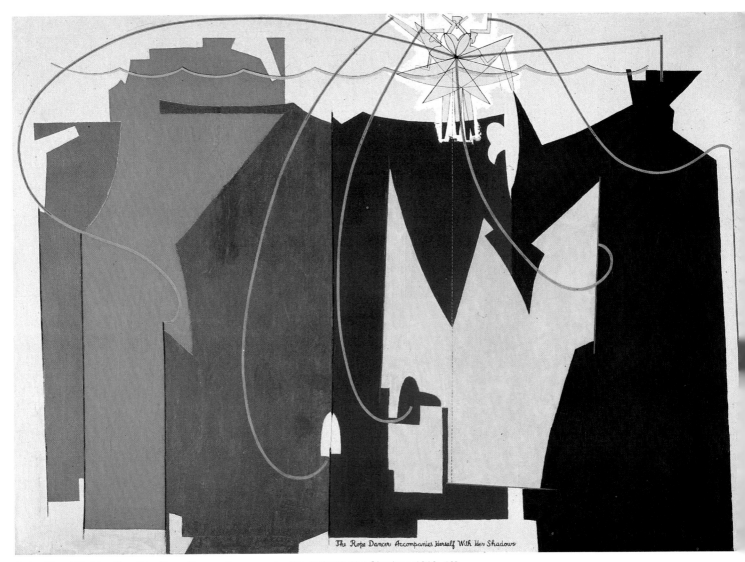

The Rope Dancer Accompanies Herself With Her Shadows

Color Plate VIII. Man Ray, *The Rope Dancer Accompanies Herself with Her Shadow,* 1916  [3].

structions demonstrating the straightforward iconoclasm noted by Breton; while Arp's poetic temperament caused him to reflect the unity of nature in all its myriad forms and metamorphoses in his work. Furthermore, Schwitters' sly wit and Arp's good-natured humor contrast sharply with Ernst's highly erotic, scatological, and occasionally black humor.

All three artists utilized stimuli that came easily to hand to make sophisticated and elegant works. Schwitters used the debris of the streets, Arp chose biomorphic forms from nature, and Ernst made rubbings from the grain of wood planks and other irregular surfaces which he joined with clippings from old journals to develop bizarre images and combinations of images. In contrast to Duchamp, who relished the vulgar objects that he found, these three composed them in ways that demonstrated the victory of human sensibility over brute, mundane matter.

Because of Ernst's major importance as a Surrealist artist, he will be treated later, in Part Three.

1. Hans Richter, *Dada: Art and Anti-Art* (New York and Toronto: McGraw-Hill, 1965), p. 25.

2. Herbert Read, *The Art of Jean Arp* (New York: Harry N. Abrams, Inc., 1968), p. 38.

3. Jean Arp, "Art Is a Fruit," and "Concrete Art," in *On My Way: Poetry and Essays, 1912-1947* (New York: Wittenborn, Schultz, 1948), pp. 51, 70.

4. "Genesis and Perspectives of Surrealism in the Plastic Arts," reprinted in André Breton, *What Is Surrealism?* (New York: Monad Press, 1948), p. 221.

5. Richter, p. 145.

**18** Max Ernst, *Landscape Fantasy,* ca. 1916

# The End of Dada

Following the Armistice, despite the flurries of Dadaist activity elsewhere, Paris emerged as the new center of Dada. Literary figures — particularly poets — still dominated the movement. The domineering, charismatic leader of the Dada movement in Paris was André Breton. In January 1920 he was joined by Paul Eluard, Louis Aragon, Philippe Soupault, Benjamin Péret, and others to give Tzara a hero's welcome when he arrived in Paris. However, in hindsight, it seems all but inevitable that these two forceful personalities would eventually clash.

Despite the active participation of Picabia, Arp, Ernst, and Schwitters in Dadaism, visual artists were not highly regarded by many of the literary figures. Although the writers had an obvious advantage in articulating ideas verbally, the painters, collagists, and sculptors faced the paradoxical problem of creating visual art forms which renounced plastic form and aesthetic value. Duchamp's logical mind led him to almost give up creating art objects altogether. Most Dada painters and sculptors agreed with Dada's theoretical platform but continued to make aesthetic objects — even though they seemed shockingly unaesthetic at the time.

Relations between Breton and Tzara gradually deteriorated in a series of unfortunate incidents. The Rumanian remained staunchly anarchistic, while the Frenchman was increasingly inclined toward a positive program. Breton had been gradually organizing his ideas and gathering followers since 1921, when Tzara reluctantly participated in a mock trial of the ex-liberal turned patriotic writer, Maurice Barres, over which Breton presided as judge. An open break occurred in 1922 when Tzara refused to participate in a congress which Breton proposed to organize in Paris. In retaliation, Breton declared that Serner, not Tzara, had written the Dada manifesto in 1918. Breton was criticized and condemned by the Dadaists for his attack on Tzara, and support for his congress was withdrawn. Tzara counterattacked by lampooning Breton in the pamphlet *Le Coeur à Barbe* (The Bearded Heart), which he edited.

In July of 1923 Tzara organized a soirée which included a performance of his *Coeur à Gaz* (Heart of Gas). With his friends Louis Aragon, Benjamin Péret, and Paul Eluard, Breton carried out a demonstration at Tzara's performance that caused a riot. The police were summoned and Eluard was sued for the cost of the damages done to the theater. Breton accused Tzara of the odious act of calling in the paid enforcers of the despised bourgeoisie's laws against his own comrades. Tzara, however, claimed that Picasso, who was seated in a box, shouted, "Tzara, no police here!" Tzara's name was therefore linked with the police unwittingly by Picasso.

Thus, Dada lived out its paradox: brought into being by opposition to conflict, Dada died from internal conflict. Its life span was barely ten years.

*Opposite*
André Breton (center, in white) in a French army hospital, World War I. Photograph from Malcolm Haslam, *The Real World of the Surrealists* (London: Weidenfeld and Nicolson, 1978).

# PART TWO
## The Surrealist Spirit Emerges

Expression is not one of the curiosities that the mind can propose to examine, it is the mind's existence as art.      Merleau-Ponty

# The Crucial Role of André Breton

As André Breton gathered his forces for an attack on Dada and on Tristan Tzara, he emerged by far the strongest figure of his group. His very physical presence was imposing. A serious demeanor and a massive head with a great shock of hair combed straight back gave him a leonine appearance. His strictness in interpreting his own orthodoxy, and his uncompromising nature, led him to quickly excommunicate those who disagreed with him, thereby earning him the designation, *Il Papa* (The Pope) of Surrealism.

The Manifesto of Surrealism published by Breton in 1924 marked his final separation from Dada. The break had become inevitable in 1922 when Breton renounced Dada in "Leave Everything," an article published in the second issue of *Littérature.* Referring to Tzara, Breton wrote: "During recent years I have realized the damage wrought by a certain intellectual nihilism whose malice consisted in raising, upon every possible occasion, the broadest and most futile question of confidence." Breton believed that the time had come for the destructive program of Dada to be replaced by a more positive, creative approach. In the Manifesto he defined Surrealism in the following terms:

SURREALISM, *n.* Psychic automatism in its pure state, by which one proposes to express — verbally, by means of the written word, or in any other manner — the actual functioning of thought. Dictated by thought, in the absence of any control exercised by reason, exempt from any aesthetic or moral concern.

ENCYCLOPEDIA. *Philosophy.* Surrealism is based on a belief in the superior reality of certain forms of previously neglected associations, in the omnipotence of the dream, in the disinterested play of thought.[1]

Earlier he stated: "I believe in the future resolution of these two states, dream and reality, which are seemingly so contradictory, into a kind of absolute reality, a *surreality,* if one may so speak."[2] The term Surrealism had been used loosely by Guillaume Apollinaire in 1917 as part of the subtitle for his drama *Les Mamelles de Tirésias;* earlier he had used it in a brief, printed discussion of the ballet *Parade.* Ivan Goll, an Alsatian writer, also used it as the title of a short-lived review. However, Breton used it in a way which linked it specifically to Sigmund Freud's psychoanalytical theories and techniques. Breton was deeply influenced by Freud's methods and had used them in treating victims of battle fatigue during World War I when he served in the Medical Corps. He was so impressed by his successes — and by Freud's theory of the personality structure — that he visited the pioneer psychoanalyst in Vienna in 1921. Furthermore, Breton's Manifesto of Surrealism was decisively influenced by Freud's means of treating pathological personalities by probing the unconscious levels of their minds.

In brief, Freud conceived of the psychic apparatus as beginning at birth with the id — the bundle of primitive urges, drives, and hungers that motivate every form of animal life. In order to live, most animals satisfy these basic urges regardless of whether or not they are ethical or moral in the human sense. As the human child matures, it learns to discriminate between what is good and bad in the outer world (touching a hot stove, for example, hurts), and between virtuous and evil behavior. The part of the psyche that becomes aware of the outer world — the ego — is also the part which helps to prevent the child from satisfying its blind drives. All animals have a well developed ego which prohibits them from taking dangerous risks. Only man, however, develops the superego which represents the internalization of parental (especially pater-

nal) prohibitions, resulting in moral attitudes and a sense of guilt. When the drives of the id are frustrated to an exorbitant degree, extreme psychic tensions may result, and the personality seeks to preserve its equilibrium by allowing them to find symbolic expression in dreams or by sublimating them into socially acceptable actions, such as the creation of works of art. If this proves insufficient for the person, neurotic or even psychotic behavior may result. Freud's primary method for aiding his patients was the recall of dreams and their analyses by means of free association — a method adapted by Breton and the Surrealists in order to explore the unconscious as a new source for poetic imagery.

Freud's investigations into the development of the structure of the psyche in the individual child and the function of dreams also led to speculation about the childhood of the race and the function and meaning of myths and fairy tales. The Oedipus complex, for example, which refers to the first struggle between the son and his father, is found in primitive history when a son often actually did kill the father and eat his flesh. The civilized boy today goes through the same struggle with his father that his remote ancestor did; the difference is that the primitive boy really killed his father, while the civilized child represses this urge and only dreams of his father's death.

Through Breton's influence, Surrealism was thus led by psychoanalysis from a concern with individual dreams to an interest in myth and fairy tales as well. It accepted the proposition that the human personality begins as a healthy unit that is dissipated as rational thought compartmentalizes experience.

It proposed that illogically related images, such as those occurring in dreams, provide greater insight into the nature of reality than rationally organized concepts. Logical thought, as an intellectual tool, was developed at a rather late date in man's history; according to Surrealism, its failure was dramatized by the First World War.

The war had exploded the myth of inevitable progress in human affairs when they are controlled by reason, particularly as it is manifested in Western science. Traditional scientific method itself was questioned. Doubts were raised about the possibility of scientific objectivity as well as the scientist's abilities to investigate and control the environment for man's benefit. Dada had simply ridiculed these ideas, while Surrealism went farther by arguing that each individual human being is an integral part of all nature and, therefore, incapable of distinguishing himself from the outer world and investigating it objectively.

Even some scientists had begun to question the validity of their traditional assumptions and methods of problem-solving. Physicists such as Max Planck, Niels Bohr, Werner Heisenberg, and Albert Einstein postulated systems so small (or large) that Newtonian physics no longer applied and complete determinism became impossible. Non-Euclidian geometrics and quantum mechanics appeared to explain phenomena that could not be accounted for by traditional science. Terms such as "relativism," "tychism," and "uncertainty principle," began to appear in reputable scientific publications.

While all the Surrealists could hardly have been fully aware of the significance and ramifications of these developments, some were at least broadly conscious of them and the affinity with their own mistrust of empiricism, materialistic-mechanism, and

rationalism as means of explaining human experience.

Breton had first appeared on the literary scene in Paris during the last years of the First World War when he published some poems in a somewhat Symbolist, Mallarméan style that attracted the attention of Paul Valéry, a disciple of Mallarmé's. Valéry helped Breton find publishers and got him a job proofreading Proust's great novel, *Remembrance of Things Past.* In fact, Breton's technique of automatic writing is not too unlike Proust's free-flowing method of memory recall.

In 1919 Breton collaborated with Philippe Soupault in composing *Les Champs magnetique* (The Magnetic Fields), which Breton later declared to be the first "incontestable Surrealist works . . ." and "the first systematic applications of automatic writing."[3] The key word here is systematic; for Surrealism structured, to a degree, the freer, more chaotic experiments of the Dadaists.

Among Breton's most important creative writings, aside from the poems, are *The Soluble Fish,* a prose poem appended to the first Manifesto in 1924, and the autobiographical novel, *Nadja,* published in 1928. The latter is a strange tale about his chance encounter with a disturbing — and disturbed — girl possessing psychic powers, who led him into frightening adventures which culminated in her insanity and suicide. Breton claimed the story was completely factual, although it should be remembered that he aimed to achieve a merger of reality and dream in an overriding sur-reality. In any case, he was so obsessed by the events — whether completely factual or not — that it precipitated a break with his wife, Simone.

Breton's major importance as a writer, however, lies in his theoretical and polemical works, which include the first and second Manifestoes of Surrealism (1924 and 1930), *Legitimate Defense* (1936), *On the Time When Surrealists were Right* (1935), *What Is Surrealism?* (1936), *Short Dictionary of Surrealism* (with Paul Eluard, 1938), *Anthology of Black Humor* (1940), and *The Communicating Vessels* (1932). The vessels in the last work represent dream and sensible reality, and Breton reaffirmed his conviction that the two were interdependent — two parts of a single reality.

In 1937 Breton published *L'Amour fou* (Mad Love). In this work, he defined a kind of love which is analogous to automatism. It strikes like a bolt from the blue, causing the lovers to do whatever is necessary — to violate all social mores and routines — in order to realize their passionate devotion. There is no explanation for *l'amour fou* and no denying its demands. It is revolutionary love since it recognizes no authority but itself. Further, it is monogamous love which does not decline with time. "Reciprocal love," according to Breton, "is an arrangement of mirrors which reflects back to me, by the thousand angles which the unknown can take for me, the faithful image of the one I love, always more surprising by divination of my own desire and more brilliantly gilded with life."[4]

*L'amour fou* has much in common with Benjamin Péret's concept of *l'amour sublime.* Together, they form a Surrealist myth in which the beloved is the idol. It is, in short, the deification of love, replacing love of God with human love.

Above all, Surrealism sought to reveal what Breton called *le merveilleux* (the marvelous) from deep in the unconscious. In his first Manifesto Breton declared: "Let us not mince words; the marvelous is always beautiful, anything marvelous is beautiful, in fact only the marvelous is beautiful."[5] A few years later Breton expressed an idea in the last line of his novel *Nadja:* "Beauty will be convulsive or will not be at all." Nearly ten years after that, in *L'Amour fou,* he repeated this conviction in the words: "Convulsive beauty will be erotic-veiled, explosive-fixed, magic-circumstantial or will not be at all."[6]

These three concepts — *le merveilleux, l'amour fou,* and *la beauté convulsive* — are all related: they form the basis of the Surrealist aesthetic. Opposed to traditional notions of aesthetic form and beauty, Breton applied the concept of convulsive beauty to the revelation of the marvelous from the unconscious and to mad love. In *L'Amour fou* he writes that he is unmoved by views of nature and works of art that do not produce in him "a state of physical disturbance characterized by the sensation of a wind brushing across my forehead and capable of causing a veritable shiver. . . . The word *convulsive,* which I have used to qualify the only beauty that in my opinion should be served, would lose its whole meaning for me if it were imagined as being in movement instead of in the exact expiration of this movement . . . there can be beauty — convulsive beauty — only at the price of the affirmation of the reciprocal relationship that joins an object in movement to the same object in repose . . . a photograph of a very handsome locomotive after it had been abandoned for many years to the delirium of a virgin forest."[7]

Breton's writings about art are meager and largely restricted to artists who were his friends. Even in such cases, he tended to write about the artists themselves rather than their works. When he did write about specific works, his words refer — as might be expected — to the subject rather than to formal elements. Breton's major work on art is to be found in *Le Surréalisme et la Peinture,* first published in 1928. Otherwise, one must rely on a few enthusiastic prefaces of catalogs and sporadic reviews.

In the first Surrealist Manifesto Breton resurrected a number of pre-Dada artists and writers whom Dada had rejected along with all traditions. In addition to Lautréamont, Rimbaud, and Jarry, he acclaimed Baudelaire, Apollinaire, Gerard de Nerval, Novalis, Achim von Arnim, and other German romantics and writers of *romans noirs.* Breton also mentioned some artist precursors (in a footnote) including Moreau, Seurat, and Chirico, along with some names difficult to reconcile with Surrealism — such as Matisse, Braque, and Derain. Also included were Picasso, Klee, Ernst, Picabia, Masson, Man Ray, and Duchamp, as well as one old master, Paolo Uccello. In his essay entitled "Distances," Breton sought to rehabilitate Gauguin and Redon, while Rousseau was acknowledged only much later.

By the time Breton published his second Manifesto in 1930, however, he had experienced several crises, and his leadership of Surrealism had been challenged by some members of his own group. Following a meeting of intellectuals in 1929, intended to protest Trotsky's ruthless treatment by the Stalinist regime, he found it necessary to rethink and restate a purified position on Surrealism. He wrote that automatism and the investigation of dreams could still be useful but that they had too often led to the production of works of art. He therefore called for a return to their original purpose as means for investigating the unconscious.

In the second Manifesto Breton rejected a number of writers whom he had praised in the first Manifesto: Baudelaire, Poe, Rimbaud, and de Sade, among others (the last was later restored to his former position of prominence). Tzara, on the other hand, was now invited to accept a place among the Surrealists.

Among the artists welcomed to Surrealism by Breton in *Le Surréalisme et la Peinture* were Pablo Picasso, Giorgio de Chirico, Marc Chagall, and Paul Klee, none of whom were ever actually members of the movement. They were generally sympathetic to Surrealism, however, and participated in Surrealist exhibitions. Chirico's proto-Surrealist period ended by 1918, although his early work was a major influence on many Surrealist painters. Chagall's fantastic images derived from his Chassidic background rather than from dreams or any deliberate attempt to explore his unconscious. Klee's creative efforts, on the other hand, were deliberate and rational attempts to recapture the integrity and the naive imagination of children. Picasso went his own way, as always, but was a welcome participant in Surrealist exhibitions and publications such as *Le Révolution Surréaliste, Littérature,* and *Minotaure.* He did a number of paintings, water colors, sculptures, drawings, and prints as well as poems and a play *(Desire Caught by the Tail)* that are distinctly Surrealistic, but he remained aloof from Surrealist exercises in theory.

Breton's defense of the validity of Surrealist painting in *Le Surréalisme et la Peinture* rested on the use of painting as another means for the investigation of the unconscious rather than the attempt to create aesthetic objects.

During the *Epoche floue* (hazy epoch), from 1921 to 1924 when Surrealism was in the process of defining itself and separating itself from Dada, the techniques that are identified with Surrealism were being developed. Automatism was most important during the early years of Surrealism in the mid-twenties; Masson and Miró especially adapted this method for drawing and painting. Ernst invented a process of developing images which his imagination read into rubbings made from irregular surfaces, and he also continued making collages which joined discrete images in shocking and marvelous relationships. The illusionistic dream imagery that is so often identified with Surrealism in the public's mind was first clearly developed in 1927 by René Magritte and Yves Tanguy, both of whom harked back to Ernst's proto-Surrealist works of the *Epoche floue* and to Chirico's metaphysical paintings done during the second decade of the century. In 1929 Dali carried this approach to an unprecedented level of precision.

It was Max Ernst, however, who wrote most perceptively about Surrealist art. In 1937 he published the essay "Inspiration to Order," in which he stated: "Since the becoming of no work which can be called absolutely surrealist is to be directed consciously by the mind (whether through reason, taste, or the will), the active share of him described as the work's 'author' is suddenly abolished almost completely. This 'author' is disclosed as being a mere spectator of the birth of the work.... Just as the poet has to write down what is being thought — voiced — inside him, so the painter has to limn and give objective form to *what is visible inside him.*"[8]

Clearly, automatism as a creative principle was central to early Surrealist painting as well as poetry. Furthermore, the recognition that objective and subjective experiences are inextricably linked in a single process of perceiving reality was basic to the notion of absolute — or *sur* — reality in all the arts. Thus, despite Breton's admonitions concerning the purely investigative role of painting, these artists, along with Klee, Picasso, and others, inevitably created structured, aesthetically valuable works of art.

Breton was unquestionably the dominant figure of Surrealism, although other writers such as Louis Aragon, Philippe Soupault, Paul Eluard, Benjamin Péret, Robert Desnos, René Crével, and Max Morise participated in the early formation of the movement. Later, they were joined by René Char, Jacques Prévert, Michel Leiris, Pierre Naville, Georges Sadoul, and Raymond Queneau, along with others. In the following section, however, we shall briefly review the major contributions of several earlier writers.

1. André Breton, *Manifestoes of Surrealism,* trans. Richard Seaver and Helen R. Lane (Ann Arbor: University of Michigan Press, 1969), p. 26.

2. Ibid, p. 14.

3. Quoted in William S. Rubin, *Dada and Surrealist Art* (New York: Harry N. Abrams, Inc., 1968), p. 116.

4. André Breton, *L'Amour fou* (Paris: N.(ouvelle) R.(evue) F.(rançaise), 1937); quoted in Maurice Nadeau, *The History of Surrealism* (New York: Macmillan Company, 1965), p. 315.

5. Breton, *Manifestoes of Surrealism,* p. 14.

6. Breton, quoted in Nadeau, pp. 312-16.

7. André Breton, *What Is Surrealism? Selected Writings,* ed. and intro. Franklin Rosemont (New York: Monad Press, 1978), pp. 161-62.

8. Max Ernst, "Inspiration to Order," *Max Ernst: Beyond Painting* (New York: Wittenborn, Schultz, Inc., 1948), p. 20.

# The Influence of Some Earlier Writers

Originally a literary movement, Surrealism first turned to earlier writers in establishing a genealogy. Parts of Dante's and Shakespeare's works were claimed to be proto-Surrealistic, as well as works by Edward Young *(Night-Thoughts),* the Marquis de Sade, Jonathan Swift, Lewis Carroll, Edgar Allen Poe, Novalis, and Thomas de Quincy, among many others. These writers had demonstrated fantastic imaginations as well as contempt for the conventions of Western society. Most important, however, for the Surrealists were Isidore Ducasse (Le Comte de Lautréamont), Arthur Rimbaud, and Alfred Jarry.

## LE COMTE DE LAUTREAMONT 1846-1870

Born in 1846 of French parents in Montevideo, Uruguay, Isidore Ducasse — who wrote under the name of Comte de Lautréamont, or simply Lautréamont — came to France at the age of fourteen, living there unnoticed until 1870, the year of his death. He produced two books: the strange epic *Les Chants de Maldoror* and a short volume of satirical, critical writing about poetry, *Poésies.* The latter was published and sold just a few months before his death, while *Les Chants de Maldoror* — because of the shocking nature of its contents — was not released to the public until nine years after the author's death.

Little is known about Lautréamont's life, and his works were relatively unknown until Breton discovered the last remaining copy of *Poésies* in the Bibliothèque Nationale in 1919. He became a major Surrealist hero, surpassing even Rimbaud and Jarry, due to his uncompromising attack on the values of Western civilization and his revolutionary redefinition of man's fundamental nature. So great was the Surrealists' regard for him that they jealously opposed all attempts to analyze Lautréamont's work and assign him a place in history. André Breton, leader of the Surrealist movement, quoted Philippe Soupault with approval: "One does not judge M. de Lautréamont. One can only recognize him as he passes and bow down, for Lautréamont, to all intents and purposes is not of this world."[1]

*Les Chants de Maldoror,* organized in six cantos, was completed ten years after the publication of Darwin's *Origin of the Species.* Lautréamont never mentioned Darwin's work, but his writing suggests that the biologist's theory of evolution had profoundly influenced him. Darwin's theory had a great impact on Judeo-Christian moral precepts; for if man evolved from lower forms of life instead of having been created in the image of God, traditional moral and ethical convictions are open to question and possible redefinition. In fact, a large part of nineteenth-century European thought is incomprehensible without first recognizing the enormous influence of biology — particularly Darwinian theory — on that period.

Lautréamont insisted that man must accept his integral relationship with all other forms of life. His romantic discontent derives from disillusionment about man's assumed moral and spiritual superiority to other forms of life. Lautréamont's hero, Maldoror, asks: "What is good and what is evil? Are they both one single thing with which we furiously attest our impotence and passion to attain the infinite by even the maddest means?"[2] And following the description of a sadistic crime committed against a child, he declares: "I know your forgiveness was as immense as the universe. But *I* exist still!"[3] Maldoror's thesis is that if self-preservation is a basic law of nature, then logically, morality should be based on the will to survive by a willingness to destroy. His wish to kill a beautiful child, however, stems from his reluctance to see it attain the repulsiveness and dishonesty of adulthood.

Without moral restraints, Maldoror lives as freely as other beasts. In one much-cited passage in the second canto, he mates with a monstrous female shark, the only creature with

whom he feels a sympathetic bond. This dramatic event is preceded by a description of a sinking ship in a raging storm. Maldoror delights in watching the drowning people; he even shoots one who has nearly reached the shore. He sees six sharks destroy those who haven't drowned, and then, diving into the bloody sea, he aids a gigantic female shark in killing the other sharks. This spectacle of wild carnage is followed by the coupling of Maldoror and the great shark. He exults in experiencing his first true love.

Such scenes demonstrate Lautréamont's anger at man's moral and intellectual pretensions and his view that it is only man's concept of God and of himself as God's special creature that has led him to develop moral codes which cause him to judge his actions as good or evil. By describing man's vicious behavior, Lautréamont, by implication, condemns the Judeo-Christian God who supposedly created mankind in his own image. Judged by the very standards he has imposed on man, the Creator himself is pictured as abominable, cruel, and obscene. In one instance he is described seated on "a throne fashioned of human excrement and gold . . . with idiotic pride." He sits there, "swathed in a shroud made of unwashed hospital sheets."[4] To demonstrate man's identification with all other forms of life, Lautréamont's hero metamorphoses into various bestial shapes. When this occurs, it causes him to feel joy. Applying traditional aesthetic criteria to the human form, Lautréamont finds it repellent. He refers to "those hideous holes in [the reader's] unspeakable snout. . . ."[5] Again and again he refers to mankind in terms such as "the brother to the leech," "toad-face man," and man as

"naked as a worm."[6] Compared to the "old ocean" which Maldoror hails, man is seen as a mere frog puffing itself up with scientific knowledge which cannot emen reveal the secrets of the ocean. The final result of man's efforts to elevate himself through knowledge is the discovery that he is only another animal.

Another of Lautréamont's images has become particularly famous as a simile for beauty; he describes his English hero as "fair . . . as the chance meeting on a dissecting table of a sewing-machine and an umbrella!"[7] This is often quoted as an instance of the poetic possibilities of completely illogical associations. A Freudian interpretation, however, suggests an obvious sexual symbolism. The umbrella is a phallic image associated with rain — a traditional symbol of seminal fluid. A sewing machine is associated with woman and symbolizes the coital act. These two objects meet on a symbolic bed. Such Freudian symbolism undoubtedly was not intended, yet it may well have reinforced Breton's claim on Lautréamont for Surrealism. Maldoror's (Lautréamont's) passionate quest is for the infinite. "I am son of man and woman," says Maldoror, "so they tell me. That astounds me . . . I thought myself more!"[8] Angry with God for not having made him more, he sarcastically chides man for foolishly harboring the illusion that he is more than other creatures. The impact of Darwin's theory of evolution was clearly very great on the young Lautréamont. Yet he did not seek to escape his dilemma in art; instead, his art was precisely his means of confronting the problem and accepting the painful consequences.

Because of this attitude, including his furious revolt against the Judeo-Christian God and traditional moral precepts, as well as his insistence on man's unity with all of existence,

Lautréamont became a major Surrealist hero. His ironic wit and multiple puns, his violation of traditional syntax, and his creation of a new form in writing in an effort to simulate a nightmare endeared him to the Surrealists. Above all, they fell under the spell of his fantastic vision of a reality beyond what can be encompassed by logical sentences and can only be evoked by poetic images and metaphors that must emerge intuitively — unencumbered by logic.

In *Poésies* Lautréamont ironically mimics the dishonesty of mankind by proclaiming the wisdom of God, love of family, respect for social institutions, and the greatness of man. But he had really expressed his true beliefs in *Maldoror,* and as a result, it was not published. In *Poésies* he contradicted everything he had celebrated in *Maldoror,* thereby cynically mocking man's propensity to lie — even to himself.

# ARTHUR RIMBAUD
# 1854-1891

Born in Charleville, France, in 1854, Arthur Rimbaud was eight years younger than Lautréamont. He was equally precocious and was held in almost equally high esteem by Breton and other Surrealists. When he was fifteen years old Rimbaud sent some of his poems to Paul Verlaine, who invited the youth to join him in Paris. During 1872 and 1873 the two lived together in London and Brussels, precipitating the end of Verlaine's tempestuous marriage. Their liaison broke up shortly thereafter when Verlaine wounded his young paramour in a drunken quarrel.

Rimbaud's career as a poet lasted but four short years, ending when he was only nineteen. From then until his death in Marseilles at the age of thirty-seven, he traveled throughout Europe and North Africa, engaging in various adventures and business enterprises.

Among Rimbaud's most important works are: *Le Bateau Ivre* (The Drunken Boat), his first major poem; *Une Saison en Enfer* (A Season in Hell), considered by some critics to be his last poem and a confessional; *Les Illuminations,* a collection of prose poems which dispenses with traditional syntax and narrative elements; and *Lettre du Voyant* (Letter of a Seer) which he wrote to Paul Demeny on May 15, 1871. This letter — a kind of manifesto proclaiming his poetic doctrine — had a profound influence on the Surrealists as well as on other twentieth-century poets. In it, the sixteen-year-old poet suggests that the self which is familiar to the world and which has been molded by social pressures and institutions is not one's real self. *Car JE est un autre* ("For *I* is someone else") begins a passage which continues: "If brass wakes up a trumpet, it is not its fault."[9] Two paragraphs later

he writes: "Universal mind has always thrown out its ideas naturally; men would pick up a part of these fruits of the brain; they acted through them, they wrote books through them; and so things went on, since man did not work on himself, either not yet being awake, or not yet in the fullness of the great dream. Writers; civil servants — author, creator, poet, *that* man never existed!" The meaning of this criticism is clarified by the third sentence of the letter: "From Greece to the romantic movement . . . there are men of letters, versifiers. . . . It's all in rhymed prose, a game, the enfeeblement, flabbiness and glory of countless idiotic generations."[10]

The adolescent Rimbaud set about deranging his senses and his tendency toward logical order. He violated traditional moral strictures in a furious, romantic effort to set the banked fires of his inner poetic vision blazing. In another letter (written May 13, 1871, two days earlier than the one to Demeny) to his teacher Georges Izambard, he had declared: "I am cynically getting myself *kept*. . . . I am lousing myself up as much as I can these days. Why? I want to be a poet, and I am working to make myself a seer."

Like Lautréamont, Rimbaud seems to anticipate certain aspects of Freud's theory of the structure of personality. The unconscious is where both writers, like the later Surrealists, insisted that the spirit of true poetry is located. Preceding Surrealism's use of automatism to investigate this region as a source for poetry and art, Rimbaud advocated writing while in a kind of poetic delirium. His letters to Izambard and Demeny imply a complex theory about the nature of creativity. The poet, he suggests, must begin by exhaustive introspection. He discovers subjective experiences which have never been appropriately articulated and he must then invent a language to adequately define his unique, inner experience so that it becomes part of the human heritage: "He must

see to it that his inventions can be smelt, felt, heard. If what he brings back from down there has form, he brings back form; if it is formless, he brings forth formlessness. . . . The poet would define the amount of the unknown awakening in the universal soul in his own time; he would produce more than the formulation of his thought or the measurement of his *march toward Progress!* An enormity who has become normal, absorbed by everyone, he would really be a *multiplier of Progress!*"[11]

When Breton wrote, "There roam the world today certain individuals for whom art, for instance, has ceased to be an end,"[12] he was referring, among others, to Rimbaud. For Rimbaud's life, and certain convictions concerning creativity, served as a model for the Surrealists. It was all but inevitable that Breton would claim Rimbaud for Surrealism in his 1924 Manifesto. By the time Breton published the second Manifesto in 1930, however, he reproached Rimbaud for having left a way open in his writings for Catholic writers — particularly Paul Claudel — to explain him in terms of their religious beliefs.[13]

Rimbaud, like Lautréamont, sought to invent a new poetry which would derive its structure from the immense effort to penetrate the unconscious regions of the mind and to articulate what was experienced there in an appropriate form. Both young prodigies began by destroying the effects of traditional mores on themselves. For example, in *Une Saison en Enfer,* Rimbaud writes of separating out the enchantments assembled in his mind. His visions were based on his recovery of the pure, primitive sensations of childhood.

After four years of deliberately deranging his senses in every imaginable way to go beyond previously defined experience and to formulate the unknown, Rimbaud reached his physical and psychological limits and quit his extraordinary quest.

# ALFRED JARRY
# 1873-1907

Alfred Jarry was born in Laval, Mayenne, in France in 1873. He died in Paris on November 1, 1907, at the age of thirty-four after living out a life patterned on that of his own grotesque creation, Père Ubu. Like Lautréamont and Rimbaud, Jarry was precocious. He entered the lycée at Rennes at ten years of age and at eighteen went to Paris, where he studied with the philosopher and mathematician Henri Bergson. While at the provincial lycée, Jarry helped to perpetuate a tradition of poking vicious fun at a particularly unpopular teacher, M. Hébert, known to the students as Père Hébé or Heb.

Young Jarry displayed a fierce sarcastic wit in a marionette play, *Les Polonais,* which he and some of his young friends wrote and performed in 1888 in an attic marionette theater. The leading character, based on the incompetent M. Hébert, served as a prototype for later plays about the anti-hero, Père Ubu. The first of the series, *Ubu Roi,* was a drama in five acts parodying Shakespeare's *Macbeth* and, to a lesser extent, *Julius Caesar.* It was written by Jarry and produced by Lugné-Poe in the Théâtre de L'Oeuvre in 1896. The setting was Poland (which, as Jarry remarked, is to say nowhere, since at that time Poland had been dismembered and removed from the map). Père Ubu was grotesque, with an enormous *gidouille* or "gut" (which was built of cardboard and wicker and entirely covered the actor's body); his face was concealed by a mask having a nose like a crocodile's snout.

At the time that Jarry wrote *Ubu Roi,* nineteenth-century French theater was dominated by the "Grand Actor," who often put his own image ahead of the play.[14] One of Ubu's functions, therefore, is to parody the egotistical actor who hogs the stage. In addition, he serves to reflect the playwright's idea of the spectator. The great, distorted marionette hiding the actor inside suggests man's dark, hidden, inner appetites and selfish nature. In his introduction to the first performance, Jarry says: "Several actors have been pleased to make themselves impersonal for the evening and to play closed up within a mask, in order to be exactly the interior man and the soul of the huge marionettes which you are going to see."[15] Ubu's appearance, as Spingler notes, is that of "a walking bestiary, a concrete image of the instinctual or libidinal parts of men."[16]

Thus, Jarry, like Lautréamont and Rimbaud, is concerned with the unconscious part of the human personality. Lautréamont defines it in *Maldoror* as instinctual, cruel, wild, uninhibited, amoral, and free. In his pursuit of the Absolute, Maldoror (Lautréamont) must fight against a Creator whose vile image is reflected in mankind. For Rimbaud, the deep recesses of the mind are the source of all true creativity, and this source can only be tapped by deliberately rejecting reason and deranging the senses. Creative man then arrives at the unknown and by creating a language to appropriately formulate his experience adds to the body of human experience. Jarry exposes man's natural greed, cruelty, and cowardice. Ubu represents the bourgeoisie in power who indulges his base instincts. W. B. Yeats, who was at the opening performance, comments that while he felt bound to support the play, he was, at the same time, "very sad. . . . What more is possible? After us the Savage God."[17]

As a final gesture of contempt for bourgeois society, Jarry himself assumed an Ubuesque role in life. A handsome young man, he was described by André Salmon as having "long, dark hair falling almost to his shoulders, a face of pure oval shape, a straight mouth, a short well-modelled nose, and black eyes that were honest and ardent."[18] However, he so transformed himself into a grotesque caricature that he was later described by André Gide as "a strange kind of clown, with a befloured face, a black beady eye, and hair plastered down on his head like a skull cap" and effected a way of speaking "without inflection or nuance, with equal accentuation on all syllables, even the mutes. There would not have been the slightest difference if a nutcracker had spoken."[19]

Jarry, an alcoholic whom Breton called "Surrealist in absinthe," lived in squalid poverty in a tiny hotel room with two owls (later stuffed) and a stone phallus. Gabriel Brunet perceptively noted: "He offered himself as a victim to the derision and to the absurdity of the world. His life is a sort of humorous and ironic style which is carried to the point of the voluntary, farcical, and thorough destruction of the self. Jarry's teaching could be summarized thus: every man is capable of showing his contempt for the cruelty and stupidity of the universe by making his own life a poem of incoherence and absurdity."[20]

Jarry himself wrote about *Ubu Roi* in an essay first published in the *Revue Blanche:* "It is not surprising that the public should have been aghast at the sight of its ignoble other-self, which it had never before been shown completely. This other-self, as M. Catulle Mèndes has excellently said, is composed 'of eternal human imbecility, eternal lust, eternal gluttony, and vileness of instict magnified into Tyranny; of the sense of decency, the virtues, the patriotism and the ideas of those who have just eaten their fill.'"[21]

In the same article Jarry comments on the public's inability to understand anything that is not patiently explained. He then asked a question repeated by many modern artists: "Have we [the artists] no right to consider the public from our point of view?" He remarked that the public, not comprehending intelligent works of art, "pretend to think of writers and artists as a lot of crackpots, and some of them would like to purge all works of art of everything inexplicable and quintessential, of every sign of superiority, and to castrate them so that they could have been written by the *public in collaboration* ... it is they who are the mad-men.... They are suffering from a dearth of sensations, for their senses have remained so rudimentary that they can perceive nothing but immediate impressions."[22]

Jarry recognized the intellectual gulf between creative human beings and the general public in a society where democratic principles are extended from politics to the arts. In another essay published in the *Mercure de France,* September 1896, he commented: "If we want to lower ourselves to the level of the public there are two things that we can do for them — and which *are* done for them. The first is to give them characters who think as they do and whom they understand perfectly.... The other ... is to give them a commonplace sort of plot — write about things that happen all the time to the common man.... Because genius, intelligence, and even talent, are larger than life, and so inaccessible to most people."[23]

Jarry's episodic novel, *Gestes et Opinions du Docteur Faustroll, Pataphysicien,* was not published until after his death — in 1911. The name of its hero indicates that he is half-Faust and half-troll; he is also a pataphysician. Pataphysics is defined in *Faustroll* as "the science of imaginary solutions, which symbolically attributes the properties of objects, described by their virtuality, to their lineaments";[24] in short, to imaginatively express psychological states by objectifying them. (The College of Pataphysics in Paris still lists among its members — past and present — such figures as René Clair, Jacques Prévert, Raymond Queneau, and Marcel Duchamp.) What had begun as a burlesque of science developed into the basis of Jarry's aesthetic — indeed, of his life.

## THE SYMBOLISTS

There are significant differences between the Surrealist and the late nineteenth-century Symbolist movements, yet they also share some common concerns. Separating the two are certain ideas to which Symbolism was attached and which Surrealism rejected. Mysticism and the cult of decadence, for example, flourished in the nineteenth century, counteracting the influence of the empirical sciences which were burgeoning and touching the lives of almost everyone. Many artists and poets espoused Swedenborgianism, Rosicrucianism, and mystical cults. Indeed, Neoplatonism was in the air and, in a general sense, was nearly as important to the theorists of late nineteenth-century Symbolism as it had been to the Medici and other followers of the New Learning in fifteenth-century Florence. There are echoes of Plotinus in the strange writer and theorist Joséphin (Sâr) Péladan who, along with the occultist Stanislas de Guaïta, attempted a revival of Rosicrucianism. "The beautiful," Péladan declared, "is an interior vision where the world is clothed in supereminent qualities."[25] The fifteenth-century Florentine literary followers of Neoplatonism held that physical manifestations of love and beauty introduce us to their spiritual counterparts which then render the physical versions superfluous.

Decadence, on the other hand, was a term that became almost synonymous with the Symbolist movement. In fact, two Symbolist reviews, *La Décadence* and *Le Décadent,* used the term in their titles; the first one became *Le Scapin* when the second appeared in 1886. In 1884 J. K. Huysmans published *A Rebours* (Against the Grain) in which the dandified, autobiographical hero, des Esseintes, proclaimed his admiration

for Paul Verlaine and Mallarmé, as well as the painters Gustave Moreau and Odilon Redon. The book was labeled decadent by Huysmans' enemies, but the term was readily accepted by some of the poets. An anonymous writer in *Le Décadent* announced: "'Not to admit the state of decadence which we have reached would be the height of nonsense. Religion, morals, justice, everything is in decadence.... Refinement of appetites, of sensations, of taste, or luxury, of pleasure; neurosis, hysteria, hypnotism, morphinomania, scientific charlatinism, Schopenhauerism to the utmost, these are the symptoms of social evolution....'"[26]

Huysmans' next novel, *Là-bas* (Down There), continued his earlier theme with an exploration of Satanism. Later, following his conversion to Catholicism, Huysmans proclaimed: "It is through my glimpse of the supernatural of evil that I first obtained insight into the supernatural of good. The one derived from the other!"[27]

Decadence implies disillusionment with both material and moral progress; while Surrealism agreed that the modern Western world was decadent, it aimed to change those conditions, not celebrate them. In fact, since Surrealism did not admit the validity of traditional moral precepts, it could hardly consider their violation as evidence of decadence. Catholicism, Plotinus, and Neoplatonism provided the philosophical bases for many Symbolists, while Freudianism and Marxism were the two strongest influences on Surrealism. Marx and Freud sought to cure social and individual ills; neither was concerned with mysticism.

The hermeticism of the Symbolists was also rejected by Surrealism. This Symbolist attitude was succinctly expressed by the theorist-critic, Teodor de Wyzewa: "The aesthetic value of a work of art is always in inverse relationship to the number of people who can understand it."[28] While it is true that the Surrealists were concerned about the content of works of art, and that the content of Surrealist works was often ambiguous and enigmatic, this was the natural result of the Surrealists' attempts to probe the unconscious through automatism and dreams. Furthermore, they were not concerned with aesthetic value.

The leftist political stance of both groups was due in part to their contempt for the bourgeoisie. However, the ultra-individualism and love of liberty on the part of the Symbolists led them to anarchism and Prince Kropotkin; the Surrealists — in their desire to create a new society — found the socialist theories of Marx and Engels more attractive.

The two movements were related to the encompassing Romantic movement, however; they both supported Romanticism's challenge to rationalism and subscribed to its emphasis on subjective experience. The artists of both movements looked to Eugène Delacroix as the first modern artist, whereas the poets disputed only whether Baudelaire or Rimbaud was the first modern poet.

Both movements were primarily literary in nature, and the major Symbolist poet, Stephane Mallarmé, provided a key idea linking Symbolism to Surrealism (and eventually to American Abstract Expressionism): "To *name* an object," he declared, "is to suppress three-quarters of the enjoyment to be found in the poem which consists in the pleasure of discovering things little by little: *suggestion,* that is the dream."[29]

Extending this notion to the visual arts, we might say that to imitate nature is to suppress most of the enjoyment to be derived from a painting, which consists in slowly exploring its images and penetrating its content: *allusion,* that is the aim.

Both movements were concerned with discovering or creating appropriate means to formulate subjective experiences without relying entirely on a specific system of symbols with precise denotations. The Symbolists mixed these references with symbols and metaphors which they invented and whose meanings could be understood by only a few. Surrealism used the notion of open symbols in developing images spontaneously and intuitively, while their denotations or connotations were deduced only later.

Symbolism and Surrealism, therefore, conceived of the work of art as articulating — without naming or describing — subjective experience. If successful, the work provides insight into its content for the reader or perceiver. In painting, the Symbolists often manipulated images as well as formal elements with intellectual and emotional associations. The Surrealists, on the other hand — aiming at a synthesis of objective and subjective experience — relied on automatism with full confidence in this method to release images and forms from the unconscious, arriving at unpremeditated content and structure.

1. Anna Balakian, *Surrealism: The Road to the Absolute* (New York: Noonday Press, 1959), p. 21.

2. Isidore Ducasse, *Lautréamont's Maldoror*, trans. Alexis Lykiard (New York: Thomas Y. Crowell, 1972), p. 6.

3. Ibid., pp. 6, 7.

4. Ibid., p. 52.

5. Ibid., p. 2.

6. Ibid., pp. 30, 34, 35.

7. Ibid., p. 177.

8. Ibid., p. 10.

9. Rimbaud is here proclaiming the independence of his true, inner self from the self formed by social institutions. In an earlier letter to Georges Izambard (his former teacher) he used the same expression and said that he was born a poet. He therefore disclaims responsibility for what his education has made him and argues that to regain his inherent, poetic self he must alter his senses and violate all the formal, moral, and aesthetic structures which have inhibited the free expression of the true poet within him.

10. Here, Rimbaud dismisses all poets, from the ancient Greeks to the nineteenth-century Romantics, as feeble versifiers — except Racine.

11. From the May 1871 letters to Izambard and Demeny, reproduced in the original French in *Oeuvres de Rimbaud,* ed. Suzanne Bernard (Paris: Garnier Frères, 1960), pp. 343-47.

12. André Breton, "Caractères de l'evolution moderne," *Les Pas Perdus,* quoted in Maurice Nadeau, *The History of Surrealism* (New York: Macmillan Company, 1965), p. 74.

13. André Breton, *Manifestoes of Surrealism,* trans. Richard Seaver and Helen R. Lane (Ann Arbor: Univ. of Michigan Press, 1972), p. 127.

14. Michael K. Spingler, "From the Actor to Ubu: Jarry's Theatre of the Double," *Modern Drama,* January 11, 1973, p. 2.

15. Ibid.

16. Ibid., p. 5

17. W. B. Yeats, *Autobiographies* (London: Macmillan Company, 1955), pp. 348-49.

18. Alfred Jarry, *Ubu Roi,* trans. and introductory essay, Barbara Wright (Norfolk, Conn., and New York: New Directions, 1961), p. VIII.

19. Ibid.

20. Ibid., p. IX.

21. Ibid., p. 174.

22. Ibid., pp. 174-75.

23. Ibid., p. 177.

24. Alfred Jarry, *Gestes et Opinion du Docteur Faustroll* (Paris: Fasquelle, 1955), p. 32. (Translation in *Evergreen Review,* no. 13 [1960], p. 131.)

25. Edward Lucie-Smith, *Symbolist Art* (New York and Washington: Praeger, 1972), p. 12.

26. John Rewald, *Post Impressionism: From Van Gogh to Gauguin* (New York: Museum of Modern Art, 1956), pp. 149-50.

27. Lucie-Smith, p. 51.

28. Teodor de Wyzewa, "La Littérature wagnérienne," *Revue Wagnérienne,* June 1886, quoted in Rewald, p. 152.

29. Lucie-Smith, p. 54.

# The Influence of Some Earlier Philosophers

The central problem for Surrealism was to demonstrate the overriding unity of all experience, objective and subjective — that received through the senses and that of the unconscious. The various facets of Surrealism — political, literary, artistic, psychoanalytical, and philosophical — all derived from attempts to deal with this major question. Freud seemed to provide the most efficacious tool for investigating the nature of the inner life; Marx seemed to point the way to a society wherein human beings could pursue this quest without fear of reprisals from bourgeois institutions; Lautréamont, Rimbaud, and other writers had anticipated certain Surrealist concerns in their poetry; above all, however, philosophers had long speculated on the essential nature of reality as a whole (metaphysics) and on how human beings can know things (epistemology).

At the beginning of the nineteenth century a German philosopher, Immanuel Kant, proposed an over-arching dualistic system that allowed room for previously conflicting views such as phenomenalism and transcendentalism. After Kant came a line of German philosophers that established nineteenth-century German philosophy as one of the most important in history. Hegel, Feuerbach, Marx, Kant, and Nietzsche — all contributed to Surrealist efforts to achieve a synthesis of objective and subjective experience, aiming at a concept of a single reality superior to any of its various aspects: what Breton called *sur-réalisme.*

This chapter will attempt to summarize the elements in the systems of these philosophers that seem to be most significant for Surrealism. Obviously they cannot be treated in depth. These brief notes are intended only to indicate connections which Surrealists such as Breton, Aragon, Eluard, and others clearly recognized.

## IMMANUEL KANT 1724-1804 Dualism

During the nineteenth century science and technology made enormous gains in the Western world and provided the tools for European-American civilization to impose its will on the rest of the world. At the same time, Western philosophy attempted to bridge the gap between the theoretical doctrines of empirical materialism and rationalist idealism. Immanuel Kant tried to establish a comprehensive doctrine of experience that would include both in a complex, dualistic system. He divided existence into two parts: the phenomenal world of sensory experience, and the noumenal world, or the world as-it-is-in-itself. According to Kant, we can never experience the noumenon, but we can know that it exists, since it is necessary to explain the operation of the free will of rational beings.

Kant taught that information provided by our senses is screened and organized according to certain inborn categories of thought. These a priori categories are twelve in number, three each under four headings: quantity, quality, relation, and modality. Under quantity, for example, Kant listed "one, many, and totality"; under modality, he listed "possible, impossible, and contingent." Space and time, also considered a priori principles, help structure our sensory perceptions. No matter how random our sensations may be, they are organized according to the synthetic principles of space, time, and the twelve categories. Indeed, experience cannot be accounted for except in these terms. Kant concluded, therefore, that since space, time, and the categories exist *prior* to sensations, they are part of the basic structure of the human mind.

If we cannot know the true nature of the world-as-it-is-in-itself, we can at least know that something exists which excites our sensory perceptors. For simple animals, the world consists largely of smells and tastes; for a constructive animal, it is perceived as weighty masses; for a preying animal, as apprehensible and resistant matter. In short, knowledge of the world takes forms in large part determined by the nature of one's sensory perceptors and the biochemical relations of appetites. Without the noumenon, according to Kant, human beings would be only superior forms of machines. In his *Critique of Practical Reason* Kant demonstrated that the will of a rational being is autonomous. It acts morally only because of a self-imposed determination to adhere to the categorical imperative "to treat humanity in every case as an end and never as a means."

Surrealism sought to regain the world as it is experienced *before* logical thought processes organize it. For the Surrealists, the development of thought, creative activity, and revolution all demand absolute freedom. Thus, Kant's notion of the noumenal world was in sympathy with the Surrealists' emphasis on free will. Indeed, Surrealism generally approved of nineteenth-century German philosophical thought following Kant. Breton referred to Germany as "the marvelous country of thought and light which in one century gave birth to Kant, Hegel, Feuerbach, and Marx."[1] The Surrealist writer René Crevel said: "When I was taking philosophy at the *lycée,* Kant appeared to me, in the icy halo of his intangible noumena, as an avenger...."[2]

# GEORG HEGEL
# 1770-1831
# Dialectical Idealism

While Kant attempted a reconciliation of empirical materialism and rational idealism in terms of a dualistic metaphysic, Georg Hegel essayed the complex task of synthesizing these two modes of being. In his second Manifesto of Surrealism (1930), Breton acknowledged that the Hegelian concept of the "penetrability of subjective life by 'substantial' life . . ." was uncontested by those with as widely differing viewpoints as Feuerbach, Marx, Hartmann, and Freud.[3] And in *What Is Surrealism?* he observed that Hegel's influence was strongly felt by the Surrealists, since they recognized that they were as much concerned with knowledge as with expression.[4]

The Hegelian dialectic stresses the notion of a teleological, historical evolution by means of the synthesis of antithetical propositions, defining knowledge as the linking of thought and its object. Although J. G. Fichte introduced the triad of thesis, antithesis, and synthesis into German philosophy, Hegel is often mistakenly given credit for it — the reason is that even though Hegel did not use these exact terms, he was inclined toward the use of triads in showing how concepts pass over into their opposites before achieving a higher unity. For example, the broadest, most basic concept of which the mind is capable is that of *being.* Yet, the idea of *being* — without any *thing* that *is being* — is empty and therefore the same as *not being.* To postulate absolute *being* is, therefore, to also say that the absolute does not really exist. The resolution of this contradiction lies in Hegel's notion that the absolute is *becoming:* that is, the historical process of phenomenal reality, evolving according to the resolution of contradictions, is in process of *becoming* absolute. In short, Hegeli-

anism begins with the basic concept of *being* and evolves toward the all-embracing theory of Absolute Idea. This concept of the world process exists in and through phenomenal reality, and its final resolution, Absolute Idea, is simply the "truth" of all *being.*

When, for purposes of speculation, we separate the notions of form and content, we are inevitably led to separate the phenomenal world from our inner experiences. Kant, on the one hand, proposed a dualistic system in which our experience of form in nature depends on certain a priori categories of thought which structure our random perceptions. Hegel, on the other hand, beginning with the notion of pure *being* and applying the theory of constant conflicts and their resolution on a higher level, reasoned his way to the complete integration of phenomenal existence and thought.

Since complete self-knowledge becomes attainable only when we recognize that phenomenal existence cannot be separated from our subjective experience of it, and since objective reality must be experienced subjectively, and subjective experience in turn conditions the nature of our apprehension of the world, the Surrealist postulation of a synthesis of material reality and dream into a superreality found a rough analogy in Hegel's theory of Absolute Reality. In a lecture delivered in Prague in 1935 Breton said: "Even today it is Hegel whom we must question about how well-founded or ill-founded Surrealist activity in the arts is."[5]

## LUDWIG FEUERBACH
## 1804-1872
## Materialism

Feuerbach moved from Hegel's objective idealism toward materialism. He influenced most "left-Hegelians," and although he was not as political as Marx and Engels would have liked, they agreed with other left-Hegelians in approving Feuerbach's dictum: "Man is what he eats. If we wish to improve a nation, do not give it ideology and declamations against sin, but better food."[6] Feuerbach's "new philosophy" was decidedly materialistic, but at the same time it took into consideration Hegel's insights into the workings of the human mind.

According to Hegel, human reason was a manifestation of Absolute Idea in process of becoming conscious of itself. Feuerbach responded that the only true reality is material existence. In the 1843 preface to *Das Wesen des Christentums* (The Essence of Christianity) he wrote: "I found my ideas on materials which can be appropriated through the senses. . . . I do not generate the object from thought, but thought from the object, and I hold that alone to be a proper object which has an existence beyond one's brain. . . . I am nothing but a natural philosopher in the domain of the mind."

"Being is the subject," he wrote in *Vörlaufige Thesen* (Preliminary Theses), "thought the predicate. Thought is a product of being, not being of thought. . . ." Man differs from the lower animals by a qualitative change in his nature which occurs when he "awakes to consciousness" and becomes aware of himself.

Feuerbach's concept of religion and deity in many ways coincided with the Surrealists.' He insisted, for example, that myth and religion tell us more about the inner life of man than about any presumed deity. Like other animals, man is born amoral. Religion is simply a dream of the human mind and a means by which — unlike other animals — man formulates his own vision of what he might be. By vesting his best qualities in another Being, however, man assumes his worst qualities to be his own essence. Like the Surrealists and Marx, Feuerbach urged the destruction of the religious illusion in order to free man to realize his ideals in his life on earth.

## KARL MARX
## 1818-1883
## Dialectical Materialism

Intellectually, Surrealism was closer to Marxism than to any other social theory; only Freud and Hegel had as great an impact as Marx, Engels, and Lenin on Breton and his friends. In suggesting that he had set Hegel "right-side up," Marx simply meant that the dialectical process of history is determined by efficient rather than final causation — that is, by the material relations of human beings and social classes. Still, Hegel's *objective* idealism (the belief that objects in the world are imperfect manifestations of universals) was far more acceptable to Marx, and to the Surrealists, than Plato's *subjective* idealism (the belief that ideas are imperfect manifestations of universals).

As a left-Hegelian, Marx was influenced by Feuerbach in developing his own materialistic version of the dialectic. When he concluded in his philosophy of history that the dialectical process operates through the conflict of classes, he became actively involved with revolutionary politics. His concern for the proletariat was due largely to his belief that the urban working classes were the means by which mankind could achieve a new plateau in the evolutionary spiral of history. Marx accepted both Kant's and Hegel's concepts of a reciprocal influence between causes and effects and constituent parts and wholes. If causes produce effects and parts make up wholes, effects react upon their causes and wholes react upon their constituents. Thus, he rejected extreme mechanistic materialism along with Hegel's teleologically determined dialectical process. By allowing for the free will of human beings to influence events, Marx and his theories became acceptable to the Surrealists.

Marx's theory depends on the concept of society as composed of conflicting classes. He proposed that the historical domination of one class over others rests upon its control of the means of production. Once it fully realizes the potential of these means, however, it is challenged by another class upon which it depends but whose interests do not ultimately coincide with its own. The inevitable struggle between these two classes normally results in victory for the once-dominated class which, in turn, becomes a dominating class continuing the cycle on another level.

To drastically oversimplify Marx's view of history: theocratic power was destroyed by military power in the ancient world; military autocracy gave way to landed aristocracy in the feudal world; and, in the modern world, the nobility was overthrown by the bourgeoisie whose power was first based directly on industry and commerce and later on speculative finance.

Marx predicted that the dictatorship of the bourgeoisie would almost inevitably be supplanted by the dictatorship of the proletariat. He speculated that industrial workers, once gathered together in cities, would become conscious of themselves as an exploited class actually producing the capital which both supported the bourgeoisie and paid their own wages. When this happened, he assumed, they would seize the means of production and establish a proletarian society which would gradually metamorphose into a classless society, thus ending the class struggle. It would follow that if all the members of a society became contributing workers of various kinds, there would be no other classes to exploit.

Philosophically, this position views society and the individual as interdependent and interdetermining human units. Like the component organs of a living body, individuals stand in a position of reciprocity to one another and to the social community. The change called for by Marx in the Communist Manifesto can occur only by revolution (according to Lenin and the Bolsheviks), since the holders of privilege will never surrender it voluntarily. Many bourgeois intellectuals such as Lenin, Trotsky, and the Surrealists welcomed the prospect of a proletarian revolution. They were convinced that in defending their privileges, the bourgeoisie repressed ideas which they found threatening and supported those that served to strengthen their position. For example, large parts of the theories of Darwin and Freud were at first denounced by the bourgeois-supported institutions, while patriotism, religion, and private property were sacrosanct. The revolutionary Marxists taught that only in a classless society without vested interests could there be true intellectual freedom. It was for this reason alone that the Surrealists originally sought an alliance with them.

Although Surrealism and Marxism agreed that objective and subjective experience were interdependent, reciprocal aspects of a single phenomenon, Marxists emphasized material relationships, while Surrealists stressed the dynamics of the human pesonality.

# FRIEDRICH NIETZSCHE 1844-1900

Although Nietzsche's philosophical writings seem to lack any unifying program or set of principles, this inconsistent and even paradoxical character is precisely what appealed to the Surrealists. Since good French translations of Nietzsche's writings were lacking in the early part of the century, only certain key ideas among his aphoristic pronouncements were embraced by many Surrealists.

His insistence that the pre-Socratic Greek philosophers of Ionia were greater than their more illustrious followers is one example. According to Nietzsche they had the courage to face life as it is without suppressing any parts of it as being evil or immoral. The Socratic attempt to find logical reasons for spontaneous, intuitive, non-rational actions and the Christian insistence upon moral justifications for actions, Nietzsche claimed, served to emasculate the mentally and emotionally strong.

Nietzsche and certain Surrealists also admired the early Greeks because they considered the emotions to be at least as important as cool cerebration. According to Nietzsche the moral code of the West was a "slave morality," imposed by the multitudes of the weak — through Christianity — on the few strong enough to face life squarely and honestly. However, Nietzsche insisted that since the Christian version of Christ comes from the writings of St. Paul, we cannot hold Christ responsible for his effete image in Christian theology. The true Christ was emasculated in Paul's version of him just as Dionysius had been emasculated by Plato. Both gods were tragic heroes, according to Nietzsche, and must be

resurrected in all their virility if mankind is to be saved. The slave morality must be renounced and the joy of life and the exultation of identifying the individual with existence in all its aspects — terrible as well as majestic — must be reaffirmed. A new morality will then emerge, free of illusions and self-deceptions, thus allowing the will for power to assert itself: *Ubermensch* — a superior form of human being — will appear. Like Lautréamont's Maldoror, this superman will reject nothing in the universe except the Christian God of the weak.

Art played a major role in Nietzsche's writing as a means of investigating and revealing reality in all its aspects. A work of art may even refer to man's tragic role in the universe, and it will be contemplated with delight by the strong. The weak, however, will denounce as ugly and revolting those works which define that which they fear, find immoral, or don't understand.

For example, Nietzsche admired Richard Wagner (until a dispute over the Christian elements in *Parsifal*) as an artist who broke the traditional laws of music and violated Christian moral strictures in the dramas of his operas. Unbridled physical love and even incest were themes in the tetralogy *Das Ring der Nibelungen* and in *Tristan und Isolde.* The French Surrealists championed Wagner for much the same reason (as well as the simple fact that he was German), despite Breton's antipathy for music.

Giorgio de Chirico, in particular, admired Nietzsche. He once reported: "In my way of thinking and working . . . revelation always played the central role.

. . . A revelation can be born of a sudden, when one least expects it . . . it belongs to a class of strange sensations which I have observed in only one man: Nietzsche. When Nietzsche talks of how Zarasthustra was conceived, and says, 'I was surprised by Zarathrustra,' in this participle — surprised — is contained the whole enigma of sudden revelation."[7]

Still, Nietzsche's importance for Surrealism did not approach that of Hegel, Marx, or Freud. He aroused the admiration of the Surrealists mainly for his rejection of traditional Judeo-Christian morality and his proposal that mankind embrace a more honest and vigorous view of life.

1. André Breton, "Du Temps que les surréalistes avaient raison," *Documents surréalistes,* ed. Maurice Nadeau (Paris: Aux Editions du Seuil, 1948), p. 311; quoted in English in Anna Balakian, *Surrealism: The Road to the Absolute* (New York: Noonday Press, 1959), p. 103.

2. André Breton, *What Is Surrealism? Selected Writings,* ed. and intro. Franklin Rosemont (New York: Monad Press, 1978), p. 368.

3. André Breton, *Manifestoes of Surrealism,* trans. Richard Seaver and Helen R. Lane (Ann Arbor: University of Michigan Press, 1972), p. 139.

4. Breton, *What Is Surrealism? Selected Writings,* p. 117.

5. Breton, *Manifestoes of Surrealism,* p. 259.

6. Breton, *What Is Surrealism? Selected Writings,* p. 131.

7. James T. Soby, *Giorgio de Chirico,* trans. Louise Bourgeois and Robert Goldwater (New York: Museum of Modern Art, 1955), p. 244.

## Some Artist Ancestors

Certain writers on Surrealism have taken the position that there is a tradition of fantasy running through the history of art that provides the ancestry of Surrealism.[1] These forerunners usually include Paolo Uccello, Pieter Breughel the Elder, Hieronymous Bosch — as well as some of the works of Giovanni di Paolo, Hans Baldung Grien, Giovanni-Battista Bracelli, Giuseppe Arcimboldo, and certain other old masters. Some medieval bestiaries, the bizarre sculptures often found in secluded areas in romanesque and gothic cathedrals, the hybrid gods of Egypt, Greek satyrs and centaurs, the Cretan Minotaur, and other monsters of the ancient world and primitive societies are also claimed as precursors of Surrealism. More important, however, are later artists such as Francisco José de Goya y Lucientes, William Blake, Henry Fuseli, Arnold Böcklin, Gustave Moreau, and other nineteenth-century Symbolists. Many of the earlier artists claimed as part of the geneaology of Surrealism were in fact convinced that the images they created referred to things that truly existed; they therefore were dealing with a prevailing concept of reality rather than fantasy. (Meyer Schapiro has pointed out that a work cannot be considered fantasy when it is generally accepted within its own cultural context as referring to reality.[2]) William Rubin suggests that Alfred Barr solved this problem in the exhibition *Fantastic Art, Dada, Surrealism* that he organized for the Museum of Modern Art in 1936; he included only "those infrequent, aberrational images that propose something outside the limits of collective belief...."[3]

Since Barr deliberately chose the term Fantastic Art to be included in his title, he was quite right to include only marginal images. However, in view of the fact that Surrealism itself actually aspired to present a fuller version of reality than its surface appearance, just as did many of the earlier artists who were not consciously creating fantasy, it would seem that these artists might reasonably be considered proto-Surrealists.

This study will be restricted, however, to a consideration of several important, immediate forebears of Surrealism. Among these is the Cubist inventor of collage, Pablo Picasso, who will be considered in a later section with the Surrealists. The technique of collage is the only serious rival to automatism in creating Dada and early Surrealist works of art; it was adapted by the Surrealists as a means of juxtaposing logically unrelated images on the same plane, thus transforming what originated as a formal device into an iconographical one. Max Ernst, more than any other Surrealist, used collage as a major means of creating astonishing visions.

The poetry, painting, and graphic arts of late nineteenth-century Symbolism were probably the most relevant for Surrealist art. Among the most important Symbolist painters for the Surrealist artists were Gustave Moreau, Odilon Redon, and Paul Gauguin, along with Georges Seurat, Henri Rousseau, and Giorgio de Chirico.

# GUSTAVE MOREAU
# 1826-1898

Although Gustave Moreau was a *chef d'atelier* and taught at the Ecole Nationale des Beaux-Arts, he was no stuffy academician. Among his pupils were Henri Matisse, Georges Rouault, Albert Marquet, and Jean Puy — all of whom became important Fauvist painters. Except for Rouault, however, these artists did not share Moreau's literary concerns; he turned to the Bible and mythology for the subjects of his richly colored, paint-encrusted canvases. He was admired by the Surrealists for his erotic subjects and the luxuriousness of his impastoed surfaces; only Ernst approached the density of his compositions and, along with Matta, his glittering, molten, gem-like passages; and only Ernst and Dali approximated his perverse eroticism. Moreau depended heavily on ''femmes fatales'' — Salome, Delilah, Helen of Troy, Semele, and the Chimera — to serve as subjects.

His status as a precursor of Surrealism is based on Breton's inclusion of him in the essay ''Distances.'' Breton declared that, at sixteen, his discovery of the Musée Gustave Moreau influenced his idea of love. He likened the museum to ''the perfect image of a temple . . . and the other image of the 'place of ill repute' which it might also become.''[4] The decadent eroticism of Moreau's paintings such as *The Apparition* (Figure 3) impressed the youthful Breton, and their flouting of bourgeois moral ideals appealed to his own antipathy toward what he termed middle-class wholesomeness.

Moreau's reliance on subjective experience as a means to discovering reality was clearly revealed when he declared: ''I believe neither in what I touch nor in what I see. Only my inner feeling seems eternal to me.''[5]

Breton thought it imperative to take issue with those who considered Moreau a reactionary artist who had refused to be influenced by Impressionism. He contrasted him with Renoir, much to the detriment of the ingratiating paintings by the Impressionist.

Long before Breton's admiration of Moreau's paintings, Moreau was held in the highest regard by J. K. Huysmans, who wrote about his work in the Salon of 1880. Later, Huysmans also wrote about Moreau's work in his book *A Rebours.* He (as well as his hero, des Esseintes) was especially enraptured by Moreau's *Apparition* for its romantic, literary qualities. Moreau, however,

Figure 3. Gustave Moreau. *L'Apparition,* ca. 1876.

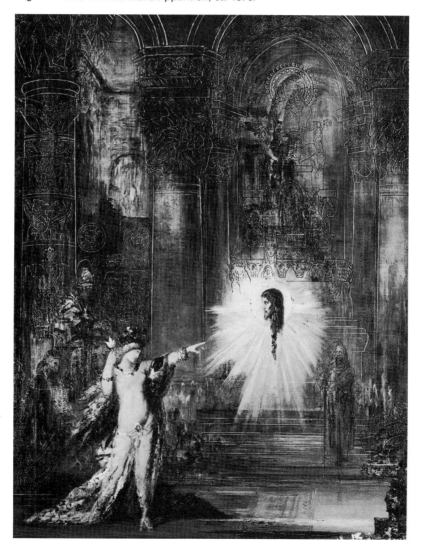

seemed more concerned with the poetic content suggested by formal elements. In his notes he wrote: "How admirable is that art which, under a material envelope, mirror of physical beauty, reflects also the movements of the soul, of the spirit, of the heart and imagination, and responds to those divine necessities felt by humanity throughout the ages. . . . To this eloquence, whose character, nature and power have up to now resisted definition, I have given all my care, all my efforts: the evocation of thought through line, arabesque, and the means open to the plastic arts — that has been my aim!"[6]

Figure 4. Odilon Redon. *Orpheus,* after 1913.

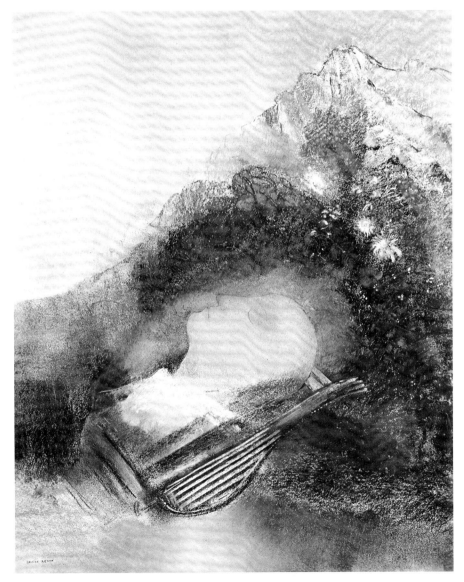

## ODILON REDON 1840-1916

Born in 1840, Odilon Redon was of the same generation as the Impressionists, yet was never tempted to depict the natural world as they did. In a conversation with Paul Sérusier he remarked that "The Impressionist boat's ceiling was too low."[7] He expressed his views even more clearly with the statement: "Some people insist upon the restriction of the painter's work to the reproduction of what he sees. Those who remain within these narrow limits commit themselves to an inferior goal. The old masters have proved that the artist, once he has established his own idiom, once he has taken from nature the necessary means of expression, is free, legitimately free, to borrow his subjects from history, from the poets, from his own imagination. . . .[8] My originality consists in bringing to life in a human way, improbable beings and making them live according to the laws of probability, by putting — as far as possible — the logic of the visible at the service of the invisible."[9]

Thus, like the Surrealists, Redon aimed at a fusion of objective and subjective reality. His dreamlike images derive from his own careful studies and drawings of natural objects. "It is only after making an effort of will power to represent with minute care a grass blade, a stone, a branch, the face of an old wall, that I am overcome by the irresistible urge to create something imaginary. External nature, thus assimilated and measured, becomes by transformation, my source, my ferment. To the moments following such exercises I owe my best works."[10]

Redon's first album of lithographs, *In a Dream,* was greatly admired by Symbolist poets and painters such as his friends Mallarmé and Gauguin. Although Breton acknowledged him as a precursor of Surrealism, the Surrealists never gave him the attention they did Moreau, Gauguin, or Rousseau (Marcel Duchamp did, however). William S. Rubin proposes two reasons for this lack of interest: "Redon's insistence on the primacy of plastic structure in determining the quality of painting" and "the way in which his fantastic images evolved through organic metamorphosis."[11]

The biomorphic Surrealist painters, André Masson, Joan Miró, and Roberto Matta, also evolved images through organic metamorphosis, yet their methods were far from Redon's way of beginning with minute studies of nature and restructuring them to form fantastic images. Redon himself wrote: "It is precisely in the presence of unconscious forces that one must retain the greatest lucidity; without this, the art of painting would be like that of lunatics, children, and fools."[12] But the art of the insane and children was of particular interest to the Surrealists — as it also was to Freud. The difference in attitude can be explained by the Surrealists' determination to explore the unconscious, as contrasted with Redon's concern to create works of art.

Nevertheless, an affinity between Redon and Surrealism is undeniable. The pastel painting *Orpheus* (Figure 4) demonstrates his concern with subtle representations of images taken from dreams and myths. The profile head of the mythological poet-musician is seen reclining with eyes closed. He is supported by his lyre and is drifting before an island mountain flickering with glowing flowers. Resonant colors and muted values suggest a soft light that seems to emanate from the painting itself.

Redon chose to represent the point in the myth when Orpheus had lost Eurydice and had been torn to pieces by the wild Maenads. They had already scattered his limbs and threw his head and lyre into the river Hebrus, where they floated, playing and singing, down to the Aegean Sea and the island of Lesbos. There they were received with loving sorrow by the Lesbian women, who reverently buried the head.

Redon, deeply involved with Symbolism, must have been aware of the newer symbolism attached to the myth: the idea of Orpheus's descent into the nether world as a descent into his own soul. When Orpheus looks back in an effort to discern the form of Eurydice, he loses forever his female counterpart. He then discovers the more sublime character of masculine love and becomes a priest of an Apollonian cult opposed by the Thracian women, aggressive followers of Dionysius. Before murdering and mutilating Orpheus, they killed their own husbands who had followed him in worshiping the rational, intellectual (and therefore masculine) Apollo.

Orpheus's near-rescue of Eurydice from Hades suggests the immense power of poets who only barely fail to overcome death itself, and then only because of their inability to separate themselves entirely from the world of the flesh. The loving care accorded Orpheus's head by the Lesbian women clearly contrasts with the brutal actions of the wild Thracian women who remain at a more primitive, sensual stage of human existence. As the nineteenth-century Swiss social philosopher Johann Jakob Bachofen points out, it is important to remember that "The masculine Eros was welcomed as a promoter of virtue by the ancients. . . . Like Orpheus, they made it the foundation of a higher Apollonian existence. Socrates attributes [to it] a liberation from the dominion of matter . . . a transfiguration in which love rises above sensuality. . . ."[13]

The myth of Orpheus is "myth . . . looking at itself. . . . Orpheus is poetry thinking about itself."[14] The late nineteenth-century Symbolists developed the multilevel complexities of the Orpheus myth; the brief indication here of some of its symbolic references is only intended to identify their interest in mythological subjects and poetic metaphors which preceded that of the Surrealists. Nietzsche, Freud, and the Surrealists were all concerned with various aspects of the Orpheus myth. Nietzsche stood on the side of the primitive and emotional followers of Dionysius, while Freud and the Surrealists emulated Orpheus's descent into the lower regions (the unconscious).

Redon's early lithographs, etchings, and charcoal drawings were even more important for the young Symbolist artists than his later oils and pastels of flower still lifes. The subject matter of the earlier works included strange, hybrid, half-human insects and plants; enormous floating eyes; and other such visions of his enchanted inner world. Their dark, mysterious mood and metamorphic character caused Huysmans to attribute a taste for them — as well as for Moreau's work — to des Esseintes, the decadent hero of *A Rebours.*

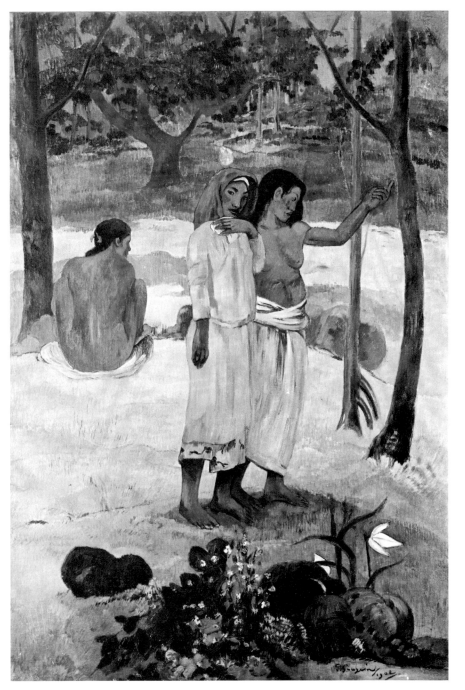

Figure 5. Paul Gauguin. *L'Appel (The Call),* 1902.

# PAUL GAUGUIN
# 1848-1903

Redon reluctantly replaced Paul Gauguin as a leader of the Symbolist artists when Gauguin fled to Tahiti. Like Redon and Moreau, Gauguin was interested in mythology, although classical myths did not interest him so much as those of primitive societies. Indeed, it was the process of myth-making that most concerned him.

Breton was the first among the Surrealists to recognize that Gauguin's rejection of Western European cultural values in his art as well as his life was of significance for Surrealism. Gauguin attempted to create art anew by beginning with the ingenuous attitudes and values of primitive cultures. His success as an artist derives from desperate attempts to recapture the pure poetry of primitive, mythical images. His failure to fully realize his ambition does not change his position as a major artist and precursor of Surrealism. Gauguin was simply too much a part of his own culture to escape it completely. He carried nineteenth-century European traditions and values with him in his flights to Martinique, Tahiti, and the Marquesas.

In Tahiti, Gauguin was hoping to find a primitive society unspoiled by European intelluctual and moral traditions. However, European influence was already so strong there that he was driven to try to reconstruct the primitive world of his dreams in his paintings. His allegories such as *Where Do We Come From? What Are We? Where Are We Going?* are usually simple transformations of traditional Western philosophical queries.

Many of the paintings from his last sojourn in Tahiti and the Marquesas have more oblique symbolic subjects. One of his last works done in the Marquesas is titled *L'Appel* (Figure 5). Like most of the canvases he did in the Marquesas, it is more luxuriant in color than the Tahitian paintings or those done in Brittany.

The three female figures in *L'Appel* are quiet, mysterious, and brooding. One raises her arm and hand in a calling gesture, while her companion looks at the viewer enigmatically. A seated figure has her naked back turned, although her dark profile can be seen against a rich pinkish-lilac ground just below the lush foliage.

Gauguin had only started painting seriously in his late twenties, when he was encouraged by Camille Pissarro. His first paintings were in the Impressionist manner, yet his significance as an artist depends on the works which demonstrate his ultimate opposition to the naturalist tradition in art.

While waiting to raise the money for his first trip to Tahiti in 1891, Gauguin became the artist-in-residence with the Symbolist writers who met regularly at the Café Voltaire in Paris. There he met with the critics Albert Aurier, Julien Leclerq, and Charles Morice, as well as the poets Paul Verlaine — who was ill and aging — Stephane Mallarmé, and the theorist Jean Moréas.

Gauguin was well received by the younger Symbolists, and while he accepted their admiration, he also joked about their insistent theorizing, referring to them as "cymbalists."[15] Still, he was sympathetic with their aims. Indeed, five years earlier he had written in a significant letter to Emile Schuffenecker: "A strong emotion can be translated immediately; dream on it and seek its simplest form."[16]

# GEORGES SEURAT 1859-1891

It seems incongruous that Georges Seurat — meticulous inventor of Pointillism and organizer of strict geometrical compositions — should be claimed by Breton as a precursor of Surrealism. Traditional art criticism views Seurat's major contributions to art as restoring formal order to the naturalism of Impressionist painting and indicating the emotional connotations of certain formal elements. Conservative and reserved, he appeared to be a typical bourgeois — the antithesis of the flamboyant Gauguin and of many Symbolists and Surrealists. His compositions are mathematically orchestrated and, as Meyer Schapiro first noted, the figures in works such as *La Parade du Cirque* (Figure 6) are seen as though the observer were standing before each one in turn. Negating traditional perspective, this becomes, according to Schapiro, a "collective perspective."[17]

Seurat approached the creative act slowly, carefully, and thoughtfully, trying to provide a scientific basis for the intuitive, retinal realism of Impressionism. Furthermore, far from seeking to escape to a more primitive culture as did Gauguin, he was quite content in his studio in Paris. And although he attempted to express moods, he did so according to a rational and formal system rather than spontaneously.

Rather than remarking about Seurat's formal accomplishments, Breton referred to him as a "crack" in the face of Alice's looking glass. He admired "Seurat's disturbing insinuations concerning the way certain forms of figures 'echo' their background (as in *Le Chahut*) or . . . the magic of certain confusing lighting effects *(Parade)*. . . ."[18]

Paintings such as *Un Dimanche d'Etè a l'Ile de la Grande Jatte, Les Poseurs,* or *La Parade du Cirque* do indeed suggest an air of mystery behind the facade of ordinary appearances similar to that elicited by Paolo Uccello's *Battle of San Romano* and Piero della Francesca's *Flagellation.* Seurat's remote and expressionless figures — as Uccello's and Piero's — exist in a geometrically constructed world. Paradoxically, his concern with formal qualities and scientific methods produced mysterious and enigmatic paintings. The images depicted by Uccello, Piero, and Seurat — like those by Giorgio de Chirico and Surrealists such as René Magritte and Yves Tanguy — seem static and silent, fixed forever in time and space.

The poet Rimbaud's prose poem *Parade* was published May 13, 1886, and Seurat's *La Parade du Cirque* was painted in 1887-88. Félix Fénéon, a close friend of Seurat's, read the manuscript of Rimbaud's *Les Illuminations,* and another friend, Gustave Kahn, published it. It seems very likely, therefore, that Seurat read Rimbaud's *Parade.* The prose poem used circuses to mirror the condition of mankind in the new industrial cities of the late nineteenth century. It mentions the raillery or terror which could last there for a minute or forever.

Rimbaud wrote that he alone had the key to this savage parade. Seurat's mathematically precise, frieze-like composition is an enigmatic scene of this demimonde on a dimly lit, misty night. It depicts the blurred forms of a row of nondescript circus musicians, a clown playing a trombone, a child performer, a sinister ringmaster, and an indifferent audience. A malevolent spirit inhabits the fog-shrouded scene. Seurat might well claim to share Rimbaud's key to the savage parade of modern life.[19]

It was Seurat's ability to refer to such subtle experiences in appropriate poetic images that caused Breton to accord him a place among the precursors of Surrealism along with Uccello, Redon, and Chirico in his first Manifesto of Surrealism (1924).

Figure 6. Georges Seurat. *La Parade,* 1888.

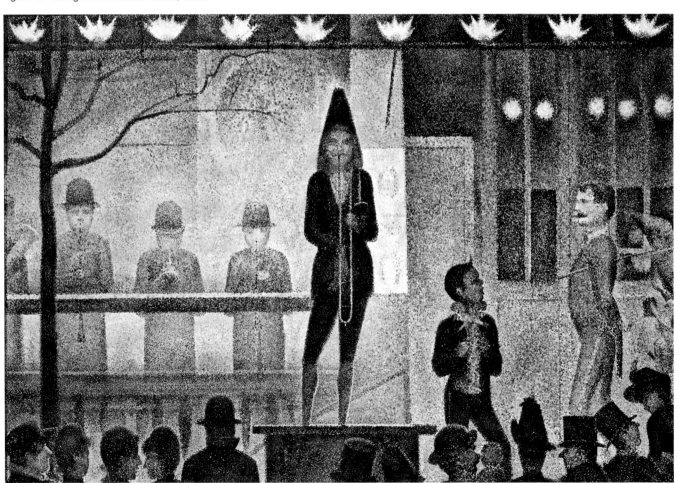

# HENRI ROUSSEAU
# 1875-1933

Guillaume Apollinaire called Henri (The Douanier) Rousseau the Uccello of our century. Rousseau influenced Surrealism through his effect on Chirico, Apollinaire, Picasso, and Jarry (who "discovered" and first defended him); and because he shared certain goals with some Surrealists. Among these aims were: an interest in dreamlike subjects, a tendency to bring together logically unrelated images, a commitment to enigmatic and poetic subject matter, and meticulously finished images.

Furthermore — and most importantly — he seemed unable, or unwilling, to separate art from life.

Considering the many attitudes they shared, it would seem that Rousseau would have been wholeheartedly embraced by Surrealism from its beginning. That he wasn't may be due to the Surrealists' lack of conviction that Rousseau's eye was truly innocent. His straightforward articulation of his visions, however, caused Breton to refer to him simply as an autodidact (someone who is self-taught) rather than a *naïf*.

Among Rousseau's paintings, perhaps the most relevant to Surrealism are *The Sleeping Gypsy* and *The Dream* (Figure 7). However, *The Jungle: Tiger Attacking a Buffalo* (Figure 8) is also a major example of Rousseau's imagination and naivety. *The Jungle* depicts a combat between a buffalo and a tiger in which the action seems to be arrested in time and space. In dreams things seem to proceed in slow motion; in Rousseau's painting (as in Uccello's, Piero's, Seurat's, and Chirico's) they have apparently come to a full stop.

Figure 7. Henri Rousseau. *The Dream,* 1910.

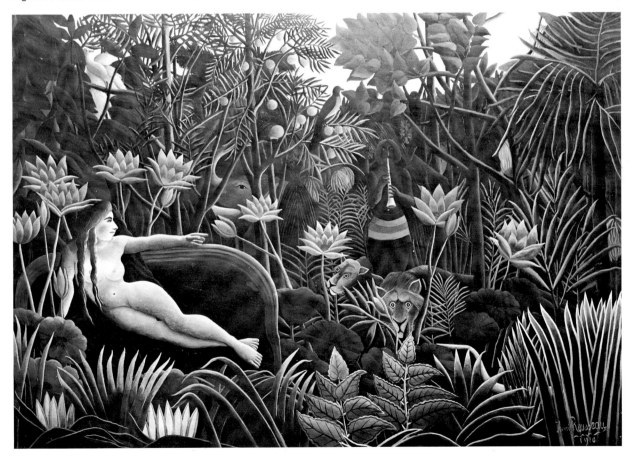

Actually, neither of these animals inhabits a jungle, both preferring an open veldt. The tiger is native to Asia, where Rousseau never even pretended to have visited; this buffalo is a wild African (rather than a domesticated Indian) type; and bananas do not grow pendant as they are shown here — they curve upward in clusters around the branch.

Such iconographical errors are due to Rousseau's ignorance of exotic geography; although he claimed to have served in Mexico with the French army there is no evidence that he did so. His "Exotic Landscapes" and "Jungle Scenes," painted from 1900 to 1907, are actually based on sketches and notes he made at the Jardin des Plantes in Paris. Nevertheless, paintings such as *The Jungle* are "dreams" convincingly realized in paint a generation before similar Surrealist paintings by René Magritte and Salvador Dali.

Figure 8.  Henri Rousseau. *The Jungle: Tiger Attacking a Buffalo,* 1908.

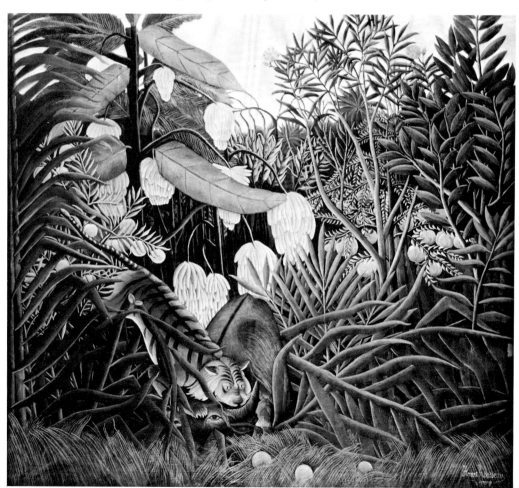

# GIORGIO DE CHIRICO
# 1888-1978

Although Ernst, Miró, and Masson dominated the classic period of Surrealist art during the 1920s, it is essential to consider the metaphysical paintings of Giorgio de Chirico, done between 1911 and 1917, in order to understand the imagist or illusionist Surrealism of René Magritte, Yves Tanguy, Salvador Dali, and Paul Delvaux, that prevailed during the 1930s.

Despite Chirico's inclusion in the first Surrealist exhibition and the high regard in which his early work was held by the Surrealists, he was never a member of the Surrealist movement; in fact, he had stopped painting the kind of works the Surrealists admired five years before the Manifesto of Surrealism was published. Yet, a chance viewing of one of those early canvases caused Tanguy to decide to become a painter. Ernst and Magritte were also directly influenced by Chirico's work of this period, and Dali and Delvaux belong to the same line of development.

In 1914 the poet Guillaume Apollinaire declared Chirico to be the most astonishing painter of his time. Breton hailed him as a master, and many minor Surrealist painters translated his work into their own visual idioms. More than any other artist — with the possible exception of Ernst — his works manifest Lautréamont's classic simile for beauty in visual terms: the juxtaposition of clearly defined but logically unrelated images.

Born in Greece in 1888, Chirico started to follow his Sicilian father's profession as an engineer when he suddenly decided to become a painter. At eighteen years of age, after his father's death, he left Greece to study in Munich. While there, he came under the spell of the German romantic painters, especially the Swiss-born Arnold Böcklin. He was also impressed by the

**13** Giorgio de Chirico, *The Nostalgia of the Infinite*, 1913-14 (?), dated on the painting 1911

philosophical writings of Nietzsche and Schopenhauer.

In 1910 and 1911 he lived in Florence, Milan, and Turin; in 1911 he moved to Paris and became one of a group of artists and poets around Apollinaire. Although Chirico never accepted the Cubist style, then championed by Apollinaire, the poet was enthusiastic about Chirico's painting. Many of his acquaintances claimed that he was gifted with prophetic powers, particularly when Apollinaire was wounded in the head during the war — an event that occurred after Chirico had painted his head as a target with a bullet hole in it.

Most of Chirico's paintings from this period, such as *The Nostalgia of the Infinite* [13], *The Song of Love* [14], and *The Anguish of Departure* [15], combine clear representations of lonely city streets and squares, arcades, walls, clocks, trains, gloves, balls, looming chimney stacks, towers, classical sculptures, artichokes, stalks of bananas, threatening shadows of unseen presences, and occasionally, distant human figures seen in silhouette. These eerie images and settings are almost invariablly bathed in a flat, cold, late-afternoon sunlight. The source of such paintings was revealed in Chirico's autobiography (1945), when he wrote that what interested him most in Nietzsche's writings was "a strange, dark poetry, infinitely mysterious and lonely, based . . . on the atmosphere of an afternoon in autumn when the weather is clear and the shadows are longer than they have been all summer, because the sun stands low in the sky. . . . The place where this phenomenon can best be observed is the Italian city of Turin."[20]

Obviously, many of the images he painted lend themselves to Freudian interpretations. Towers and chimneys, for example, are phallic, and arcades and artichokes, vaginal. However, as Rubin points out, too many critics have tried to define the exact degree of sexual symbolism in Chirico's paintings. There is general agreement, on the other hand, that, unlike Dali's deliberate and conscious use of sexual symbols, those in Chirico's work are unintentional. This was important to the Surrealists whose premises depended on the validity of Freud's theories concerning repressed sexual urges appearing unconsciously in symbolic forms.

**14** Giorgio de Chirico, *Song of Love,* 1914

Neither iconographical nor formal analyses of Chirico's paintings reveal exactly how he achieved his mysterious effects. Certain devices are obvious but go only so far in explaining the entire ambience: for example, the long, sharp-edged shadows and peculiar light imply a sun low in the sky; trains suggest departures, strangers, exotic places, and a contemporary industrial world (when combined with classical settings, sculpture, and architecture, time seems strangely wrenched); sharply defined contours and the precise definition of distant forms indicate a thin atmosphere and — since sound depends on air for its waves to travel — silence. (In writing *Sur le Silence,* Chirico warned to "beware of the silence" that precedes great cataclysms.[21]

Thus, Chirico's immutable, silent, metaphysical world suggests an ominous dream world. Chirico himself wrote: "We must not forget that a picture must always be the reflection of a profound sensation, that profound signifies strange, and strange signifies not-known or perhaps entirely unknown. A work of art, if it is to be immortal, must go beyond the limits of man. Good sense and logic have no place in it. That is the way in which a painting can approximate to a dream-like or child-like state of mind."[22]

By 1916, in paintings such as *Interno Metafisica con Biscotti* [16] and *Jewish Angel* [17], Chirico was employing images of engineers' instruments, carpenters' tools, biscuits, disembodied eyes, frames, and easels. He often constructed figures (as in *Jewish Angel*) out of instruments that mankind has invented to measure his own constructions. These figures gave way in turn to mechanical mannequins done several years before Duchamp's anthropomorphic machines.

**15** Giorgio de Chirico, *The Anguish of Departure,* 1913-14

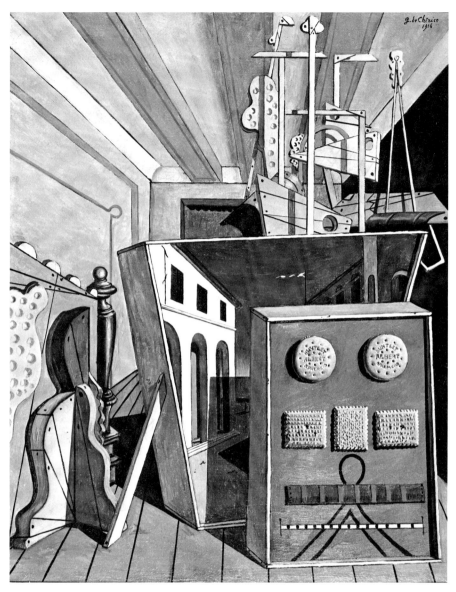

**16** Giorgio de Chirico, *Interno Metafisico con Biscotte,* 1916

In 1922 Chirico wrote to Breton from Rome that he was "tormented by . . . the problem of craftsmanship."[23] He began to copy Quattrocento artists such as Uccello and then the Venetian masters of the High Renaissance. He diligently studied the paintings of these artists and analyzed their techniques, grinding his own colors and attempting to emulate their methods and styles. Breton and Aragon, outraged by Chirico's heavy-handed and pretentious efforts, denounced his works of this period.

When Chirico returned to Paris and in 1926 had an exhibition of his new work at Leonce Rosenberg's gallery, the Surrealists condemned the exhibition. In 1928 they countered with an exhibition in which they included his early works. Aragon attacked his new work in print while praising his older paintings, remarking on their special significance for Surrealism. Chirico indignantly broke with the Surrealists and renounced his own earlier work. Although he never recovered his muse, he later painted forgeries of his own earlier paintings. Despite their dispute, Breton subsequently referred to Chirico, along with Lautréamont, as one of two "fixed points" by which the Surrealists could determine "the straight line ahead. . . ."[24]

In Chirico's canvases, as in Magritte's, Delvaux's, and Tanguy's, one looks in vain for the fine quality of painting-as-painting that one finds in a Miró or Gorky. The illusionist Surrealists, like Chirico, are concerned with images and their connotations or symbolic references to the exclusion of the aesthetic values of painted surfaces. Their brushwork is notable only for its lack of character and elegance. The images and their bizarre relations alone carry the ineffable content of these works.

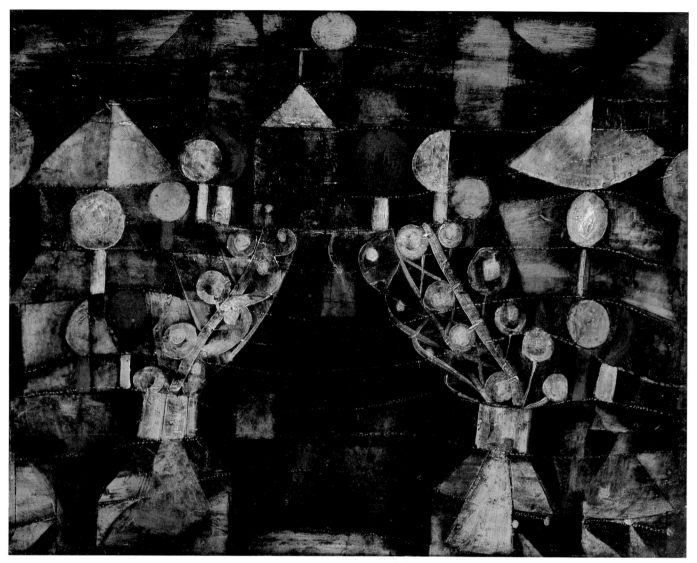

Color Plate IX. Paul Klee, *Women's Pavilion (Frauen Pavillon)*, 1921 [60].

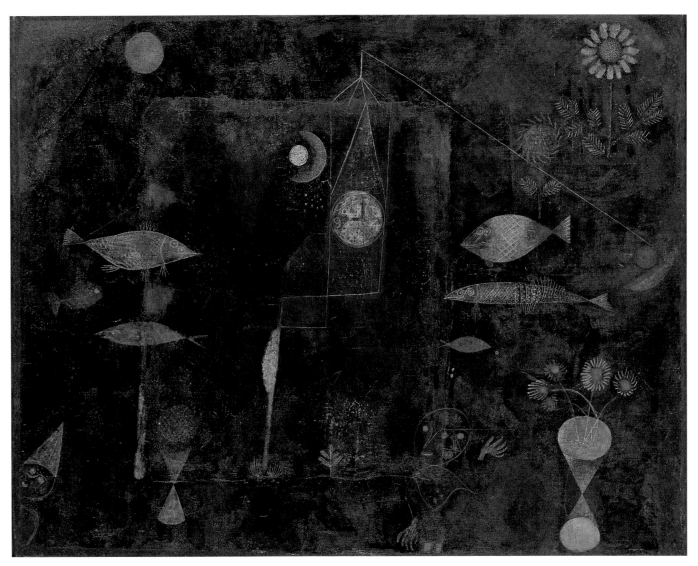

Color Plate X. Paul Klee, *Fish Magic,* 1925 [63].

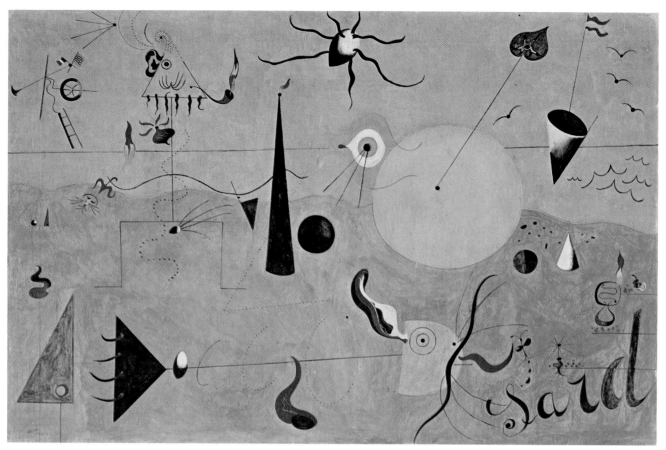

Color Plate XI. Joan Miró, *The Hunter (Catalan Landscape),* 1923-24  [25].

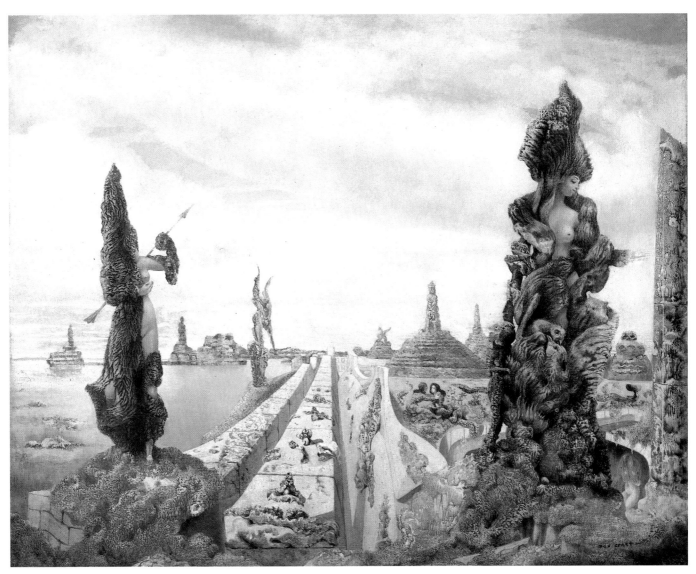

Color Plate XII. Max Ernst, *Stolen Mirror*, 1941  [24].

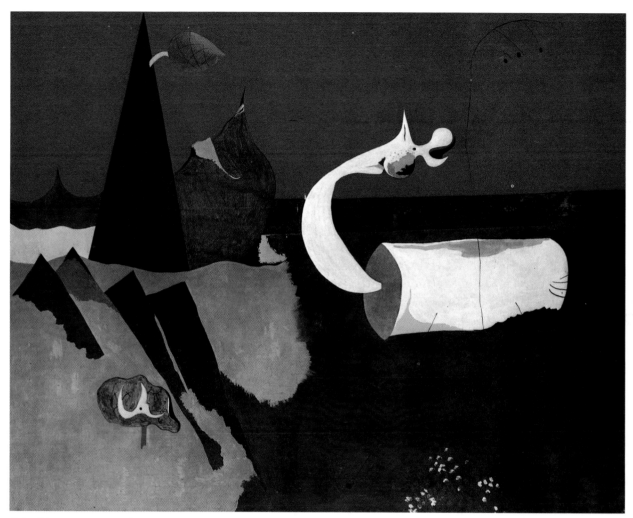

Color Plate XIII. Joan Miró, *Horse at the Seashore,* 1926  [28].

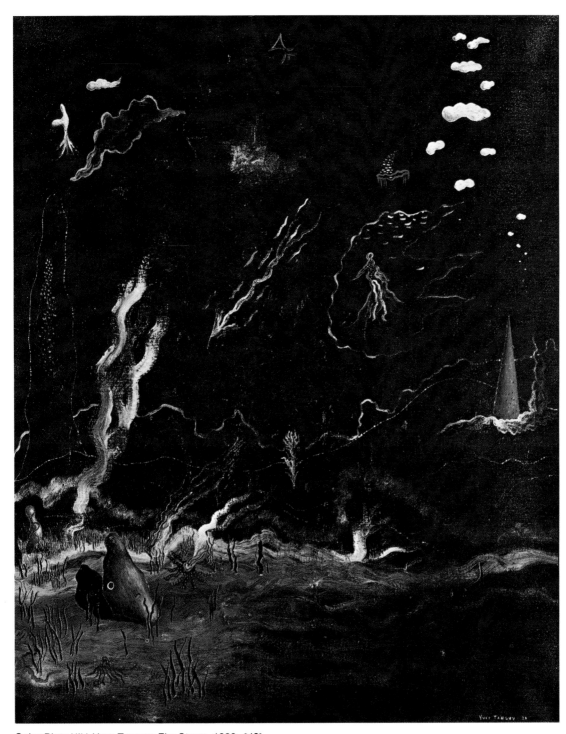

Color Plate XIV. Yves Tanguy, *The Storm*, 1926  [49].

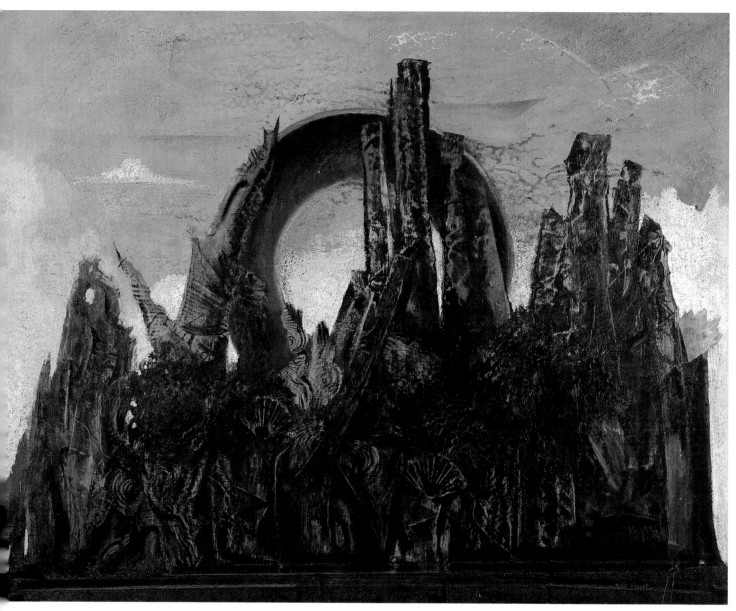

Color Plate XV. Max Ernst, *Forêt (Forest),* 1927 [21].

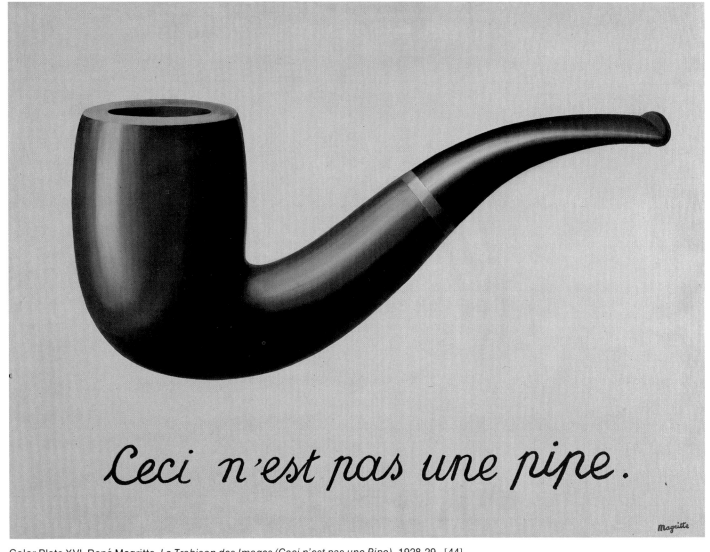

Color Plate XVI. René Magritte, *La Trahison des Images (Ceci n'est pas une Pipe),* 1928-29   [44].

Chirico wrote: "Certain aspects of the world, whose existence we completely ignore, suddenly confront us with the revelation of mysteries lying all the time within our reach and which we cannot see because we are too short-sighted, and cannot feel because our senses are inadequately developed. Their dead voices speak to us from near-by, but they sound like voices from another planet."[25]

Thus Chirico enunciated the philosophical thesis that the appearance of the phenomenal world is dependent on the nature of our limited senses. The artist-poet may intuit a reality beyond the range of his sensory perceptions, but it is as strange as "voices from another planet." This is not necessarily mysticism; John Archibald Wheeler, a physicist at the University of Texas, has recently observed: "What we conceive of as reality is a few iron posts of observation with papier-mâché construction between them that is but the elaborate work of our imagination."[26]

Chirico was the strongest single influence on Surrealist art. Indeed, his metaphysical paintings so clearly anticipated works by Ernst, Magritte, Tanguy, Dali, and others, that it has often been mistakenly assumed that he was himself a Surrealist.

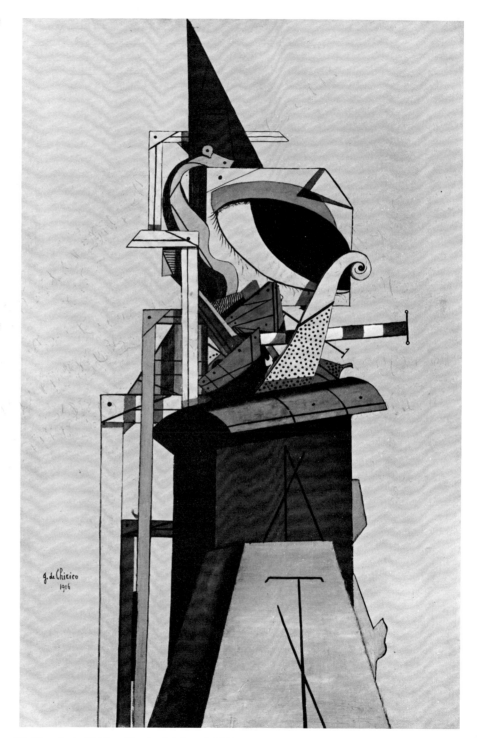

**17** Giorgio de Chirico, *The Jewish Angel,* 1916

1. Four such writers are: Claude Roy (*Arts fantastiques,* Paris, 1960); Marcel Brion (*Art fantastique,* Paris, 1961); Marcel Jean (*History of Surrealist Painting,* New York, 1960 and 1967); and Sarane Alexandrian (*Surrealist Art,* New York and Washington, 1970).

2. William S. Rubin, *Dada and Surrealism* (New York: Harry N. Abrams, Inc., 1968), p. 123.

3. Ibid., p. 124.

4. André Breton, *Surrealism and Painting,* trans. Simon Watson Taylor (New York: Harper & Row, 1972), p. 363.

5. Ibid., p. 361.

6. Edward Lucie-Smith, *Symbolist Art* (New York and Washington: Praeger, 1972), p. 66.

7. Breton, p. 360.

8. John Rewald, *Post-Impressionism: From Van Gogh to Gauguin* (New York: The Museum of Modern Art, 1956), p. 169. Redon's quotes were first published in *La Gironde,* 19 May 1868.

9. Ibid., p. 170; from *La Gironde,* 9 June 1868.

10. Ibid., p. 169; from *L'Art Moderne,* 25 August 1895.

11. Rubin, p. 125.

12. Ibid.

13. J. J. Bachofen, *Myth, Religion, and Mother Right,* trans. Ralph Manheim (Princeton: Princeton Univ. Press, 1967), pp. 204-7.

14. Michael Grant, *Myths of the Greeks and Romans* (New York: New American Library, 1962), p. 277.

15. Wayne Anderson, *Gauguin's Paradise Lost* (New York: Viking Press, 1971), p. 139.

16. Ibid., p. 138.

17. Rubin, p. 129.

18. Breton, p. 52.

19. John Russel, *Seurat* (New York: Frederick A. Praeger, 1965), p. 218.

20 Uwe M. Schneede, *Surrealism* (New York: Harry N. Abrams, Inc., 1974), p. 17.

21. Rubin, p. 131.

22. Jacques Lassaigne, *History of Modern Painting: From Picasso to Surrealism* (Geneva: Albert Skira, 1950), p. 104.

23. Sarane Alexandrian, *Surrealist Art* (New York and Washington: Praeger, 1970), p. 58.

24. Breton, p. 13.

25. Lassaigne, p. 104.

26. *Newsweek,* 12 March 1979, p. 62.

*Opposite*
Max Ernst (left) and Robert Motherwell playing chess. Photograph from William Rubin, *Dada and Surrealist Art* (New York: Harry N. Abrams, 1968).

Reason tells man to stand above nature and to be the measure of things. Thus man thinks he is able to live and to create against the laws of nature and he creates abortions. Through reason man became a tragic and ugly figure. . . . Reason has cut man off from nature.     Jean Arp

# Surrealism and Communism

In 1947 Breton wrote: "There are *three* major goals in Surrealism: the social liberation of man, his complete moral liberation, and his intellectual rejuvenation."[1] Since these goals depended on the repudiation of bourgeois capitalist society, Surrealism was originally sympathetic towards the Bolshevik Revolution and its ideal of an international classless community developing out of a proletarian society and enjoying complete freedom of thought and speech.

The Communist ideals were first put aside during the civil war following the Bolsheviks' seizure of power in Russia; they were indefinitely postponed with Stalin's triumph over Trotsky for leadership following Lenin's death in 1924. The policy of self-containment and the protection of the single socialist state resulted in the growth of a massive bureaucracy and state police force responsible to a personal dictator. Criticism was suppressed; old Bolsheviks were executed; and Trotsky, living in exile after 1936, was assassinated. Marxist theory was transformed into Stalinist dogma, while the vested interests of the Communist Party bureaucracy replaced vested capitalist interests.

At one point or another, many of the Surrealists joined the Communist Party. However, most soon recognized that the society they envisioned as essential for the social, moral, and intellectual liberation of mankind was not located in the Stalinist state. Some, such as Louis Aragon, vacillated before electing to remain in the party, while others, like Breton, withdrew and eventually sided with Trotsky.

In theory, the Surrealists were justified in believing that their intellectual and psychological revolution would complement the Marxist social revolution. When the Communist revolution occurred in Russia, however, it accepted avant-garde art for only a brief period, after which it suppressed all modernist movements, including Surrealism. The question of why a revolutionary political movement should assume a reactionary cultural position caused much agonizing among many leftist intellectuals, especially the Surrealists. Any explanation must consider the unique facts of the revolution, as they actually occurred quite differently than Marx had predicted them.

Most obvious are the unique circumstances of World War I that caused the social revolution to happen first in a predominantly agrarian nation rather than an advanced industrial one with a large and self-conscious proletariat. Instead of looking to urban workers for their base of support, the Russian intellectual leaders had to depend on a coalition of workers, soldiers, and peasants whose interests were often opposed to each other. Furthermore, instead of spreading to other, more highly industrialized states the revolution was contained within the boundaries of a single, semi-feudal, nation-state — an outcome that Trotsky predicted would doom the revolution. The Soviet Union did in fact become a threatened and suspicious national socialist state.

Under Stalin's leadership it was determined that the construction of a single Marxist state within a hostile environment should take precedence over the active provocation of a world-wide social revolution. After Lenin's death in 1924 this policy became a major issue in the struggle among the Bolshevik leaders, with Bukharin on the right; Trotsky on the left; and Stalin, Zinoviev, and Kamenev in the center. By 1929 Stalin had all but won the battle. Although the purge trials did not occur until the mid-thirties, Trotsky and Zinoviev had been expelled from the Communist Party in 1927 and Kamenev and Bukharin were reduced to impotence.

One result of the policy of socialism in a single state was the conscription of the arts as propaganda weapons. This was accomplished by imposing certain subjects and a naturalistic or neo-classical style on the arts, thus making their messages easy for illiterate workers and peasants to comprehend.

Artists such as Wassily Kandinsky, Marc Chagall, El Lissitzky, and Kasimer Malevich, who were at first supported by the Bolsheviks and received important positions in the officially sanctioned Institute for Artistic Culture, were by the mid-twenties faced with the choice of producing socialist art or leaving the Soviet Union. Kandinsky, Chagall, and others left; Malevich and Lissitzky were among those who remained. Even Serge Eisenstein, the great film director, was accused of excessive formalism in films such as *The Battleship Potemkin* and *Ten Days That Shook the World.* (He heeded the warning; with *Alexander Nevsky,* made in 1938, he created an entertaining and patriotic propaganda film.) When the predicted attack by reactionary forces occurred with Nazi Germany's invasion of the Soviet Union in 1941, Stalin's repressive, dictatorial measures suddenly seemed justified to some otherwise skeptical Communists. What many of them failed to perceive, however, was that the character of the revolution itself had changed.

Surrealism thus found itself in the dilemma of having to choose between a social revolution that it wished to support but which discouraged freedom of expression, and a bourgeois society that it abhorred but which tolerated and even encouraged intellectual freedom. Ferdinand Alquié asked: "Can one, in fact, claim to emancipate men when one has begun by betraying beauty and truth?"[2] And Breton commented: "All of us seek to shift power from the hands of the bourgeoisie to those of the proletariat. Meanwhile, it is nonetheless necessary that the experiments of the inner life continue, and do so, of course, without external . . . even Marxist control."[3]

The Surrealists had expected a sympathetic and mutually supportive relationship with the Marxist revolutionaries, but their expectations were cruelly disappointed by the Bolshevik apparatus. In spite of this, many Surrealists joined the Communist Party at one time or another and attempted to maintain good relations with Communism while simultaneously defending their own creative independence.

The mechanistic-materialism of Stalinist Communism leaned heavily on I. P. Pavlov's behaviorist psychology which was difficult to reconcile with Freudian psychoanalysis on which Surrealism depended. Pavlov developed the notion of conditioned reflex as a major means for explaining patterns of behavior. The Freudian theory of the id as an unconscious mass of interacting energies that determines conscious behavior therefore was not taken seriously by the Stalinist regime, which hoped to demonstrate that human nature itself could be altered by manipulating the environment.[4] Freud's concept of the personality structure (fundamental to Surrealist theories and creative attitudes) held that while behavior could be affected by the environment, the basic structure of the personality remained intact. Surrealism, therefore, rejected Pavlov's mechanistic theory of human behavior which denied individual freedom of thought and action.

The Surrealists were reluctant to accept the idea that Marxism and Freudianism were incompatible, yet Stalin's distortions of Marxist theories were facts of life. Breton finally elected to support Trotsky's leftist Bolsheviks and his concept of "the permanent revolution," while Aragon and Eluard chose to support Stalin's Soviet state as offering the best available hope for the liberation of the human mind from bourgeois strictures, even if in the distant future.

How can the un-Marxist character of the first Marxist state be accounted for? If we consider Marx toiling for years in the British Library as analogous to a theoretical scientist compiling evidence to explain certain events under consideration, and the Bolshevik revolutionaries as analogous to laboratory technicians attempting to put the theories to practical use, we may have a clue to the solution of this apparent paradox. The active revolutionist, like the technician, is part of his experiment, both affecting and affected by the system being dealt with. Thus, the Bolsheviks became active elements within the very social system they were attempting to put into effect. They could neither completely control nor accurately predict what would happen since, as elements in the experiment, they could not view it and deal with it objectively. There was a reciprocal influence between the revolutionary leaders and the social environment of which they were integral elements. If they altered the environment, it, in turn, changed them.

In addition, Marx's assumption that the proletarian revolution would occur first in highly industrialized bourgeois states proved wrong; it actually occurred in a single, predominantly agrarian, semi-feudal state that had never experienced a bourgeois revolution. The problem faced by the Bolsheviks was how to convert a large, unwieldly, backward nation — torn first by war, then by revolution and civil war — into an efficient

industrial state without passing through a bourgeois phase and, at the same time, retain Marx's socialist ideals and a measure of individual freedom. Stalin's willingness to sacrifice ideals to ruthless practices triumphed over Trotsky's internationalist revolutionary ideals on the one hand and Bukharin's gradual collectivization on the other.

In France, headquarters for the Surrealist revolution, the problem of whether or not to support the Communist revolution was complicated by Breton's conviction that a commitment to Communism was the best hope for the future — he pointed out that whatever its defects, Communism was the only system so far to have overthrown the old order and defeated the bourgeoisie. Furthermore, he felt that an alliance with Communism would provide Surrealism with a moral integrity to aid it in the battle against certain intellectual enemies such as Jean Cocteau, considered by Breton to be a frivolous socialite, a plagiarist, and a fop. Breton was convinced that a distinction could be made between the political revolution — which was primarily social and economic — and the Surrealist revolution, which was concerned with moral and intellectual values. In his essay "Legitimate Defense" published in 1926 Breton indicated the Surrealists' desire to play a role both in the Communist Party's intellectual debates and, in particular, their literary activities. "It is not," he wrote, "the material advantage which each man may hope to derive from the Revolution which will dispose him to stake his life — *his life* — on the red card."[5] However, André Thireon, a member of the French Communist Party and once a Surrealist, asked: "What could the Party do with Max Ernst or André Breton to win over the miners of Lens . . .?"[6]

Despite their many intellectual conflicts, the Surrealists often found themselves on the same side as the Communists. They chose to support Sun Yat-sen's revolution in China, for example, and sided with the Riff mountain tribesmen in their struggle for independence against the Spanish and French in Morocco, and backed the Loyalist regime in Spain. At the same time, Breton was appalled by the intellectual poverty of the writing in *L'Humanité* and especially by the French Communists' placid acceptance of Trotsky's expulsion from the Communist Party. Trotsky was seen as an intellectual, idealist, and a brilliant writer and revolutionary strategist; Stalin, on the other hand, appeared to be a stolid, stubborn, political tactician. Trotsky had declared that "The field of art is not one in which the Party is called on to command."[7] Under Stalin, however, the Party dictated subject matter and style in all the arts. Indeed, intellectuals, in general, became figures for derision and persecution.

In 1927 Breton, Aragon, Eluard, Péret, and a young Surrealist named Pierre Unik joined the French Communist Party. However, the Party was in no mood to debate philosophical issues or concern itself with the exploration of the unconscious; it was the directives emanating from the Soviet Union, then in the midst of the Stalinist-Trotskyist crisis, that occupied them. The Surrealists were assigned to various workers' cells and directed to act as journalists for the Party, a task that Breton refused, on the basis that it was "dirty business." Such occurrences led most of the Surrealists to leave the Communist Party, even though they remained uneasy allies after their departure.

The year 1929 not only marked the end of a decade, it also saw apparent evidence of a breakdown in laissez-faire Capitalism with the collapse of the stock market as well as the end of Marx-ist idealism in the Soviet Union with the consolidation of Stalin's power. The Surrealists, who had earlier agreed that the revolution in Russia should be supported, now began to waiver and to split over political differences.

In 1930 twelve Surrealists attacked Breton for his high-handed control of the Surrealist movement. Ironically, their attack was published in a pamphlet titled *Un Cadavre,* the same as that used in 1924 by Breton and his friends to revile the recently deceased Anatole France.

In the fall, Aragon and Georges Sadoul attended the Second International Congress of Revolutionary Writers held in Kharkov. While in the Soviet Union, they signed a document denouncing Freud, Trotsky, and Breton's second Manifesto of Surrealism "to the extent that it contradicts the teachings of dialectical materialism." When they returned to France, however, both retracted this statement.

In the face of the rising tide of reaction, Breton found himself defending Aragon who had been criticized by the public for his poem *Front Rouge,* while at the same time he also attacked the literary posture of *L'Humanité.* Soon after, he was expelled from the Communist-backed Association of Revolutionary Writers and Artists for criticizing the Russian film *The Road to Life* and for attacking the Russian writer Ilya Ehrenburg in the Surrealist publication *Le Surréalisme au Service de la Révolution.* Later, when that review ceased publication the Surrealists began contributing instead to the elegant *Minotaure,* directed by Edouard Tériade and published by Albert Skira.

In the early 1930s everything seemed to go badly for Marxist idealists. France was rocked by a scandal in which a number of liberal political leaders were

accused of taking bribes from Serge Stavisky, an alledgedly dishonest entrepreneur. Two governments fell, Stavisky was mysteriously slain, and the extreme right was strengthened, while the Radical Socialist Party and parliamentary democracy in general was discredited.

In Germany, Hitler became Reichsführer after Hindenburg's death. Then, in quick succession, Italy invaded Ethiopia; Germany occupied the Rhineland; the Spanish Civil War broke out; Germany and Italy formed the Berlin-Rome axis, and Germany annexed Austria. In Moscow, the infamous purge trials began. Trotsky had been dismissed as Commissar of War by Stalin in 1925, expelled from the Politburo in 1926, and from the Communist Party in 1927. In 1928 he was exiled to Turkestan and in 1929 ordered to leave the Soviet Union. He first found refuge in Turkey, then in 1933, in France. In 1935 he was expelled from France and moved to Norway. The following year, under pressure from Moscow, he was ordered to leave Norway by Trygve Lie and sought refuge in Mexico.

Meanwhile the Moscow purge trials dragged on for three years as old Bolshevik leaders such as Zinoviev, Kamenev, Karl Radek, and Bukharin were accused of treason by plotting with Trotsky against the Soviet State. One after the other they were found guilty and executed.

The Surrealists were torn between the desire to support the Marxist revolution and their revulsion at the events occurring in the Soviet Union. Matters were further complicated by their necessary alliance with the Communists in the Spanish Civil War and their opposition to the aggressive behavior of Germany and Italy.

Breton visited Trotsky in Mexico in 1938 and collaborated with him on a manifesto: *For an Independent Revolutionary Art.* (Diego Rivera signed it in place of Trotsky.) Breton now accepted

Trotsky's thesis that in an industrially and economically backward country such as Russia, the revolution must first pass through a bourgeois and democratic phase before it can become proletarian and socialist in nature. Trotsky reasoned that having gained power but being faced by the problems of the bourgeois revolution, the workers would be forced into the socialist, "permanent revolution."

Aragon continued to support the Stalinist regime, and Breton quarreled with Eluard when the latter published some poems in *Commune,* a Communist-backed review. Eluard and Ernst both left the Surrealist movement in 1938; however, many new members joined the movement during the 1930s.

In 1939 Generalisimo Francisco Franco and the Spanish Falangists, aided by German and Italian troops, won their revolt against the Spanish Republic; Germany invaded Czechoslovakia; the Soviet Union and Germany signed a non-agression pact and, shortly after, Poland was invaded from both east and west. The French Communist Party crumbled after supporting the Russo-German pact, and the Russian invasion of Finland in the fall of 1939 further demoralized long-time Communist supporters. The declaration of war on Germany by France and Britain surprised many on the extreme left who had expected them to remain neutral while awaiting the inevitable clash between Nazi Germany and Communist Russia.

Breton and other French Surrealists were called up by the army, and Max Ernst entered a camp for enemy aliens. Eventually, many of the Surrealists found their way to the United States, where they had a profound effect on a group of young artists living in New York who later became known as the New York School, or the Abstract Expressionists.

1. André Breton, "Cométe surrealist" (1947), in *La Clé des champs* (Editions du Sagittaire, 1953), pp. 104-5; quoted in Herbert S. Gershman, *The Surrealist Revolution in France* (Ann Arbor: University of Michigan Press, 1974), p. 80.

2. Ferdinand Alquié, *The Philosophy of Surrealism* (Ann Arbor: University of Michigan Press, 1965), p. 66.

3. André Breton, "Légitime défense," *La Révolution surréaliste,* 8 (December 1926); reprinted idem, *What is Surrealism? Selected Writings,* ed. and intro., Franklin Rosement (New York: Monad Press, 1978), p. 39.

4. For example, Trofim Lysenko became the leading official geneticist in the Soviet Union during Stalin's regime by ostensibly demonstrating that characteristics acquired due to environmental influences are inherited.

5. Breton, "Legitimate Defense," quoted in Malcolm Haslam, *The Real World of the Surrealists* (London: Weidenfeld and Nicolson, 1978), p. 158.

6. Ibid, p. 161.

7. Ibid, p. 159.

# Surrealism and the Visual Arts

In 1924, the year that Breton published the Manifesto of Surrealism, Francis Picabia withdrew from the newly formed Surrealist group and lampooned it in the last issue of *391*. Max Ernst and Jean Arp had subscribed to Breton's theories from the time that he began defining Surrealist principles in 1922. Joan Miró and André Masson were among the first artists to join the movement in 1924; Yves Tanguy became a Surrealist officially in 1925, and in 1926 Louis Aragon acted as an intermediary between the Surrealists in Paris and a group in Brussels led by René Magritte, Louis Scutenaire, and E. L. T. Mesens. In the fall of 1929 Salvador Dali moved to Paris from Spain and, along with Louis Buñuel and the poet René Char, joined the Surrealists.

Surrealism, aspiring to a revolution of the human mind, began by rejecting traditional aesthetic and moral values and by acknowledging the unity of objective and subjective experience in an organic universe. Subjective reality was even accorded pride of place by virtue of Freud's theories concerning dreams and the unconscious. Visual artists at first found it difficult to preserve their identity within this all-encompassing program, and in fact, Breton's definition of Surrealism seemed to preclude the possibility of a specifically Surrealist art ("Dictation by thought . . . beyond any aesthetic or moral preoccupation"). Pierre Naville, among other Surrealist poets, considered the very possibility of Surrealist painting or sculpture as self-contradictory. In 1928, however, Breton wrote *Le Surréalisme et la Peinture* in which he advanced the notion that a painting or sculpture could be considered as coming up to the mark as Surrealist only if the artist's goal was to reveal the landscape of the inner world, particularly if his creative process was automatic.

In this key essay on Surrealism and painting Breton referred to a painting as a window and stated that his first concern was to know "what it looked out on."[1] The "plastic work of art," he wrote, "will either refer to a *purely internal model* or will cease to exist."[2] He praised Picasso highly, acknowledging that his genius frustrated all attempts to encompass his art with any label, even Surrealist. Matisse and Derain he considered to have been tamed by the art dealers, while Braque was found to be worthy of a probably forlorn hope that he would renounce his love for "the rule that corrects emotion."

Surrealist artists during the 1920s sought subjects in their unconscious by using methods paralleling those of psychoanalysts and Surrealist writers. Miró and Masson, for example, used the free play of the brush, at least in the generative stages of painting; Magritte and Tanguy developed illusionary images, illogically distorted and related in ways supposedly referring to dreams. Ernst utilized both methods, adapted the technique of collage to Surrealist aims, and developed his method called frottage (wherein he began drawings and paintings with rubbings from irregular surfaces). The spontaneous methods of Miró and Masson tended toward biomorphic abstraction that was not unlike Kandinsky's works executed from 1910 until his return to Russia in 1918; the "dream images" of Magritte and Tanguy, on the other hand, derived from Chirico's metaphysical paintings.

Collage played a major role in early Surrealist art. Ernst, Arp, Miró, and others brought together on the same plane heterogeneous images and objects (as distinguished from the homogeneous elements of Cubist collages), administering a jolt to the perceiver's sensibilities and establishing visual and psychic tensions quite different from what might be expected if these images were placed in logically relevant contexts.

When Dali entered the Surrealist scene in 1929 he had an electrifying effect on the movement. Only twenty-five years old, with arresting good looks and a shocking imagination as well as a brilliant technique, he was at first regarded as the bright hope for the future of Surrealist art. He disappointed these hopes during the mid-1930s, however, when he began exploiting the commercial market (especially in the United States) by "selling" his eccentric behavior along with his art. Even more serious in the eyes of his Surrealist comrades, he became fascinated by the mystique of Adolf Hitler.

Some of the most significant Surrealist-related works of art were produced by artists such as Chirico, Klee, Picasso, and certain artists from the New York School during the 1940s and 1950s. While they did not submit to the strict program defined by Breton, these artists — at various times in their careers — did share the main objective of Surrealism to use the creative process as a means of investigating the unconscious. They too sought to acquire knowledge of subjective experience and to create a new kind of poetry in painting based on such experience rather than on pure formalism or subjects taken from the exterior world of nature.

A major goal for modernist art after Impressionism had been to gain critical recognition of the fact that visual form in itself can be significant and aesthetically valuable. From Cézanne to Cubism and the many styles deriving from it, the emphasis had been on formal pictorial structure as the real subject of the work of art. The tendency leading from Van Gogh and Munch to Expressionism, on the other hand, stressed the visual manifestation of moods and emotions aside from the purely aesthetic. This was accomplished, however, by manipulating the formal elements of the work while considering their common associations and connotations. In contrast to both these developments, the major concerns of Surrealism involved exploring the interior world of the unconscious and developing methods to unmask its content. Revelation, not expression, was its goal. The mere presence of form, however, did not preclude the consideration of a painting as Surrealist. Even the most spontaneous and intuitive artists developed formal order during the process of creation. This disciplined spontaneity was aimed at revealing what Breton called *le merveilleux.*

Improvisational artists such as Ernst, Masson, and Miró dominated the first phase of Surrealism. They particularly reacted against the formalistic character of Cubism. Ernst, along with his friend and collaborator Arp, made the transition from Dada to Surrealism with virtually no change in the appearance of their works. Although Schwitters never joined the Surrealist movement, his Merz collages and unique constructions were in the spirit of Surrealism. The illusionist Surrealism of Magritte and Dali became prominent during the 1930s, and, along with Tanguy, these artists came to represent Surrealism in the public mind. Not until the 1940s did the improvisational Surrealists again direct the course of the Surrealist spirit as it produced a new branch in the New York group of painters called Abstract Expressionists.

1. André Breton, *Surrealism and Painting,* trans. Simon W. Taylor (New York: Harper & Row, 1973), p. 2.
2. Ibid., p. 4.

# MAX ERNST
# 1891-1976

Max Ernst was the most inventive and influential figure among the pioneer Surrealist artists. His fertile imagination led to the creation of various techniques, images, and even new kinds of art. In 1925 he began making rubbings from irregular surfaces as a means of stimulating his imagination. This adaptation of a child's game — frottage — involved rubbings made from wood grains, leaves, and other such surfaces, which were then worked into representations of humanoids, forests, birds, and other images joined together in bizarre combinations. Ernst's astonishing imagination and inventiveness are evident in early Dada works, sometimes done in collaboration with Arp, and in his later novels in collage: *La Femme 100 Têtes* (The Hundred [*cent*] Headed Woman, or The Woman without [*sans*] Heads), *Dream of a Young Girl Anxious to Enter a Convent,* done in 1929 and 1930 respectively; and *Une Semaine de Bonté, ou Les Sept Elements Capitaux* (A Week of Kindness, or The Seven Capital Elements), from 1934.

Ernst studied philosophy, psychiatry, and art history (the last under Wilhelm Wörringer) at Bonn University. He began painting after meeting Auguste Macke in 1911 and becoming friendly with Arp in 1914. Later Ernst wrote: "Max Ernst died the first of August 1914. He resuscitated the eleventh of November 1918 as a young man aspiring to become a magician to find the myth of his time."[1]

His exceptional intelligence led him to constantly develop new methods of realizing the images revealed by his imagination — images signifying some private and ineffable content. Memories of childhood played a major role in determining his subjects. His many paintings of forests, for example, refer to the "enchantment and terror" he felt when his father — an amateur painter — took

him into the woods on a painting trip. And Loplop, Bird Superior, who appears in many of his works, is an image with which he identified; it refers to the coincidental death of a pet cockatoo which he adored and the birth of a sister.

A prolific writer as well as painter, sculptor, and collagist, he wrote of his own birth: "The 2nd of April 1891 at 9:45 a.m., Max Ernst had his first contact with the sensible world when he came out of the egg which his mother had laid in an eagle's nest and over which the bird had brooded for seven years."[2]

In his diary, on 10 August 1925, Ernst made the following entry in which he quotes from Leonardo da Vinci's *Treatise on Painting:*

Botticelli did not like landscape painting. He felt that it was "a kind of short and mediocre investigation." He says with contempt that "by throwing a sponge soaked with different colors against a wall one makes a spot in which may be seen a beautiful landscape." That statement brought him a severe admonition from his colleague, Leonardo da Vinci:

"He [Botticelli] is right; in such a daub one may certainly find bizarre inventions. I mean to say that he who is disposed to gaze attentively at this spot may discern therein some heads, various animals, a battle, some rocks, the sea, clouds, groves, and a thousand other images — it is like the tinkling of the bell which makes one hear what one imagines. But though this stain suggests some ideas it does not teach one how to finish any part of the painting. And the above-mentioned painter [Botticelli] makes very bad landscapes. . . . It is not to be despised, in my opinion, if after gazing fixedly at the spots on the wall, the coals in the grate, the clouds, the flowing stream, if one remembers some of their aspects; and if you look at them carefully you will discover some quite admirable inventions. Of these the genius of the painter may take full advantage, to compose battles of animals and of men, of landscapes or monsters, of devils and other fantastic things which bring you honor. In these confused things genius becomes aware of new inventions but it is necessary to know well (how to draw) all the parts that one ignores, such as the parts of animals, and the aspects of landscape, rocks and vegetation."[3]

Ernst then goes on to relate how finding himself one rainy evening at a seaside inn, he was astonished by obsessive images awakened in his imagination by the well-worn floorboards and the patterns of their grain. Taking sheets of paper, he made lead rubbings of sections of the floor at random. His visionary capacities were intensified by the results, and he was surprised by the variety of often-contradictory images rapidly suggested to him. He then experimented with rubbings of leaves, ragged edges of pieces of linen, unwound thread, and even the thick brushstrokes of modern paintings. In these rubbings — following Leonardo's advice — he discovered an incredible variety of fantastic images including "human heads, earthquakes, the sphinx in her stable . . . a shawl of frost flowers . . . Blows of whips and threads of lava . . . seismic plants, fans . . . the vaccinated bread, the conjugal diamonds, the cuckoo . . . the feast of death, the wheel of light. . . ."[4]

Ernst's curiosity and constant experiments led him to collaborate with fellow artist Francis Picabia and the Surrealist poets — Breton, Desnos, Eluard, and Crevel — in automatic writing. He also participated in a game the Surrealists called The Exquisite Corpse, in which each person in turn wrote a line and then passed the paper to the next person after folding it so no one could see what had been written before him.

The finished product supposedly revealed what Nicolas Calas characterized as "the unconscious reality in the personality of the group."[5] Ernst was among the first to adapt this technique for drawings, thus demonstrating his ability to move easily between the literary and visual realms.

Between 1914 and 1918 Ernst served in the German army, suffering the boredom of military life during the war for what he called "three trifles: God, Emperor and Country." During this time he found some spare moments to paint water colors, most of which are now lost, and *Landscape Fantasy* (or City with Animals) [18]. Although his canvas is related in style to Cubism, it is closest to the paintings by Marc Chagall of this period, as well as to those of Auguste Macke and Paul Klee, all members of the Young Rhineland Group which Ernst joined in 1911. It has elements of fantasy and some images — for example, the bird — which became common in Ernst's later works. Perspective and proportion are deliberately sacrificed and even reversed. Buildings and animals fit neatly into a tightly organized and designed space. The furtive human images are reminiscent of those by George Grosz and some of the German Expressionists. While the work can be designated neither Dadaist nor Surrealist, it indicates some of the marvelous images that Ernst was to invent in the years to come.

Following his demobilization, Ernst, along with Baargeld and Arp, established The Dada Conspiracy of the Rhineland in Cologne, a movement dedicated to the overthrow of tradition in every field. A few years later, beginning in 1921, his paintings and collages took on certain characteristics of Chirico's illusionist space and dream images. These proto-Surrealist works were done for the most part in Paris, where he moved in 1922. The years from 1921 to 1924, known as the *époque*

*floue* (the hazy epoch), are years when Breton and his friends were trying to define Surrealism in a way that would clearly differentiate it from Dada. At the same time, Ernst was bringing about a synthesis of Dadaist collage and Chirico's spatial definition that provided a prototype for the illusionist Surrealists who followed.

In 1924, the year in which Breton published the Manifesto of Surrealism and Ernst participated in the founding of the Surrealist movement, he completed a major canvas, *Weib, Greis und Blume* (Woman, Old Man, and Flower) [19].

Two figures appear on a rocky shore: an old man on the left strides forward around a vertical pole stuck in the ground, and a figure with its back to us gestures in fluid movements of his arms and hands which are defined only by linear contours. Both figures are constructed of some anatomical parts and some mechanical elements reminiscent of Chirico's mannequins. The old man's leonine head is pressed against the pole and his huge, gnarled hands emerge

from a torso (which is also a broken cup) to support a tiny, reclining female nude. His striding leg is exposed as a pole emerging from his pant leg. The figure with its back to us is composed of a pierced cuirass through which the distant water and foliage are visible. A strange metal casquette with a spread fan form its head and hat. These two parts are connected to its torso by a painted neck, and the figure is supported by painted buttocks and upper thighs. The cup-torso of the old man and open cuirass may refer to the concept of the synthesis of interior and exterior reality. (Breton later used vases in

**19** Max Ernst, *Weib, Greis und Blume (Woman, Old Man, and Flower),* 1923-24

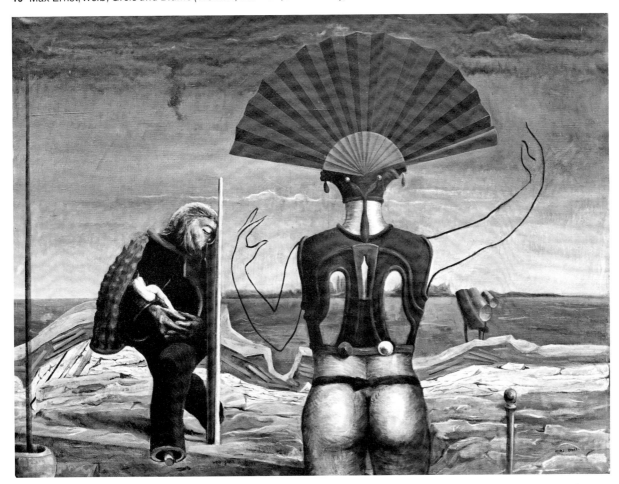

just such a metaphorical way in his essay on the interpenetration of dreams and waking life, *The Communicating Vessels.)* The old man and the woman of the title are clear enough, and the flower may be the fan head, although in *Beyond Painting* Ernst refers to "tube flowers"; thus the flower of the title may also be the three curved tubes on stems at the seashore.

Attempts to logically decipher Ernst's paintings, however, are almost certainly doomed to fail. At this point in his life, Ernst considered himself to be a "recording device" for the unconscious,

He said that he intended to reveal the experiences of "the journeys of discovery into the unconscious," and to note "what one . . . sees, experiences . . . in that border region between the inner and the outer worlds."[6] Since images cannot be precisely decoded in terms of their symbolic references, they establish an unsettling dream-like ambience.

Ernst's lack of concern for the quality of the paint surface is typically Surrealist. Images alone matter, particularly incongruous combinations of im-

probable elements executed in a realistic manner. Like Chirico, Magritte, Tanguy, and Dali, Ernst causes us to question what we assume to be real. This kind of painting grew out of Surrealist and Dadaist collages, which in turn developed from Chirico's strange combinations of images, and relates to Lautréamont's simile about the beauty of the chance encounter of a sewing machine and an umbrella. But this notion was not foreign to earlier German Romantic poetry; Novalis, an eighteenth-century German poet, had written: "When the strangest things come together through a place, a time, a peculiar resemblance, the results are amazing units and curious connections."[7]

In 1924 Ernst traveled in the Far East for three months in the company of Paul and Gala Eluard; during the trip, Gala and Ernst became lovers. Following his return, Ernst did virtually no work until late summer in 1925. He then created a series of frottages which were gathered together under the title *Histoire Naturelle* and published by Jeanne Bucher in 1926. That same year he collaborated with Miró on the settings and costumes for Diaghilev's ballet *Romeo and Juliet,* an activity for which they were thoroughly reprimanded by Breton.

In 1927, the year Ernst married Marie-Berthe Aurenche, he painted *Undulating Earthquake* [20] and *Forest* [21]. In *Beyond Painting* he wrote about a fantasy that occurred at this time: "It was then I saw myself, *showing my father's head to a young girl.* The earth quaked but slightly."[8] *Undulating Earthquake* is an image taken from Ernst's earlier series of drawings, *Histoire Naturelle;* this series, in turn, was probably inspired by Redon's cosmic and biological imagery.

*Forest* is one of the largest and most complex of a series devoted to this subject. Ernst relates his first childhood

**20**  Max Ernst, *Undulating Earthquake,* 1927

visit to a forest with his father: "Mixed feelings the first time he [Ernst] enters a forest, delight and depression. And a feeling which the Romantics have called *Naturgefühl* [nature feeling]. A wonderful elation at being able to breathe freely in the open air, and at the same time an oppressive sense of being imprisoned by hostile trees all around. Outside and inside at the same time, free and imprisoned."[9]

The forest pictures were made possible by Ernst's development of the technique of frottage as a complement to that of automatism. Both are used to stimulate the creative process by improvisatory means. Yet, as Rubin points out, there is an important difference. With automatism, the initial marks derive their impetus from the artist, no matter how unconscious the dictates may be. With frottage chance plays the central role. Even though the artist selects the surfaces to be rubbed, these are chosen at random so that he cannot predict the result, especially as he mixes and overlaps various surfaces in the same rubbing. Thus, reading images into chance surface effects was substituted for gestures of the unconscious. (In psychoanalysis there is a similar difference between the use of Rorschach ink blots and free association.)

Ernst's use of frottage in the forest pictures also permitted a major role for deliberate control. Indeed, it is the interaction between accident and control that so constantly produced poignant images that serve to open Breton's "window" onto the artist's inner landscape. In the forest series, grattage (scraping the surface) played a role equal in importance to frottage. *Forest,*

**21** Max Ernst, *Forêt (Forest),* 1927

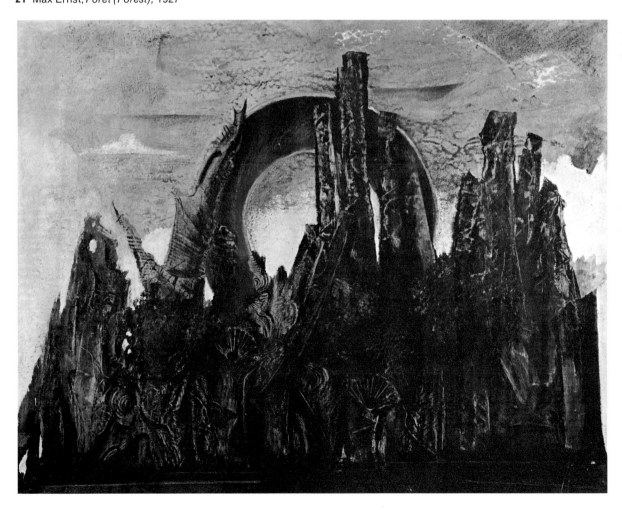

for example, was produced by applying layers of paint to the canvas and then scraping sections away until the general configuration of the forest appeared. It was then worked over until the final image was complete.

With this series of paintings, Ernst was paying homage to Caspar David Friedrich, a German Romantic landscape painter much admired by Ernst. Although Friedrich's landscapes are traditional in appearance, they too provide insight into the artist's subjective experience in relation to nature. Like Friedrich's forests, Ernst's are also dense, dark, brooding, and mysterious.

(German forests seem more terrifying than those of other countries.) The overall shape of the forest partially hides multitudes of images among the piled-up details. Gnarled forms, starkly barren poles, fan shapes, birds, eyes, and much more yield to stubborn inspection. And always above the dark forest is the great, round, celestial orb — whether sun or moon.

Ernst's ability to create fascinating and significant images from the chance surfaces caused by frottage and grattage is reminiscent of Thomas de Quincey's observation that opium cannot give one interesting dreams unless one already has the ability to dream interestingly.[10]

In 1934 Ernst composed a satrical piece of prose about his ambivalent feelings toward forests. Entitled *Les Mystères de la Forêt,* it concerns a forest that has lost its mystery and its inspirational power and has become quite civilized. In it, Ernst asks whether a group of diplomats who are going hunting will praise the forest for its good behavior: "I, for one, will not."

Like Breton, Ernst had studied Freud. The methods he used and the images he created, however, were far from being unconsciously used and developed — as in the case of Chirico or

**22** Max Ernst, *Loplop Introduces,* 1932

Rousseau. He understood exactly what he was about. As in the forest pictures, he often refers to art-historical precedents. Despite the anti-aesthetic attitude of Surrealism, Ernst created works of art.

After 1930 Ernst produced a series of paintings, collages, and painting-collages called Loplop Introduces or Loplop Presents; in this series the bird (Loplop) appears as an anthropomorphic figure resembling Ernst himself. Usually a line drawing (although sometimes modeled with paint and in at least one instance with paint on plaster), Loplop oversees the presentation of images taken from photographs, textbook illustrations, and motifs developed by Ernst.

*Loplop Introduces* [22] has the familiar bird-like head drawn at the top of the composition, while two hand-like shapes — one at the bottom right-hand corner and the other at the top left — frame the images presented by Ernst's totemic figure. A mixture from the artist's own creative repertoire, they include a photograph of a nude female torso mounted against a marbleized rectangle; two painted, gracefully posed female nudes — one striped — with a complex pattern probably created by frottage; and a striped rectangular shape with three ambiguous images woven into the stripes as they cross the rectangle.

One can infer several kinds of meanings from the *Blind Swimmer* [23], painted by Ernst in 1934, although none is definitive. A pattern of irregular, vertical red stripes on a gray ground is disturbed by three elements: an egg-like shape on the left and an elongated lozenge on the right propelled upward by a long, thin phallic shape. Ernst wrote in reference to his own development of frottage: "I came to assist *as spectator* at the birth of all my works from the tenth of August 1925, memorable day of the discovery of *frottage.* A man of 'ordinary constitution' (I employ here the words of Rimbaud), I have

done everything to render my soul monstrous [meant in the sense of great or immense]. Blind swimmer, I have made myself see. *I have seen.* And I was surprised and enamoured of what I *saw,* wishing to identify myself with it."[11] The image of a blind swimmer is thus identified with the artist moving blindly into the dangerous waters of the unconscious; yet, using the technique of frot-

tage, he makes himself see the generative forces of his investigative-creative activity. Forests, birds, erotic images, all emerge in various forms based on his childhood experiences. The blind swimmer (Ernst) recognizes them in what his hand forms; he is both surprised and pleased.

23  Max Ernst, *Blind Swimmer,* 1934

69

In the painting the swimmer with a blind eye moves swiftly down the vertical bands created by frottage and is guided by them. The lozenge-like shape, prodded by the phallic shape, disrupts the natural order of vertical lines. An analogy between the creative act in art and the sexual act seems to be intended. The artist, like the male spermatozoon, swims blindly and instinctively toward his goal. He forces himself to see what lies hidden and, enamored, wishes to "identify [himself] with it." Creation occurs.

The visual and verbal metaphors are both apt and poetic. Ernst tells us that on "the 24th of December, 1933, I was visited by a young chimera in an evening dress. Eight days later I met a blind swimmer."[12] Ernst appears to be informing us exactly when and how he came to understand completely the investigative nature of his creative act.

In the early 1940s Ernst did a series of compositions in which clearly painted parts of nude women emerge from thickly textured robe-like coverings.

The dense coatings covering the figures — as in the *Stolen Mirror* [24] — are developed by the methods of frottage and grattage. In this painting several figures stand upright, the texture of their forms silhouetted against a light but cloudy sky. They are part of a strange, unsettling landscape with a stone bridge leading across swampy waters to isolated islands which culminate in fantastic figures. Among the details are hybrid human-lizard images, a great snake emerging from the swamp to metamorphose into one of the two embracing women, a nude female

**24** Max Ernst, *Stolen Mirror*, 1941

crouching at the base of the main figure, various birds, and odd griffin-like winged forms. The figure in the right-hand foreground gazes down at her outstretched hand that — one surmises — had been holding a mirror. The hooded figure on the left holds a spear in one animal-like paw, while her other hand is deliberately raised as if to cup her breast.

This work was done during the period when Ernst executed the prophetic canvas titled *Europe after the Rain.* Naziism was triumphant and the idea of a return to barbarism and the destruction of the veneer of civilization seems to have been on Ernst's mind. The mirror is a common symbol for the surface

appearance of things; to enter a mirror (as in *Alice Through the Looking-Glass)* indicates a penetration of the ordinary sensory world to another realm of being behind appearances.

Ernst's titles are often arbitrary, yet the imagery of *The Stolen Mirror* seems to suggest that the appearance of civilization has indeed disappeared. Slugs, snakes, and monsters have taken charge of a dank and dismal world. Only a glimpse of parts of two beautiful young women remain amid the encroaching abominations.

Ernst also did some important sculptures, including *The Table Is Set* [24A], 1944. A flat slab supports several groups of objects which — although abstract — suggest various kinds of food.

1. Max Ernst, ''Beyond Painting'' in *Max Ernst: Beyond Painting and Other Writings by the Artist and His Friends,* trans. Dorothea Tanning and Ralph Manheim (New York: Wittenborn, Schultz, Inc., 1949), pp. 4-8.

2. Ibid., p. 26.

3. Ibid., pp. 4-5.

4. Ibid., pp. 4-8.

5. William S. Rubin, *Dada and Surrealist Art* (New York: Harry N. Abrams, Inc., 1968), p. 278.

6. Uwe M. Schneede, *Surrealism,* trans. Maria Pelikan (New York: Harry N. Abrams, Inc., 1974), p. 64.

7. Ibid., p. 19.

8. Ernst, p. 9.

9. Schneede, p. 66.

10. David Larkin, ed., and A. W. Rassabi, trans., *Max Ernst* (New York: Ballantine Books, 1975), p. 9.

11. Ernst, p. 9.

12. Ibid., p. 10.

**24A** Max Ernst, *The Table Is Set,* 1944

# JOAN MIRO
# 1893·

Despite Surrealism's anti-aesthetic theories, Joan Miró's masterly ability to compose with clear, unmodulated hues evenly distributed over the surface of a painting rivals that of Matisse. While he gained much from the spontaneous methods of Surrealism, his tendency to develop coherent, balanced compositions was not to be denied.

Miró hails from Barcelona, the major industrial, commercial, and cultural center of Catalonia. Picasso came to Barcelona from Malaga in 1895, while Miró was born there in 1893. (Julio Gonzales, Pablo Gargallo, and Salvador Dali also come from Catalonia, although Dali went to Madrid rather than Barcelona from his home in Figueras to study art. Catalonia is related linguistically and culturally to Provence in southwestern France; indeed, it was once ruled by the Counts of Toulouse. Thus, Barcelona has always looked north to France and has kept open intellectual lines of communication with Paris; it is the traditional center of avant-garde cultural life in Spain.)

When Miró was fourteen he began work with a well-known painter, Modesto Urgell, at the Barcelona School of Fine Arts. Urgell admired the romantic paintings of the Swiss-German artist Arnold Böcklin, who had also influenced Chirico. Miró has acknowledged his debts to the poetic works by Urgell as well as the flat compositions of the Romanesque frescoes from the churches in Catalonia.[1]

By 1918 Miró saw Cubist paintings at the gallery of José Dalmau, a friend of Picasso's, as well as paintings by Matisse and other French avant-garde artists in an exhibition sent to Barcelona by the French dealer Ambroise Vollard. Also in 1918 Dalmau gave Miró his first one-man show, and the following year Miró visited Paris for the first time. During the three months that he spent there, he met Picasso, who bought one of his paintings. While he was neither disoriented by Cubism or Matisse's paintings, nor even by Picasso's works, Paris itself apparently threw him somewhat off-balance.

Miró has always assimilated new perceptions and information slowly, digesting them thoroughly before essaying his own interpretations. Only after his return to his family's farm in Montroig did he begin to paint again — his new paintings evincing some of the effects of his experiences in France. By the winter of 1919-20, however, he was ready to return to Paris and participate in the avant-garde activities occurring there. Afterward, he returned to Barcelona and Montroig during the summer and fall of every year until the Spanish Civil War broke out in 1936.

From 1919 until 1923 his works were figurative; images were defined with a hard-edged precision according to a geometrical structure related to Cubism. Certain curvilinear shapes and flat compositions also suggest the influence of Art Nouveau for which Barcelona was a major center. Miró's most important paintings of this period are densely composed with precisely defined details and a relatively somber palette.

Beginning in 1923 Miró's work went through a decisive change in style, culminating in the complex, brilliantly colored Surrealist painting *Harlequin's Carnival* (Figure 9), done in 1924-25. At this time Miró's attitude and working method were affected by the art of Paul Klee and Jean Arp; the prose and poetry

Figure 9.  Joan Miró. *Carnival of Harlequin,* 1924-25.

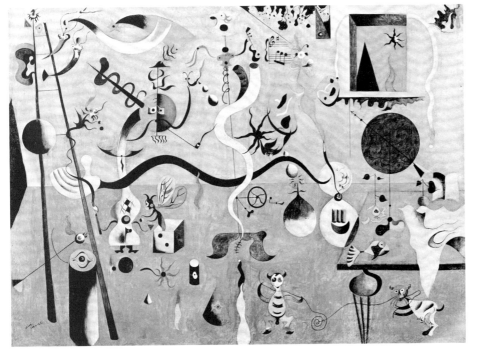

of Louis Aragon, Paul Eluard, Jacques Prévert, and Ernest Hemingway; and the Surrealist theories of André Breton. His carefully defined subjects gave way to semi-abstract, biomorphic images inspired by the automatic methods of the Surrealists.

*The Hunter* (Catalan Landscape) [25], done in 1923-24, depicts images that have been reduced to schematic references to the vital attributes of the subjects. There are just three main images: a Catalan peasant returning from the hunt, a fish, and a carob tree. The hunter stands on the left side of the composition, a gun in one hand and a dead rabbit in the other; he wears a *barettina* (which resembles the Phrygian caps of French revolutionaries) and smokes a pipe. Toward the right side of the canvas a large circular shape with a straight line extending from its center and ending in a leaf refers to the full, round form of the carob tree, an evergreen that grows in the region of the Mediterranean Sea. Emerging from it are two wavy lines, an eye, and three radiating lines suggesting a bird. At the bottom of the composition lies a fish, suggested by a long straight line with a rounded head at one end and a tail at the other. The letters S A R D which appear in the lower right-hand corner can be completed as Sardine — or Sarda (a kind of mackerel).

The sea in the background is identified by a long, straight, horizontal line; an undulating line marking the edge of the beach; and a few schematic waves on the right. Seagulls fly overhead, a cone-shaped buoy supporting a flag is placed against the sea, a scarab-shaped sun sends out wavy rays, and an airplane is seen on the extreme left in the

**25**  Joan Miró, *The Hunter (Catalan Landscape),* 1923-24

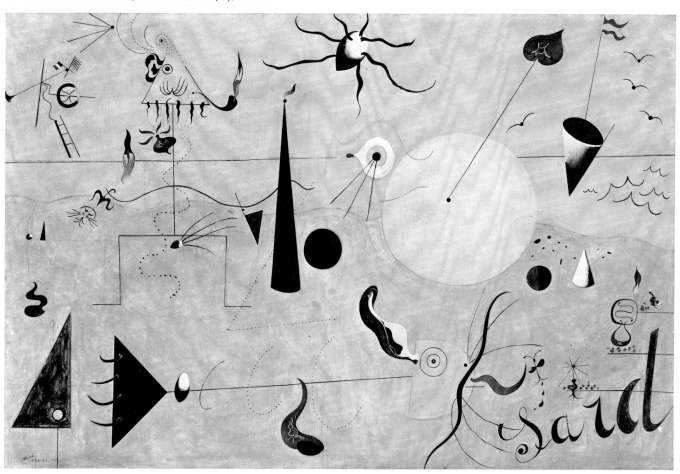

light, warm sky. Jacques Dupin identifies the airplane as one that had been put into service between Toulouse and Rabat and flew over Montroig.[2] Other details, such as insects and pebbles, fill in the spaces between the main images. Undulant and curved lines, especially if defined with dots, express life (for example, one such dotted line moves up the body of the hunter; others surround the body of the fish.)

In the same year that Breton was publishing the Manifesto of Surrealism (1924), Miró was taking these first steps along the path of exploring his subjective experiences, as demonstrated in this work. He reported that he was "not so much trying to escape *from* reality as to escape *into* nature . . . into all of nature, including the imaginary as well as the real. . . ."[3]

In 1925 Miró began a series of paintings that Jacques Dupin has called "dream paintings." For the next several years he did over one hundred canvases that are more spontaneously and loosely painted than anything he had done previously. Miró himself attributed this in part to hallucinations provoked by hunger. At the same time, he was immersing himself in the writings of Lautréamont, Rimbaud, and Jarry, as well as the eighteenth-century German writer Novalis.

These works differ from Miró's earlier works in that they are no longer interpretations of subjective experiences; rather, they are the direct translation of inner gestures of the spirit into gestures of the brush onto the canvas. The ground colors are usually thin and translucent with strange shapes, signs,

26  Joan Miró, *Painting,* 1925/1964

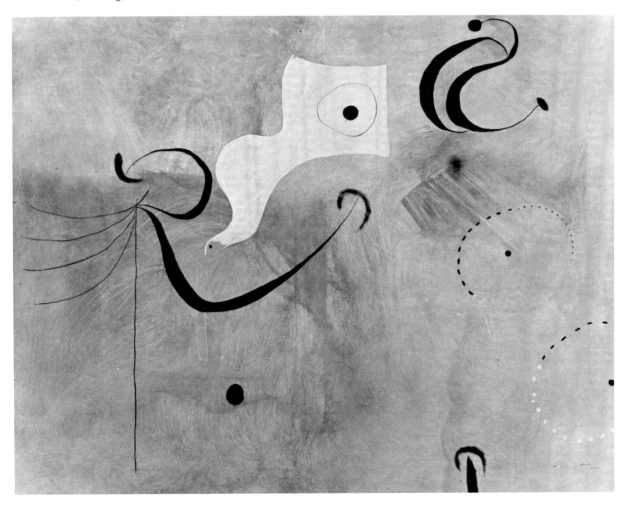

and lines which do relate — however distantly — to images of figures and landscapes.

One such painting, begun in 1925 and finally finished in 1964, is simply titled *Painting* [26]. It is clearly related to another oneiric canvas painted in 1925: *The Siesta*. A white shape representing a sleeping figure on a beach appears in the latter picture; an almost identical white shape is the central figure in *Painting*. Similar signs appear in the upper right-hand corner of both pictures as well as irregular circles made up of dots. In *Painting* a thin vertical line rises on the left with swinging lines and irregular ribbon-like shapes spinning from its topmost point. It might be a tree, but one cannot be certain since Miró reports that he jotted down impressions in a notebook while he walked or sat dreaming and hallucinating at this time. Like Ernst, he often would stare fixedly at old walls, rough floorboards, or clouds, letting these suggest images that he recorded and subsequently used as starting points for paintings.

Miró's paintings of this period (1925-27) are probably his most authentic Surrealist works, although he still resisted Breton's rigid program. And even while Breton was admitting that Miró was probably the most Surrealist of all the artists, he seemed to resent Miró's natural mastery of the art of painting.

Following *The Hunter* and the key painting *Harlequin's Carnival,* certain major works such as *The Hare (Landscape)* [27] are more sparely composed and somberly toned. The composition in the latter work is reduced to a few isolated biomorphic shapes on a flat —

27 Joan Miró, *Landscape (The Hare),* 1927

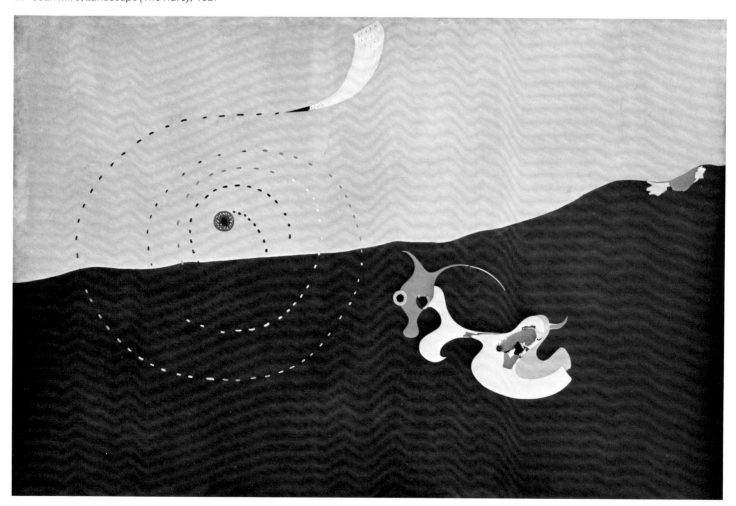

or nearly flat — ground, thus relating it to the wooden, assembled reliefs of Miró's friend, Arp. And while the subjective character of the work brings it within the spirit of Surrealism, the flat shapes and shallow space still reflect the influence of Cubism.

The landscape setting in *The Hare* is established by a sharply defined, gently rolling horizon rising gradually toward the right-hand side of the canvas. A fantastic animal-like image made up of a brightly colored curvilinear shape appears just below the horizon, silhouetted against the dark ground. A curved, horn-like image appears against the sky, very probably referring to a comet.

(Miró has always been fascinated by heavenly bodies and must have been much impressed by Halley's comet that appeared in 1910 when he was seventeen.)

The spare composition and hot colors recall the austere Catalan landscape. The hare's curvilinear shape with its red, orange, yellow, and violet sections and the richly toned ground plane and orange sky establish the sensuous character of the painting. The spiral movement of the dotted line, beginning with the small violet circle and ending with the yellow half-crescent shape against the orange sky, is contemplated by the hare.

The hare is a symbol of importance in various mythologies from ancient Egypt to China and even among American Indians.[4] The more obvious references relate to procreation and fleetness. In some instances the hare was considered as naturally amoral and lascivious. The Chinese held it to be an animal of augury, said to live on the moon. Its swiftness alone would relate it to the comet.

At the time that Miró painted this work he had adopted Surrealist methods as part of the creative act. By the 1930s he had reduced the role of

**28**  Joan Miró, *Horse at the Seashore,* 1926

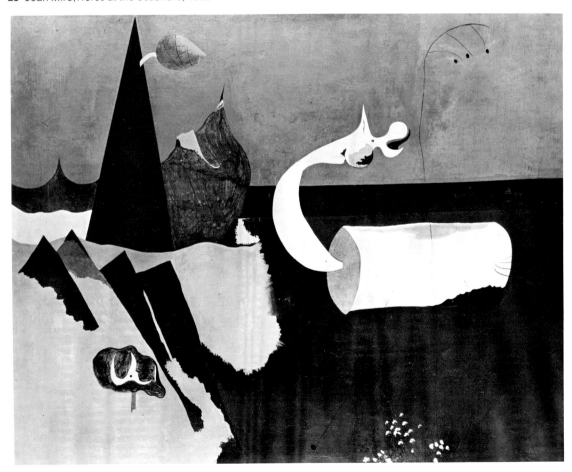

chance in his art, although it always remained important to him as a means of generating the creative process. In a radio interview with Georges Charbonnier in 1960, Miró described his working method as follows: "Never, never do I set to work on a canvas in the state it comes in from the shop. I provoke accidents — a form, a splotch of color. Any accident is good enough; I let the *matière* decide. Then I prepare a ground by, for example, wiping my brushes on the canvas. Letting fall some drops of turpentine on it would do just as well. . . . The painter works like the poet; first the word, then the thought. I attach much importance to the initial shock."[5]

However, conscious control played a greater role as the painting progressed. His early academic training and the influence of Cubism and Fauvism on his art before 1924 seem to impose certain logical controls on his creative process no matter how spontaneously he may begin.

During the 1920s and 1930s Miró took part in Dadaist and Surrealist activities in Paris. He had a one-man exhibition at the Galerie Pierre in 1925 just before participating in the first Surrealist exhibition at the same gallery. Despite his association with the Surrealists and his sharing in their activities, however, Miró never fully subscribed to Breton's injunction against traditional aesthetic considerations in painting. Although he joined the Surrealist movement, he was no more a doctrinaire Surrealist than were Picasso or Klee.

In contrast to the flat compositions and sober colors of paintings such as *The Hare,* Miró did a strongly colored canvas in 1926 with space implied by a series of planes, overlapping shapes, and a three-dimensional figure of a horse: *Horse at the Seashore* [28]. In addition to the horse there is another cone-shaped tree, again identified by a single leaf. Rock-like shapes, pebbles, and the sea are easily identified. The hot, red sky contrasts starkly with the deep blue of the sea and the brown

earth tones. The horse's head turns back as his long neck swings up and around. The cone-shaped tree and leaf echo this movement, as does the tenuous linear shape rising up beside the figure of the horse. Again, formal considerations were obviously of concern to the artist.

By the mid-thirties Miró's imagery was dominated by demons. The monstrous forces that were soon to be

loosed in Spain and the entire Western world seem to have overwhelmed him, and images of terror found their way into his art. From October 23, 1935, to May 22, 1936, he produced six oil paintings on copper and six tempera paintings on masonite panels. One of the paintings on copper, *Nocturne* [29], is executed in a rare old-master technique that almost dictates a meticulous appli-

29  Joan Miró, *Nocturne,* 1935

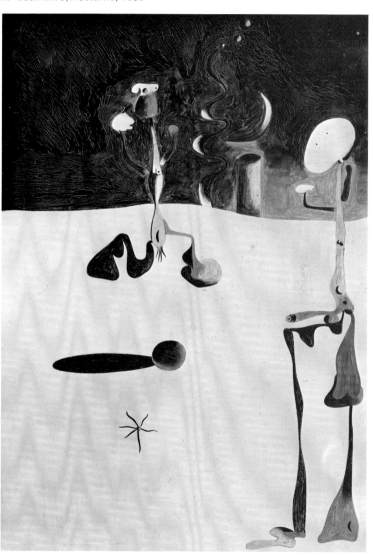

77

cation of paint with a small, soft-bristled brush. The non-absorbent metal surface causes the oil to dry slowly, permitting the artist to work into painted areas that remain wet for a long time. The use of this method raises the question of whether Miró deliberately chose a painstaking technique in order to control the definition of the monsters which forced their way into his conscious mind.

The schematic character of earlier paintings now gave way to precisely defined, distorted images. Miró even used the traditional method of modelling images with changes of tone and value. The deep space defined in *Nocturne* is reminiscent of that in Chirico's metaphysical paintings and in Tanguy's lunar landscapes.

Acerbic colors reflect Miró's tormented mood, even while they form a subtle, if strident, harmony. The distorted human figures can be identified as male and female only by the unmistakable genitalia. Like some strange snake and mushroom-like hybrids, their forms undulate upward to be capped with bulbous heads. The female figure strides forward toward the male; their arms are raised, as though in greeting, under a lurid blackish-green night sky. Rising from behind the horizon is a columnar, phallic image reminiscent of Chirico's smokestacks. Beside it, a ribbon-like shape writhes upward against the sky like a palpable column of smoke. The crescent moon, so familiar in Miró's oeuvre, lies low in the sky, just over the orange column. Below the female a sphere casts a long shadow — again harking back to Chirico and Tanguy — emphasizing the brilliant light cast across this eerie landscape. Miró has said: "Empty spaces, empty horizons, empty plains, everything that is bare and empty always impresses me...."[6]

In 1940, while working at his studio at Varengeville on the Channel Coast in Normandy, Miró unexpectedly began a series of small, lyrical paintings. Women, birds, stars, moons, and night skies are the dominant motifs of this series — called *Constellations* — on which he worked for two years. The monsters that had earlier emerged from his unconscious to assume pictorial form had found living counterparts who were rapidly moving toward control of Western Europe.

It seems that once the grotesque images of man that had haunted his inner self became reality, Miró reverted to sources of poetry and love. He later said: "At Varengeville-sur-Mer, in 1939, began a new stage in my work ... about the time when the war broke out. I felt a deep desire to escape. I closed myself within myself purposely. The night, music, and the stars began to play a major role in suggesting my paintings. Music had always appealed to me, and now music in this period began to take the role poetry had played in the early twenties...."[7]

**30** Joan Miró, *Le Reveil au Petit Jour (Awakening at Dawn),* 1941

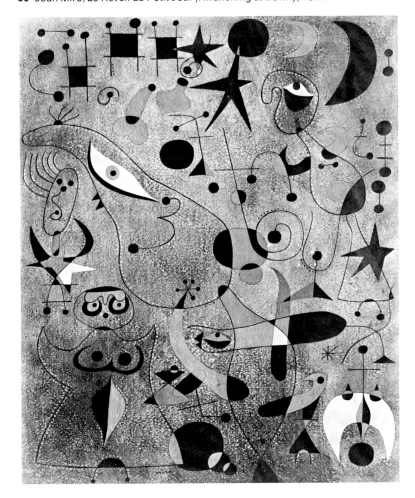

To the amazement of his friends, he worked at Varengeville on this series of paintings as if possessed, ignoring outside events until he was directly threatened by the advancing German armies. He caught the last train to Paris and then a refugee train to Spain. He went first to his ancestral home at Palma on Majorca, where he continued painting *Constellations,* and then to Montroig on the Spanish mainland, where he finished the series in 1941.

These twenty-three oil and gouache paintings comprise a remarkable achievement. The heavy paper ground is saturated with a thin, irregular coat of oil paint over which Miró developed a linear composition with small, flatly colored shapes painted with gouache. Breton remarked about this series: "At a time of extreme perturbation . . . by a reflex striving for the purest, the least changeable, Miró let go with the full range of his powers, showing us what he could really do all the time."[8]

Although these works appear to have been painted with an easy spontaneity, Miró said that they were "exacting, both technically and physically. . . ."[9] The skillfully articulated images and the formal order they establish in works such as *Awakening at Dawn* [30], *The Migratory Bird* [31], and *The 13th Ladder Brushed Against the Heavens* [32] attest to Miro's conscious control of his material following his early, spontaneous moves. His dedicated labor is easily inferred from the fact that each of these small works took about a month of concentrated work to complete. With each painting the ground was laid on in a succession of thin layers of oil paint.

**31**  Joan Miró, *L'Oiseau Migrateur (The Migratory Bird),* 1941

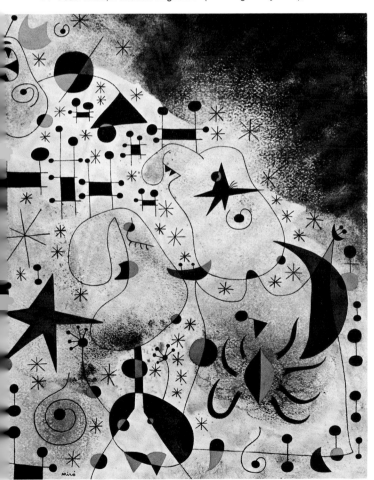

**32**  Joan Miró, *The 13th Ladder Brushed Against the Heavens,* 1940

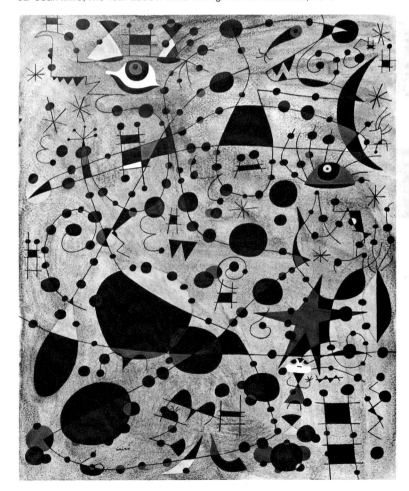

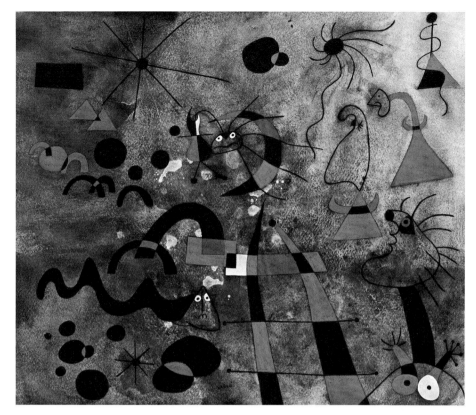

These were rubbed, matted, blotted, and caressed into a velvety, sooty surface, evoking a sensation of the soft, warm night. On this ground Miró developed systems of colored dots, circles, and other regular and irregular geometrical and biomorphic shapes. These were then woven together by meandering, serpentine lines referring to human anatomies, birds, and other beings and objects.

Miró did ten of these works at Varengeville and the rest on Majorca and in Spain. The earlier ones such as *Ladder for Escape* [33], *Woman with Blond Armpit Combing Her Hair by the Light of the Stars* [34], *Wounded Personage* [35], and *Woman in the Night* [36] tend to be more open in composition than most of the later ones done at Palma and Montroig. For example, *The Nightingale's Song at Midnight and Morning Rain* [37], *The Poetess* [38], *Woman at the Border of a Lake Irradiated by the Passage of a Swan* [39], and *The Beautiful Bird Revealing the Unknown to a Pair of Lovers* [40] are more dense, tightly composed, and abstract.

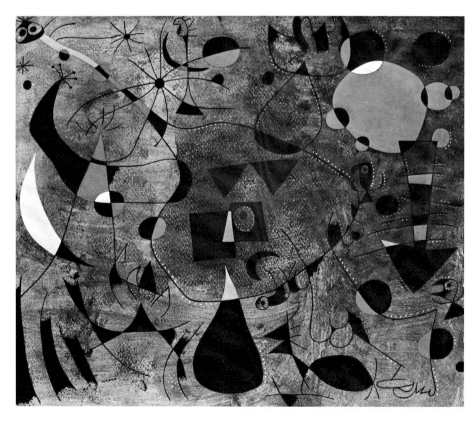

**33** Joan Miró, *The Ladder for Escape,* 1940

**35** Joan Miró, *The Wounded Personage,* 1940

Nevertheless, all twenty-three works are closely related; they grew, one from the other, to comprise an obvious unit that seems to contradict Miro's insistence that he started fresh with each work, allowing accidents to inspire the character of the work. The contradiction, however, is more apparent than real; if one considers Miró's state of mind at this time — his yearning to escape the brutal realities of life in dreams of night skies, women, and birds — it becomes evident that the "accidents" which generated the creative act functioned, like Rorschach blots, as the means by which the artist's subjective concerns are revealed. He articulated these in visual rather than verbal forms, although the poetic titles contribute to one's understanding of the paintings' contents. The elements in each painting are integrated in a kind of visual counterpoint as precise as a Bach fugue or a Mozart quartet. Significantly, Miró was most involved with the music of these two composers while he painted the *Constellations*.[10]

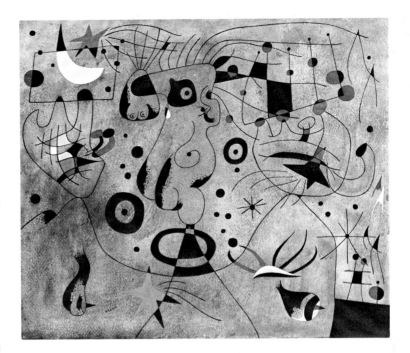

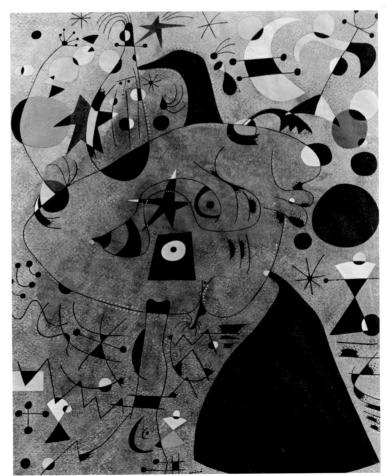

**34** Joan Miró, *Woman with Blond Armpit Combing Her Hair by the Light of the Stars*, 1940

**36** Joan Miró, *Femme dans la Nuit (Woman in the Night)*, 1940

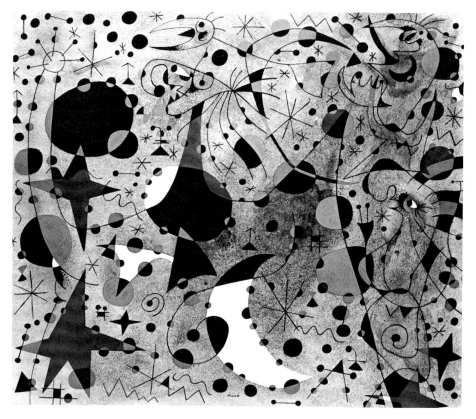

Twenty-two of this series of twenty-three paintings were the first works of art created in Europe during the Second World War to be exhibited in the United States after the war ended. They were shown at the Pierre Matisse Gallery in 1945 and have since come to be regarded as a major achievement in Miró's oeuvre.

Of the original Surrealist painters, Miró probably had the most profound influence on the young American painters who came to prominence during the 1940s and the 1950s as The New York School, or Abstract Expressionists. It was Miró's and Masson's automatic and abstract methods which they followed (as well as Picasso's and Klee's examples) rather than the imagist Surrealism of Magritte, Tanguy, and Dali. Roberto Matta proclaimed his own version of the doctrines of automatism and abstraction to the Americans during the war years. However, Gorky, Motherwell, Pollock, and Baziotes, among others, had earlier seen and been impressed by Miró's paintings. Therefore, when the exhibition of the *Constellations* appeared at the Pierre Matisse Gallery, it had a considerable impact on these artists who were to create aesthetic works using the Surrealist methods of automatism and collage.

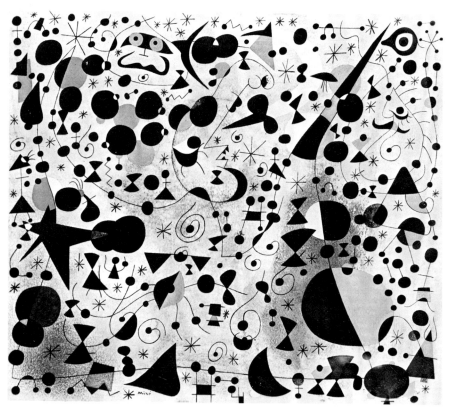

**37** Joan Miró, *Le Chant du Rossignol à Minuit et la Pluie Matinale (The Nightingale's Song at Midnight and Morning Rain)*, 1940

**38** Joan Miró, *La Poétesse (The Poetess)*, 1940

1. James Johnson Sweeney, "Joan Miró: Comment and Review," *Partisan Review,* no. 2 (February 1948); quoted in Clement Greenberg, *Joan Miró* (New York: Quadrangle Press, 1948), pp. 10-11.

2. Jacques Dupin, *Miró* (New York: Harry N. Abrams, Inc., 1962), p. 141.

3. Ibid., p. 140.

4. The symbolism of the hare has been taken from J. E. Cirlot, *A Dictionary of Symbols* (New York: Philosphical Library, 1962).

5. Jacques Lassaigne, *Miró,* trans. Stuart Gilbert (Geneva: Albert Skira, 1963), pp. 46-48.

6. Dupin, p. 21.

7. Sweeney, p. 210; quoted in James Thrall Soby, *Joan Miró* (New York: Museum of Modern Art, 1959), p. 100.

8. André Breton, quoted in Jacques Dupin, *Joan Miró, Life and Work* (New York: Harry N. Abrams, Inc., 1962), p. 360.

9. Sweeney, quoted in Soby, p. 100.

10. Dupin, p. 370.

**39** Joan Miró, *Woman at the Border of a Lake Irradiated by the Passage of a Swan,* 1941

**40** Joan Miró, *The Beautiful Bird Revealing the Unknown to a Pair of Lovers,* 1941

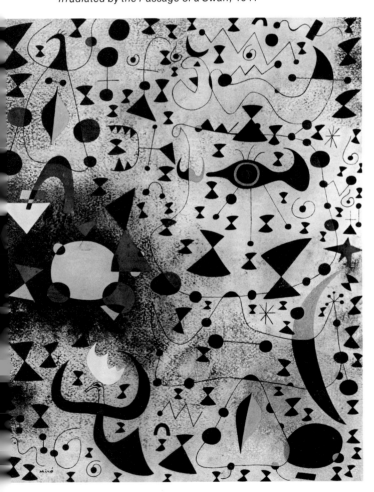

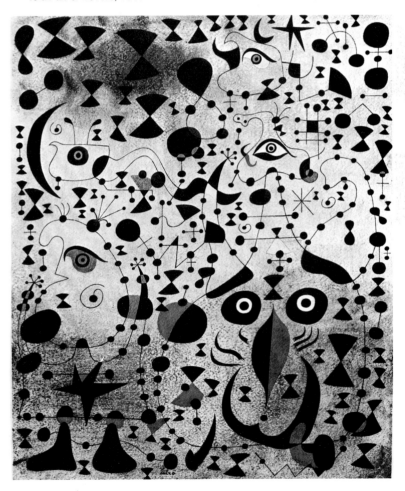

# ANDRE MASSON
## 1896·

André Masson was born in Balagny on the Oise in France, but his family moved to Brussels while he was still an infant. He studied at the Academy of Fine Arts there before moving to Paris in 1912 at sixteen years of age. In the French capital he continued his studies at the Ecole Nationale des Beaux-Arts. His mature work was first influenced by Cubism — especially that of Juan Gris. In 1922 the art dealer Daniel Henry Kahnweiler took an interest in his work and helped support him.

After meeting Breton and his friends during the winter of 1923-24, Masson began to experiment with automatic drawings. At the time, his studio was next to Miró's, and the two began the Surrealist adventure almost simultaneously. Both started from Cubism, but Miró seemed to make the transition to automatism and a biomorphic style in his paintings more readily than Masson.

Masson's doodled drawings of this period are more successful as experiments with automatic methods than are his paintings. It was some time before the free-flowing line of these drawings broke through the structured form of

41 André Masson, *In the Tower of Sleep (Dans la Tour du Sommeil),* 1938

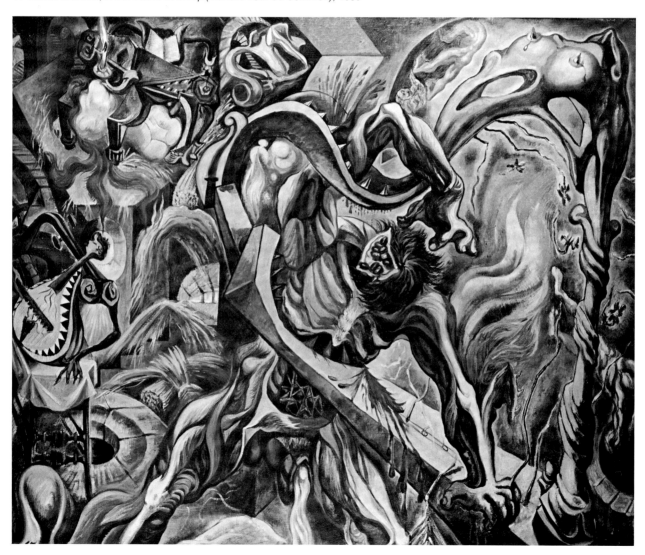

his paintings, which still exhibited ties to Cubism. The artist Saul Steinberg has said that "Doodling is the brooding of the hand." Masson was clearly more adept at this kind of "brooding" than he was in realizing his own unconscious processes of thought in the tougher medium of paint.

It was 1927 before he finally developed a technique allowing him to realize the freedom and spontaneity of his drawings in his paintings. He began by spilling glue onto the surface of a raw canvas and trailing it around, often using his fingers. Sand — sometimes colored — was then poured over the canvas, which he tilted, moving the sand about so that some adhered to the glue. Sometimes several layers were built up by using sands of different colors. He completed these paintings by drawing on the canvas with ribbons of paint squeezed directly from the tubes; this final stage provided a way of loosely defining images of animals, fish, or human figures suggested by the chance shapes created by the glue and sand.

The metamorphic images and scenes of battles of fish and animals recall Lautréamont's Maldoror. Masson failed to follow up this promising series of sand and tube pictures, however, and after 1928 he ended his close association with the Surrealists but maintained contact with them.

During this early Surrealist period, Masson's drawings and sand and tube paintings demonstrated his remarkable personal vigor — sometimes even spilling over into violence. His lively intelligence had been nourished by reading Heraclitus, de Sade, German romantic writers, Lautréamont, and especially Friedrich Nietzsche. His determination to put the revolutionary aspects of Nietzsche's philosophy into a picture increased after he suffered a serious wound during the First World War.

Masson's extremely physical method of painting during this early period was manifested by attacking the canvas in a fury, talking aloud and repeating words such as "falling," "whirling," or "attraction"; sometimes he even sang. In short, he used every conceivable method of achieving a trance-like state while painting. If the results dissatisfied him, he slashed the canvas with a knife. "One must get some physical idea of revolution," he would say.[1] His sharp, angular contours and sudden changes

**42** André Masson, *Meditation on an Oak Leaf,* 1942

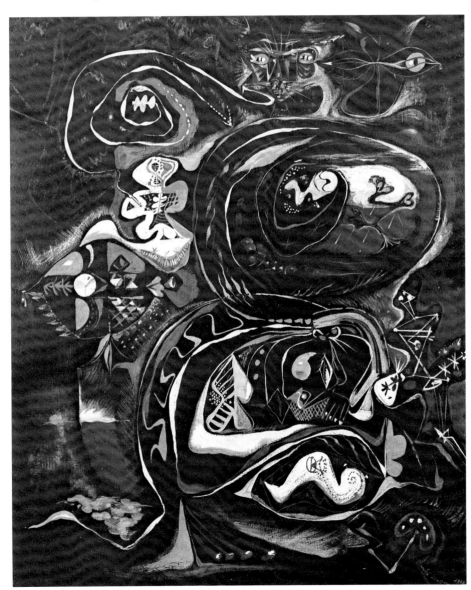

of linear direction contrast vividly with the sensuous character of Miró's poetic canvases of the same period.

In 1933 Masson finally broke completely with the Surrealists, but four years later the Spanish Civil War brought about a reconciliation with them. His second Surrealist period began with a recapitulation of themes and techniques that he had used previously. Paintings like *In the Tower of Sleep* [41] reveal the return to such typ-ical Surrealist themes as sexual fantasies, physical violence, and metamorphosis. The agonizing, flayed male figure in this work is entwined in a spiked, twisting form which becomes an upper female torso with large breasts and sharply pointed nipples; the head is thrown back and changes into a biomorphic form growing out of the very instrument of torture. The male figure spurts both blood and semen.

Thus, sex and torture are merged in a sadistic image. Among the forms surrounding these two figures are a table with a mandolin being sawed in two by a figure which is part of the instrument itself, a burning candle on a distorted piano, falling flowers amidst flames, and other deformed mutations. A Freudian reading of the iconography might suggest that the burning, tortured flesh of man is victimized by moral restrictions and a romanticized notion of love.

In 1941 Masson came to the United States. He then undertook a number of paintings derived from natural forms, of which *Meditation on an Oak Leaf* [42] is a masterpiece. The uncontrolled vitality and proliferation of images in many paintings from the late thirties gave way to greater control over form. Colors deepen and become resonant, while shapes are more sharply defined. The suggested space is shallow, and the violence implicit in images of earlier works is replaced by passion — implied by whiplash brushstrokes and intense colors. The main image is that of a great cat's head at the top of the canvas and a body in two contorted sections. As both Rubin and Greenberg have pointed out, Jackson Pollock's *Totem I* (Figure 10) indicates that the American knew, and was affected by, this painting.

Impressed by the art and legends of American Indians, Masson turned to totemic subjects and to Indian as well as classical mythology. His painting *Pasiphaë* [43] demonstrates this latter interest. The images of Pasiphaë and the bull are clearly defined without the violent emotional distortions occurring in many earlier works. The myth of Pasiphaë, wife of Minos, the ruler of Crete, and her passion for a great white bull fascinated many artists — most especially the Surrealists, who saw its symbolic possibilities. The familiar story concerns the queen who had Daedalus, the master artist, build a hollow wooden cow for her to enter in order to consummate the sexual act with the bull.

Figure 10. Jackson Pollock. *Totem I*, 1944.

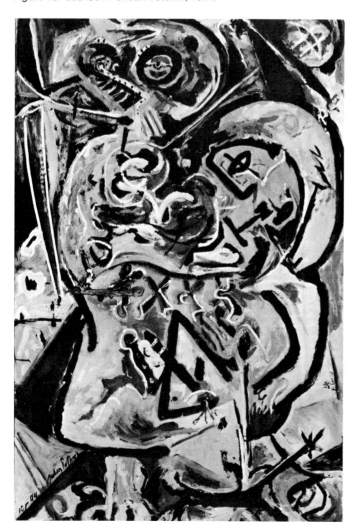

The offspring of that union, the Minotaur (the subject of numerous works by Picasso), was then confined in a labyrinth, also built by Daedalus.

The union between Pasiphaë and the bull was interpreted by Surrealists as a rejoining of man and nature, recalling Lautréamont's Maldoror and the shark. The labyrinth was seen as the deep unconscious which man explores in order to discover his own hidden animalistic nature.

Jackson Pollock also painted this subject the same year and in a similar style. The coincidence may be due partly to Masson's influence, but it is probably also due in part to the similar personalities of Pollock and Masson: tough, vigorous, earthy, and more given to action than theory.

Like *Meditation on an Oak Leaf, Pasiphaë* demonstrates Masson's increased control over the creative act and the greater significance of formal qualities relative to iconography.

1. Sarane Alexandrian, *Surrealist Art* (New York and Washington: Praeger, 1970), pp. 66-67.

**43** André Masson, *Pasiphaë,* 1943

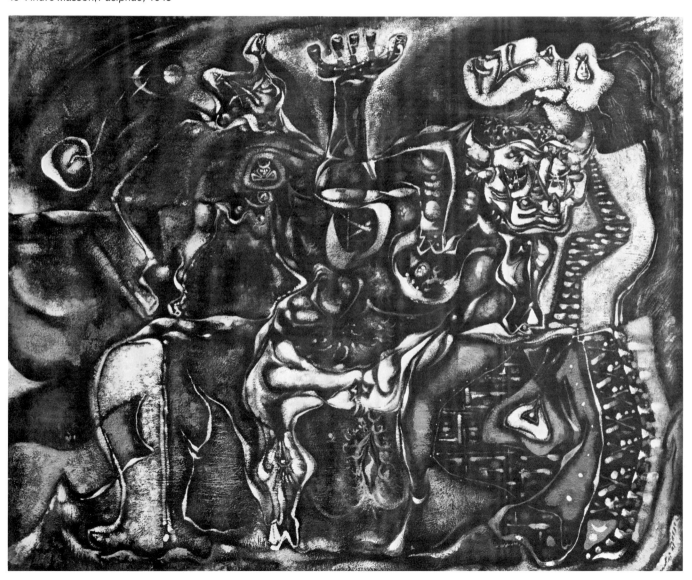

# RENE MAGRITTE
# 1898-1967

A Surrealist group was organized in Brussels in 1925 with the poets E. L. T. Mesens and Louis Scutenaire and the painter René Magritte as the leading figures. Magritte was working as a commercial artist — particularly in wallpaper design — as well as doing some abstract painting influenced by Italian Futurism and Cubism when he discovered a reproduction of the painting *The Song of Love* by Chirico. This experience caused him to give up commercial art and affected the direction that his serious painting took from then on. In 1965 he wrote, "Chirico was the first to dream of *what must be painted* and not *how to paint*."[1] He considered Chirico to be the greatest painter of the early twentieth century, and his own work was always dedicated to the task of painting a poetic idea rather than an aesthetic object. He received additional support for his position about painting from Max Ernst's collages.

In the 1920s automatist paintings by Masson and Miró (along with Ernst's frottages) were accounted to be the most important Surrealist works of art. Magritte's entry on the scene as a painter in the tradition of Chirico clearly defined the dichotomy of automatist and illusionist Surrealism. Later, in the 1930s, Tanguy, Dali, and Delvaux — along with Magritte — established the illusionist tradition firmly in the public consciousness as the dominant form of Surrealism.

Just as Chirico has ancestors among Quattrocento Italian painters, so Magritte's tightly defined super-realist technique in some works harks back to early Netherlandish painting. His first Surrealist compositions, influenced by Chirico, juxtaposed realistic images of figures and objects that would never be seen together in real life. Magritte wrote, "The lizards we usually see in our houses and on our faces, I found more eloquent in a sky habitat. . . . A woman's body floating above a city was an initiation for me into some of love's secrets. I found it very instructive to show the Virgin Mary as an undressed lover. . . . The creation of new objects, the transformation of known objects, the association of words with images, the putting to work of ideas suggested by friends, the utilization of certain scenes from half-waking or dream states, were other means employed with a view to establishing contact between consciousness and the external world. The titles of the pictures were chosen in such a way as to inspire a justifiable mistrust of any tendency the spectator might have to over-ready self-assurance."[2]

Magritte came to France in 1927, staying at Perreux-sur-Marne near Paris, where, according to Mesens, he conceived his most brilliant ideas. He was close to the Surrealists, especially Eluard and Breton, during this three-year stay in France. It was an exceptionally active period for Surrealism. Early in 1927 Breton, Aragon, Péret, and other Surrealists joined the Communist Party, although some of them left it before the end of the year. In 1929 Breton wrote the second Manifesto of Surrealism and in 1930 twelve Surrealists attacked Breton in a pamphlet, *Un Cadavre.* Aragon and Georges Sadoul attended the Second International Congress of Revolutionary Writers at Kharkov in the U.S.S.R., where they signed a letter denouncing Trotsky, Freud, and Breton's second Manifesto "to the extent that it contradicts the teachings of dialectical materialism" — views which they retracted when they returned to France.

Magritte did not accept the Surrealists' devotion to either automatism or the dream as a source for subject matter. He took his subjects from the world around him but rearranged them to present new versions of reality; his paintings coincided with philosphical and even scientific questions being raised about the nature of reality. Magritte's compositions query the role of logic as the only means of arriving at the truth about the world. He recognized the validity of poetic truth arrived at by rearranging the images created in our minds by logically organized sensory perceptions. It is therefore necessary to adjust our own thought processes if we are to apperceive his paintings.

While Magritte's sympathies lay generally with Surrealism's leftist politics, he refused to play an active political role. His political views as expressed in the first of *The Five Commandments,* which he and Mesens published in 1925, reflect an anarchist (and Dadaist) rather than Marxist view: "In politics we will practice auto-destruction with all our might, and trust in human virtues."[3]

Magritte's paintings reflect his mistrust of the middle-class social order. He aimed to upset — with an initial shock — the viewer's complacent self-assurance that everything had its place in the hierarchical scheme of things. Speaking of his early years as a Surrealist, Magritte himself said that the only thing he wanted to provoke was an emotional shock. Among the means he used to accomplish this include: dramatic enlargements of details (an apple which fills a room); associating complementaries (street lamps illuminating a daylight cityscape); animating inanimate objects (shoes with living toes and a dress with breasts); mysterious images (a window opening onto a landscape with a picture of an easel placed so that the portion of the landscape which it blots out is reproduced exactly in the painting within the painting);

material transformations (a stone bird flying above a seashore); anatomical surprises (a woman's face which is made up of parts of her torso); and painted words which are part of the composition and contradict the mimetic image.

Magritte early recognized the arbitrary relationships between words and objects, actions and qualities to which they refer. Ludwig Wittgenstein's investigations of the relations between language and the phenomenal world found a parallel in Magritte's paintings. "A word," Magritte said, "can replace an object in real life. An image can replace a word in a proposition." "Ceci n'est pas une pipe" (This is not a pipe) were words affixed to a canvas depicting a pipe and titled *Le Trahison des Images* (The Treachery of Images) [44].

**44** René Magritte, *La Trahison des Images (Ceci n'est pas une Pipe),* 1928-29

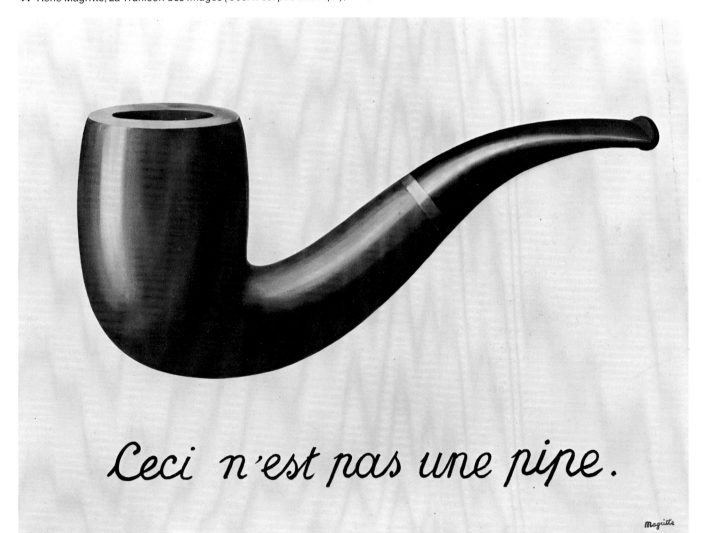

Ceci n'est pas une pipe.

In brief, Magritte's paintings question the validity of our primary means of communication, as well as our sensory perceptions of a disorderly and contradictory world. He wrote: "That pictorial experience which puts the real world on trial inspired in me belief in an infinity of possiblities now unknown to life. I know that I am not alone in affirming that their conquest is the only valid end and reason for the existence of man."[4]

One of Magritte's early Surrealist paintings, *The Menaced Assassin* [45], is possibly an oblique homage to the heroic criminal so much admired by the Surrealists — the free man who contemptuously defies the morality and laws ostensibly made for the protection of vested interests and of the weak. Among such Surrealist heroes are de Sade, Lautréamont's Maldoror, Rimbaud, and the fictional, modern French Robin Hood, Fantômas. (Louis Feuillade filmed a serial based on the ex-

**45** René Magritte, *The Menaced Assassin (L'Assassin Menacé)*, 1926

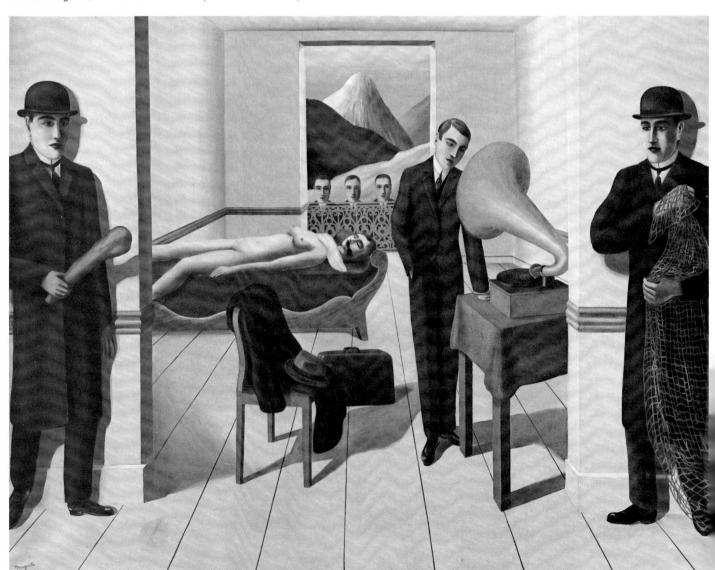

ploits of Fantômas, who stalked the streets of Paris outwitting the police and whose identity remained secret.)

Magritte's *The Menaced Assassin* calls to mind an outrageous Fantômas-like crime. The nude body of a young woman, presumably murdered, lies on a couch in an open room. Blood coagulates in the corner of her mouth. A young man — apparently the killer — stands nonchalantly listening to a gramophone. Two men stand outside the room hidden from the assassin's sight, one on either side of an archway; one holds a club, the other a net. Three male heads appear above the balcony railing, blocking the only other exit from the room. In the distance, a mountain shaped like a breast rises against the sky.

Thus, the observer views the scene as though he were a spectator at a drama. He is outside the room looking into the two rooms and beyond into distant space, but his gaze is directed back into the room by the three faces outside the balcony peering in. All faces are expressionless; no emotion is betrayed in this scene of a terrible crime. The threatened criminal appears to be a handsome and gentle young man who enjoys music. The odds against him are overwhelming, yet he is apparently oblivious to the threat. In this work Magritte has shocked the sensibilities of his audience, arousing its sympathies for the monster, and causing it to question values that it held to be self-evident.

In 1929 Magritte painted *La Loi de la Pesanteur (The Law of Gravity)* [46] depicting a bird and a baluster — or perhaps a rook from a chess set (two rooks would create a visual pun). They appear side by side in the air before the corner of a stone building. The bird's wings are spread, yet the feathered, live creature who can fly seems to be obeying the law of gravity. The baluster hovers behind the bird. Is Magritte again shocking his audience into questioning even the laws of physics?

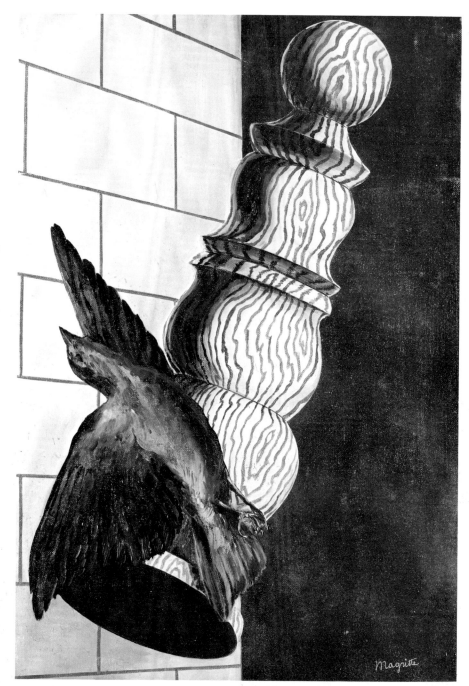

**46** René Magritte, *La Loi de la Pesanteur (The Law of Gravity),* 1929

**47** René Magritte, *The Empire of Light, II (L'Empire des Lumières, II)*, 1950

*The Empire of Light, II* [47] is a theme that Magritte repeated many times with variations. Always, however, there is a row of houses in the night beneath a light, daytime sky. A lamplight glows in the dark, while fleecy clouds hover in the light blue sky. Shutters are closed on windows in the houses, and in some instances lights shine through the windows. The streets are empty. Nature's domain is light, while man's is dark and lonely. The sky is flooded with natural light; man's artificial lights struggle feebly against the encroaching night. The paradox creates a strange and unsettling enigma.

*Force de L'Habitude* (Force of Habit) [48], painted in 1960, was wittily altered by Max Ernst, who owned the painting. The original painting is of a large apple within a painted frame. The legend "This is not an apple" is written in script above the apple. Ernst painted a barred window in the apple behind which a bird (Ernst's alter ego) peers out. Below the apple Ernst wrote "Ceci n'est pas un Magritte" (This is not a Magritte) and added his own signature.

Ernst's wry wit turned Magritte's own disconcerting use of language against himself in a Surrealist joke, apparently not much appreciated by Magritte, but creating a more interesting painting.

1. From a letter to James Thrall Soby, quoted in Pamela Pritzker, *Magritte* (New York: Leon Amiel, n.d.), p. 8.

2. Quoted in Lucy Lippard, ed., *Surrealists on Art* (Englewood Cliffs, NJ: Prentice-Hall Inc., 1970), p. 159.

3. Ibid., p. 154.

4. Ibid., p. 161.

**48** René Magritte, *Force de l'Habitude (Force of Habit)* (altered by Max Ernst), 1960

## YVES TANGUY
## 1900-1955

One day in 1923 as Yves Tanguy was passing Paul Guillaume's gallery in Paris, he happened to see a painting by Chirico in the window. That chance view determined that he was to become a painter. His early paintings from 1925 include recognizable but primitive images of figures, eggs, fish, and other obvious symbols. By 1927, however, in paintings such as *The Storm* [49] and *Mama, Papa is Wounded!* [50] he was organizing biomorphic shapes in a deeply receding space. After this, the only changes in his style were a tightening of technique, heightening of color, and increasing density of composition.

The lifelike abstract shapes of his mature paintings are reminiscent of those in Arp's wooden reliefs. Tanguy shaded these shapes to create the illusion of rounded, three-dimensional forms sitting on vast planes or hovering above them, casting long shadows reminiscent of Chirico's deep vistas and cast shadows. These smoothly curving, rocklike shapes — whether resting on the ground or floating above it — sometimes suggest tentacles, sometimes sprout hair, and occasionally resemble undersea fronds.

49  Yves Tanguy, *The Storm,* 1926

Of all the early illusionist Surrealists, Tanguy alone did not define recognizable figures and objects. While the shapes, elongated shadows, deep illusionistic space, and eerie lighting substantiate the influence of Chirico and relate him to Magritte and Dali, the images defy exact identification.

Tanguy never passed through a Cubist period as many Surrealists did. Self-taught, he painted highly personal images unlike those of any other artist. Paradoxically, his technique led him to a highly realistic style even though the images are not recognizable. Like Magritte and Chirico, it was the total poetic image that concerned him.

Works such as *The Storm* (1926) and *Mama, Papa is Wounded!* (1927) were done shortly after he and his friend, the poet Jacques Prévert, joined the Surrealists in 1925; they suggest strange undersea regions and vast unexplored deserts. They are, in fact, windows opening on Tanguy's interior visions.

**50**  Yves Tanguy, *Mama, Papa Is Wounded! (Maman, Papa est Blessé)*, 1927

The biomorphic character of his images gradually gave way during the 1930s and 1940s to forms suggesting smoothly worn stones or bones — for example, *Passage of a Smile* [51] (1935), *Movements and Acts* [52] (1937), and *The Five Strangers* [53] (1941). In the last two the horizon line that appears in earlier works has disappeared in a haze where ground and sky merge imperceptibly.

Tanguy was born in Paris in 1900. His father was a sea captain, and Tanguy served as an officer cadet in the merchant marine. His experience with the sea and memories of the rocky beaches of Brittany where he grew up influenced the character of his painting. In 1939 he came to the United States with his wife, the American painter Kay Sage. They lived in her home in Connecticut until his untimely death in 1955. The works of this last period continue the beach-like scenes of the 1930s but become increasingly crowded with rock-like forms piled densely along the ground plane.

**51** Yves Tanguy, *Passage of a Smile,* 1935

**52** Yves Tanguy, *Movements and Acts,* 1937

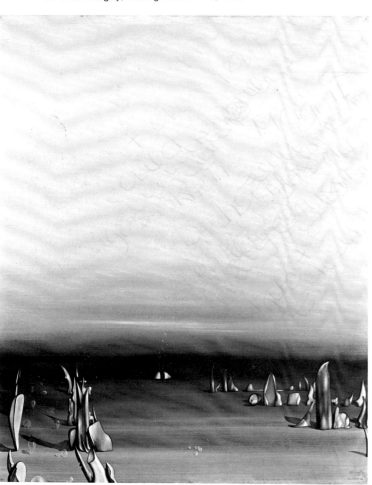

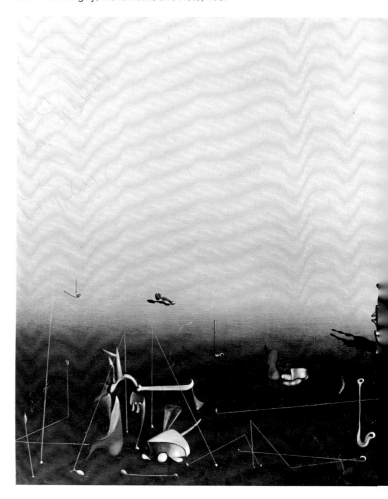

The irregular, bizarre forms painted by Tanguy inevitably suggest objects from the real world and living creatures. Although titles to his works were usually suggested by friends after the work was completed (and therefore have nothing to do with the artist's intentions), it is significant that they almost always refer to human figures and acts.

Clues suggesting living forms in *Mama, Papa is Wounded!*, for example, are obvious. The long pole is covered with hair; the dark, irregular shape appears to be moving like a colored gaseous substance; the vertical, undulating, worm-like image in the distance is giving off a jet of tiny particles; the form on the left clearly suggests a standing, robed figure; and the kidney shape in the foreground is hovering above the earth, casting its shadow below. Later paintings such as *The Five Strangers* can be related to living forms only by their softly rounded shapes and vertical positions.

Tanguy's art varied less than that of most Surrealists and is more difficult to discuss in terms of iconography. His images are neither symbols, nor could they have been done by using automatic methods; they are dream-like, yet dreams do not include such unrepresentational forms. Tanguy refused to try to explain his art, claiming that he himself didn't understand it. We are forced to the same conclusion. Yet his works, though disorienting, do seem to awaken memories long buried in our unconscious.

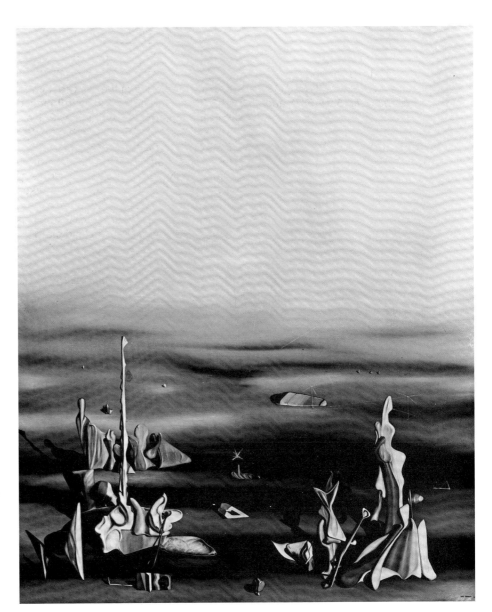

**53** Yves Tanguy, *The Five Strangers*, 1941

# SALVADOR DALI 1904-

The strange career of Salvador Dali is one of the enigmas of the Surrealist movement. Once considered by Breton and other Surrealists to be a brilliant young artist who would carry Surrealism forward into new areas of psychic investigation, he was later denounced by them for his reactionary politics and avaricious actions.

He was born in the town of Figueras in Catalonia in 1904. At seventeen years of age he went to the School of Fine Arts in Madrid, where, along with Luis Buñuel and Federico Garcia Lorca, he was active in a group of rebellious young students. By his own account in *The Secret Life of Salvador Dali* he was a perverse, stubborn, and arrogant young man, given to fits of rage, cruel jokes, and voyeurism. He often allowed his imagination to carry his actions to excess.

In 1929, the year he painted his first Surrealist pictures, he was visited by Magritte, Paul and Gala Eluard, and the dealer Camille Goemans. (He had already met Picasso and Miró on his trips to Paris.) At that time he was engaged in painting his first major Surrealist picture, *Le Jeu Lugubre* (The Lugubrious Game), which he regarded as a personal manifesto.

Almost immediately a close relationship developed between Dali and Gala Eluard; it resulted in her deserting the poet to marry Dali. Her influence on his work has been so great that he has even signed some of his paintings with both their names. It was she who convinced him to put his thoughts down for the composition *La Femme Visible* (The Visible Woman) in 1930. She then organized these into a statement revealing his creative method that he called "paranoiac-critical." Dali described it as "a spontaneous method of irrational knowledge based upon the critical and systematic objectification of delirious associations and interpretations."[1] He thus accepted the Surrealist emphasis on free association but went beyond it in simulating a state of paranoiac delirium in order to generate the images which served as the basis for his creative act.

Dali was careful to make clear that he was not truly paranoid (paranoia being a mental disorder characterized by delusions and hallucinations), but that he could induce this paranoid-like state at will and thereby use self-induced hallucinations to stimulate his imagination. He also stressed his power of seeing multiple images in fully defined, discrete images by concentrating intensely on the canvas.

Dali made greater use of Freudian symbols (and images derived from his reading of Krafft-Ebing) than any other Surrealist painter; and Freud was more interested in Dali's work than in the other Surrealists' works or theories. The psychoanalyst was visited by Dali in London in 1939 and admitted that he found this strange young Spaniard fascinating. However, Freud — whose own analyses of works of art are somewhat less than profound — suggested to Dali, "It is not the unconscious that I seek in your pictures but the conscious. While in the pictures of the masters — Leonardo or Ingres — that which interests me, that which seems mysterious and troubling to me, is precisely the search for unconscious ideas, of an enigmatic order, hidden in the picture. Your mystery is manifested outright. The picture is but a mechanism to reveal it."[2]

Dali has been more than a painter and theorizer, however; he has also designed jewelry, furniture, dresses, and store windows, as well as sets and costumes for the ballet. He has made prints, organized carnivals, and collaborated on films. Yet his most striking creation remains himself: the mad dandy, leading an ocelot on a leash down Madison Avenue. Far from being mad, however, he attempts to expose the insanity and stupidity of society by means of his solemn clowning on the one hand, and commands attention and garners rewards for his bizarre and entertaining behavior on the other. He protests against the word clown as applied to himself, however: "I am the *Divine Dali* . . . the word 'harlequin' is synonymous with Hermes, with Mercury as a go-between . . . makes me . . . a harlequin."[3]

Dali has said his ambition is to make of painting hand-made photography in color. His idols are Vermeer (above all), Velásquez, Raphael, Bouguereau, Millet, and the late nineteenth-century academician Ernest Meissonier. Dali's technical ability to produce slick, overall surfaces does indeed rival Meissonier's; however, he uses his technique to beguile his audience into accepting the hallucinatory images that he creates. Obsessed with erotic and scatalogical subjects, his iconography deals openly with onanism, putrefaction, excrement, voyeurism, castration, and impotence.

The small, jewel-like paintings that he did during the half-dozen years following 1929 are his most impressive works. These pictures "are ideal for an image projected from the imagination, analogous as they are in size to the 'screen' of the mind's eye, which we feel to be located just inside the forehead."[4]

In the second Manifesto of Surrealism published in 1930, Breton recognized that Dali added a new dimension to Surrealism. In this Manifesto Breton deplored the fact that automatism, which he had hailed in the first Manifesto, often led to the creation of works of art rather than the liberation of man through self-knowledge gained by exploration of the unconscious. At the time, the Surrealists did not consider Dali's paintings to be works of art, since they were not concerned with formal values and their subjects were derived from his so-called "paranoiac-critical" method. Their primary significance lay in their role as evidence of the artist's investigations of his unconscious, Furthermore, his method for *controlled* simulation of a paranoiac condition was intended to be applied to all actions and not just the production of paintings. Although Dali's technique is closely related to that of Meissonier, his painting contains elements related to works by Chirico, Ernst, Magritte, and Tanguy (especially the latter's extended spaces and carefully modeled shapes). Dali's results, however, are quite different from works by any of these painters.

His insistent perversity finally caused him to react against the Surrealist program. In the face of Surrealism's dalliance with Communism, Dali accepted the Cross of Isabella the Catholic from Generalisimo Franco and was reconciled with the Catholic Church. He also seemed obsessed by the figure of Adolf Hitler. Confronted with this charge by Breton, he "innocently" replied that as a Surrealist he was committed to recording his dreams without any outside intervention and that it was not his fault if he dreamed about Hitler. Finally, contrary to the Surrealists' anti-bourgeois, anti-capitalist stance, he came to the United States and hired out his talents to outrageously commercial ventures.

In recent years he explained his acceptance of the Falangist decoration by insisting that he has always rebelled against his bourgeois background and has touted the virtues of aristocracy and monarchy at the same time that he was an anarchist: ". . . both aim at absolute power. I accepted the Cross of Isabella the Catholic from Franco's hands simply because Soviet Russia never offered me the Lenin Prize. I would have accepted it. I'd even consent to a badge of honor from Mao Tse-tung. I've never committed myself. . . . Only people with a servant's mentality commit themselves. I prefer being a nobleman and so I couldn't ask for anything better than being covered with all kinds of medals."[5]

As for his commercial ventures, he explains, "I am a supreme swine. The symbol of perfection is a pig. . . . The pig makes his way with Jesuit cunning, but he never balks in the middle of the crap in our era. I feed my crap to the Daliists. Everybody's satisfied. . . . I've always been impressed by what August Comte wrote. . . . He felt that we cannot build the world without bankers. I myself decided that for my personal and absolute power, the essential thing was to have lots of money."[6]

Concerning the time that he spends in the United States, he says he lives there simply "because I'm always in the middle of a cascade of checks that keep pouring in like diarrhea."[7] He refers to "Daliists" as parasites and *arrivistes,* at the same time admitting that he himself is a great *arriviste.* "I get more out of them than they get out of me. They give and they give. And I profit immensely."[8] Concerning his return to the Church, he compares his attitude with Voltaire's: "Whenever he passed a monstrance he would doff his hat. One day an astonished friend cried out: 'I thought you were an atheist.' Voltaire rejoined: 'Listen, God and I are not on speaking terms, but we do greet one another on the street.' "[9]

Finally, about his own paintings, he says: "They're badly painted . . . the *Divine Dali* of today would be incapable of doing even a mediocre copy of a canvas by Bouguereau or Meissonier, both of whom could paint a thousand times better than I can."[10] Earlier he had said: "I have always affirmed that I'm a very mediocre painter. I simply believe that I'm a better painter than my contemporaries. If you prefer, they're much worse than I am."[11]

When is Dali serious? Is he a poseur and opportunist who, according to Breton's accusation, has sold himself for dollars? Or has he taken Jarry's advice and made his life "a poem of incoherence and absurdity" in order to demonstrate his "contempt for the cruelty and stupidity of the universe"? His arrogant attitude, even toward his admirers, tempts one to believe that he is fully aware of the implications of his actions. Perhaps he has made of his life a continuous Surrealist act, so extreme that it mocks the seriousness of Surrealism itself. Many people, and most Surrealists, believe that he is a Surrealist *manqué* — that, like Chirico, he has simply lost his way. He himself has said that he goes through life appearing to make fun of everything, and "that is what most successful dandies do. . . . But whatever happens, my audience mustn't know whether I'm spoofing or being serious; and likewise, I mustn't know either. . . ."[12]

Yet, for more than ten years Dali did produce major works such as *Accommodations of Desire* [54], *Illumined Pleasures* [55], and *Angélus Architectonique de Millet* [56]. Rubin has analyzed *Illumined Pleasures* in detail, tracing the symbolic images to their sources. Since many of these motifs play an important role in Dali's early works, a brief summary may serve as a clue to other paintings of this period.

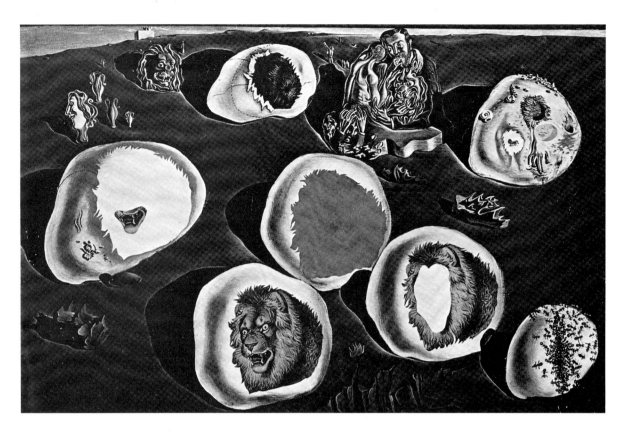

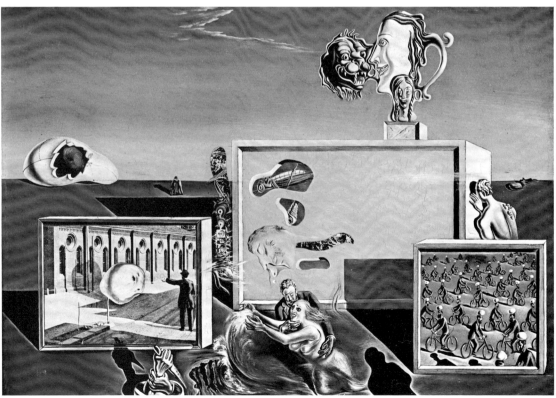

Three boxes containing different scenes appear in the foreground of an extended, flat landscape. Various images that play a significant role in Dali's symbolic iconography surround the boxes; many of them can be traced to the influence of other artists (including Chirico, Ernst, Magritte, and Tanguy) and to Dali's early life.

The central and largest box contains Dali's self-portrait which rests face downward with eyes closed (an image which reappears in many of his early works). Rubin points out that this attitude was suggested to Dali by two anthropomorphic rocks at Cape Creus.[13] Irregularly shaped holes cut in the covers of the boxes reveal other images; especially significant is the grasshopper, which Dali sometimes calls a locust or a praying mantis. The multiple associations of this image, also repeated in other paintings, include onanism, the connection of erotic elements of sex and of eating (Dali referred to the luscious, crunchy taste of locusts), and Dali's childhood fear of being eaten (the peculiar habits of the praying mantis have already been noted; Eluard raised these insects which fascinated Dali).

The left-hand box contains a photographic image of architecture which refers to Ernst's early collages, and a male figure gesturing magically at a cephalic rock. The right-hand box depicts a crowd of Magritte-like men on bicycles with sugared almonds on their heads (according to Dali: ''the sugared almonds of the Playa Confitera which tantalize onanism'').[14]

The surrounding images include a column of birds clearly referring to Ernst's bird images; a lion's head (Dali's father image) joined with a leering woman's head, which is also a pitcher (an obvious Freudian symbol of the woman as a vessel); an apparently shamed young man on the right side of the central box; the father image holding a woman attempting to cleanse her bloody hands in a miniature wave, while her hand holding a bloody knife is seen to the left being restrained by another hand. Rubin remarks that any interpretation of this must be speculative since,

**56** Salvador Dali, *Angélus Architectonique de Millet,* 1933

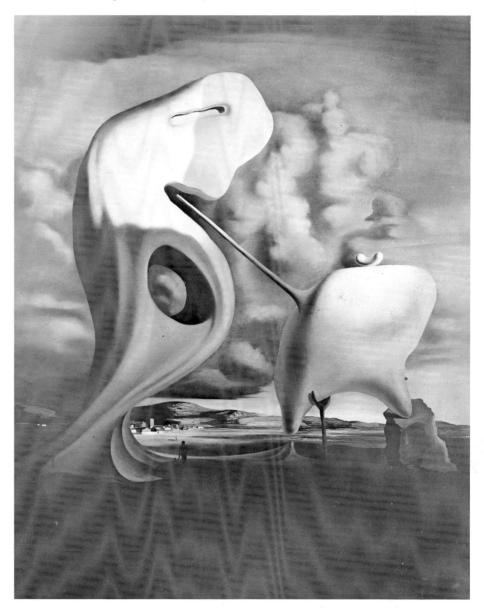

**54** Salvador Dali,
*Accommodations of Desire,* 1929

**55** Salvador Dali,
*Illumined Pleasures,* 1929

101

unlike the other images, it does not appear in any of Dali's other works. One perhaps-too-obvious interpretation is that of the castrating mother; however, there are many other possibilities. In the distance a metal, cephalic, seamed shape — obviously referring to Chirico's mannequins — is torn open to reveal a toupee, which appears in other paintings by Dali and in several by Chirico. Near this image two male figures embrace in a manner suggesting Chirico's *Return of the Prodigal*. The ominous cast shadow in the foreground is another Chiricoesque device.

The dominant figure in this work is the father, and the major theme is onanism. Dali's startling clarity and technical precision seem to shock and fascinate his many admirers.

*Accommodations of Desire* [54] reveals many of the same images. The lion-father image is repeated nine times — partially or completely — most often on boulders strewn across the flat landscape. The woman vessel appears on the left and the father embracing the shamed son while biting his fingers appears in the upper right center of the

painting. One of the rocks is covered with ants, referring to overwhelming sexual desire.

*Hallucination Partielle: Six Images de Lenine sur un Piano* (Partial Hallucination: Six Images of Lenin on a Piano) [57], painted in 1933, is one of the very few paintings in which Dali refers to the political concerns of Surrealism. The figure seated with his back to the viewer may be Max Ernst, judging from the shock of light hair and the lean figure. In 1932 Ernst was blacklisted by the Nazis; here he seems to be contemplating the hallucinatory father image of

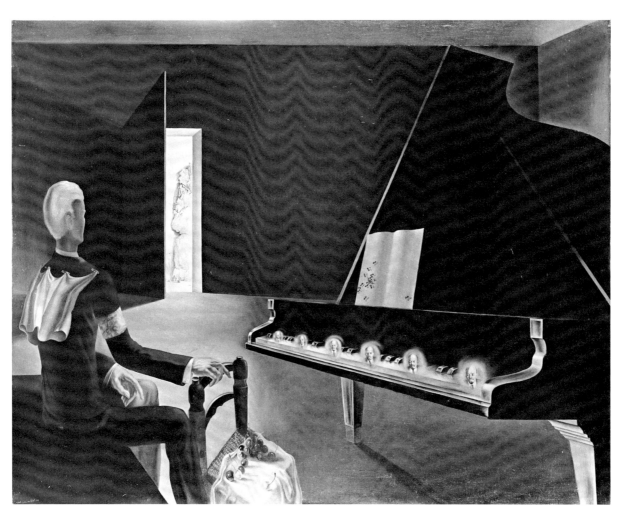

**57** Salvador Dali, *Hallucination Partielle: Six Images de Lenine sur un Piano,* 1931

102

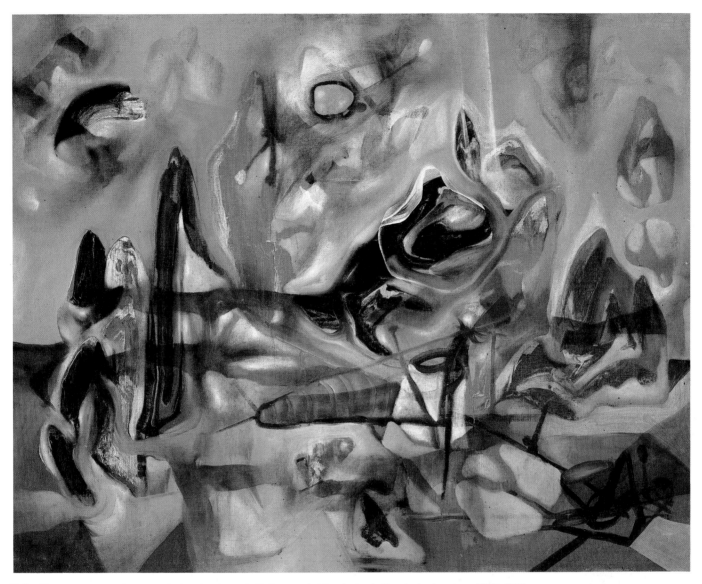

Color Plate XVII. Matta (Roberto Sebastian Antonio Echaurren), *Morphologie Psychologique*, ca. 1939 [78].

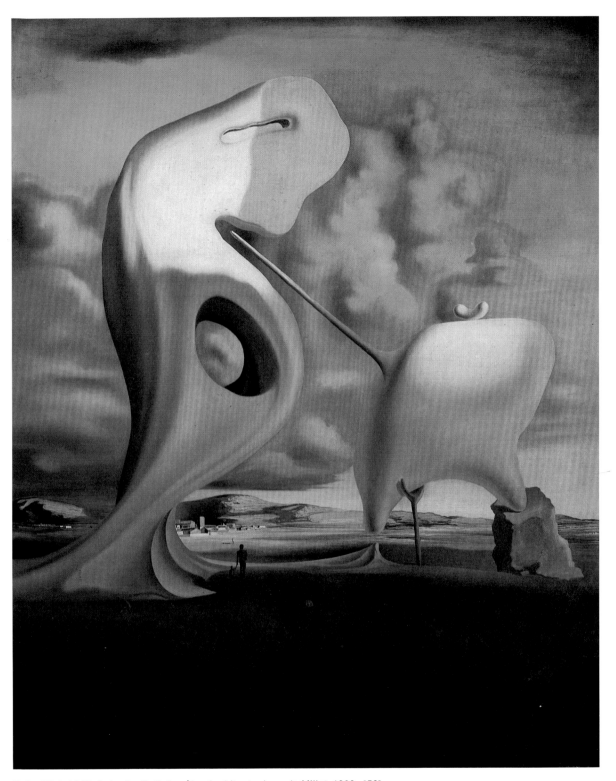

Color Plate XVIII. Salvador Dali, *Angélus Architectonique de Millet,* 1933  [56].

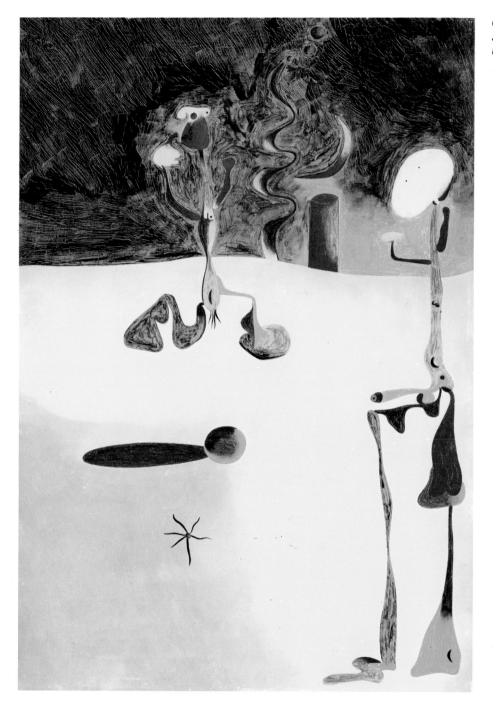

Color Plate XIX.
Joan Miró,
*Nocturne,*
1935  [29].

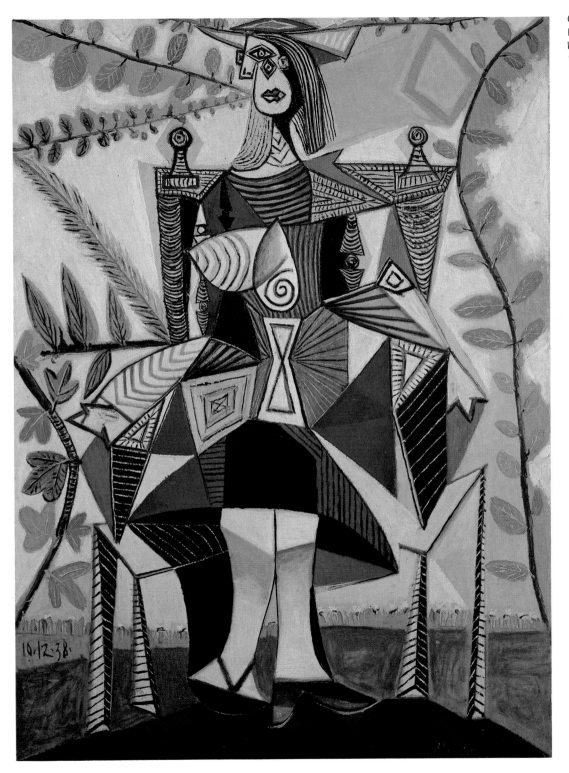

Color Plate XX.
Pablo Picasso,
*Woman in a Garden*,
1938 [68].

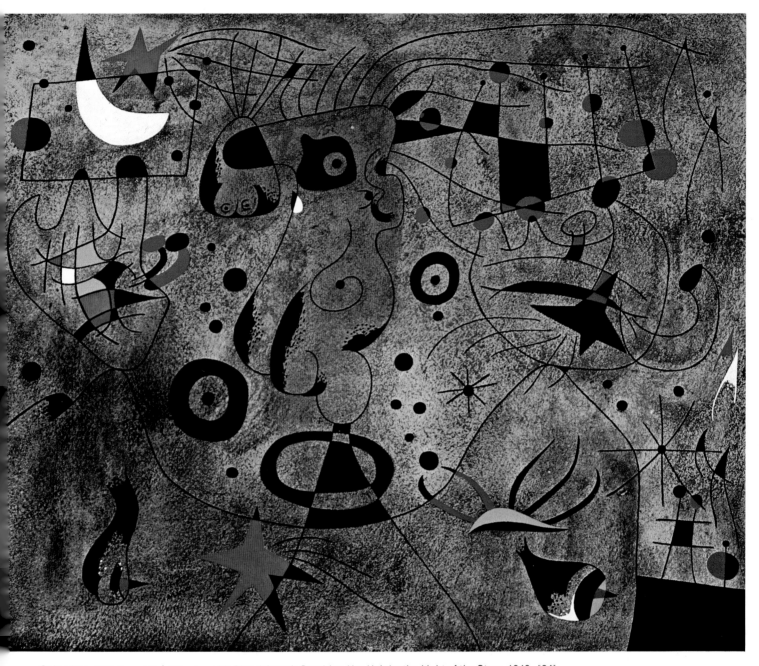

Color Plate XXI. Joan Miró, *Woman with Blond Armpit Combing Her Hair by the Light of the Stars,* 1940  [34].

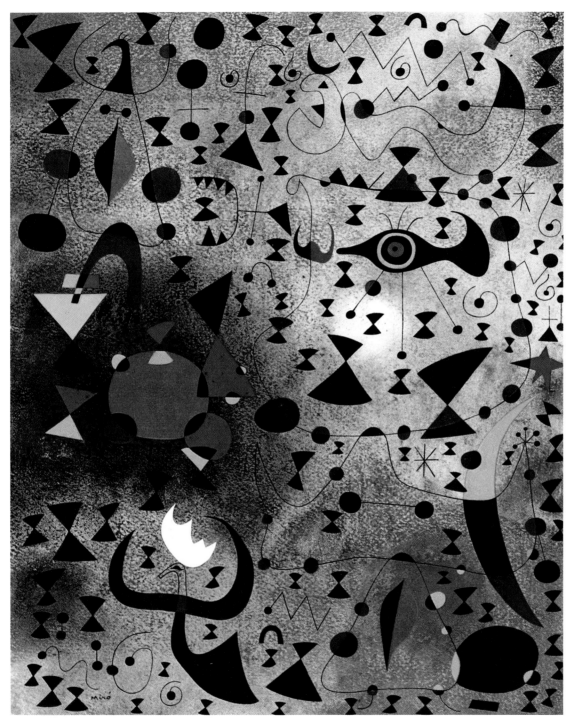

Color Plate XXII. Joan Miró, *Woman at the Border of a Lake Irradiated by the Passage of a Swan*, 1941 [39].

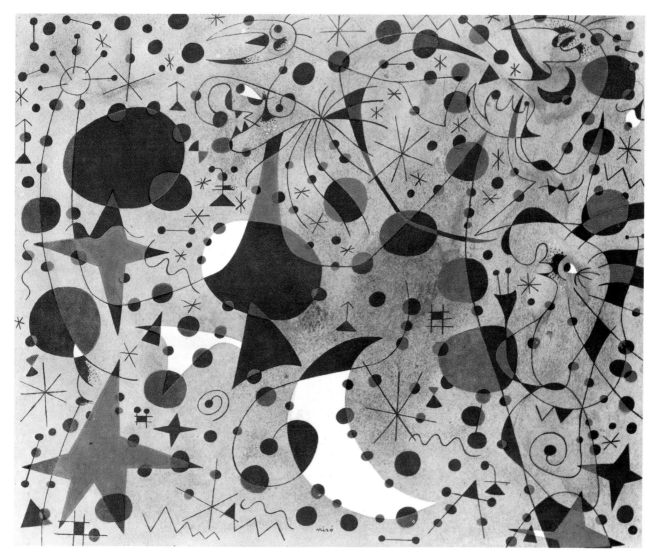

Color Plate XXIII. Joan Miró, *Le Chant du Rossignol à Minuit et la Pluie Matinale*
*(The Nightingale's Song at Midnight and Morning Rain)*, 1940  [37].

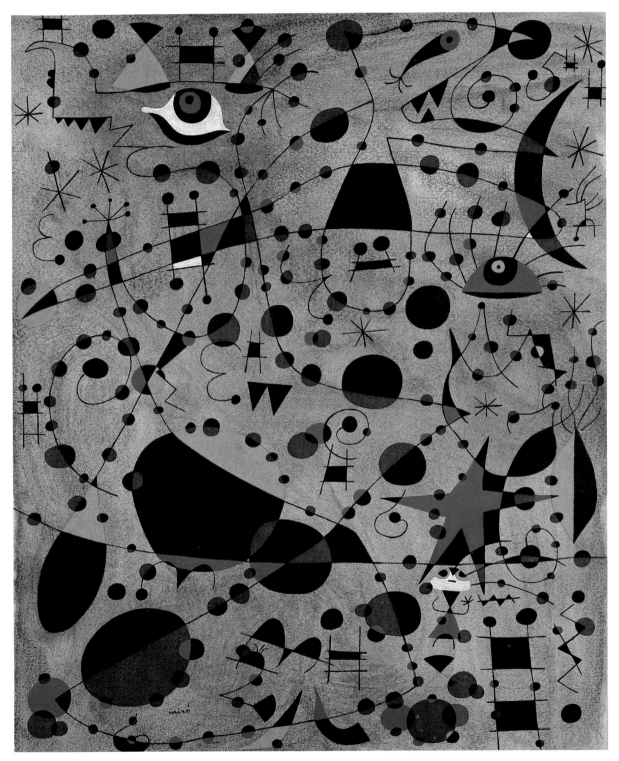

Color Plate XXIV. Joan Miró, *The 13th Ladder Brushed Against the Heavens*, 1940 [32].

Lenin, but the music sheet above is covered with the ants of sexual desire. The luscious cherries on the chair again suggest the association of sexual and gustatory eroticism, and the great rock formation outside a half-open door culminates in the head of a young woman. The piano top repeats the angle and invites opening of the door. The seemingly obvious implications of the combination of political and erotic images in this painting are surely too simple. The dangers of speculation, however, forbid drawing further inferences.

Jean-Francois Millet's famous painting *The Angelus* has provided the theme for a number of Dali's drawings and paintings. For Dali, the religious sentiment simply concealed its sexual implications. One of the most successful versions is his painting *Angélus Architectonique de Millet* [56], done in 1933. The figures of the peasants have been replaced by great looming, anthropomorphic rocks with Gaudiesque architectural overtones. The female image is on the left, head bowed as in Millet's painting; she can be identified by the orifice in the center of her form.

The smaller male form penetrates her with an enormous erect member while at the same time he is supported by one of Dali's crutches (perhaps doubling for one of Millet's peasant's pitchforks). Beneath this great sexual act by the "figures of the earth" a father and son walk hand in hand toward a small figure in the distance before low-lying hills and buildings.

*Cardinal, Cardinal* [58], painted by Dali in 1935, is signed by Gala as well as Salvador Dali. On the left-hand side, four mysterious figures barely emerge from the shadows of a dark stone wall.

**58** Salvador Dali, *Cardinal, Cardinal,* 1935

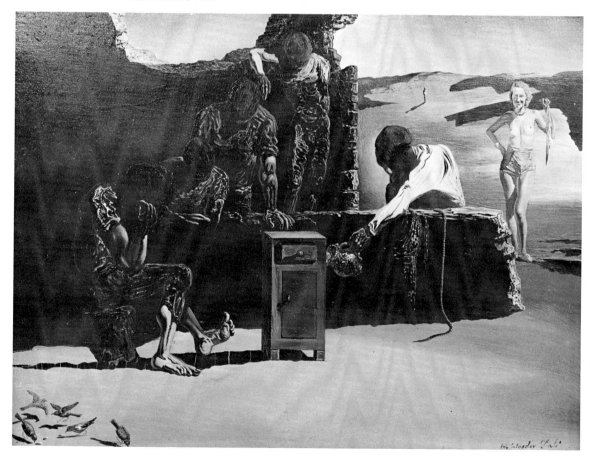

They seem to be made of almost the same material as the wall. On our right, Gala stands, smiling in the bright sunlight, bare to the waist and holding up her removed halter. A strange figure sits between Gala and the darkling figures; he hunches over a low wall pouring the contents of a pitcher behind a cabinet. A rope dangles over the wall in front of him.

The contrast between the brilliantly lit, smiling, half-nude Gala and the mysterious male figures — none of whose features are defined — is startling. Her form is photographic, theirs resemble molten lava. If the pitcher is here interpreted as the female vessel, and the chest with a drawer and cabinet also as a female image, how do we interpret these symbols? The small flock of birds feeding on crumbs in the left foreground are surely not there for compositional reasons.

This appears to be one of Dali's most ambiguous paintings. Are the shadowed figures, so intently scrutinizing the female symbols, impotent? Does the limp rope refer to the same thing? Is Dali contrasting them with the healthy sexuality of Gala? And who is the small Chiricoesque figure in the distance?

Darkness and light; symbol and reality; walls and open ground; photorealism and thick, viscous surfaces — contrasts abound. What was Gala's role in creating this work that she too signed it? Dali's earlier works are more easily deciphered; works done in the mid-thirties, such as *Cardinal, Cardinal,* become more difficult.

Always one ends with the same question: Who is the real Dali? Dali seems to pose that very question to himself.

1. William S. Rubin, *Dada and Surrealist Art* (New York: Harry N. Abrams, Inc., 1968), p. 216.
2. Ibid., pp. 216-17; originally recounted in Salvador Dali, *The Secret Life of Salvador Dali,* trans. Haakon M. Chevalier (New York: Dial Press, 1942), p. 267; amended account given by Dali to Rubin in a conversation, February 1967.
3. Alain Bosquet, *Conversation with Dali* (New York: E. P. Dutton & Co., 1969), p. 20.
4. Rubin, p. 113. Rubin credits Meyer Schapiro for bringing to his attention, while discussing the work of Paul Klee, the "location and size of the 'screen' of the imagination."
5. Bosquet, pp. 12-13.
6. Ibid., pp 11-12.
7. Ibid., p. 14.
8. Ibid., p. 11.
9. Ibid., p. 59.
10. Ibid., p. 22.
11. Ibid., p. 15.
12. Ibid., p. 69.
13. Ibid., p. 220.
14. Ibid., p. 226.

# PAUL KLEE
# 1879-1940

In 1902 Paul Klee wrote, "It is a great difficulty and a great necessity to have to start with the smallest. I want to be as though new-born, knowing nothing, absolutely nothing, about Europe; ignoring poets and fashions, to be almost primitive. Then I want to do something very modest; to work out by myself a tiny, formal motive, one that my pencil will be able to hold without any technique."[1]

Until he went to Munich to study in 1898, Klee was not certain whether he would follow a career in music or painting. Born in 1879 in München-Buchsee near Berne, Switzerland, Klee was the son of an orchestra conductor; as a child he studied the violin. When he moved to Munich, however, it was to study with the painter Franz von Stuck. After traveling in Italy he moved back to Munich, became friendly with Kandinsky and other artists who later formed the Blue Rider movement, and decided on painting for his career. Even then, his method of creating had much in common with the approach of a musical composer to his art. He did not, for example, set out to illustrate a preconceived idea — the idea was inspired as the work of art was being created. Klee has said that he created symbols which reassured his mind.

Klee's rejection of traditional techniques and his interest in the art of children, primitive art, and that of such visionaries as Goya, Blake, Redon, and Gustave Doré, paralleled the Surrealists' interests — as did his concern with images from the preconscious and unconscious levels of the mind. To continue the quotation above: "One favorable moment is enough. The little motive is easily and concisely set down. It's already done! It was a tiny but real affair, and someday, through the repetition of such small but original deeds, there will come one work upon which I can really build."[2]

Thus, the germinal ideas and forms of his works were the result of an intuitive, almost automatic method. Klee noted that during the act of making the work of art, a large part of the process of creation occurs in the subconscious.

Further, in his *Creative Credo* Klee stated: "We used to represent things visible on earth which we enjoyed seeing or would have liked to see. Now we reveal the reality of visible things, and thereby express the belief that visible reality is merely an isolated phenomenon latently outnumbered by other realities. Things take on a broader and more varied meaning, often in seeming contradiction to the rational experience of yesterday. There is a tendency to express the essential in the random."[3] Such a belief concerning a reality beyond — and different from — what can be perceived by our limited senses is as old as Plato. However, when combined with the idea that insight into this reality might come through investigating the unconscious, Klee's thinking is nearly identical to that of the Surrealists. He referred to the ultimate mystery behind ambiguity and which the intellect is powerless to illuminate. In 1918 he wrote in his diary: "Contact with the archetype can occur through hallucination. . . . Thus a new reality is produced by purely psychic means."

Finally, however, any connection between Klee and the Surrealists seems to lie in the degree of emphasis placed on intuition, spontaneity, and chance in the creative act. The collaborative experiments of the Surrealists, for example, raised chance to the highest level. It played a key role in Klee's additive method of building a composition, but there was always the unifying guidance of a single, conscious — or subconscious — aim. In 1915 Klee had already referred to inventive "strolls" by his pencil and the ideas which developed

out of the stroll. In the *Creative Credo,* however, he made it clear that the automatic, spontaneous, intuitive parts of the creative act are by no means the whole story: "Action may well be the start of everything, *but actions are governed by ideas.* And since infinity has no beginning, like a circle, ideas are of the primary realm." Thus, Klee recognized the role of intuition, but always in conjunction with a guiding intelligence. He pointed out that since creation is not a clear-cut process wherein it is easy to determine precedents and causes, we must accept the proposition that ideas are of primary importance — and that ideas are intellectual, not instinctual. He believed that both intellect and instinct are important in the creative act, while the Surrealists elevated intuition to a position of overriding importance.

Klee varied his emphasis on the roles of intellect and instinct in the creative act as his mastery over technique grew and his thinking about art developed. While he was in Tunisia in 1914, where he came to terms with color for the first time, he stressed the irrational and emotional aspects of the creative process. At the Bauhaus in Wiemar during the early 1920s he was involved with technical inventions and became more systematic and constructive; after 1926, however, at the Dessau Bauhaus, he allowed greater freedom to intuition and subconscious impulses.

When Klee writes about the characteristics of line, tone, and color as being measure, weight, and quality, and then proceeds to build on these ideas in a logical way, he sounds closer to Seurat than to Breton or Ernst. And he sounds like the very antithesis of Surrealism when he writes:

When the artist is still exerting all his efforts to group the formal elements purely and logically so that each in its place is right and none clashes with the other, a layman, watching from behind, pronounces the devastating words, "but that isn't a bit like uncle." The artist, if his nerve is disciplined, thinks to himself, "To hell with uncle." *I must get on with my building.* . . . This new brick is a little too heavy and to my mind puts too much weight on the left; I must add a good-sized counterweight on the right to restore the equilibrium. . . . Sooner or later, the *association* of *ideas* may of itself occur to him, without the intervention of the layman. Nothing need then prevent him from accepting it, provided that it introduces itself under its proper title.[4]

Thus, Klee explained that the formal qualities of his work are logically developed while the content evolves, perhaps unconsciously, and is recognized and accepted by the artist only later. The Surrealists, on the other hand, were first concerned with the spontaneous and intuitive development of the content of the work, allowing form to develop without conscious guidance by the artist. All his life Klee was consumed with the ambition to provide a system for the composition of paintings that would correspond to harmonic theory for music.

Throughout his writings, especially in the *Pedagogical Sketchbook,* there is evidence that Klee was trying to arrive at a basic set of pictorial symbols — grounded in the realm of feeling but based on common associations in life situations and on empathy — which could serve as a vocabulary for the artist's more intuitive and spontaneous creative adventures. In this concern, he was a follower of Seurat.

Surrealism (as Klee said about nature) permitted itself "extravagances in every way." Klee, however, was frugal and discreet. The primitive quality that some people attribute to his work is in

reality the result of a disciplined reduction to essentials. It is therefore the reverse of true primitivism and of the primitive art that Surrealism admired.

Why, then, did the Surrealists court Klee? Partly because he opposed the academic tradition and stressed the importance of feelings, intuition, and the subconscious in art. "We construct and we construct," he said while at the Bauhaus, "but intuition still has its uses."[5] But also partly because the automatist Surrealist painters themselves permitted a larger role to consciously controlled formal order than Breton's

thesis allowed. Like life, art for Klee and many Surrealist painters was made up of many parts — integrated, unified, and undifferentiated.

By 1921, when Klee did the water color *Aging Venus* [59], he had recognized his own ability as a painter and was teaching at the Bauhaus in Weimar. German society was in a state of moral decay following the end of World War I; artists such as George Grosz and Otto Dix were satirizing it viciously in their paintings, drawings, and prints. Klee's

painting of a much-experienced prostitute is a gentler satire on the surface and is tinged with a wit lacking in works by the bitter Grosz.

The soft lavender and blue of the background of *Aging Venus* is subtle and ingratiating. The line defining the figure is so graceful that one almost doesn't notice the incisive lines rimming the narrowed eyes, the large nostrils of the protruding snout-like nose, the pendulous breasts, and the curling fingers of the right hand as the woman penetrates herself. Her rigid, booted legs are spread; the graceful curves of

**59** Paul Klee, *Aging Venus,* 1922

her torso and right arm contrast with the rigidity of her legs and bent left arm. Klee has used a minimum of means to make every element in the work express his subjective feelings as poignantly as possible. Yet, if we believe Klee's words, the painting began by spreading the washes of color on the surface and allowing the chance shapes to suggest where the line should first wander.

A year earlier Klee had painted *Women's Pavilion* [60]. Schematic images of trees and potted plants stand before (as the title suggests) a house of prostitution. The composition is based on a structure of wavy horizontal lines traversing the surface of the painting; these are crossed by spaced verticals. The images of trees, flowers, the house, and other elements almost invariably coincide with the irregular, grid-like lines. The tops, bottoms, side edges, and centers of each shape are determined by the lines which were laid down before the images were defined. Thus, the chance relationships of an arbitrary linear pattern serve as a control on the imaginative images that emerge from the artist's brush.

Klee's versatility is apparent in these two works painted only a year apart. One is thinly painted, with the image defined by a precise and elegant line drawing; the other is densely painted, with rich impastoes, dark tones, and mixture of techniques.

**60** Paul Klee, *Women's Pavilion (Frauen Pavillon),* 1921

**61** Paul Klee, *Karneval im Schnee (Carnival in the Snow),* 1923

Klee's erotic nature during these early years is again revealed by the water color *Karneval im Schnee* (Carnival in the Snow) [61], done in 1923. Soft washes of clean color put down in patches establish the underlying formal structure for the amusing and fantastic scene of acrobats supporting one another. A jug-like shape establishes a female image to the viewer's left. She helps support the two figures, one atop the other, to the viewer's right. The lower figure's torso is also a face; its hoofs, tail, and squat shape suggest an animal. The composition is dense, with double images and symbols carrying multiple sexual connotations.

*Composition* [62], painted in 1931, appears to be almost completely abstract. Within the edges of the picture there is a roughly painted, irregular, horizontal rectangular frame. Within this painted frame a dark, geometrical J shape stabilizes the composition. The shorter of its two vertical elements supports a horizontal band which spreads gradually as it moves out to the left before its irregular end is dissipated in the background. Two vertical trapezoids appear on either side of the dark central motif. The lighter one on the left supports the horizontal bar, the longer and narrower one on the right touches corners with the central shape above and a smaller, irregular geometrical shape below. A circle above suggests the moon, and a heart below and to one side of it reinforces the romantic implication. The heart shape is not painted, but rather is the texture of the canvas outlined by pigment. Klee's abstract vocabulary is in full control in this unusual painting. Only the circle and heart seem to refer to images taken from the familiar world of objects and symbols.

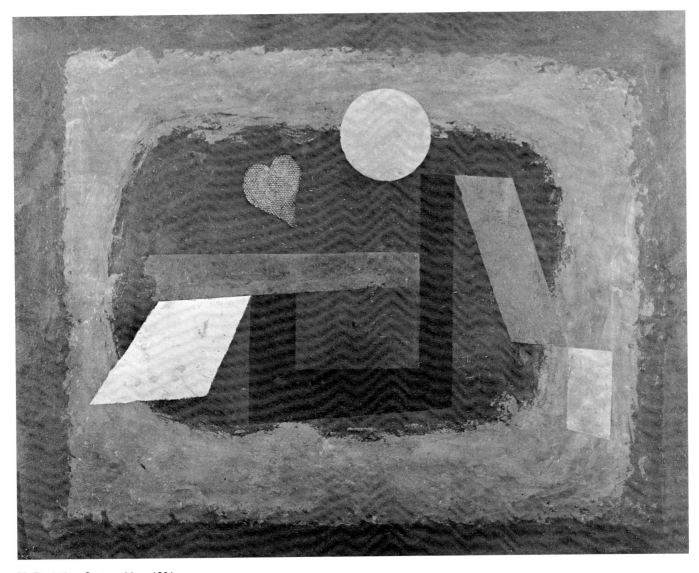

**62** Paul Klee, *Composition*, 1931

*Fish Magic* [63], done in 1925, is related technically to *Women's Pavilion;* however, it is much larger. It is also a dream-like painting, with logically unrelated images brought together in a magic world. Against the rich, dark ground, a clock is mounted on a belfry that is also a fishnet. Brilliantly colored fish swim to and fro. Flowers appear in the upper and lower right-hand corners.

A lavendar moon hovers overhead while a double-faced woman waves and a clown peeks in from the lower left-hand corner. A red curtain swings down from the upper left as if to suggest a stage.

Fish, flowers, moons, and clocks all suggest the transitory. The architectural forms are so dim as to be almost imperceptible. Yet all of these images incon-

gruously share the same environment — surely one which derives from the artist's inner, illogical world.

*Mask of Fear* [64] was painted in 1932, the year before Hitler and the Nazi Party came to power in Germany, and also the year before Klee left Germany and returned to Switzerland (where he died eight years later). Might it be a premonition of the terror to come and its psychological effect on so many inno-

**63** Paul Klee, *Fish Magic,* 1925

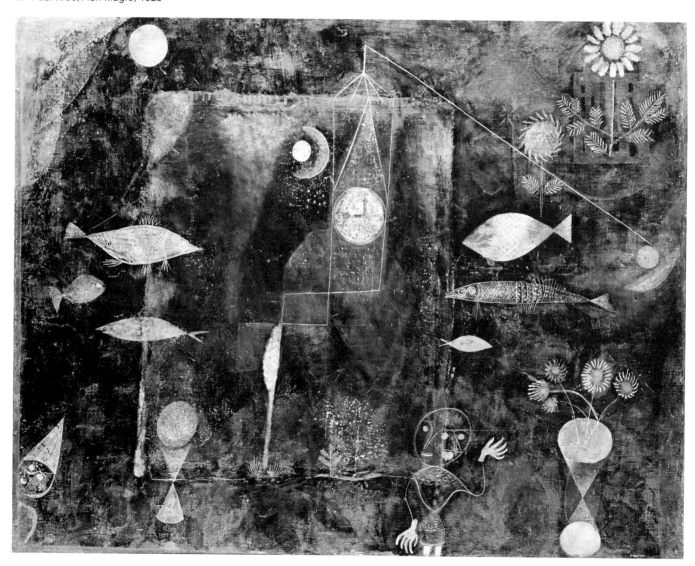

cent victims? A great oval head takes up most of the surface of the burlap which supports the pigment. A low horizontal line runs through the lower part of the face, serving as a rigid, tightly controlled mouth. Two round, blankly staring eyes flank the long, straight nose. A black arrow emerges from the top of the head (suggesting active, upward striving), and a motif of five crossed lines at the tip of a vertical aerial-like line at the back of the head may refer to balance and communication.

Strangely, two pairs of legs appear below the single mask. Thus, Klee seems to suggest that individual freedom of expression is ending and that all mentally active citizens are potential enemies of the new society. Their common mask is one of fear.

Like the Surrealists, Klee was concerned with exploring the unconscious and utilizing automatic methods and chance effects to stimulate his creative process. Unlike the Surrealists, however, he acknowledged a greater role for the intellect, and set out to devise a visible language of abstract motifs that would be universally comprehensible — a language analogous to musical structures in their power to express subjective experience by means of pure form. Obviously, such a goal was not in complete harmony with the anti-formalist position of Breton and his friends.

1. Klee, Diaries, June 1902; quoted in *Artists on Art*, ed. Robert Goldwater and Marco Treves (New York: Pantheon, 1945), p. 442.

2. Ibid., pp. 442-43.

3. As quoted by Will Grohmann, *Paul Klee* (London: Lund Humphries, 1954), p. 181.

4. Klee, "On Modern Art," in *Modern Artists on Art,* ed. Robert L. Herbert (Englewood Cliffs, NJ: Prentice-Hall, 1964), pp. 82-83.

5. *Artists on Art,* p. 444.

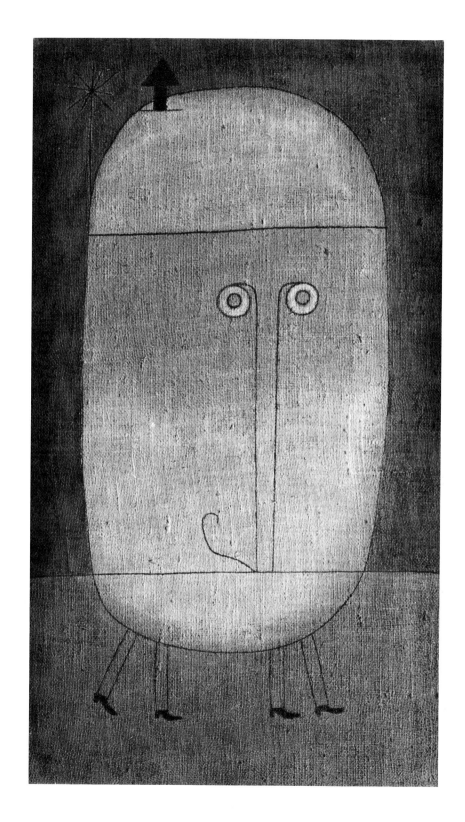

**64** Paul Klee, *Mask of Fear,* 1932

# PABLO PICASSO
## 1881-1973

Like Klee, Picasso was never a member of the Surrealist movement, although many of his works are as Surrealistic in spirit as any produced by doctrinaire Surrealists. Picasso was an elemental force in modern art. Larger than any movement or style, he created Cubism (along with Georges Braque) — the most influential movement of the twentieth century — and was the most inventive, prolific artist of his time. What he didn't invent, he appropriated and im-

proved. He was acclaimed — and claimed for Surrealism — by Breton, who included his name on the roster of major Surrealists. And indeed, he did exhibit with them and illustrate Surrealist publications as well as generally sharing the Surrealist attitude toward creativity and life during the late 1920s and much of the 1930s. In the Manifesto of Surrealism Breton recounts a daydream about a castle "in a rustic setting, not far from Paris" which he shares with friends such as Aragon "who only has time enough to say hello"; Soupault "who gets up with the

stars"; Eluard, Desnos, Vitrac, and many others including "gorgeous women"; while "Picasso goes hunting in the neighborhood."[1]

The metaphor is apt, for no matter how close he came to it, Picasso remained independent of the Surrealist movement. Whatever is revealed of his unconscious in his work is completely involuntary. He himself remarked, "I attempt to observe nature, always. I am intent on resemblance, attaining the surreal. It was in this way that I thought of Surrealism."[2]

Picasso did not follow the Surrealist program based on psychoanalysis, but he moved instinctively in a direction parallel to Surrealism. His pre-Cubist painting *Les Demoiselles d'Avignon* (Figure 11) reveals the enormous energy of his personality which manifested itself in the images of this early experiment with formal structure.

Pablo Ruiz Picasso was born in 1881 in Malaga. His father, José Ruiz, was a painter and art teacher in that Andalusian town in southwestern Spain. Jaime Sabartès — Picasso's long-time companion, secretary, and biographer — has traced Picasso's father's origin to Aragon and New Castile, while his mother's family had lived in Malaga for many years.

Picasso demonstrated his prodigious gifts at an early age. When he was only thirteen years old, according to an often-repeated story, he did such excellent work painting in the details of his father's composition that the elder painter turned over his brushes to him. Records and existing works reveal that at fourteen he applied for entry to the Barcelona Academy of Fine Arts after his family had moved north so that his father could take a teaching position at the Academy. Because of his father's influence, young Pablo was permitted to take the examination for entrance to the advanced class called "Antique, Life, Model, and Painting." One month was normally allowed to complete the ex-

Figure 11. Pablo Picasso. *Les Demoiselles d'Avignon,* 1907.

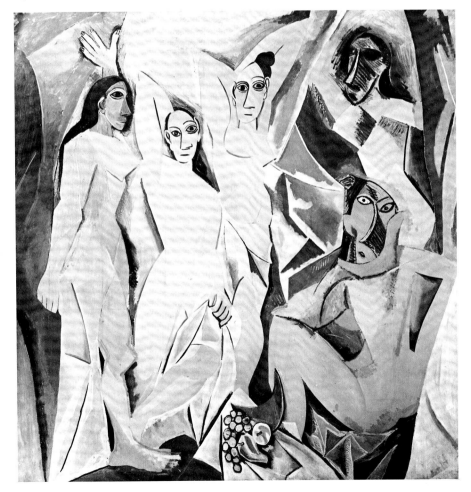

112

amination; incredibly, Picasso completed the examination with honors in one day.[3]

As Picasso matured, he found a group of young avant-garde artists in Barcelona who accepted him as their leader. In 1900, at nineteen years of age, he made his first visit to Paris, where he sold some paintings to Berthe Weil. For the next four years he moved back and forth between Spain and Paris several times before finally settling in the French capital in 1904.

In Paris Picasso soon became the center of a group of expatriate Spanish artists and poets. He had passed through a period of working in the manner of Toulouse-Lautrec when he began the pictures of his "blue" period toward the end of 1901, when he had just turned twenty-one. The drawing of the emaciated beggars and paupers of this period are reminiscent of El Greco's elongated figures. The subject matter indicates young Picasso's romantic sympathy for the miserable victims of a more affluent society. His "rose" period expressed more lyrically his sympathies with society's other social misfits — wandering acrobats and circus performers — figures that are traditional symbols for artists and poets in general.

During the short-lived "negroid" period, in 1901, resemblances to nature gave way to the artist's instinct for plastic form. Then for nearly seven years, beginning in 1908, Picasso and Braque worked together as closely as any two artists ever have. Classical and rational in the best tradition of French good taste, Braque exercised a restraining influence on Picasso's more volatile temperament during the period of Analytical Cubism extending from 1908

Figure 12. Pablo Picasso. *Three Dancers,* 1925.

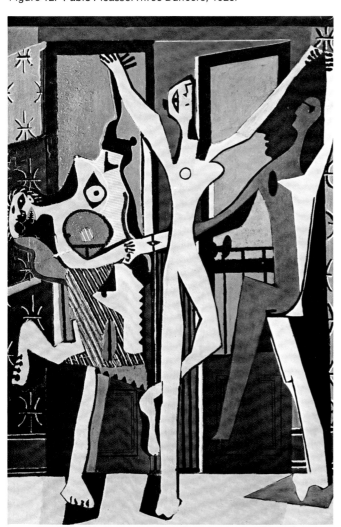

Figure 13. Pablo Picasso. *Girl Before a Mirror,* 1932.

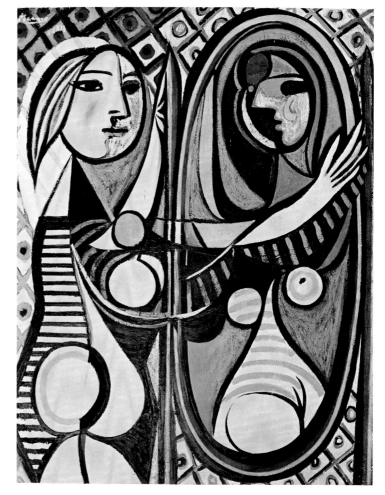

to 1912. The close collaboration between these two artists ended in 1914 when Braque was called up by the French army. Picasso went his own way thereafter, and in 1925, with the large canvas *Three Dancers* (Figure 12), he was able to adapt the Synthetic Cubist vocabulary for the direct expression of his impulsive vitality. As Roland Penrose remarks about this painting: "It is the first to show the violent distortions which have no link with the classical serenity of the preceding years . . . it is fundamentally . . . related to the anguish of a crucifixion. . . . Picasso's necessity to express his rage could no longer be contained."[4]

In 1912 Picasso had completed a Cubist painting by attaching a piece of oilcloth with simulated chair-caning to its surface and surrounding its oval shape with a heavy rope which served as its frame. This marked the beginning of the Cubist collages which — in the form of papiers collés — marked a transition from the analytical phase of Cubism to its synthetic mode. The process of analyzing the form of objects and the interrelationship between objects and surrounding space gave way to that of organizing broad, flat, colored shapes in a synthetic process resulting in images that refer to figures and objects in the outer world. The adaptation of this technique to define convulsive images referring to the artist's subjective experiences in response to the outer world occurred naturally with Picasso. At the same time, he did Ingres-like drawings of his friends, neo-classical figure paintings, and a series of classic Cubist still lifes. Among the major works adapting the Cubist vocabulary to realize Surrealist ambitions (in addition to *Three Dancers*) are *Seated Woman,* 1926-27; *Harlequin,* 1927; *Seated Bather,* 1930; *Bather with a Ball,* 1932; and *Girl Before a Mirror,* 1932 (Figure 13).

While the Cubist violations of the appearance of reality had been prompted by an urge to investigate formal structures and their interrelationships, the grotesque images that now appeared on Picasso's canvases resulted from his feelings of repugnance for mankind, stimulated by contemporary events as well as the problems of his personal life.

Robert Rosenblum has justly remarked about Picasso's works of this period: "His masterpieces of the early thirties are, in fact, the greatest triumph

**65** Pablo Picasso, *Seated Woman (Femme Assise),* 1926-27

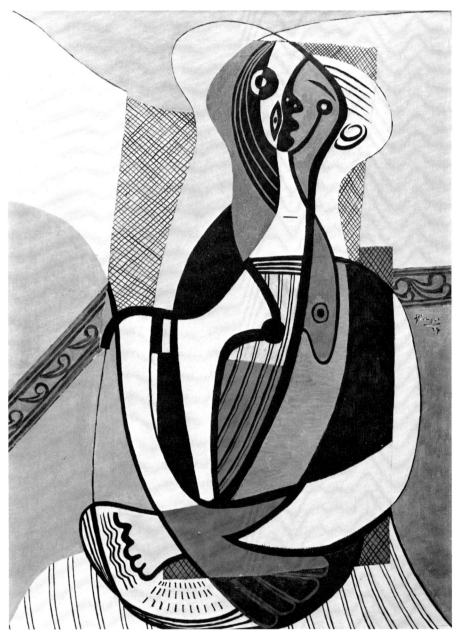

of the Surrealists' efforts to create a pictorial style and imagery appropriate to the exploration of dreams, and to the uncovering of those profound biological roots that link men more firmly to irrational nature than to a technological civilization. To do this, Picasso invented a language of multiple metaphors far more evocative and poetic than the more literal-minded *trompe-l'oeil* double images and fantastic figures of many Surrealists who attempted to unchain the subconscious."[5] And Wallace Fowlie in *Age of Surrealism* uses Picasso to epitomize the Surrealist artist.

During the late 1920s Picasso became interested in neolithic art, as did the Surrealists. In both instances their concern was for an art that developed long before the concept of aesthetic value existed; the primitive images were the result of a direct articulation of inner desires and wishes, often as sympathetic magic. Picasso was particularly fascinated by Easter Island hieroglyphs; indeed, some of his figure paintings done during the late twenties almost seem like enlarged and complicated versions of these small images.[6] *Seated Woman* [65], done in 1927, is reminiscent of the lively, curvilinear shapes of the Easter Island figures, but its interlocking shapes, intense hues, and patterns are far more complex. The curving arms, shoulders, breasts, head, and features are woven together in a complicated yet integrated design. Here, the profiles face both right and left, a three-quarter view of the head is also turned to our left, and there is another view in which the head appears to be turned completely sideways with the top of the head on our left. In the latter view, the curved slash, which can be read as an eyebrow, becomes a smiling mouth.

The two profile views apparently combine a female figure with long, sweeping hair (on our left) and a male with short, straight hair (on our right).

As often occurs in Surrealist images, the facial features double as sexual organs. The breasts of the figure are suspended directly from the head by a continuous flowing line. The integration of various views of the model and the background, along with the shallow space, hark back to Cubism. The

character of the image, however — the multiple distortions and prominent sexual references — is closely allied with Surrealist concerns.

Picasso executed another painting in 1927 of one of his favorite subjects, *Harlequin* [66]. The sad, lyrical harlequins of his rose period and the formal

**66** Pablo Picasso, *Harlequin,* 1927

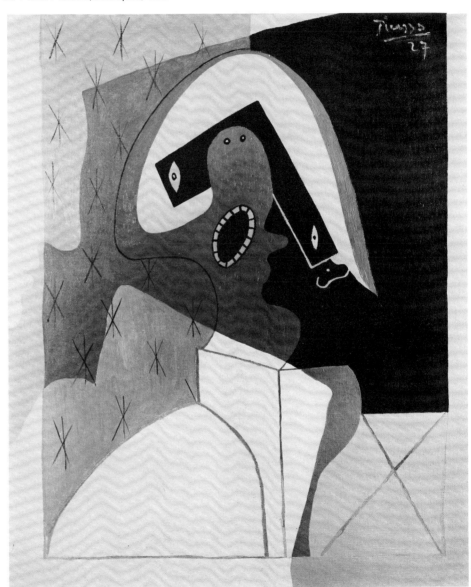

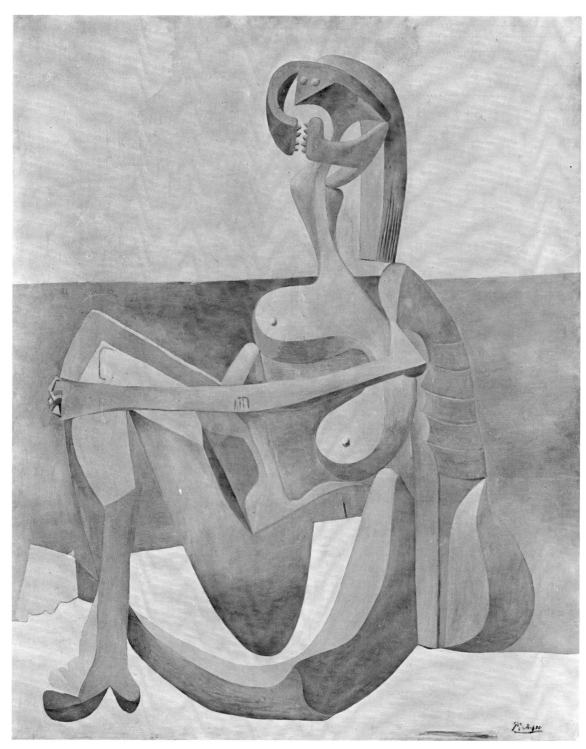

**67** Pablo Picasso, *Seated Bather*, 1930

ones of Synthetic Cubism have here metamorphosed into a monster, forming a multiple representation of Picasso's familiar alter ego. Seen head-on, the nose twists upward like a great snout, revealing two round nostrils. An oval orifice is stretched in a scream, revealing cruel, threatening teeth. The vertical, lozenge-shaped eyes express anguish. On our right, a dark profile bisects the face. The black, geometrical, right-angled shape partly hidden by the nose is Harlequin's mask. At the left edge of the canvas a light profile of the artist does double duty as a flat, decorative shape in the composition. The colorful, diamond-patterned costume of Harlequin has been replaced by clear blacks, whites, and grays. Traditionally a witty prankster — a figure with which Picasso usually identified — Harlequin has become horrible, threatening, and pitiful all at the same time.

In earlier years Picasso had often painted himself in his pictures as Harlequin; now his profile calmly observes the distorted image of a figure with which he had previously identified. Since his works are more autobiographical than those of most other artists, one can reasonably infer that Picasso was going through a critical period in his life; the torment that he experienced at this time was largely due to the failure of his marriage and is suggested in the sexually threatening — and apparently threatened — double image of Harlequin.

In 1930 Picasso painted one of his most potent images of woman as a monster. Seated Bather [67] presents a rock-like creature with blank, expressionless eyes, great chiseled breasts, and deadly pincer-like jaws, sitting complacently on the beach of a calm sea beneath a clear blue sky. The center of her sculptured torso is open in the center, revealing the sea behind her.

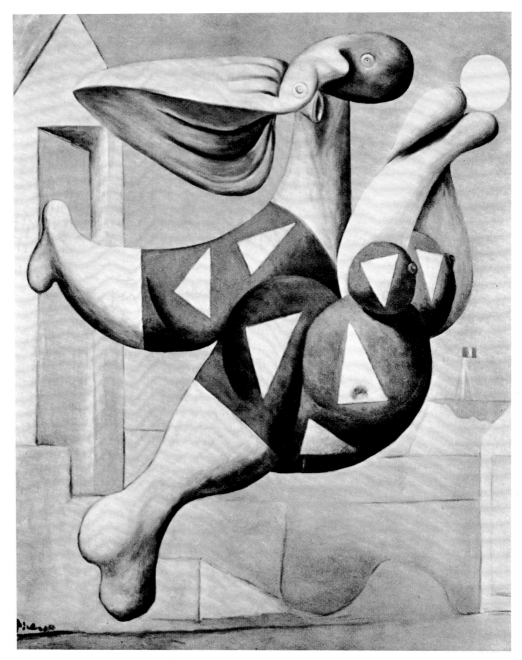

**67A** Pablo Picasso, *Bather with a Ball,* 1932

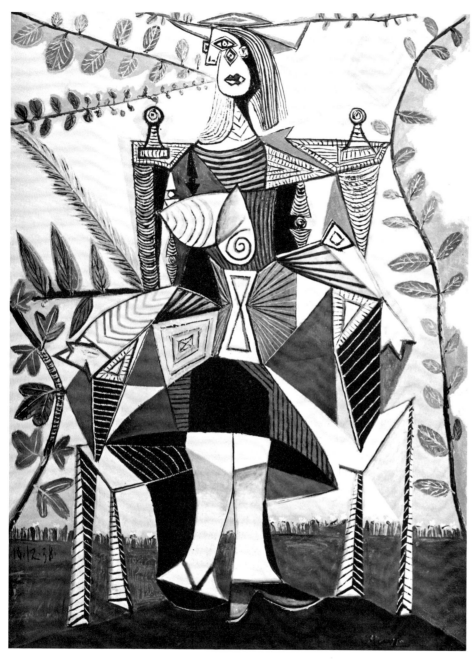

**68** Pablo Picasso, *Woman in a Garden,* 1938

Her heavy spinal column supports her limbs, breasts, pelvis, and head in a complex feat of engineering. She is made up largely of a menacing head, limbs, and sexual parts.

Golding points out that this figure suggests an enormous praying mantis — an insect that fascinated the Surrealists, since the female devours the male after mating. For Picasso, at this unhappy point in his life, the symbol seems apt: the female sits in silence, placid and unconcerned, enticing and threatening, as eternal as the sea behind her or the rock from which she is formed.

*Bather with a Ball* [67A] was painted in 1932, the year that Picasso met the placid and erotic Marie-Thérèse Walter. The predatory monster in *Seated Bather* gave way to languid images of his new love and to playful figures like the *Bather with a Ball.* Distinctly three-dimensional in appearance, her balloon-like form floats along the beach, in contrast to the immovable *Seated Bather.*

Eight years later Picasso's marital problems had been settled, but a liaison with the somewhat unstable Surrealist photographer Dora Maar was beginning to cause problems. The Spanish Civil War was drawing to an unhappy conclusion, and the rise of fascism in Germany and Italy all but assured that another great European conflict would occur. Picasso spent the summer of 1938 at Mougins, where he painted Nusch Eluard and the three daughters of his housekeeper. He also continued painting Dora Maar, whose image he invariably distorted. *Woman in a Garden* [68] is one of his portraits of Dora: the familiar snout on one side of the head and the rather full cheeks are features which usually identify her, and the large, conical breasts assure us that it is not the sylph-like Nusch.

During 1938 Picasso began to use parallel lines repeated all over a form, suggesting basketwork or the obsessive repetition of lines often appearing in the art of the insane. Picasso was eminently stable mentally, but life with Dora Maar and her rapidly changing moods — along with his liaisons with Marie-Therese Walter and Nusch Eluard — must have been somewhat unsettling. In this solidly painted, colorful work the repeated linear patterns appear in the chair, the model's breasts, and in other parts of the composition. The emphasis on line is continued in the various vines, zigzagging up the left side of the canvas and gracefully curving up the right side. The insistent angular shapes (even the sun is diamond-shaped) and many sharply pointed form suggest a testy — if not downright unpleasant — relationship with the model. This would accord with the deterioration of Picasso's long affair with Dora. However, the vicious, pointed, and angular shapes seen here appear in a number of other paintings done in 1938. In fact, the distortions of Dora's features and figure are not as extreme in this composition as in others, and the garden setting is unusually pleasant for works of this period.

Picasso also made sculptures throughout his long career. Indeed, if he were not so well recognized as the major painter of the twentieth century, he would probably be known as one of its most important sculptors. His work in this medium varied in style and technique as much as his paintings. Some of the assemblages that he did during the Cubist period are Surrealist in spirit — because of the way he joined disparate objects and images in illogical combinations. His most Surrealistic sculptures were done during the 1930s, however, when he was, in fact, close to the Surrealists.

In the late 1920s Picasso worked on sculpture with his friend Julio Gonzalez. Gonzalez, who had learned to weld metal in a factory, taught the technique to Picasso, who in return inspired the production of a major body of welded iron sculpture by Gonzalez.

Even earlier, however, Jacques Lipchitz (1891-1973) had done open metal sculptures very close in spirit to Surrealism. He understood — as did Picasso — the significance of visual metaphors. Picasso's well-known *Bull's Head* (Figure 14) of 1943, for example, was made of a discarded bicycle saddle and handlebars. In 1951, despite the

Figure 14. Pablo Picasso. *Bull's Head,* 1943.

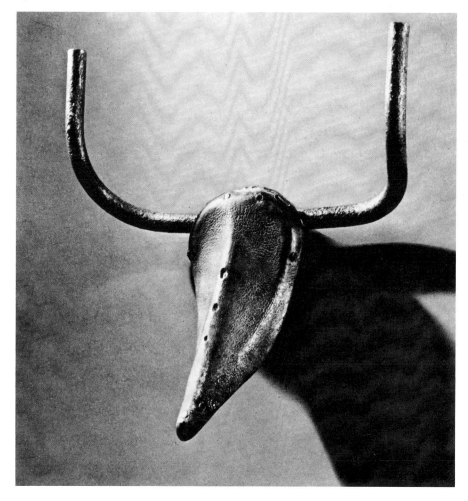

fact that he was no longer close to the Surrealists, Picasso created one of his strongest Surrealist sculptures in the famous *Monkey and Her Baby* [69]. Assembled of a ball (the monkey's torso), two toy automobiles (her head), and an old spring (her tail); held together by clay; and cast in bronze; it is an absolutely convincing and witty image. The act of discovering subjects and content in random materials is a typical Surrealist technique. However, Picasso was making such metamorphic assemblages long before his association with Surrealism.

**69** Pablo Picasso, *Monkey and Her Baby,* 1951

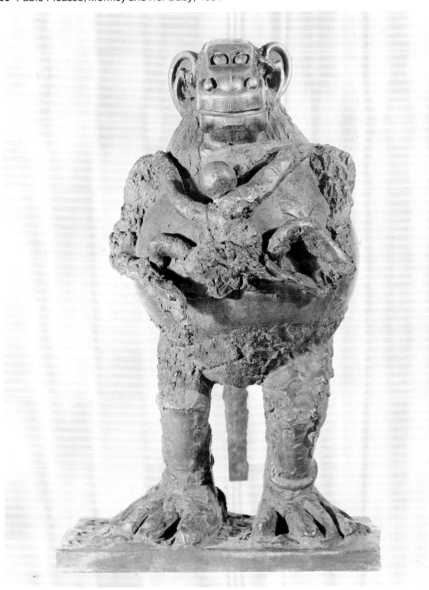

The following year, in 1952, Picasso completed another sculpture with strong Surrealist overtones — a still life called *Goat Skull and Bottle* [70]. Again, it is made up of various, discrete elements selected at random by the artist, assembled, cast in bronze, and painted. Like Ernst's collages, the illogical assemblage is a startling and puissant image that provides insight into the artist's interior experiences and concerns.

Picasso, incredibly gifted in so many ways, was politically naive, however. He chose to associate with the Existentialists during and after World War II and to become a nominal member of the Communist Party because he was impressed by the leading roles played by these two groups in the underground resistance against the Nazis during the occupation, when the Surrealists had fled.

He remained aloof from Surrealist dogma and steadfastly refused to become involved in the endless disputes among the members of the movement; at the same time, however, they provided the kind of exuberant intellectual climate that he enjoyed. Despite his aloofness, he held a privileged position in the Surrealist hierarchy for twenty years. In the fourth issue of *Revolution Surréaliste* Breton had gone so far as to declare that if Picasso's courage had failed during his Cubist years, the development of Surrealism would have taken much longer or even might never have occurred.

Picasso's work avoided the enigmatic and ambiguous character of much Surrealist art — even at his most Surrealistic, the content of his work is relatively clear: the images refer to the vicious and monstrous parts of human nature and to sexuality. Although he contributed heavily to the Surrealist spirit in art, Picasso never surrendered control over his actions to any force but his own powerful imagination and will.

1. André Breton, *Manifestoes of Surrealism,* trans. Richard Seaver and Helen R. Lane (Ann Arbor: University of Michigan Press, 1974), p. 17.

2. Picasso, quoted by Brassai, *Picasso and Co.* (London: Thames & Hudson, 1967), p. 28; repeated in John Golding, "Picasso and Surrealism," *Picasso in Retrospect* (New York and Washington: Praeger, 1973), p. 77.

3. Roland Penrose, *Picasso: His Life and Work.* (New York, Evanston, San Francisco, London: Harper and Row, 1973), pp. 32-33.

4. Ibid., pp. 258-59.

5. Robert Rosenblum, "Picasso as Surrealist," *Artforum* (Special issue on Surrealism, September 1966), p. 23.

6. Golding, pp. 92-93.

**70** Pablo Picasso, *Goat Skull and Bottle,* 1951-52

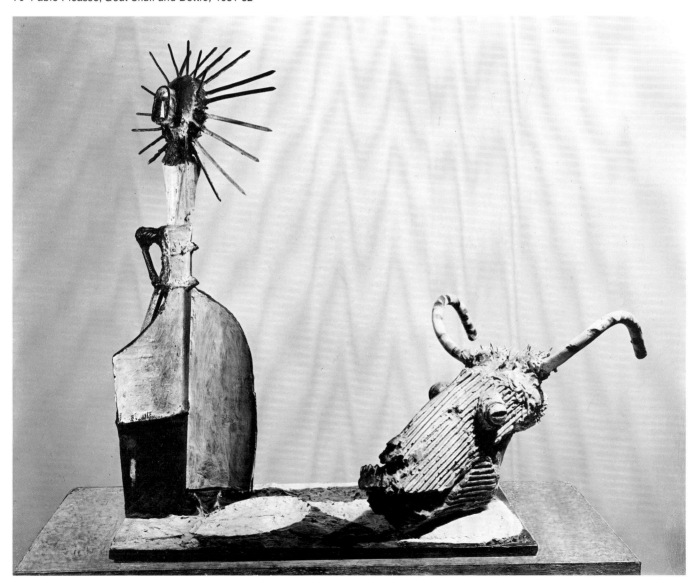

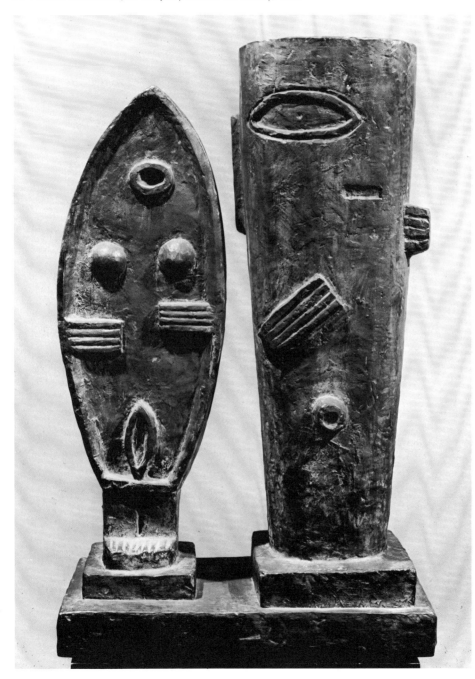

71 Alberto Giacometti, *Le Couple (Homme et Femme),* 1926

## ALBERTO GIACOMETTI 1901-1966

Alberto Giacometti joined the Surrealist group in 1929 when he was twenty-eight years old. Born in Stampa, in the Italian section of Switzerland, he came from a family of artists (his father, Giovanni, was a painter, as was his uncle, Augusto, who associated with the Dadaists in Zurich). He studied painting and drawing at the Academy in Geneva for about six months and took private lessons in sculpture with Maurice Sarkissoff. He then went to Paris in 1922 and studied for three years with Antoine Bourdelle at the Académie de la Grande-Chaumière.

Earlier, Giacometti had been much taken with Tintoretto's paintings on a visit to Venice before going on to Padua, where Giotto's frescoes struck him even more forcefully. After that, the ancient Christian mosaics, as well as the African, Cycladic, Oceanic, and Sumerian sculpture that he saw in Paris, and an Egyptian bust in Florence, all had a determining influence on his art.

Like many other Surrealists, Giacometti worked in various arts. He painted; made sculpture, drawings, and prints; and wrote. During his Surrealist years, from 1929 to 1935, however, he devoted himself almost entirely to sculpture. While Picasso and Ernst had done earlier sculptures that are Surrealist in spirit, and Arp's Surrealist biomorphic images evolved from his Dadaist work, Giacometti was in some ways the first to solve the problem of translating the Surrealists' preoccupations with dreams and irrational images into free-standing sculpture. The medium itself ruled out the method of automatism and the definition of irrational perspectives in the style of Chirico. The very solidity of the materials, its undeniable presence, seemed to contradict the Surrealist's concern with inner experience.

Giacometti arrived at a solution to this problem in a series of steps beginning with the work he did from the model under Bourdelle's tutelage. Then in 1925 when he took his first studio — and permanent residence — in Paris, he began a concentrated effort to work from memory rather than from nature. From there he made a gradual transition to working from imagination.

From 1925 to 1929 Giacometti came under the ubiquitous influence of Cubism, particularly that of Laurens and Lipchitz, although Brancusi's sculpture probably affected him more than any other. *Le Couple* [71], done in 1926, is clearly related to Brancusi's work. From 1927 to 1929 he did a number of works, such as *Reclining Woman Who Dreams* [72], that are more closely related to the series of sculptures called "Transparencies" begun by Lipchitz in 1926. These sculptures by Giacometti are the first explicit references to his enduring concern with space as the central sculptural element. In *The Couple* this concern was evident but not so obvious. The two vertical forms proclaim their sexuality and their formal, as well as psychological, relationships to one another. The schematic shapes of the eye, hands, breasts, and vulva of the female, and the eye, hands, and phallus of the male, are rimmed within the over-all abstract forms. The curved sides of the female join her vertical legs, contrasting with the straight and angled contour of the male beside her, creating an incisive space between the two which also functions as an element within the sculpture.

The lozenge shape of the female's vulva repeats that of the male's eye, while her circular eye echoes that of his phallus. Thus, the Surralist tendency to relate facial and sexual elements and to blur the distinction between the sexes is evident. The monumental character of

**72** Alberto Giacometti, *Reclining Woman Who Dreams,* 1929

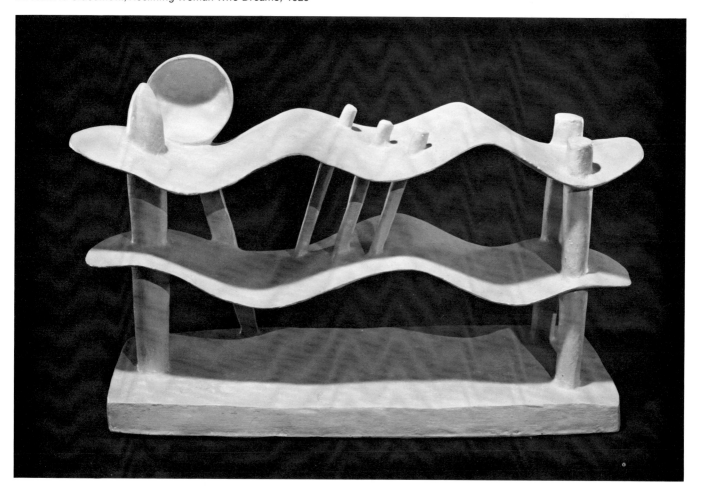

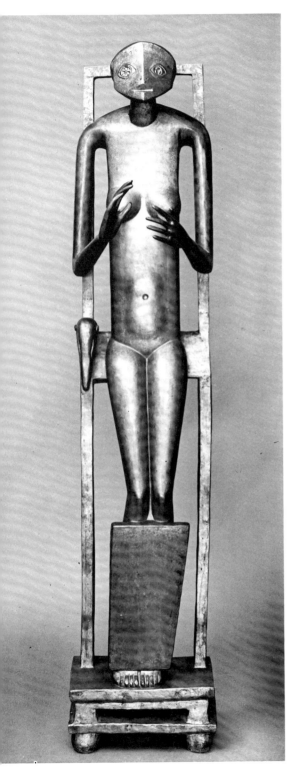

this modest-sized work harks back to that of Cycladic art, affirming Giacometti's constant concern with man's primitive origins.

When he broke with Surrealism in the mid-thirties, Giacometti remarked that "in every work of art the subject matter is of primordial importance and its origin is not necessarily Freudian."[1] If not Freudian, however, Giacometti's primitive images suggest a Jungian concern for archetypal forms.

One of the most important sculptures of Giacometti's Surrealist period is the last one, *Hands Holding the Void* [73], done in 1934 and 1935. In the original French, the title creates a pun which can be read as either *Mains tenant le vide* ("Hands holding the void") or *Maintenant le vide* ("And now the void"). Giacometti always insisted that "Sculpture rests on void," and "Space is hollowed to build up an object and, in its turn, the object creates space."

Reinhold Hohl suggests that this sculpture and its title are "a rebuke to the Surrealist cult of the object."[2] Hohl also maintains that Breton was mistaken in his story that a mysterious object (an iron protection mask designed by the French Medical Corps in the First World War) had inspired Giacometti to "find his forms." Hohl goes on to say that the artist actually borrowed his forms "from a Solomon Island *Seated Statue of a Deceased Woman,* which he had seen in the Ethnological Museum in Basel, and had combined them with other elements of Oceanic art, such as the bird-demon of death."[3] Yet, having served in the Medical Corps himself during the First World War, Breton would surely have recognized a medical protection mask. Are not both sources possible? Furthermore, the mythical content of objects Giacometti might have seen in the Ethnological Museum

**73** Alberto Giacometti,
*Hands Holding the Void,* 1934-35

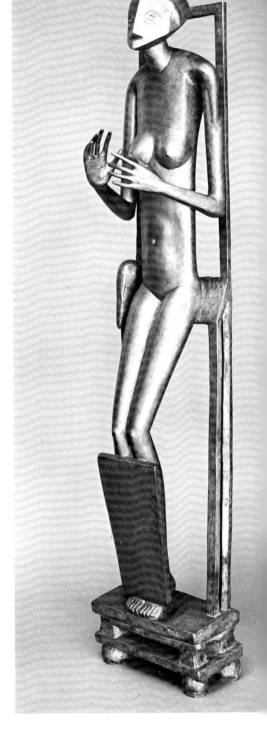

is something that would have concerned him very much — myth being considered by the Surrealists as dreams of the race.

*Hands Holding the Void* in and of itself, however, evokes a mysteriously moving response. The elongated, stylized female form stands, knees bent, contained within an angular framework, with her hands describing a spherical volume of space. It is a dramatic demonstration of how space is manipulated by the artist to become a nearly palpable part of the form of the sculpture. Space and material interact to create the whole; a void is described by the hands of a figure that is itself contained within a volume of space defined by a geometrical structure. Rubin suggests that this structure "might have constituted a high-back chair in the *Palace* [at 4 A.M.]."

The metal plate in front of the lower legs of the figure is not so easily explained. Like the mask which serves as a face disguising the human character, this plate seems to suggest armor, while the bird attached to the outer structure probably refers to death. Thus, reaching out for a formal, enclosing structure and protective armor — constructions of reason — are the hands, in many ways the most expressive part of the human anatomy.

Roberto Matta acquired the original plaster of this figure, and echoes of it appear in his paintings of the mid-forties, such as *To Escape the Absolute,* done in 1944. Giacometti's sculpture may well be intended — as are Matta's paintings — to refer to the inner reaches of the mind and at the same time to the cosmos.

1. Quoted in *Giacometti,* exh. cat. (New York: Solomon R. Guggenheim Museum, 1974), p. 13.

2. Ibid., p. 20.

3. Ibid.

4. William S. Rubin, *Dada and Surrealist Art,* exh. cat. (New York: Museum of Modern Art, 1968), p. 117.

# Reinforcements in the 1930s

The political conflicts involving the Surrealists during the 1930s were complicated by defections from the group, excommunications by André Breton, the addition of new members and associates, and the return of a few artists and poets who were earlier disaffected. Giacometti, Aragon, Eluard, and Ernst were among those who left Surrealism. René Crevel committed suicide, and Dali ceased to be an effective member after settling near Hollywood in 1939. At the same time, however, artists and poets such as Hans Bellmer, Meret Oppenheim, Wolfgang Paalen, Marcel Jean, Victor Brauner, Leonora Carrington, Kurt Seligmann, Oscar Dominguez, Wilfredo Lam, and Roberto Matta joined the group. The Belgian painter Paul Delvaux never officially joined the Surrealist movement, but, inspired by Magritte and Chirico, he associated with the Belgian group around Magritte and E. L. T. Mesens; he worked in a manner that was both romantic and surrealistic. Masson, who had left the movement in the late twenties, was reconciled with it in 1937. Alexander Calder associated with the Surrealists but never joined the movement. Needless to say, Picasso remained independent, although many of his paintings from the thirties are in the spirit of Surrealism. Breton said of him: "Picasso of his own accord turned towards Surrealism, and, as far as he was able, came to meet it."[1]

Among the many converts to Surrealism in the 1930s, however, two stand out as continuing the traditions of imagist Surrealism and biomorphic abstract Surrealism: Paul Delvaux and Roberto Sebastian Matta Echaurren.

# PAUL DELVAUX
## 1897-

Paul Delvaux was thirty-nine years old before he came upon paintings by Chirico in an exhibition at the Palais des Beaux-Arts in Brussels in 1936. Until that time he had worked in a realist style somewhat influenced by Fauve and Expressionist painters such as Maurice de Vlaminck, James Ensor, Constant Permeke, and Gustave de Smet. Although he was deeply impressed by the work of his countryman, Magritte, it was the paintings by Chirico that had the greatest influence on him.

From that point on he applied his tight technique and realist style to paintings in the tradition of illusionist Surrealism. He visited Italy, where his study of Quattrocento painters confirmed his proclivity toward a classical style and scenes defining great spatial depth. Space is defined — as in Chirico's paintings — by long vistas such as in *Procession* [76], or eerie cityscapes with elaborate architecture or architectural ruins. Among the inhabitants of these strangely silent towns and landscapes are, almost invariably, voluptuous, nude or semi-nude women. Joining

them are men, usually fully clothed and often in bowler hats, reminiscent of similar figures by Magritte. Savants, sculptures, trains, and skeletons appear in later paintings. Architecture is usually classical in style.

Freudian symbolism is evident in these dream-like paintings. In addition to the undisguised eroticism of the large-breasted women there are sexual symbols such as railway trains, terminals, stairways, arcades, doorways, and mountains — all of which have become Freudian clichés. In a number of his compositions, such as *Femme au Miroir* (Woman at the Mirror) [75], *Procession*

**74** Paul Delvaux, *Femme dans une Grotte (Femme au Miroir),* 1936

126

[76], and *Les Mains* (The Hands) [77], a portrait appears of the painter himself, taking a role in his own "dreams."

In *Femme dans une Grotte* (Woman in a Grotto) [74], from 1936, the "great motionless woman" (to borrow Eluard's phrase) stands inside a cave, gravely contemplating her reflection in a mirror. Caves, in Freud's symbolic vocabulary, refer to female genitals. Mirrors have multiple symbolic references; the artist's use of it here links it to the myth of Narcissus. Furthermore, a length of elegant lace is draped around the mirror which reflects the female's image, thus introducing the theme of reality versus art. The cave's opening reveals a barren landscape with distant breast-shaped mountains. Autoeroticism seems to be the subject of this painting.

In *Femme au Miroir,* or *Propositions Diurnes* (Daily Propositions) [75], the same woman stands in the foreground, again gazing into a mirror, while a nude man (probably the artist) stands to one side gesturing futilely. In the distance a female figure is fleeing through a patch of lush vegetation. Jewelled necklaces lay discarded on the weed-filled road leading back into the ruined architecture. Again, narcissism is implied and probably autoeroticism as well. The untended gardens suggest that the woman's beauty is wasted; she is uncared for as she should be (a prevalent male attitude at the time this picture was painted). The countless weeds and

**75** Paul Delvaux, *Propositions Diurnes (Femme au Miroir),* 1937

ruins reinforce this suggestion of the rejection of a "gardener." The second title (which Delvaux invariably employed) — *Daily Propositions* — is almost too obvious in reinforcing the theme implied by the images.

*Procession* [76], or *Le Chemin de la Ville* (The Road of the City), done in 1939, has a more complex iconography. The same beautiful, half-nude woman is in the immediate foreground on a winding road along which many figures promenade. The women are mostly nude, although some are partially clothed. The men are all suited; some wear overcoats and bowler hats. In only one instance are the figures in any kind of contact with one another — two nude women embrace before a bush. Many of the women carry kerosene lamps or candles; the men are unencumbered except for an occasional cane. Directly behind the inscrutable female in the foreground a male figure (again, probably the artist) appears, a flower in one hand (recalling Jan van Eyck's *Man with a Pink*) and gesturing in supplication with the other.

The formally dressed men, except for the artist, seem oblivious to the erotic women. The landscape on either side of the road consists of untended lush vegetation (a female symbol); a few trees; a small lake; and a low, rocky mountain (a male symbol) jutting up from the flat, fecund field.

**76** Paul Delvaux, *Le Chemin de la Ville (Procession),* 1939

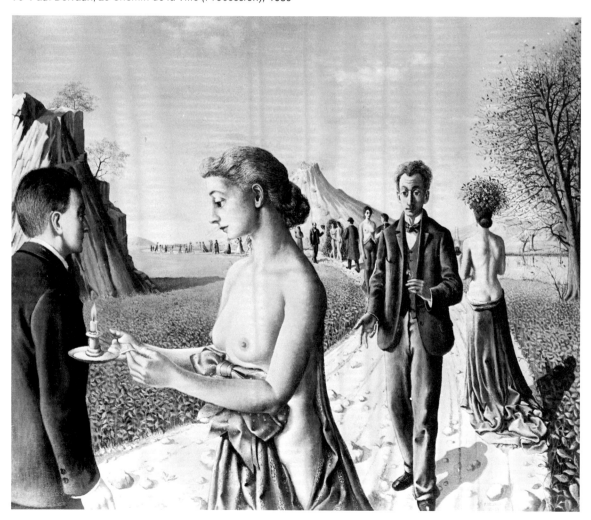

This human parade contains many images that can be interpreted in Freudian terms. However, the major concern — as in the previous two pictures — appears to be the artist's unrequited love for the same voluptuous female whose back is turned toward him. His flower is an offer of spring (the mating season of nature) and, at the same time, a reminder of the transitory quality of life. The woman carries a burning candle even in the daylight (an image with many symbolic meanings), as do most of the other women. The road is filled with a variety of figures coming and going (the two halves of existence); the women seem alluring and searching, the men impassive; only the artist openly yearns and is rejected.

*Les Mains* [77], done in 1941, shows us the same blond woman standing next to a brunette; both are nude and are gesturing expressively with their hands. Again the artist is present (identifiable by the brush in his hand) and intently watches the woman. Two couples are also present; in both cases the women are nude to the waist and the men are fully clothed and hatted. One couple faces away from the viewer, looking onto a landscape where a third couple is engaged in making love.

The other couple stands at the left-hand corner of the architectural opening, the man gesturing as though to invite his companion to pass through it.

**77** Paul Delvaux, *Les Mains (The Hands),* 1941

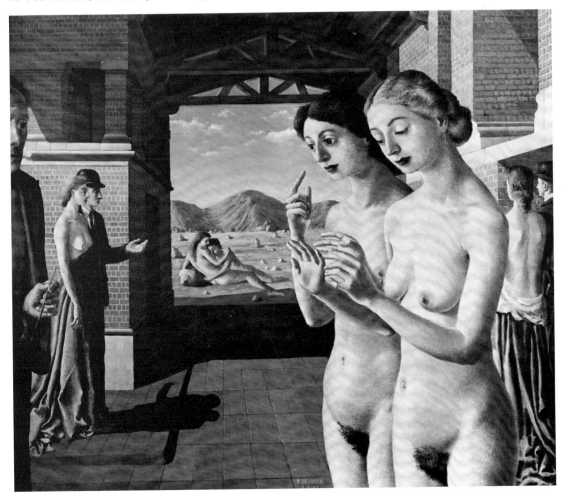

The faces of all participants are impassive. Furthermore, both of the women in the side groups resemble the blond woman of the central pair; the men look like the artist. The large image of the blond woman looks down at her own hands which seem to frame a sphere. The female beside her gestures with an extended forefinger toward herself and raises her other hand, palm outward, as if to stop the figure of the artist. The invisible sphere described by the beloved's hands is a self-enclosed form — a corporeal manifestation of her inner state of being — while the gesture of her companion seems to indicate that it is she herself, not the artist, who is preferred.

In the two small groups to either side, the man appears to be urging that they pass through the opening in the wall and into the unkempt, primitive landscape beyond.

Delvaux never participated in the Surrealist movement, yet Breton remarked that "the great artery of the dream sent the Surrealist sap through his canvases." Unquestionably, Chirico and Magritte were decisive influences on his work. He does not manipulate perspective as Chirico does, nor does he combine incongruous elements as Magritte does. Delvaux's images are symbolic, yet in an elementary way. He is obsessed with the image of the voluptuous woman. But his erotic images are isolated, physically and psychologically, and there is a constant concern with voyeurism (often the artist is the voyeur) and detail. Like the illusionist Surrealists, Delvaux concentrates on images rather than on elegant surfaces or distinguished colors.

# MATTA (ROBERTO SEBASTIAN ANTONIO ECHAURREN) 1912-

Born in 1912 in Chile of Spanish and French parents, Matta went to Paris in 1933 to study architecture with Le Corbusier. In Europe he traveled in Germany, Austria, and Spain; in 1935 he met the Spanish poet and friend of Dali and Buñuel, Garcia Lorca. Lorca introduced him into Surrealist circles, where he quickly took an active part. In 1937 he officially joined the Surrealist movement; in 1939 he was among the first of the group to leave Europe for the United States. While in this country during World War II, he played a major role in the contacts established between the European Surrealists and the young American artists who were soon to create the movement later called Abstract Expressionism.

Matta was one of the few emigrés who spoke English well (Duchamp and Ernst being others), and was also about the same age as many of the Americans. Furthermore, his origins on the American continent seemed to ease his contacts with the New York artists. He soon became friendly with Robert Motherwell, Arshile Gorky, and Isamu Noguchi, among others. A charismatic figure with strong personal ambitions within the Surrealist movement, he fired the imaginations and aspirations of the Americans. For a short period, he was especially friendly with Motherwell, who was searching for an original creative principle and found Matta's singular exposition of the Surrealist method of psychic automatism appropriate for his own purpose.

Matta started painting in 1937; in 1938 and 1939 his work took on a distinctive character somewhat related to Tanguy's abstract illusionist Surrealism. His paintings of this period have a soft, amorphous character, resulting in part from his technique of beginning by spilling thin washes of paint on surfaces, wiping with a rag, and then using a brush to define certain suggested details. This version of automatism resulted in paintings suggesting deep, luminous space, with a horizon and biomorphic shapes.

These early paintings are often called "inscapes" or "psychological morphologies" — indicating that Matta was attempting to discover or invent a formal vocabulary for subjective experience. The works of this period are among his most ingratiating (although some of his finest works are colored pencil drawings which he did in 1937, and are close in character to certain paintings by Miró and Dali).

In 1941 Matta and Motherwell traveled to Mexico to visit Wolfgang Paalen. While there, Matta remarked that the trouble with Mexican artists such as Diego Rivera, David Seiqueros, and Jose Clemente Orozco was that they painted Indians instead of painting *like* Indians. He was impressed by the austere and brilliant landscape of Mexico, and his own work took on the vivid colors of that region — especially oranges, yellows, and greens.

During 1941 and 1943 Matta continued to explore the problems of creating visual metaphors for the macrocosm from his inner visions. Aside from his charismatic personality and spellbinding ability as a proselytizer, Matta's greatest influence on the American painters was his modification of Surrealist aims and methods. Although the Americans experimented with the doctrinaire versions of Surrealist automatism and with collage (the illusionist Surrealism of Magritte and Dali had little or no effect on them), they

were entranced with Matta's ambition to invent a formal language to refer to inner experience.

Matta tried out various pictorial devices, although his own style remained constant. The biomorphic and metamorphic shapes, aerial perspective, and landscape character of his works continued until 1944. *Morphologie Psychologique* [78] (which was in Max Ernst's collection) is typical of the seething activity of molten shapes and brilliant hues of these inner landscapes. Mountains thrust up into swirling skies; brilliant streams of molten lava pour unchecked over mysterious shapes; and the sky is filled with biomorphic, rock-like images.

**78**  Matta (Roberto Sebastian Antonio Echaurren), *Morphologie Psychologique,* ca. 1939

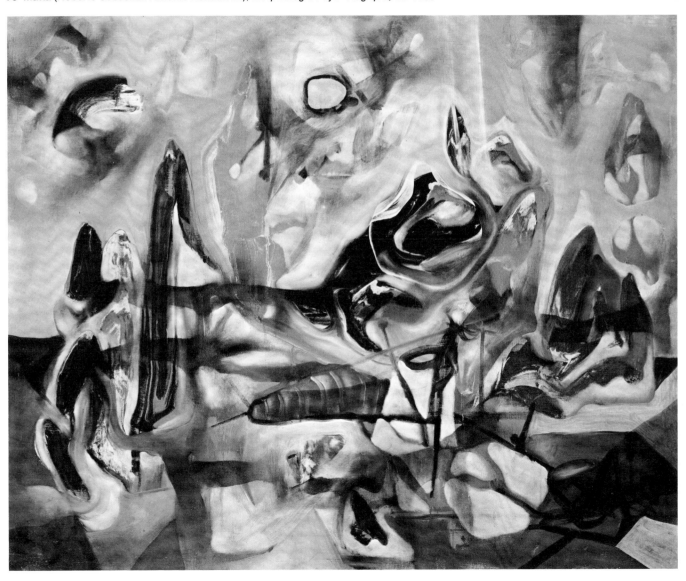

131

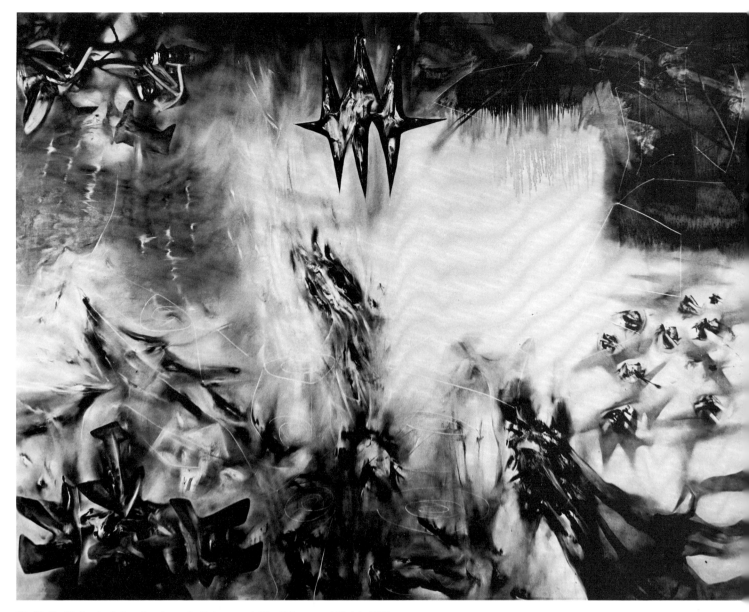

**79** Matta (Roberto Sebastian Antonio Echaurren), *The Prisoner of Light,* 1943

The year 1942 saw a significant change in Matta's painting. His horizon — and consequently the separation of earth and sky (the mundane and the divine) and all references to a landscape — gave way to an open, consistent, and over-all space: by analogy, transcending levels of being and of behavior. By 1943 paintings such as *The Prisoner of Light* [79] seem to refer to outer space in which shapes streak, flare, and hover. Brilliant light fades off into dim regions of space (defined by overlapping shapes and soft, translucent washes of color). The unexplored reaches of the psyche, like the macrocosm, are not limited by horizons.

An unusual work of the same year, *Prince of the Blood* [80] is a triptych of three apparently unrelated panels. The central image retains the more or less amorphous character of earlier paintings which are reminiscent of interstellar space; the side panels, however, introduce irregular, sharp-edged, geometric shapes which intrude into the loosely defined areas of space, flattening out and defining the sections in which they appear. Swirling linear patterns move around and over these rational images, relating them to the amorphous space around them as well as to the central image. Near the center of the panel on the viewer's left a small, anthropomorphic figure appears (perhaps signalling the birth of reason); it is curiously reminiscent of certain images of Max Ernst. This painting is a precursor of the flat planes, linear webs,

**80** Matta (Roberto Sebastian Antonio Echaurren), *Prince of the Blood,* 1943

and anatomical references in paintings done in 1944 such as *The Onyx of Electra and To Escape the Absolute* (Figure 15).

By 1945 Matta had become interested in the mechanical elements, planes, and their suggested action in some of Duchamp's works. *Splitting of the Ergo* [81] reflects this new influence as the amorphous space of earlier works gives way to a complex organization of geometrical planes which slide, swirl, and are shuffled. Space is broken into compartments, unlike the unified space of Renaissance paintings. As in Chirico's canvases, a number of inconsistent spaces are created by manipulating linear perspective at will. The title — *Splitting of the Ergo* (Splitting of the Therefore) — appears to refer to a sundering of the mathematical equation which is the archetypical logical proposition. Thus, the organization of irrational space by logical means is consistent with the paradoxical title.

Throughout the evolution of Matta's painting, a concern with vigorous movement is evident. This characteristic of his art has been compared to the Italian Futurists' interest in finding visual metaphors for the dynamic character of an industrial world. In Matta's case, however, it is the dynamics of the psyche and the universe — conceived as aspects of a single, unified reality — that are suggested.

Figure 15.  Matta. *To Escape the Absolute,* 1944.

**81** Matta (Roberto Sebastian Antonio Echaurren), *Splitting of the Ergo*, 1945-46

Many other artists, often more purely Surrealist than the pioneer figures, joined the movement during the 1930s. However, the foundations had been laid by the figures already considered. Later artists such as Brauner, Bellmer, and Paalen often represented Surrealist doctrines more consistently than Ernst, Miró, or Picasso, for example, but they had no important effect on the course of Surrealism beyond that exerted by the earlier figures. Delvaux seems to have carried the illusionist Surrealist tradition as far as it could go. Although it has been argued that some Pop Artists resurrected it in a new guise, these artists seem closer to the cynical anarchy of Dada than to Surrealism. Matta, more than any other Surrealist — even Miró and Masson — led directly into American Abstract Expressionism, especially through his direct contacts with Gorky and Motherwell. Masson's vigorous automatism was carried further by Pollock, and Miró's biomorphic Surrealism had a decisive influence on Baziotes.

During the early 1940s these and other American artists were strongly influenced by Surrealism. In the late forties, however, the Americans reacted against the rigid doctrines of Surrealism and went their own way, reintroducing elements from Cubism into their art. Among the many important American artists of this group, Gorky, Motherwell, Pollock, and Baziotes will be discussed in the next section because their mature and independent styles developed sooner than those of other major artists such as Mark Rothko, Adolph Gottlieb, Franz Kline, David Smith, or David Hare. They — along with Joseph Cornell — are representative of a group of artists who, in the 1950s, formed the most important and influential movement in the world.

1. Sarane Alexandrian, *Surrealist Art* (New York and Washington: Praeger, 1970), p. 241.

*Opposite*
The New York School of Artists. First row (left to right): Theodorus Stamos, Jimmy Ernst, Barnett Newman, James Brooks, Mark Rothko. Middle row (left to right): Richard Pousette-Dart, William Baziotes, Jackson Pollock, Clyfford Still, Robert Motherwell, Bradley Walker Tomlin. Back row (standing, left to right): Willem de Kooning, Adolph Gottlieb, Ad Reinhardt, Hedda Sterne. Photograph from William Rubin, *Dada and Surrealist Art* (New York: Harry N. Abrams, 1968).

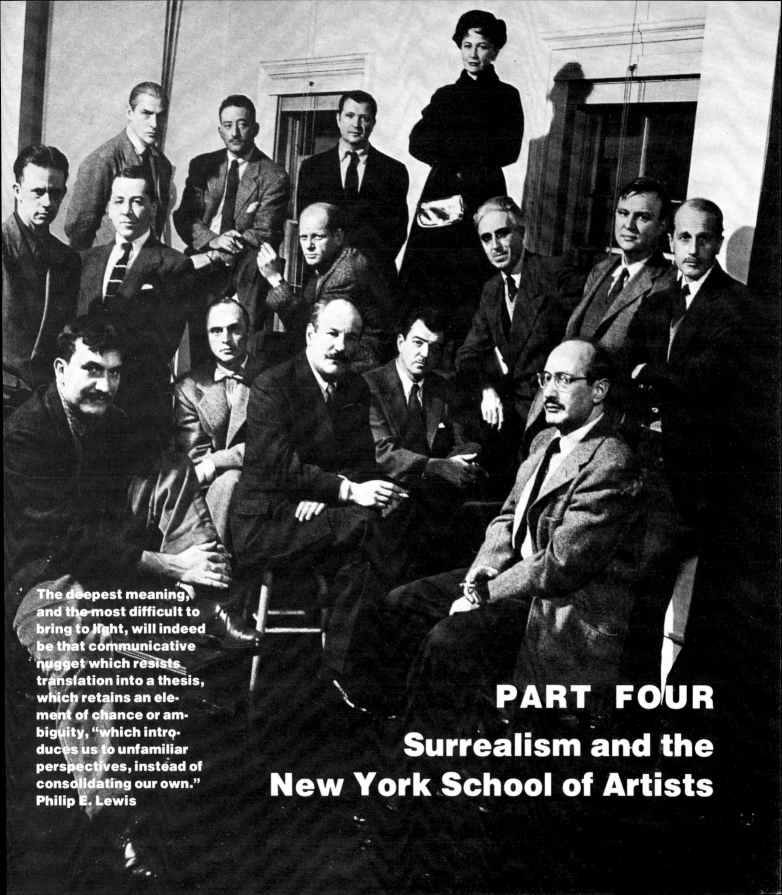

The deepest meaning, and the most difficult to bring to light, will indeed be that communicative nugget which resists translation into a thesis, which retains an element of chance or ambiguity, "which introduces us to unfamiliar perspectives, instead of consolidating our own."
Philip E. Lewis

# PART FOUR
# Surrealism and the New York School of Artists

By 1940 Man Ray, Tanguy, Matta, and Dali were in the United States. While decorating two windows for Bonwit Teller, Dali (and a bathtub) had fallen through a window in a fit of anger over a change made in his installation. His exhibition at the 1939 World's Fair in New York had made a strong impression, and his works such as the Fur-Lined Bathtub and a re-creation of the *Rainy Taxi* from the 1938 Paris exhibition became firmly implanted in the mind of the public as typical of Surrealist art. Indeed, Dali, with his outrageous costumes and behavior, embodied the archetypal Surrealist for many people who had no knowledge of Surrealism's psychoanalytical basis and revolutionary goals. In fact, many considered the movement to be nothing more than a Daliesque joke. The Surrealists themselves considered Dali their Judas, and Breton created a scornful anagram of his name: "Avida Dollars" (Avid for Dollars).

In the spring of 1940 the Julien Levy Gallery held Matta's first exhibition in New York with a catalog containing an article by Nicolas Calas; a story about Levy, Calas, Parker Tyler, and Matta; and some quotations from Breton. In December of 1939 the same gallery had exhibited *Objects by Joseph Cornell.*

In 1941 Ernst arrived in New York from Lisbon after being freed from an internment camp in France, thanks to the efforts of Paul Eluard and Peggy Guggenheim (Ernst and Miss Guggenheim were married the same year). The Museum of Modern Art, led by Alfred Barr and James Thrall Soby, had always been concerned with Surrealism; now it mounted exhibitions of works by Dali and Miró. Breton reached New York via Martinique, along with Masson and the anthropologist Claude Levi-Strauss. Tanguy and his wife, Kay Sage, a talented American painter, were living in her home in Connecticut.

In 1942 the Pierre Matisse Gallery held an exhibition of fourteen *Artists in Exile.* Of the group, six were Surrealists: Ernst, Tanguy, Breton, Masson, Matta, and Kurt Seligmann; three others (Chagall, Tchelitchew, and Eugene Berman) were associated in the public mind with Surrealism. In the same year the first issue of the publication *VVV* appeared. Founded and edited by David Hare, and with Breton and Ernst as editorial advisors, it had a definite Surrealist orientation. Thus, Surrealist writers as well as painters were beginning to find exposure in the United States, especially in New York. The architect and sculptor Frederick Kiesler designed Peggy Guggenheim's gallery, Art of This Century.

A major exhibition, *First Papers of Surrealism,* was held in October and early November of 1942 at 451 Madison Avenue. Sponsored by the Council of French Relief Socities, it included Arp, Ernst, Duchamp, Klee, Magritte, Matta, Masson, Giacometti, Tanguy, and Picasso, as well as Kiesler, Alexander Calder, Henry Moore, Hans Bellmer, Victor Brauner, Chagall, Seligmann, and other Europeans. Significantly, some young Americans — Robert Motherwell, William Baziotes, David Hare, and Ernst's son Jimmy — were also included; along with Arshile Gorky, Jackson Pollock, and a number of other Americans, they began to be invited to exhibit their works and were mentioned in publications devoted largely to Surrealism. Among them, however, only Gorky actually joined the Surrealist movement. The group — ultimately known as The New York School or Abstract Expressionists — took certain concepts from Surrealism and developed them even further than the Europeans by applying them to formal elements as well as iconography.

In addition to the Surrealists, Piet Mondrian, Fernand Léger, Joseph Albers, and other artists in the Cubist-Abstract tradition were in this country. But it was Surrealism that had the greatest impact on the American artists. For example, to the idea of investigating the unconscious by automatic means they added the notion of articulating these subjective experiences in purely formal terms. They found the use of automatism and collages by artists such as Miró, Ernst, Masson, and Matta far more provocative and challenging than the dream imagery of Magritte or Dali. Furthermore, the complex rhetoric and esoteric literary tradition that was so much a part of European Surrealism was foreign to the rambunctious spirit of the Americans.

Some of the American artists might have seen Alfred Barr's exhibition *Fantastic Art, Dada, and Surrealism* at the Museum of Modern Art in 1936. They could also have read the shorter essay in his catalog as well as David Gascoyne's *A Short Survey of Surrealism* or James Johnson Sweeney's *Plastic Redirections in 20th-Century Painting* (all published between 1934 and 1936), but it is unlikely that more than a few did all these things.[1] However, Freudian psychoanalysis (which had formed the basis of Surrealism) was at least as familiar in New York as in Paris, thus providing a common bond for the Surrealists and American artists.

While the Surrealists in Europe were concerned with philosophy and political theory, the American artists were more used to direct involvement in political action. They were, for example, attracted to Jean-Paul Sartre's existentialism: the idea that man was responsible for himself and invented himself through his actions appealed to the Americans and probably influenced the poet and critic Harold Rosenberg's theory of "action painting."

Sartre and his friends had been active in the French underground during World War II. His conviction that philosophy was merely empty words until put into action fit well with American traditions. The character and values of American life had been determined by the frontier and the ideals of self-reliance and independence. For about one hundred years the pioneers had moved westward across the Great Plains, over the Rocky Mountains, and across the deserts of the Southwest. They ventured into unknown and often hostile environments, inventing new ways of living as they went. All of this was the antithesis of the neatly bound nation states of Europe with their proximity, ancient laws, customs, and codes of behavior.

Partly as a result of their earlier history and background, the Americans were used to thinking in terms of process and action as the essence of any enterprise. For many painters the canvas became an area on which the visual record of their actions became the finished object. If, like the Surrealists, they aimed to explore the unconscious, the *process* of that exploration was what they were most intent on recording.

Furthermore, the Americans were frequently more inclined toward the psychoanalytical theories of Carl Jung than those of Freud (Pollock underwent years of analysis with two Jungians). Consequently, they were concerned with myths and totemism as the articulation of archetypal human experience. Some of the works by Pollock, Rothko, and Baziotes carry titles derived from American Indian legends or Greek mythology.

On October 13, 1943, Adolph Gottlieb and Mark Rothko discussed their principles and concerns on a radio station in New York. Rothko declared that the artist's real model "is an ideal which embraces all the human drama." He added: "If our titles recall the known myths of antiquity, we have used them

again because they are eternal symbols. . . . They are symbols of man's primitive fears and motivations, no matter in which land, at what time, changing only in detail but never in substance."[2] Gottlieb asserted that "While modern art got its first impetus through discovering the forms of primitive art, we feel that its true significance lies not merely in formal arrangements, but in the spiritual meaning underlying all archaic works."[3]

Pollock, Baziotes, Rothko, Gottlieb, Motherwell, and others typify a uniquely American tendency which, as Anthony Everitt remarks, was defined in an essay on Walt Whitman by D. H. Lawrence:

It is the American heroic message. The soul is not to pile up defenses around herself. She is not to withdraw and seek her heavens inwardly, in mystical ecstasies. She is not to cry to some God beyond, for salvation. She is to go down the open road, as the road opens, into the unknown, keeping company with those whose soul draws them near to her, accomplishing nothing save the journey, and the works incidental to the journey.[4]

The rough, aggressive American spirit, however, was leavened by strong doses of European cultural traditions in the works of some artists. Motherwell, Gorky, and Cornell, for example, probably were more concerned with the poetry of Baudelaire, Rimbaud, and Mallarmé than with the myths of American Indians. But none of the American artists could entirely avoid the impact of Cubism and its abstract heritage which merged in their work with the Surrealist concern for content.

While the American artists appreciated the theories and works of the Surrealists, their own work took on a distinctly different character. For the most part they did not deal with representational subject matter, even from

the unconscious, and they tended to work on a larger scale (because of their experience with WPA murals) and in a more expansive spirit than the Europeans.

The multiple symbols often found in Surrealist works were ultimately replaced by the Americans with canvases which functioned as single, unified, visual metaphors referring to subjective experience. This was dramatized in Pollock's "drip" paintings from the late 1940s and early 1950s, and later in Rothko's large, glowing images of blurred, hovering rectangles. It was first apparent, however, in Motherwell's collages done in the early 1940s.

When World War II ended most of the European artists living in the United States returned to Europe, although Tanguy remained here with his wife (he died in 1955). The Surrealists who had dominated European art and poetry during the 1930s, however, returned to a changed situation in Europe. Breton had been replaced as a leader of the avant-garde by Sartre, Albert Camus, and other existentialists. And a new generation of painters devoted to the formal device of the spontaneous touch of the artist's brush *(tachisme)* had grown up. Artists such as Wols, Georges Mathieu, Nicholas de Staël, and Jean Dubuffet were closer in their aims and methods to the American Abstract Expressionists than to the Surrealists. Like the Americans, they were indebted to Surrealism for having prepared the way for them. Meanwhile, Miró, Ernst, Picasso, Magritte, and other Surrealist and Surrealist-related artists continued their work.

1. Dore Ashton, *The New York School: A Cultural Reckoning* (New York: Viking Press, 1972), p. 85ff.
2. Ibid., p. 129.
3. Ibid.
4. Anthony Everitt, *Abstract Expressionism* (Woodbury, NY: Barrows, 1978), pp. 15-16.

# ARSHILE GORKY
# 1904-1948

Born in Turkish Armenia in 1904, Arshile Gorky (Vosdanig Adoian) came to the United States in 1920. He first studied engineering at Brown University while painting in his spare time, then spent short periods studying art at the Rhode Island School of Design, Providence Technical High School, and the New School of Design in Boston.

Gorky is both the last Surrealist to be officially admitted to the movement by Breton and one of the first Abstract Expressionists. His mature painting — from 1941 through 1947 — is related to both movements but is typical of neither. He was one of the key figures in creating the Abstract Expressionist movement. Adolph Gottlieb wrote that "the vital task was a wedding of abstraction and surrealism. Out of these opposites something new could emerge, and Gorky's work is part of the evidence that this is true."[1]

Gorky had been unconsciously preparing for this role since the mid-twenties. Depending largely on reproductions in magazines such as *Cahiers d'Art,* his own work followed the history of modern art through the styles of Cézanne; the Synthetic Cubism of Picasso, Braque, and Gris; Kandinsky's Non-Objectivism; and the Surrealism of Masson and Miró. His eclecticism was so blatant during the 1930s that his fellow artists used to jokingly refer to him as the "Picasso of Washington Square."[2] However, Gorky was simply more honest in acknowledging his debts than most artists.

Of the contemporary influences, Picasso and Miró were the strongest, while J. A. D. Ingres and Paolo Uccello were among his favorite old masters. All of these artists had one thing in common — they were masterful linear draftsmen. Line always played a major role in Gorky's paintings — from his earliest works to mature canvases.

Two series of paintings, *Garden in Sochi* (three versions) and *Pirate* (two versions), done between 1940 and 1943, mark a break in his dependence on other artists and the emergence of his own unique style. Probably it was Kandinsky's improvisational abstractions done between 1910 and 1918 that convinced him to work in a freer, more spontaneous way. However, the example of the Surrealists — particularly Matta — caused him to recognize the validity of his new method of working. Although younger than Gorky, Matta was a spell-binding proselytizer who moved easily between the European Surrealists and the Americans, inspiring enthusiasm for automatism as a means of generating the creative act as well as for his own modifications of doctrinaire Surrealism.

Gorky's biomorphic paintings from the early 1940s — such as *Landscape* [82], done in 1943, and *The Apple Orchard* [83], started in 1943 and finished in 1946 — clearly demonstrate his reliance on drawings made in the fields of the Virginia and Connecticut countrysides. Filled with references to plants and human organs, these works are described by Irving Sandler as containing "softly rounded and yielding shapes and pudenda-like crevices that evoke a warm, tender voluptuousness, and hard, bony thorn- and claw-like protuberances that suggest hostile, even cruel, phallic aggression."[3] Such characteristics, along with the artist's spontaneity, relate Gorky's works to the Surrealist paintings of Miró and Matta.

Gorky's confidence in his art was reinforced by Breton's friendship, despite their inability to communicate verbally and despite the fact that Gorky's automatism differed from that of other Surrealists. Breton remarked that Gorky was "of all the Surrealist artists, the only one who maintains a direct contact with nature — sits down to paint *before her*!" — his purpose being to use the "sensations that nature provides as springboards . . . in fathoming certain profound states of mind . . . [to] leap beyond the ordinary and the known."[4] Miró, Matta, and other automatist Surrealists began with spontaneous and gratuitous events such as free washes of color or splashes of pigment to stimulate the creative act, during which they worked toward biomorphic images. Gorky began with drawings from nature and worked towards more biomorphic abstract images. The final results are similar but the processes are opposite.

*Landscape* [82] was painted freely and directly. Jeanne Reynal, who owned the picture for many years, wrote: "Gorky dashed it off one evening when he and his wife and I were examining a summer's work of drawings done in Virginia. He said, 'This is how I want to paint.' He was having some difficulty in handling oil as freely as he did drawings and crayon on paper, due I imagine to his terrific respect for the 'masters' and their slow development of oil on canvas. . . . It was an historic work in that it was the first breakthrough, but I do not believe he ever repeated a work so spontaneously again."[5]

Line is the basis of the composition, with thin washes of color applied freely but fully integrated with the drawing. Stimulated by his drawings of the sun-washed fields of Virginia, and his erotic nature, Gorky reveals his joyful state of mind. He had married Agnes Magruder ("Mougouch") two years earlier and had become the father of a daughter, Maro, in the spring of 1943. His art at this time was intensely lyrical. The light, warm washes of color move into, around, and through shapes defined by line and occasionally burst into flame-like shapes.

**82** Arshile Gorky, *Landscape,* 1943

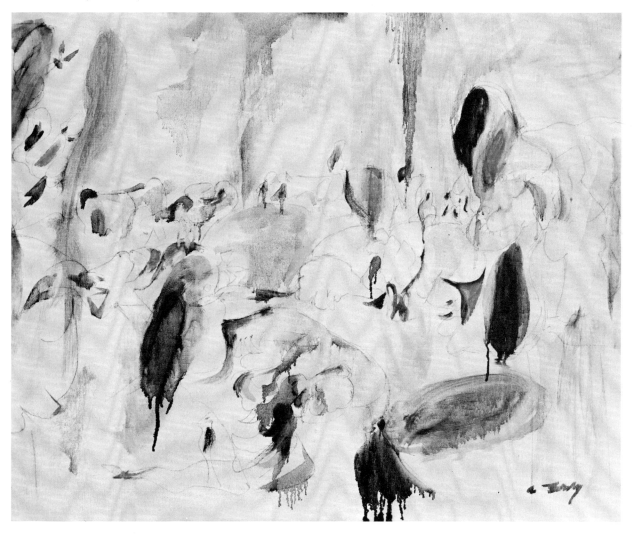

The Apple Orchard [83], started that same year, was completed in 1946. The same greens, red-oranges, yellows, and blue-greens are present, but denser and darker as they refer to trees. Gorky's mood had been happy when he began this painting, but when he took it up again in 1946 he had suffered some misfortunes. The deeper colors, heavier drawing, and several sharply pointed shapes suggest a change in his inner state.

**83** Arshile Gorky, *The Apple Orchard,* 1943-46

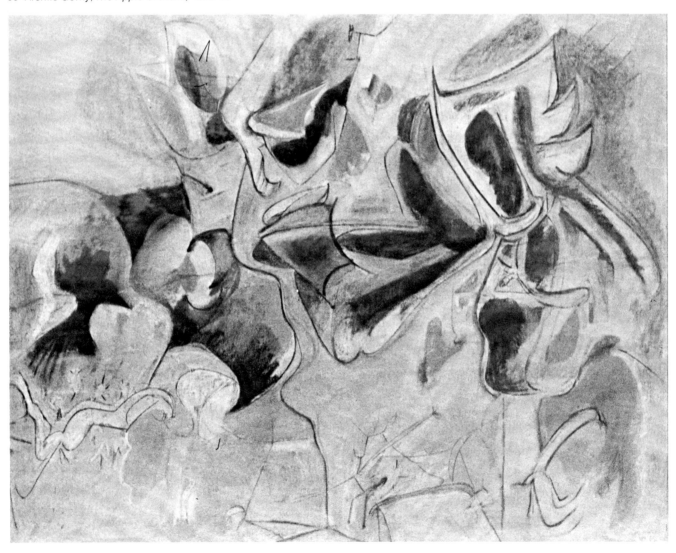

In 1944 and thereafter, Gorky continued to work from his drawings. *Water of the Flowery Mill* [84], done in 1944, was based on the drawings done in Virginia the year before. Its freely washed-on translucent greens and reds, as well as its underlying line drawing relate it to *Landscape*, although it is a larger and more densely painted work. The drawing and washes of paint appear to have been spontaneously applied, but Gorky still worked from fully developed drawings.

**84** Arshile Gorky, *Water of the Flowery Mill*, 1944

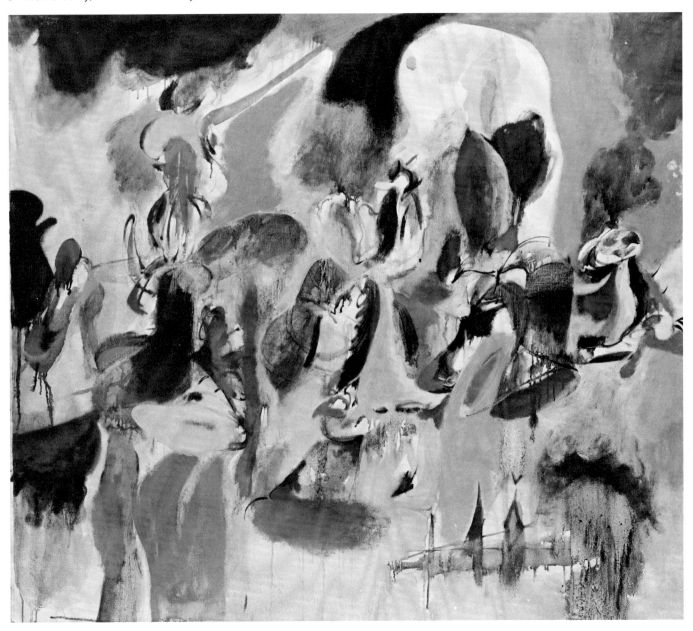

*Housatonic Falls* [85], started in 1943 and finished in 1944, is much denser and more resonant in color. Rich chocolate browns, burnt oranges, off-whites, and deep yellows predominate. The Housatonic river runs through Connecticut; it inspired a number of drawings and paintings by Gorky. The darker tones and heavier layers of pigment suggest the Connecticut landscape — perhaps in fall — rather than the sun-drenched fields of Virginia. Rocks, water, and other landscape elements are relatively clear.

*The Plough and the Song* [86] is one of a group of Gorky's last paintings in which he reached the height of his powers. He did several versions of this motif, two with heavier pigment than this thinly painted version. Translucent washes of warm orange-ochres predominate, while the seemingly abstract shapes — which are, in fact, derived from the forms in and around a ploughed field — are drawn with Gorky's typical mastery. The rich, sun-warmed earth; a plough; stiff grass

**85** Arshile Gorky, *Housatonic Falls,* 1943-44

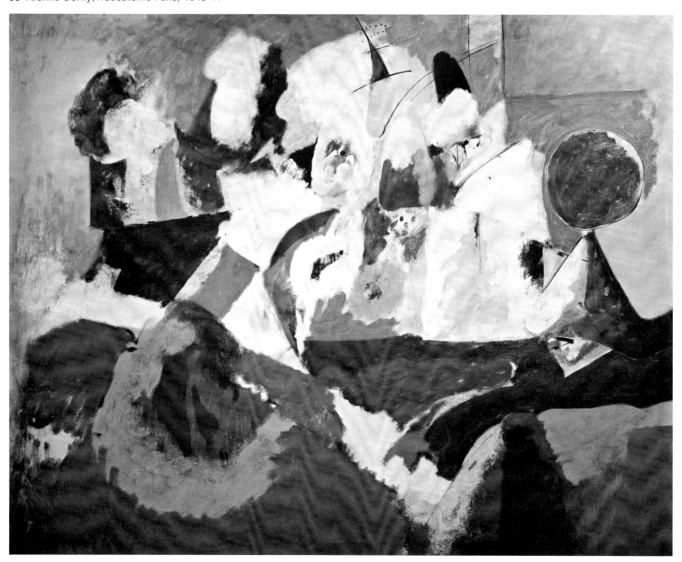

which he transformed into a bone; and a number of metamorphic plant forms can be deciphered. The content clearly refers to fertilization and birth.[6]

The Gorkys spent the summer of 1946 on Agnes Gorky's family's farm in Virginia. The year before, the barn where Gorky made his studio in Connecticut had burned, destroying a large part of the work that he was preparing for an exhibition at Julien Levy's gallery. A few weeks after the fire Gorky required an operation for cancer. Now back in Virginia, recovering in the sun, he began to work again. (Ironically, the barn there had also burned and he had no studio.) He made countless drawings in the sunny fields, singing Armenian peasant songs as he worked. He said, "What I miss most are the songs in the fields. No one sings them anymore. . . . And there are no more plows. I love a plow more than anything else on a farm."[7]

**86** Arshile Gorky, *The Plough and the Song,* 1947

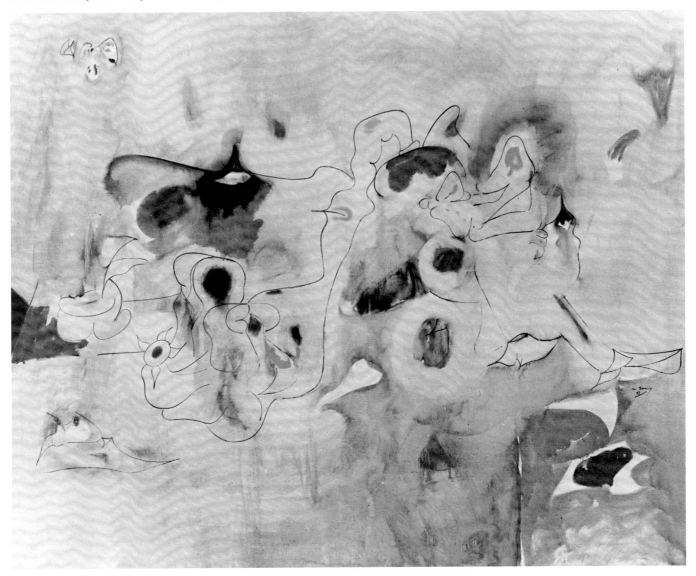

The last tragic months of his life had begun, however, and he worked as though he sensed that he had not long to live. During that summer on the Magruder farm, Gorky also did drawings in the firelit living room at night. One of the last and most moving of his paintings, *Agony* [87], done in 1947, is based on these interior drawings. The images which began with drawings of the hearth, a crib, a rocking chair, and other furniture metamorphose into biomorphic, threatening forms. All seem to be engulfing receptacles, painted in dark, intense hues. The dramatic inner struggle that was to consume the last months of Gorky's life is appropriately formulated in the sharp, dramatic images. The hot reds do not suggest the pleasant flickering of a fireplace, but rather the fire that had consumed his work, and the searing agony of his illness.

**87** Arshile Gorky, *Agony,* 1947

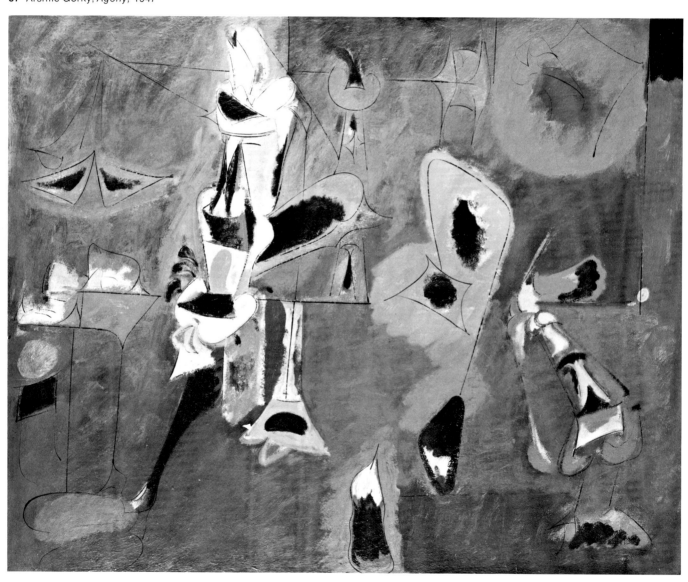

One of his last canvases, *Dark Green Painting* [83], was probably done in late 1947 or early 1948. The reds of *Agony* have been replaced by dark greens. Filled with terribly distorted, metamorphic images, the painting also reflects a curiously withdrawn quality. It is difficult to imagine that one could enter this dark space in which strange images cavort.

On June 26, 1948, Gorky suffered a broken neck in an automobile accident. Since his operation for cancer, he had become sexually impotent, but from psychological rather than physical causes. Apparently life with him had become unbearable even for his devoted "Mougouch." When he left the hospital, Isamu Noguchi drove him and Saul Schary to his house in Connecticut. Assuring Schary that he would "act as a man does," he hanged himself.

**88** Arshile Gorky, *Dark Green Painting,* ca. 1948

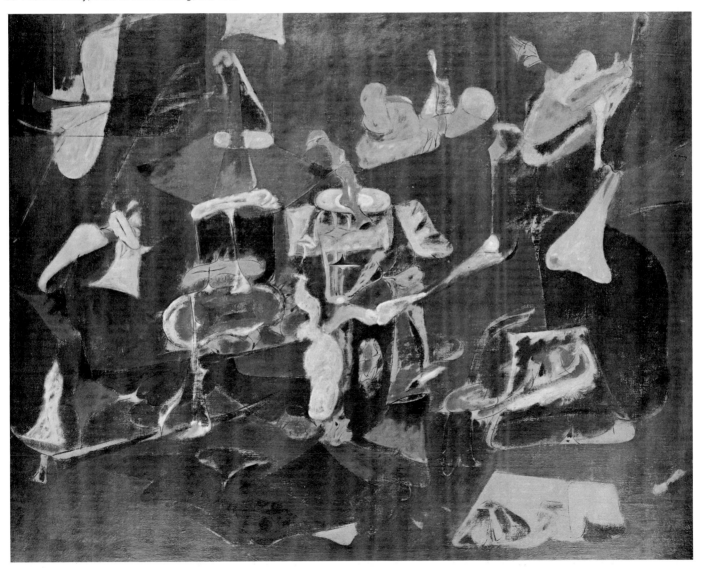

A letter from Agnes Gorky to Ethel Schwabacher following the opening of Gorky's last exhibition at Julien Levy's gallery hints at how distant Gorky's aims were from those professed by most Surrealists. After thanking Mrs. Schwabacher for not talking like the people who "go symbol snatching," she went on to remark that "there are still a few people . . . who love painting as painting, not as a sop for gossip and pathology. . . ."[8]

Yet in many ways Gorky participated in the Surrealist spirit. He loved Rimbaud, for example, particularly the lines in *Lettres du voyant* in which Rimbaud wrote: "The poet will define the amount of the unknown awakening in the universal soul in his own time: he would produce more than the formulation of his thought or the measurement *of his march toward Progress!* An enormity who has become normal, absorbed by everyone, he would really be a *multiplier of progress*." As Schwabacher remarked, "the 'amount of the unknown arising in his time' " was for Gorky (as for the Surrealists), "the knowledge of the unconscious."[9]

1.  Adolph Gottlieb, intro. to exh. cat., *Selected Paintings by the Late Ashile Gorky,* Kootz Gallery, New York, March 28-April 24, 1950, p. 1.
2.  Ethel Schwabacher, *Arshile Gorky,* intro., Meyer Schapiro (New York: Macmillan Co., 1957), p. 11.
3.  Irving Sandler, *The Triumph of American Painting: A History of Abstract Expressionism* (New York and Washington: Praeger, 1970), p. 56.
4.  Ibid.
5.  Letter to the author from Jeanne Reynal, April 12, 1963.
6.  Schwabacher, p. 128.
7.  Ibid.
8.  Ibid., p. 138.
9.  Ibid., p. 124.

# ROBERT MOTHERWELL 1915-

Born in Aberdeen, Washington, Robert Motherwell was in his mid-twenties when he traveled to Mexico City with Matta in June of 1941. They had a letter of introduction from Breton to Wolfgang Paalen, who was working there. Motherwell stayed on through the fall in order to work near Paalen. He already had much experience, having graduated from Stanford University in 1936 with a major in philosophy (his thesis was on the relationship between the playwright Eugene O'Neill and psychoanalytical theory) and having toured France, Germany, and other Western European countries in 1935.

He became interested in French literature — especially works by Baudelaire, Proust, and Gide — and in 1938 returned to Europe to study French Symbolist literature in Paris and at the University of Grenoble (at the suggestion of David W. Prall and Arthur O. Lovejoy with whom he had studied aesthetics in the Graduate School of Arts and Sciences at Harvard University in 1937). While at Harvard, he wrote a thesis on Delacroix's *Journals*. After spending much of 1938 and 1939 traveling, studying, and writing in Europe, he took a teaching post in the art department at the University of Oregon. In 1940, however, he went to New York and enrolled in Columbia University to study art history with Meyer Schapiro.

Schapiro soon recognized Motherwell's artistic ability which had manifested itself in his early childhood. He introduced him to some of the expatriate Surrealists; as a result, Motherwell studied engraving briefly with Kurt Seligmann in 1941.

Because of his background, his ability to read and speak French, his interest in French literature, and his studies in psychoanalysis and philosophy, he was eminently qualified to communicate easily with the Surrealists. Along with Cornell and Gorky, he had more interests in common with them than any of the other American artists coming to maturity at that time. Indeed, he was a central figure in bringing about contact between the Surrealists and advanced American artists.

In 1942 he contributed, along with the American poet-critic Harold Rosenberg, to the review *VVV,* and exhibited works, with William Baziotes and David Hare, in the exhibition *First Papers of Surrealism.* He shared an interest in Surrealist theories with Baziotes and Pollock; in fact, the three artists and their wives collaborated on experiments to produce "automatic" poems.

In 1943 all three artists took part in an exhibition of collages at Peggy Guggenheim's Art of This Century gallery. Motherwell and Pollock worked together on their collages. The following year Baziotes and Motherwell each had one-man exhibitions at the same gallery. The Museum of Modern Art purchased Motherwell's collage, *Pancho Villa, Dead and Alive.* A year later he became director of the Documents of Modern Art series and began a career of editing and writing about art in addition to making some of the most important paintings and collages of the second half of the twentieth century.

Almost entirely self-taught — except for the brief period spent with Seligmann — Motherwell demonstrated a decided gift for collage and an understanding that it could be the equivalent of psychic automatism as a creative method. While automatist Surrealists such as Masson and Miró recognized that their method, honestly applied, guaranteed originality and provided a powerful generative principle for the creative process, Motherwell (along with Ernst and Picasso) saw that collages — by the fortuitous association on

a single plane of disparate elements —
could provide the same level of generative force. At the same time, specifically
because they provide a way for originality, both methods inevitably reveal the
extensions and limits of the artist's personality, intelligence, and values.

Although many of Motherwell's early
works were collages, he also did paintings. *The Little Spanish Prison* [89],
done in 1941, establishes a formal
theme that was to run throughout
Motherwell's work from then on: vertical bars. Painted a few years after the
Spanish Civil War and during the early
years of the Second World War, it suggests the oppressive spirit that appeared in a much-magnified form over
the years in his series of black and white
"Elegies." Significantly, this small canvas is one of the first — if not the first —
American paintings to show certain
characteristics that were later associated with Abstract Expressionist
painting: it suggests extremely shallow
space; it is capable of being expanded
to any size without altering its character; and it is a single, unified image — in
itself a visual metaphor rather than an
accumulation of symbols.

The stripes are alternating yellow and
nuanced white, with the drawing done
freely so that a certain sensitivity of
linear contour becomes obvious. One
tends to see the yellow stripes as positive elements against a white background because of the greater intensity
of the yellow. A short, horizontal
magenta bar in the upper left-hand section of the painting seems to emerge
from behind a white stripe (or perhaps it
should be understood as turning back
around the yellow bar) and crosses over
two yellow stripes and the white one between them. Its right end extends
slightly beyond the right-hand yellow
stripe, thus penetrating into a white
area.

Yellow, white, and magenta appear in
small areas in several of the later "Elegy
to the Spanish Republic" paintings but

**89** Robert Motherwell, *The Little Spanish Prison,* 1941

**90** Robert Motherwell, *Mallarmé's Swan*, 1944

are subordinate to the large black shapes. These colors are associated in Motherwell's mind with Spain. The vertical bars suggest oppression and rigidity, but the red horizontal may imply a hopeful note. It dares to cross the bars: during the Spanish Civil War the red forces, like the anarchistic black, opposed the fascist Falangists. The small extension of the red bar beyond the constricting yellow vertical may also suggest a small but present note of hope. Later ''Elegies'' and a major canvas entitled *Iberia* are nearly overwhelming in the anguish they imply.

A few years later Motherwell created one of his major painting-collages, *Mallarmé's Swan* [90]. Dated 1944, it continues the vertical stripe motif of *The Little Spanish Prison* but with greater variety. It also introduces another motif which was to play a major role in many of the artist's later works: the oval. The colors of this work have faded over the years, but they are still elegant in the same sense that Matisse's are. Reading from left to right, two nuanced vertical yellow stripes traverse a field of soft blue. Near the center of the composition, a brown, wood-grained, vertical bar travels down part of the length of the picture; after an interval of blue, a magenta stripe travels somewhat farther; again there is blue, and finally a broad yellow stripe extending from top to bottom contains a curved, vertical, white shape with a linear motif.

The basic composition of vertical stripes is interrupted, however, by an irregularly drawn circle, a brown oval, a brown shape from which the oval appears to have been cut, linear drawing, and irregular shapes apparently created by spilling yellow and black pigments in a controlled accident. These elements are organized with a sensitivity and precision that relate this work to that of French artists such as Matisse, Bonnard, and Redon.

150

Color Plate XXV. André Masson, *Pasiphaë,* 1943  [43].

Color Plate XXVI. Yves Tanguy, *The Five Strangers,* 1941   [53].

Color Plate XXVII. Matta (Roberto Sebastian Antonio Echaurren), *The Prisoner of Light,* 1943  [79].

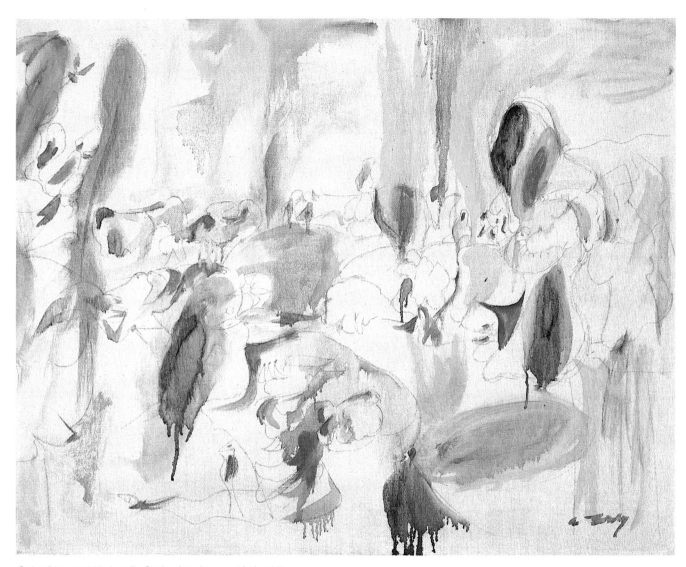

Color Plate XXVIII. Arshile Gorky, *Landscape,* 1943  [82].

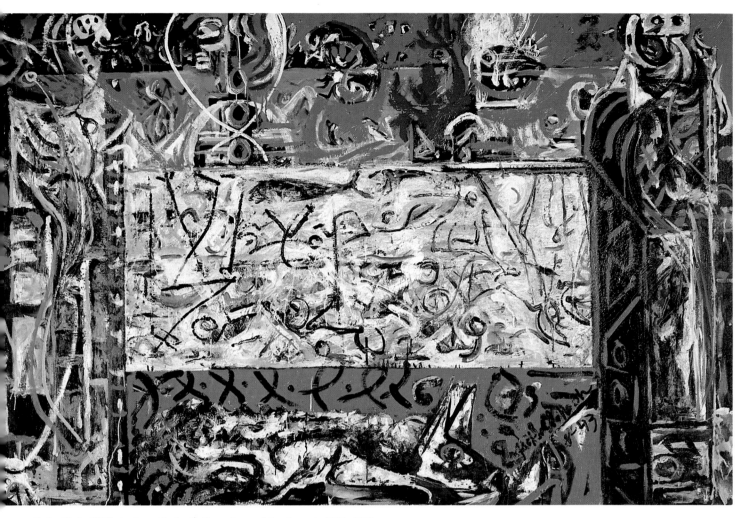

Color Plate XXIX. Jackson Pollock, *Guardians of the Secret,* 1943   [93].

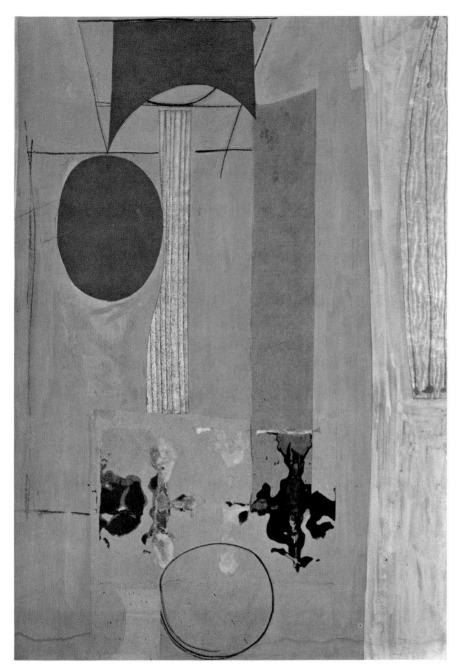

Color Plate XXX. Robert Motherwell, *Mallarme's Swan*, 1944  [90].

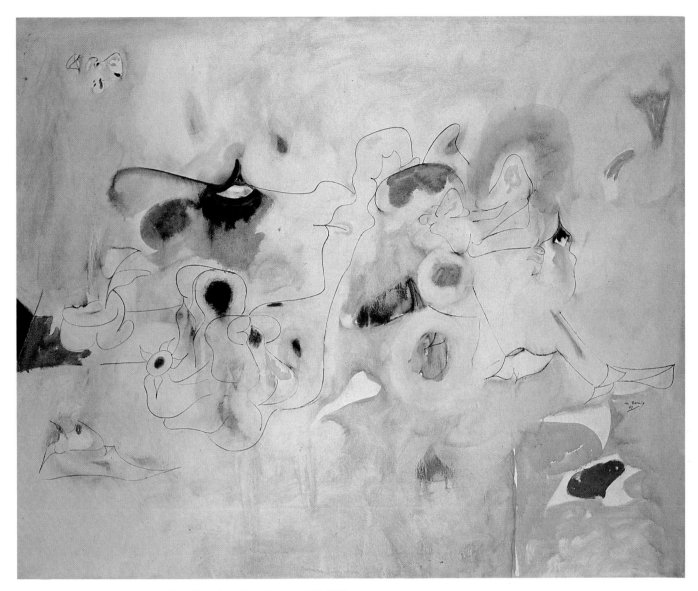

Color Plate XXXI. Arshile Gorky, *The Plough and the Song,* 1947   [86].

Color Plate XXXII.
Robert Motherwell,
*The Homely Protestant,* 1948 [92].

Motherwell's interest in French Symbolism was shared by one other American artist at this time — Joseph Cornell. Indeed, it was Cornell who was responsible for naming the painting. Although Motherwell had been inspired by Mallarmé's poem, *The Dream,* Cornell misremembered the title as another of Mallarmé's poems, *The Swan.* Motherwell changed the title, but when he realized that it was wrong, he still preferred Cornell's fortuitous error.

The delicate music of Mallarmé's language defines symbolic images so subtly that they cannot be successfully translated. The best that can be accomplished is a simple statement of the imagery and its connotations. The poem *The Dream* refers to a swan trapped in a hard (ice-covered), forgotten lake, recalling flights never made. Will the beautiful new day free the swan imprisoned in the ice high above the regions of earth of which it never sang? A swan of an earlier time recalls the hopelessness of deliverance when the ennui of winter finally ends. In vain it tries to shake off the white (pure) anguish, for the phantom bird is condemned by its own dream of cold contempt for the things of this world to remain immobile in useless exile.

In brief, the theme of the poem is creative impotence. The swan (the creative spirit) is trapped by the purity of its dreams of creation and loses contact with the wellsprings of life. Motherwell's painting-collage is not an illustration of Mallarmé's poem; in itself it is a visual poem whose form evokes the same spirit as the written poem.

In 1947 Motherwell did a small oil with collaged elements on panel: *Figure in Black* [91]. Like Franz Kline's early black and white compositions of a few years later, a heavy, black line, based on the essential form of a human figure, creates a vigorous, abstract pattern. This painting is not quite as abstract as most of Kline's, however. A strange masked figure seems to move across a

**91** Robert Motherwell, *Figure in Black,* 1947

151

hot, barren landscape. The ground is defined in orange-ochres and umbers; the sky is a cold white; and the figure is a heavy black stick-shape with a great, irregular, rectangular head. Two blankly staring eyes are the only clear features. The work is typical of a number of abstract figure painting-collages Motherwell did at this time, many of which are reminiscent of Klee's last works.

Almost without question, *The Homely Protestant* [92], a large painting on masonite done in 1948, is Motherwell's most important figure painting. The board is covered with rich, vibrant ochres with vigorous, highly visible brushwork. A round, linear drawing, vaguely resembling a figure, is worked over the ground tones — merging with them in some areas. A figure seems to be defined by changes in the value of the ochre background alone; it does not coincide entirely with the line drawing. The head appears near the top center of the composition. A long neck leads down to the topmost part of the line drawing which coincides with the shoulders of the ghostly background figure. The drawing, with two staring eyes one above the other, suggests a triangular head for the figure. In the ghost-like figure these eyes become buttons down the front of the torso. This interpretation is reinforced by another, smaller version of the same subject as a bust.

Motherwell reports that he could not find a title for this painting until — following a Surrealist method — he placed his finger at random on a page of one of his favorite books, *Finnegan's Wake*. It landed on the words "the homely protestant" and he thought, "Of course, it is a self-portrait."[1]

**92** Robert Motherwell,
*The Homely Protestant,* 1948

Other artists such as Pollock, Kline, and Still may have been more typically American in their rough, unpolished aggressiveness, but Motherwell shared with Gorky, de Kooning, Baziotes, and Cornell a certain concern for subtleties and nuances of form that put them somewhere between the former group and the more controlled Europeans. (If some of Pollock's or Kline's works succeeded brilliantly, many also failed; that was a price they paid for headlong, devil-may-care creative methods.) Motherwell subscribed to the notion that the creative artist moves into unknown regions, discovering — rather than planning — the outcome. Unlike Miró, Picasso, Klee, and other Surrealists, however, he assumes control earlier in the process. Another important difference between Motherwell and the Surrealists is that he relies heavily on formal elements — like Seurat and many of the Symbolists — to provide insight into his subjective experience.

1. Quoted in H. H. Arnason, *Robert Motherwell* (New York: Harry N. Abrams, Inc., 1974), p. 195.

# JACKSON POLLOCK 1912-1956

In 1947 when Pollock began dripping paint onto the surface of canvases, he became the most infamous of the Abstract Expressionists. Yet, by taking this step, he was simply extending the automatism which had long been employed by Surrealists such as Miró, Masson, and Matta. Dripping fluid from sticks, blunt brushes, and pouring it from cans directly onto canvases laid flat on the floor while he moved about the edges — and occasionally onto the surface — he created visual forms which articulated his dynamic inner experience.

Of the Americans who first met and exhibited with the Surrealists during the early forties, Pollock was the least European in his sensibilities and background and the most committed to characteristics commonly assumed to be typically American. He rejected all traditions in favor of independence and the individual freedom to push beyond previously defined frontiers of expression and technique — even those established by the Surrealists.

Pollock's earlier work was indebted to European art, particularly that of Picasso, Kandinsky, Masson, and El Greco. But American painting, especially that of artists such as Albert Pinkham Ryder, as well as Navaho sand painting and the work of the Mexican muralists Orozco, Rivera, and Siqueiros, was of equal or greater importance for him. He never visited Europe, but he explored many American regions, including Indian ruins in Arizona.

Born in Cody, Wyoming, into a family of sheep ranchers, Pollock was just under one year old when the family moved to San Diego. They moved many more times around the Far West before settling in Los Angeles. Pollock was seventeen, and while attending school there met Philip Guston and Reuben Kadish, among other young students who were later to gain recognition as important American artists. He was briefly influenced by Frederick Schwankovsky, an art teacher and follower of Krishnamurti.

In 1930 Charles and Frank Pollock returned to Los Angeles from New York for the summer; when Charles returned to New York in the fall, his brother Jackson accompanied him. He enrolled with Charles in Thomas Hart Benton's class at the Art Students' League and posed for Benton, who was then working with José Clemente Orozco on the murals for The New School for Social Research.

In 1935 and 1936 Pollock did some work for the WPA Federal Arts Project and worked with David Siqueiros, the Mexican muralist, who had established an experimental workshop in New York.

In 1937 he began psychiatric treatment for alcoholism. The following years were difficult ones for Pollock, who at times was in serious mental condition and probably survived only because of the selfless devotion of some close friends. In 1939 he began Jungian psychoanalysis with a doctor who used his drawings as a therapeutic aid; in 1941 he switched to another Jungian analyst who also used his drawings to help in his treatment.

Meanwhile, he was dropped from the WPA Project and became extremely concerned about repercussions over signing a petition to get the Communist Party on the ballot. "The irony of it," he wrote to his brother Charles in July 1941, "is that the real Party People I know didn't sign a damn thing and it is suckers like us who are getting it."[1] He was in touch with artists Philip Guston and John Graham as well as Lee Krasner, who was a close friend after 1941 and became his wife in October 1945. She, along with Benton and other friends, was convinced of Pollock's great artistic ability.

In 1942 William Baziotes introduced him to Robert Motherwell. About that same time he also met Matta, Hans Hofmann, and Peggy Guggenheim. Motherwell urged him to participate in an exhibition being planned by the Surrealists. Pollock, who was already convinced that the unconscious plays a central role in creative activity, refused because he didn't believe in group activity.

In 1943 Peggy Guggenheim invited Pollock and Motherwell to exhibit collages in her gallery, a center for the Surrealist emigrés. Thus, Pollock began to move into sophisticated and cosmopolitan art circles; at the same time, however, he was forced to take a custodial job at the Museum of Non-Objective Painting (later The Solomon R. Guggenheim Museum) in order to earn money to live. Pollock and Motherwell worked together on their collages for the exhibition. Afterward, having seen his work, Miss Guggenheim offered Pollock a contract and a commission to do a mural for her house. Howard Putzel (Miss Guggenheim's assistant), James Thrall Soby of the Museum of Modern Art, the critic Clement Greenberg, and others began to take a serious interest in his work. Soby recommended that the Museum of Modern Art purchase his painting The She Wolf.

Greenberg was Pollock's staunchest and most perceptive champion among the critics from the beginning. He recognized certain problems in his art, but repeatedly insisted that Pollock was the most creative, strongest painter of his time. As early as 1943, in an article in Nation, Greenberg had singled out Pollock as a painter strong enough to be compared with Ryder and Ralph Blakelock. In 1944 Motherwell wrote in Partisan Review: "[Pollock] represents one of the younger generation's chances. There are not three other painters of whom this could be said. . . .

His principal problem is to discover what his true subject is. And since painting is his thought's medium, the resolution must grow out of the process of his painting itself."[2]

If the conditions for the next twelve years and nine months of his life were not exactly propitious, Pollock's creative vitality overcame the resistance to his work by most critics, curators, collectors, and the general public. His lapses into alcoholism and rude behavior in public were probably defenses against the general misunderstanding and rejection of his work which was, as Motherwell implied, an extension of his thought processes and personality.

In some ways, Pollock was a true Surrealist. His drip paintings, for example, were automatic and impulsive. Possibly influenced by the use of his drawings during psychoanalysis, he once remarked: "I approach painting in the same sense as one approaches drawing; that is, it's direct."[3] Unlike the European Surrealists who, as Irving Sandler puts it, "devised methods to sneak politely around the barriers of reason and inherited culture, Pollock stormed those barriers; not only did he search for barbaric subject matter, but he employed the brush savagely. . . ."[4]

A painting such as Guardians of the Secret [93], for example, suggests some ancient or barbaric mystery cult. It is organized on a symmetrical, geometrical structure; two vertical shapes frame a horizontal rectangle within a larger horizontal rectangle. These form a single unit echoing the shape of the canvas. Yet the surface of this geometrical framework is shredded by vigorous brushstrokes and graffiti which coalesce to form two standing figures, a reclining animal (wolf or dog), and suggestions of small animal- and fish-like shapes.surrounding the inscribed rectangle in the center. The masked figures and the reclining animal appear to be guarding some primitive, indecipherable secret. The free, impetuous

brushstrokes play against the logical, geometrical structure; subject is integrated with form to reveal content.

Pollock was familiar with the theories and methods of both Freud and Jung. The notion of the unconscious, its secrets, and guardians were well known to him. These may be the guardians to which the title refers, while the secret is Pollock's inner self.

Between 1947 and 1950 Pollock achieved full maturity as a major creative artist. The freely painted, irregular brushstrokes of Guardians of the Secret evolved into the later dripped, rhythmical, linear swirls and puddles of pigment without recognizable subject matter. The subject of his painting had become the act of painting. Motifs were replaced by a single organized surface of colored pigment.

Some critics professed to find these works "lovely" or "pleasant" and appropriate for wallpaper, printed silk, or neckties. Time magazine, ever vitriolic, found his work similar to "a child's contour map of the Battle of Gettysburg" (February 7, 1959) and a "non-objective snarl of tar and confetti" (December 26, 1949). The year of his death, after he had been using brushwork in his painting again for several years, Time's critic, in a heavy-handed attempt at sarcasm, reported that "Jack the Dripper, 44, still stands on his work" (February 20, 1956).

While these kinds of attacks probably affected Pollock's ego, he continued to make advances in his art. The few artists, critics, and curators who sensed his importance and originality were enough to sustain his creative endeavors. The painter-collector-critic Alfonso Ossorio, for example, acquired some of Pollock's most important paintings and wrote knowledgeably and perceptively about his work.

**93** Jackson Pollock, *Guardians of the Secret,* 1943

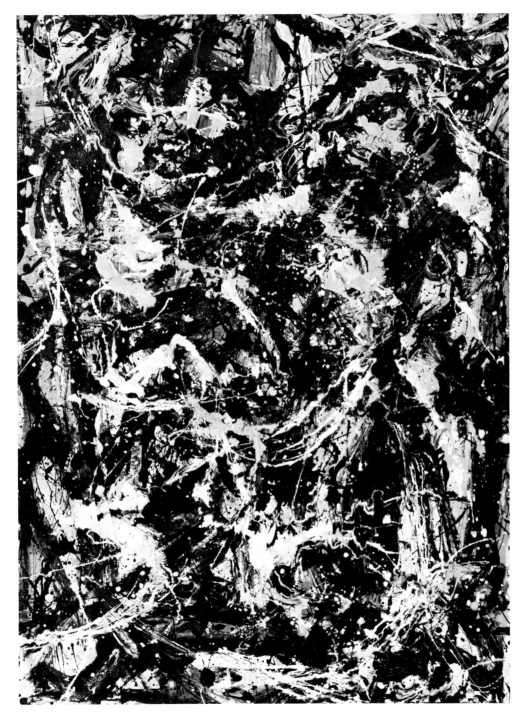

**94** Jackson Pollock, *Number 5,* 1950

Pollock's method of using sticks, blunted brushes, and other instruments for putting liquid paint on the surface of large canvases laid on the floor combined a number of means — all of which had precedents — in a highly original and effective way. As he himself pointed out, Oriental artists had long before painted on the floor. He might also have known that certain kinds of Chinese and Japanese painters cultivated the technique of painting while in a kind of delirium, especially when drunk. Even some twentieth-century European and American painters such as Picasso, Miró, Masson, Ernst, Hofmann, Gorky, and Motherwell had allowed drips of paint to remain in their paintings when it seemed appropriate. As for covering the surface with abstract linear patterns, Mark Tobey preceded Pollock by several years.

The difference between these other artists' works and Pollock's paintings after 1947 was that he made the art of painting itself into a kind of ritual. It was not Tobey's delicate and intimate movement of wrist and fingers that he cultivated, nor Franz Kline's arm movements; it was a ritual dance of the entire body — evidenced in works such as Number 5 [94], done in 1950.[5]

Pollock began such canvases by dripping, splattering, or pouring paint on the canvas, forcing accidental effects to which he then responded.

Where Miró, Klee, or Masson would gradually take the painting toward recognizable images, however, Pollock continued to develop the painting in terms of more abstract lines, spots, and puddles of pigment. This does not mean that his paintings were created by a series of accidents, nor does it mean — as some writers have implied — that he finally controlled every effect with great precision. Instead, he deliberately caused chaos out of which he brought form, while recognizing certain accidental effects and deliberately retaining them.

Pollock described his own method in an often-quoted statement: "When I am *in* my painting, I'm not aware of what I'm doing. It is only after a sort of 'get acquainted' period that I see what I have been about. I have no fears about making changes, destroying the image, etc., because the painting has a life of its own. I try to let it come through. It is only when I lose contact with the painting that the result is a mess. Otherwise there is pure harmony, an easy give and take, and the painting comes out well."[6]

Two years later, in an interview with William Wright, he was asked: "Then you don't actually have a preconceived image of a canvas in your mind?" He answered: "No — because it hasn't been created. . . . I do have a general notion of what I'm about and what the results will be."[7]

Like Gorky, Pollock was a fine linear draftsman, and like Van Gogh, his line was an expressive element. But unlike either of these artists, his line did not define images or shapes; it existed to provide evidence of his actions and clues to the emotions which generated them. At the same time, his successful abstract works from 1947 to 1951 preserve what is usually referred to as the picture plane.

Greenberg suggested that "Pollock's 1946 manner really took up Analytical Cubism from the point at which Picasso and Braque had left it when, in their collages of 1912 and 1913, they drew back from the utter abstractness to which Analytical Cubism seemed headed."[8] Greenberg then points out that at this same point in his evolution Pollock plunged on into abstraction.

Rubin comments that "Pollock showed that by accepting the challenge of wholly liberating his line, he could incorporate the essence of Cubist architecture in a new way, *at the end of his process,* i.e., as the web filled out and the freely meandering lines became locked in an architecture of their own making."[9]

Pollock's mature drip paintings from 1947 to 1950 manifest a masterly — if unconscious — synthesis of Cubism and Surrealism. Taking Surrealist automatism to an extreme and rejecting subject matter, not content, Pollock arrived at a formal structure reminiscent of hermetic Cubism and Mondrian's early development of abstraction.

In 1951 Pollock did many drawings and paintings in black and white. It was a period when — judging from his letters — he was frequently depressed: the concentration on black and white may have been a reflection of his state of mind. His wife thought it possible that it was a delayed reaction to Picasso's *Bombardment of Guernica,* which he much admired. In fact, it may have been no more than a desire to experiment with pictures in these two tones as other Abstract Expressionists such as Motherwell, de Kooning, and Kline had done.

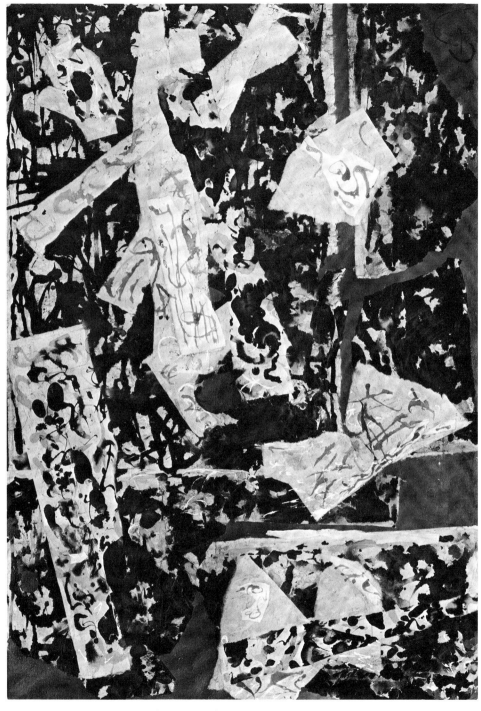

**95** Jackson Pollock, *Collage and Oil,* 1951

He also returned to collage, which he had done some years earlier. *Collage and Oil* [95] is an important example of his experiments in this direction; it also reveals that images began to reappear out of the webs of paint. The suggestions of figures that appear in this work are somewhat reminiscent of those by Dubuffet. Pollock's interest in the French artist's work developed partly out of his friendship with the painter-collector Alfonso Ossorio, who spent much time in France and collected Dubuffet's work as well as Pollock's. Dubuffet, on the other hand, saw Pollock's work at this time and, according to Ossorio, was interested in seeing more.

Two years later, in 1953, Pollock painted some of his most important works: *Blue Poles, Easter and the Totem, The Deep,* and *Portrait and a Dream* [96]. In these works, images emerge from the skeins and patches of pigment. *Portrait and a Dream* is a large diptych with a black and white panel on the left and a richly colored portrait (probably of the artist) on the right. The portrait is a double image with a three-quarter view facing left overlapped by another facing right.

The left side is often referred to as an abstraction; however, there are obvious indications of two human figures. The dark area near the top center of the composition suggests a face in shadow just above two breasts. Many

similar suggestions can be found of the two figures. Lee Pollock said that she remembers him talking about this painting once — "brilliantly" — to two visitors and that he described the upper right-hand corner of the left panel as "the dark side of the moon."

The two sides of the diptych work well together, establishing visual and psychological tensions. The freely painted images are related to certain Surrealist techniques, as is the erotic "dream" of the artist.

The content of Pollock's early works, such as in *Guardians of the Secret,* is often revealed by both subject and form working to complement one another. Later, as his paintings became purely abstract, the formal elements alone carried the energetic import of these works, providing insight into Pollock's inner experiences. As images once again emerged, the content is once more dependent on both subject and form. The dynamics of Pollock's inner self are clearly revealed in the evolution of his paintings.

1. Quoted in Francis V. O'Connor, *Jackson Pollock,* exh. cat. (New York: The Museum of Modern Art, 1960); p. 25.

2. Ibid., p. 31.

3. Ibid.

4. Irving Sandler, *The Triumph of American Painting: A History of Abstract Expressionism* (New York and Washington: Praeger, 1970), p. 107.

5. See Robert Goodnough's articles, "Pollock Paints a Picture," *Art News* 60 (May 1951), and Hans Namath's photographic record of Pollock painting *Autumn Rhythm* in 1950.

6. O'Connor, p. 40.

7. Ibid., p. 81.

8. Clement Greenberg, quoted in William S. Rubin, "Jackson Pollock and the Modern Transition, Part III: 5. Cubism and the Later Evolution of the All-Over Style," *Artforum* 5 (April 1967): 18-31.

9. Ibid., p. 35; also quoted in E. A. Carmean, Jr., *American Art at Mid-Century: The Subjects of the Artists,* exh. cat. (Washington: National Gallery of Art, 1978), p. 146.

**96** Jackson Pollock, *Portrait and a Dream,* 1953

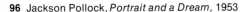

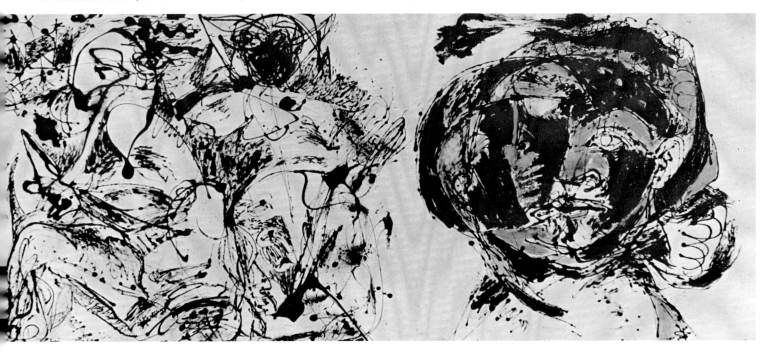

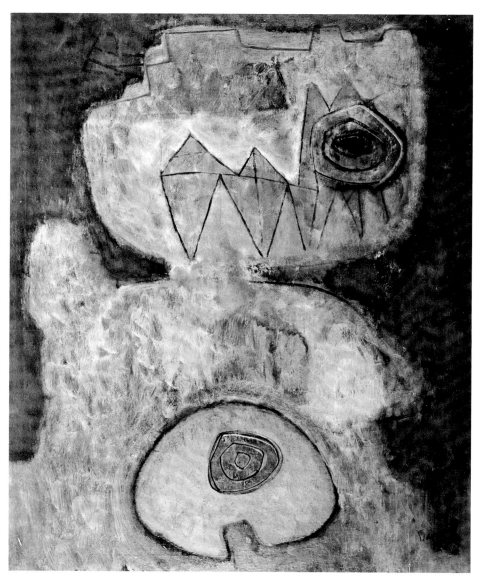

**97** William Baziotes, *Dwarf,* 1947

# WILLIAM BAZIOTES
# 1912-1963

There has been a tendency to underestimate the work of William Baziotes in some quarters since it lacks the dramatic vigor of Pollock or Kline, the tragic flare of Gorky, or the intellectual eloquence of Motherwell. However, the biomorphic shapes, fantastic animal-like images, and elegantly painted surfaces of Baziotes' canvases suggest a quiet, yet unsettling, world.

Baziotes came to New York from Pittsburgh in 1933 and studied with Leon Kroll at the National Academy of Design. He worked for the WPA Federal Arts Project during the depression years. He was a somewhat obscure figure, however, until Peggy Guggenheim began to show his work in her gallery in 1944.

Along with many other American painters, Baziotes shared the Surrealists' interest in the unconscious as a source for painting: William Rubin remarks: "This 'intimist' painter, who might be called the Redon of the new American painting, never made the transition to more marked abstraction that his colleagues did; until his death in 1963, Baziotes' art remained suspended in the transitional *surréalisant* state that characterized so much of American abstract painting in the mid-forties."[1] Baziotes himself wrote: "I cannot evolve any concrete theory about painting. What happens on the canvas is unpredictable and suprising to me. . . . Each painting has its own way of evolving. One may start with a few color areas on the canvas; another with a myriad of lines; and perhaps another with a profusion of colors. . . . As I work, or when the painting is finished, the subject reveals itself."[2]

Baziotes had been using automatist techniques for about three years when he began to exhibit in Miss Guggenheim's gallery. His images seem to refer to water forms, animals, or mythological subjects. He thought of "his pictures as 'mirrors' that reflected the strange and demonic side of his personality."[3]

It was not until 1946, however, that he began to paint his most important canvases, and 1947 was a key year (as it was for Pollock and Gorky). During that year he completed major works such as *Dwarf* [97] and *Night Mirror* [98], which demonstrate his tendency to develop large, static images and amorphous surfaces.

After beginning a painting in one of the various ways described in the statement above, he wrote: "Each beginning suggests something. Once I sense the suggestion, I begin to paint intuitively. The suggestion then becomes a phantom that must be caught and made real."[4]

**98** William Baziotes, *Night Mirror,* 1947

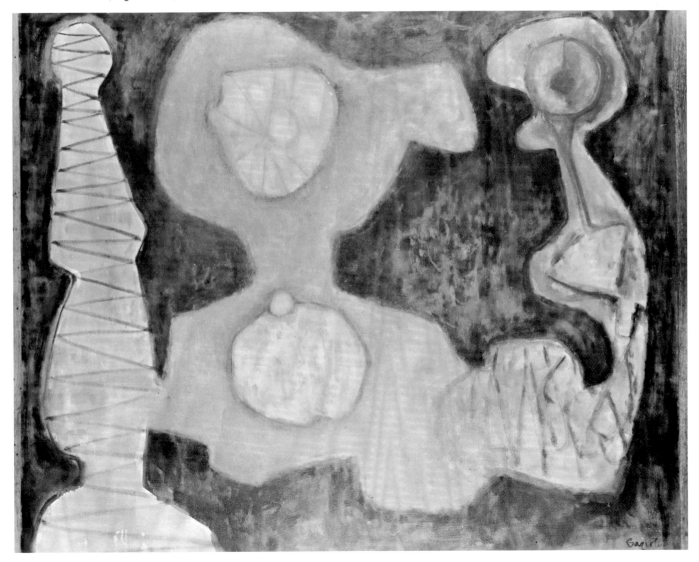

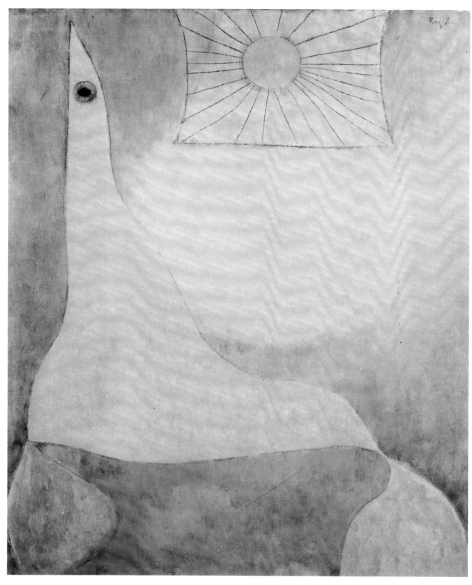

**99** William Baziotes, *Moon Animal,* 1950

Once again, as with so many other American painters, it was the influence of Picasso and Miró from afar, and Matta's presence on the scene, that was most important. Baziotes reported: "Well, I looked at Picasso [in the Museum of Modern Art's retrospective exhibition in 1937] until I could smell his armpits and the cigarette smoke on his breath. Finally, in front of one picture — a lone figure on a beach [*Seated Bather*] — I got it. I saw that the figure was not his real subject. The plasticity wasn't either — although the plasticity was great. No, Picasso had uncovered a feverishness in himself and is painting it — a feverishness of death and beauty."[5]

Matta communicated his enthusiasm about automatism and the idea that abstract art could articulate content to Baziotes, as well as to Motherwell and other Americans. Baziotes met Matta in 1940 and after that his painting changed. Although Baziotes could not accept the theoretical anti-aestheticism of Surrealism, he was accepted by the Surrealists more readily than most other American artists. Two of his paintings were included in the International Surrealist Exhibition held in New York in 1942.

It was Miró's method and his respect for aesthetic values that, in the long run, probably convinced Baziotes that he could combine automatism and good painting. However, his images were much more quiescent than Miró's. During the 1940s he spread color thinly across the canvas surface until an image suggested itself; he then developed it patiently and with care for nuances of the painted surface.

Along with Motherwell, Rothko, David Hare, and Clyfford Still, he helped establish a school called The Subjects of the Artist in 1948. They insisted that "students would gain more if they knew 'what modern artists paint about as well as how they paint.' "[6]

162

That same year Baziotes, who shared many of the other American artists' and critics' interest in Greek mythology and tragic theater as well as Nietzsche's writings, wrote a piece for the October issue of *Tiger's Eye* in a Nietzschean style: "To be inspired, that is the thing; to be possessed; to be bewitched; to be obsessed. That is the thing. To be inspired."[7] This kind of sentiment was supported, and perhaps even suggested, by critics and curators such as Nicolas Calas, James Johnson Sweeney, and Harold Rosenberg.

After 1950 Baziotes' images were more carefully composed and tightly defined. The nuanced surface of *Moon Animal* [99], for example, contrasts broad, flat images with crisp, linear patterns. The clean, undulant contours of the strange biomorphic form rearing its head skyward is carefully integrated with the few other elements in the composition. The moon sends out its rays to the edges of an irregular rectangle. Between these two, uniting them, is a large, softly blurred oval shape, suggesting light emanating from the canvas itself. Baziotes was now painting only two or three canvases a year, working many months to complete one.

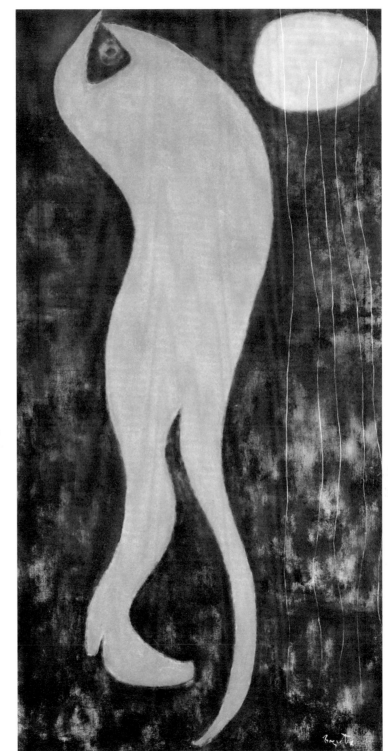

**100** William Baziotes, *Jungle Night,* 1953

163

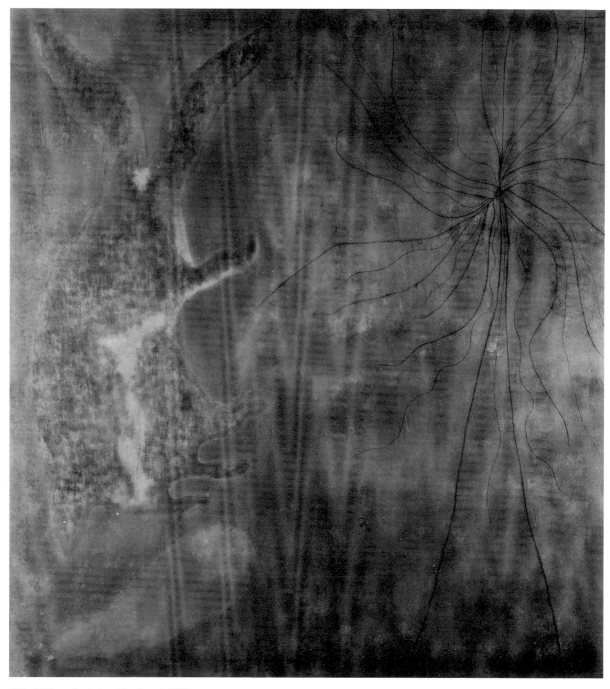

**101** William Baziotes, *The Pond,* 1955

At the same time, his subjects were strange, boneless, amoeboid creatures, as in *Jungle Night* [100] and *The Pond* [101]. His surfaces seem to project a softly glowing light, more like shimmering, gelatinous substances than the colored "mists" of Rothko. Yet, they remain quiet, tranquil, and mysterious. They are closer to orthodox European Surrealism than the work of most other Americans.

1. William S. Rubin, *Dada and Surrealist Art* (New York: Harry N. Abrams, Inc., 1968), p. 408.

2. William Baziotes, "I Cannot Evolve Any Concrete Theory," *Possibilities* 1, No. 1 (Winter 1947-48): 2; quoted in Irving Sandler, *The Triumph of American Painting: A History of Abstract Expressionism* (New York and Washington: Praeger, 1970), p. 93.

3. Sandler, p. 72.

4. Ibid.

5. Rudi Blesh, *Modern Art U. S. A.* (New York: Alfred A. Knopf, 1956), pp. 268-69.

6. Dore Ashton, *The New York School* (New York: Viking Press, 1971), p. 196.

7. Ibid., p. 188.

# JOSEPH CORNELL 1903-1972

One of the first Americans to be recognized as sharing the Surrealist spirit by Julien Levy and some of the expatriate Surrealists, Joseph Cornell was perhaps the last, and one of the greatest, Symbolists. His art is unique; it appears in some ways to be naive and childlike. His boxes and collages depend on subtle nuances of both iconography and form to elicit responses to their unique poetry.

Born on Christmas Eve in 1903, he lived his adult life with his mother and brother, who suffered from cerebral palsy, in a small house on Utopia Parkway in Flushing, New York. In answer to a Museum of Modern Art biographical questionnaire in 1936, Cornell replied: "Education: Went to Andover; No art instruction; Natural talent." And under "Particulars," he listed: "Shadow Boxes; Montages; Two surrealist scenarios . . . ."[1]

Schwitters had wandered the streets of Hanover picking up debris to use in his Merz collages and constructions; Cornell haunted the second-hand shops and bookstores in New York, accumulating bric-a-brac, old books, albums, and journals which provided the elements for his collages and stage-like boxes. In the early 1930s he was inspired by Max Ernst's montages, especially the album *La Femme 100 Têtes.* However, the major influences on his thought, and therefore his art, were nineteenth-century Romantic writers and Symbolists such as Gerard de Nerval, Thomas de Quincey, Rimbaud, and Mallarmé, as well as Americans such as Emily Dickinson, Henry James, and the founder of Christian Science, Mary Baker Eddy. He was interested in dreams, as were the Surrealists, and he juxtaposed mundane objects that were logically unrelated but which acquired a magical quality through their close association.

Cornell was closer to the mysticism of the Symbolists, however, than to the Freudian concerns of the Surrealists. As Dore Ashton suggests, Cornell recognized in his own experience the hypnagogic state described by Gerard de Nerval: "Lost in a kind of half-sleep, all my youth passed through my memory again. This state, when the spirit still resists the strange combinations of dreams, often allows us to compress in a few moments the most salient pictures of a long life."[2]

Thus, it is not the unconscious as much as the semi-conscious, dreamlike state in which one's thoughts and memories are at least partly directed by conscious desires that concerned him. He would sometimes fall silent during a conversation, for example, gazing into some private space. Such periods of reverie might last several minutes, giving one the feeling that he was probably dwelling in fantasy with one of his nineteenth-century heroines such as the great diva Malibran or his adored ballerina, Fanny Cerito.

Cornell's love for such near-legendary dancers, singers, and actresses of the romantic past merged almost imperceptibly with his idolatry of contemporary figures of beauty and innocent sexuality such as Jeanne Eagels, Hedy Lamarr, Marilyn Monroe, and Sheree North. Yet his adoration demanded a certain distance to retain its idealism. In 1946 he did an exhibition at the Hugo Gallery called *Portraits of Women*; in it he celebrated his nineteenth-century loves including Malibran, Taglioni, and Cerito. At the same time, he created a large "habitat" in a small room as an homage to the prima ballerina Jeanmaire, who was then performing in New York. She was invited to visit the room, but when she approached it, Cornell — in an agony of shyness — refused to be introduced to her.[3]

Cornell's mental excursions into the past were interrupted by real excursions into New York City, where he accumulated the objects and journals that he used as source material for his boxes and collages. Among his treasures were to be found images of voluptuous nudes taken from cheap magazines and which seemed to merge in his thoughts with the dream beauties of the past.[4]

**102** Joseph Cornell, *Homage to the Romantic Ballet,* 1942

Modern science also played a role in Cornell's interests. Albert Einstein, Niels Bohr, Max Planck and others reinforced his own convictions concerning the limit of empirical knowledge and the mystery behind the appearance of the world. As Ashton remarks: "Planck's concern with the Spirit, his readiness to cite God, and his ethical position were of tremendous moral significance to Cornell. The conclusion Planck reaches . . . reflects Cornell's deepest convictions: 'And so we arrive at a point where science acknowledges the boundary beyond which it may not pass, while it points to those farther regions which lie outside the sphere of its activities.' "[5]

Cornell did not feel at ease in museums; he was inspired by viewing the world around him, by reading, and by fantasizing. Motherwell asked: "What kind of man is this, who, from old cardboard photographs collected in second-hand bookstores, has reconstructed the nineteenth century 'grand tour' of Europe for his mind's eye more vividly than those who took it . . .?"[6]

Cornell's boxes served as stages for poetic homages to his private loves and obsessions. For example, *Homage to the Romantic Ballet* [102], 1942, is a box containing a number of clear cubes. Inside the lid of the box is the following legend:

On a moonlight night in the winter of 1855 the carriage of Maria Taglioni was halted by a Russian highwayman, and that ethereal creature commanded to dance for this audience of one upon a panther's skin spread over the snow beneath the stars. From this little actuality arose the legend that, to keep alive the memory of this adventure so precious to her, Taglioni formed the habit of placing a piece of ice in her jewel casket or dressing-table drawer where, melting among the sparking stones, there was evoked a hint of the starlit heavens over the ice-covered landscape.

The poetic legend and the casket with chunks of "ice" are both necessary for the full experience of this work. As Motherwell remarks: "His true parallels are not to be found among the painters and sculptors, but among our best poets. . . ."[7]

Among the nineteenth-century poets that entranced him, Mallarmé in particular demonstrates a similar reverence for dreams, for mystery, and for magic. Mallarmé, like Cornell, was also concerned with enclosed spaces isolated from the world. In fact, Cornell used the term "sanctuary", a word that occurs frequently in Mallarmé's poetry.[8]

Among the Surrealist painters, Cornell was attracted to Magritte's imagery, although it was Ernst he most admired. Yet, as Ashton remarks: "He sensed, as did Ernst, that there was a fundamental spiritual gulf between their sensibilities."[9] Strangely enough, of those in the Surrealist group, it was Duchamp — the most insistent anti-art figure — who fully appreciated the authentic poetry of Cornell's works. Visual similarities between some of their works are undeniable, but the satirical wit of Duchamp's works was very far from the romantic flavor of Cornell's boxes and collages.

Cornell met most of the Surrealists at Julien Levy's gallery, where he appeared and was given his first exhibition in December 1939. While he found these associations exciting and inspiring, his own work retained its ingenuous, romantic qualities — in contrast to the sophistication and irony of many Surrealist works.

The box *Observatory* [103], done in 1950, for example, evokes the cold, star-filled, immense heavens seen through an aperture in an enclosed room. Bits of wood, wire mesh, and a metal ring are carefully arranged and painted white. The poetry of the star-filled night sky could not be more sensitively evoked by the most poetic words.

**103** Joseph Cornell, *Observatory,* 1950

167

*Night Skies: Auriga* [104], dated 1954, also reveals the star-filled blackness through an opening. On the right-hand side, however, there is an engraved figure from an old astrological book carrying several animals on his back. (Auriga means guide or charioteer.) Cornell has pasted the words "Hotel de l'Etoile" (Hotel of the Star) above an opening. *(Etoile* in French also carries the connotation of fate or destiny.) A single white column runs from top to bottom of the box on the left-hand side. Thus, the heavens, astrology, fate, and other connotations emanate from this simple poetic image.

**104** Joseph Cornell, *Night Skies: Auriga,* 1954

*Homage to Blériot* [105], 1956, is purer in form. The interior of the box is stained with a thin blue tone exposing the wood grain. Toward the top center a white trapeze-like structure quivers at the tip of a coiled spring. An azure hue and a delicately balanced, simple mechanism swaying in the interior space create a visual poem in homage to Louis Blériot, the French inventor of the monoplane who, in 1909, became the first person to fly the English Channel in a heavier-than-air machine.

*Hôtel de la Duchesse Anne* [106], 1957, includes two springs, one on each side of the box. One of Cornell's favorite images, a parrot, perches on the left side of the box, a lattice and wooden column climb the right side. A colorful, marbleized ball rests on the floor. Pasted to the back wall in the upper right-hand corner are three stamps — one with a butterfly and two with beetles are pasted on top of a torn newspaper announcement which provides both the title and subject of this box. The newspaper is from Nantes; it announces the renovation and reopening for families of the Hôtel de la Duchesse Anne. Anne, Duchess of Brittany in the late fifteenth century, became queen of France as consort to Charles VIII. Before marrying Charles, however, she was married by proxy to Maximilian I of Austria. When he failed to aid her with armed forces, she was forced by Charles to have the marriage annulled and marry him. When he died without issue, she married his successor, Louis XII. The marriage of their daughter to Francis I of France led to the incorporation of Brittany by France. Surely this bit of history and the newspaper notice about the hotel stimulated Cornell's romantic imagination.

**105** Joseph Cornell, *Homage to Blériot,* 1956

Cornell was one of those rarities of history — an authentic genius, with little formal education, no training as an artist, and no experience as a world traveler; yet his wide interests and daydreams led him to construct visual poems that evoked nostalgia for places, times, and people he could not have known. His works have an air of authenticity that is more persuasive than any history text. As Motherwell notes and then asks: "His work forces you to use the word 'beautiful.' What more do you want?"

1. Dore Ashton, *A Joseph Cornell Album* (New York: Viking Press, 1974), p. 4.

2. Ibid., p. 12.

3. Ibid., p. 32.

4. On a visit to his home he once laid a half-finished collage using one of these images before me on the kitchen table next to a reproduction of a drawing of a female nude by Pierre Paul Prud'hon.

5. Ashton, p. 55.

6. Robert Motherwell, "Preface to a Joseph Cornell Exhibition." (Written for a proposed catalog for an exhibition at the Walker Art Center, Minneapolis, 1953, but the catalog was never printed. This preface was included in *Joseph Cornell Portfolio,* printed along with other material and a catalog of a Joseph Cornell Exhibition at Leo Castelli's Gallery, New York; Richard D. Feigen & Company, New York; and James Corcoran Gallery, Los Angeles, California, 1976.)

7. Ibid.

8. Ashton, pp. 64-65.

9. Ashton, p. 73.

**106** Joseph Cornell, *Hôtel de la Duchesse Anne,* 1957

# Catalog

**Jean (Hans) Arp**
French (Alsatian), 1887-1966

**5** *Collage,* 1938
Collage, 11¾ x 15⅜ inches (29.9 x 39 cm.). Mr. and Mrs. Jimmy Ernst, New York.

**6** *Forest,* 1916
Painted wood relief, 12⅞ x 7¾ x 3 inches (32.7 x 19.7 x 7.6 cm.). National Gallery of Art, Andrew W. Mellon Purchase Fund, 1977.

**6A** *Forest,* ca. 1916
Painted wood relief, 16⅛ x 20⅞ x 3¼ inches (41.3 x 53 x 8.3 cm.). Contemporary Collection of The Cleveland Museum of Art, 70.52.

**9A** *Head on Claws (Tête sur Griffes),* 1949
Bronze, 18 x 9 x 8¾ inches (45.7 x 22.7 x 22.3 cm.). Hirshhorn Museum and Sculpture Garden, Smithsonian Institution.

**8** *Homme-Oiseau, (Man-Bird),* 1956
Sprayed lacquer on masonite, 38⅞ x 29⅝ inches (98.7 x 75.2 cm.). Mr. and Mrs. Frank H. Porter.

**7** *Mountain, Table, Anchors, Navel,* 1925
Oil on cardboard with cutouts, 29⅝ x 23½ inches (75.2 x 59.7 cm.). The Museum of Modern Art, New York, Purchase, 1936.

**9** *Shell Crystal,* 1938
Bronze, 12¾ x 13 x 13 inches (32.4 x 33 x 33 cm.). Mr. and Mrs. Frank H. Porter.

**9B** *Tête Heaume,* 1960
Bronze, 21¼ x 14 x 8½ inches (54 x 35.6 x 21.6 cm.). Mr. and Mrs. Frank H. Porter.

**William Baziotes**

American, 1912-1963

**97** *Dwarf,* 1947
Oil on canvas, 42 x 36⅛ inches (106.7 x 91.7 cm.). The Museum of Modern Art, New York, A. Conger Goodyear Fund, 1947.

**99** *Moon Animal,* 1950
Oil on canvas, 42 x 36⅛ inches (106.7 x 91.7 cm.). Krannert Art Museum, University of Illinois, Champaign, Illinois.

**98** *Night Mirror,* 1947
Oil on canvas, 47¾ x 36⅛ inches (121.3 x 91.7 cm.). Vassar College Art Gallery, Gift of Mrs. John D. Rockefeller, III.

**101** *The Pond,* 1955
Oil on canvas, 72 x 66 inches (182.8 x 167.6 cm.). The Detroit Institute of Arts, gift of the Friends of Modern Art.

**100** *Jungle Night,* 1953
Oil on canvas, 72 x 36 inches (182.9 x 91.4 cm.). Private collection.

**Giorgio de Chirico**

Italian (born in Greece), 1888-1978

**15** *The Anguish of Departure,* 1913-14
Oil on canvas, 33½ x 27¼ inches (85.1 x 69.2 cm.). The Albright-Knox Art Gallery, Buffalo, New York. The Room of Contemporary Art Fund.

**16** *Interno Metafisico con Biscotte,* 1916
Oil on canvas, 32 x 25⅝ inches (81.3 x 65.1 cm.). Private collection, USA.

**17** *The Jewish Angel,* 1916
Oil on canvas, 26½ x 17¼ inches (67.3 x 43.8 cm.). Mr. and Mrs. Jacques Gelman.

**13** *The Nostalgia of the Infinite,* 1913-14 (?),
dated on painting 1911
Oil on canvas, 53¼ x 25½ inches (135.3 x 64.8 cm.). The Museum of Modern Art, New York, Purchase, 1936.

**14** *Song of Love,* 1914
Oil on canvas, 28¾ x 23½ inches (73 x 59.7 cm.). The Museum of Modern Art, New York, Bequest of Nelson A. Rockefeller, 1979.

**Joseph Cornell**

American, 1903-1972

**105** *Homage to Blériot,* 1956
Box, 18½ x 11¼ x 4¾ inches (47 x 28.6 x 12.1 cm.). Mr. and Mrs. Edwin A. Bergman.

**102** *Homage to the Romantic Ballet,* 1942
Box, 6⅝ x 10 x 4 inches (16.8 x 25.4 x 10.2 cm.). Mr. and Mrs. Edwin Bergman.

**106** *Hôtel de la Duchesse Anne,* 1957
Box, 17⅝ x 12¼ x 4⅜ inches (44.8 x 31.1 x 11.1 cm.). Mr. and Mrs. Edwin A. Bergman.

**104** *Night Skies: Auriga,* 1954
Box, 19 x 13½ x 7⅛ inches (48.3 x 34.3 x 18.1 cm.). Mr. and Mrs. Edwin A. Bergman.

**103** *Observatory,* 1950
Box, 18⅛ x 11⅞ x 5¾ inches (46 x 30.2 x 14.6 cm.). Mr. and Mrs. Edwin A. Bergman.

**Salvador Dali**

Spanish, b. 1904

**54** *Accommodations of Desire,* 1929
Oil on panel, 8⅝ x 13¾ inches (21.9 x 34.9 cm.). Mr. and Mrs. Julien Levy.

**56** *Angélus Architectonique de Millet,* 1933
Oil on canvas, 28¾ x 23¾ inches (73 x 60.3 cm.). Perls Galleries, New York.

NOTE: The largest collection of paintings and other works by Salvador Dali is the A. Reynolds Morse collection at the Dali Museum, Commerce Park Road, Cleveland. Visits are by appointment.

**58** *Cardinal, Cardinal,* 1935
Tempera and oil on panel, 6⅜ x 8⅝ inches (16.2 x 21.9 cm.). Munson-Williams-Proctor Institute, Utica, New York.

**57** *Hallucination Partielle: Six Images de Lenine sur un Piano,* 1931
Oil on canvas, 44⅞ x 57½ inches (114 x 146 cm.). Centre Georges Pompidou, Musée Nationale d'Art Moderne, Paris.

**55** *Illumined Pleasures,* 1929
Oil and collage on composition board, 9⅜ x 13¾ inches (23.8 x 34.9 cm.). The Museum of Modern Art, New York, The Sidney and Harriet Janis Collection, 1967.

**Paul Delvaux**

Belgian, b. 1897

**76** *Le Chemin de la Ville (Procession),* 1939
Oil on canvas, 43⁵/₁₆ x 51³/₁₆ inches (110 x 130 cm.). Yale University Art Gallery, Gift of Mr. and Mrs. Hugh J. Chisholm, Jr., B.A. 1936.

**74** *Femme dans une Grotte (Femme au Miroir),* 1936
Oil on canvas, 28 x 36 inches (71 x 91.5 cm.). Thyssen-Bornemisza Collection, Lugano, Switzerland.

**77** *Les Mains (The Hands),* 1941
Oil on canvas, 43¼ x 51¼ inches (110 x 130.2 cm.). Richard S. Zeisler Collection.

**75** *Propositions Diurnes (Femme au Miroir),* 1937
Oil on canvas, 41¹/₄ x 51³/₁₆ inches (104.8 x 130 cm.). Private collection, New York.

## Marcel Duchamp
American (born in France), 1887-1968

**1** *The Chocolate Grinder No. 1,* 1913
Oil on canvas, 24¾ x 25⅝ inches (62.8 x 65.1 cm.). Philadelphia Museum of Art, The Louise and Walter Arensberg Collection.

## Max Ernst
French (born in Germany), 1891-1976

**23** *Blind Swimmer,* 1934
Oil on canvas, 36¼ x 28¾ inches (92 x 73 cm.). Mr. and Mrs. Julien Levy.

**21** *Forêt (Forest),* 1927
Oil on canvas, 45 x 57½ inches (114.3 x 146 cm.). Private collection.

**18** *Landscape Fantasy,* ca. 1916
Oil on burlap, 26¼ x 24½ inches (66.7 x 62.2 cm.). The Solomon R. Guggenheim Museum, New York.

**22** *Loplop Introduces,* 1932
Pasted paper, water color, photograph, with pencil drawing, 19⅜ x 25½ inches (49.2 x 64.8 cm.). Mr. and Mrs. Edwin A. Bergman.

**24** *Stolen Mirror,* 1941
Oil on canvas, 25⅝ x 31⅞ inches (65 x 81 cm.). Mr. and Mrs. Jimmy Ernst, New York.

**24A** *The Table Is Set,* 1944
Bronze, 12⅛ x 22⅛ x 23¾ inches (30.8 x 56.2 x 60.3 cm.). Hirshhorn Museum and Sculpture Garden, Smithsonian Institution.

**20 Undulating Earthquake,** 1927
Oil on canvas, 9⁷/₁₆ x 7⁷/₁₆ inches (24 x 19 cm.). Private collection, USA.

**19** *Weib, Greis und Blume (Woman, Old Man, and Flower),* 1923-24
Oil on canvas, 28 x 51¼ inches (96.5 x 130.2 cm.). The Museum of Modern Art, New York, Purchase, 1937.

## Alberto Giacometti
Swiss, 1901-1966

**71** *Le Couple (Homme et Femme),* 1926
Bronze, 23⅝ x 14½ x 7⅛ inches (60 x 36.8 x 18.1 cm.). Pierre Matisse Gallery.

**73** *Hands Holding the Void,* 1934-35
Bronze, 60¼ inches (153 cm.). The St. Louis Art Museum, Purchase: Friends Fund 217.1966.

**72** *Reclining Woman Who Dreams,* 1929
(cast ca. 1959)
Painted bronze, 9¼ x 16⅞ x 5¾ inches (23.5 x 42.6 x 14.5 cm.). Hirshhorn Museum and Sculpture Garden, Smithsonian Institution.

## Arshile Gorky
American (born in Armenia), 1904-1948

**87** *Agony,* 1947
Oil on canvas, 40 x 50½ inches (101.6 x 128.3 cm.). The Museum of Modern Art, New York, A. Conger Goodyear Fund, 1950.

**83** *The Apple Orchard,* 1943-46
Pastel on paper, 42 x 52 inches (106.7 x 132.1 cm.). Private collection.

**88** *Dark Green Painting,* ca. 1948
Oil on canvas, 43⅞ x 55⅞ inches (111.5 x 141.9 cm.). Mrs. H. Gates Lloyd.

**85** *Housatonic Falls,* 1943-44
Oil on canvas, 34 x 44 inches (86.3 x 111.8 cm.). Private collection.

**82** *Landscape,* 1943
Oil and pencil on canvas, 19½ x 25 inches (49.5 x 63.5 cm.). Contemporary Collection of The Cleveland Museum of Art, 63.152.

**86** *The Plough and the Song,* 1947
Oil on canvas, 49⅞ x 61¾ inches (126.8 x 156.9 cm.). Allen Memorial Art Museum, Oberlin College, R. T. Miller, Jr. Fund, 52.16.

**84** *Water of the Flowery Mill,* 1944
Oil on canvas, 42¼ x 48¾ inches (107.3 x 123.9 cm.). The Metropolitan Museum of Art, George A. Hearn Fund, 1956.

## Paul Klee
Swiss (German School), 1879-1940

**59** *Aging Venus,* 1922
Water color and oil transfer drawing and paper collage, 11⅝ x 23⅛ inches (29.5 x 58.7 cm.). The Solomon R. Guggenheim Museum, New York.

**62** *Composition,* 1931
Encaustic on board, 21½ x 27½ inches (54.6 x 69.9 cm.). Collection of Dr. and Mrs. Howard D. Sirak.

**63** *Fish Magic,* 1925
Oil on cloth mounted on board, 30¼ x 38⅝ inches (76.8 x 98.1 cm.). Philadelphia Museum of Art, The Louise and Walter Arensberg Collection.

**61** *Karneval im Schnee (Carnival in the Snow),* 1923
Water color, 10½ x 10 inches (26.6 x 25.4 cm.). Contemporary Collection of The Cleveland Museum of Art, 69.46.

**64** *Mask of Fear,* 1932
Oil on burlap, 39½ x 22½ inches (100.3 x 57.2 cm.). The Museum of Modern Art, New York, Nelson A. Rockefeller Fund, 1978.

**60** *Women's Pavilion (Frauen Pavillon),* 1921
Oil on board, 15¾ x 20⅛ inches (40 x 51.1 cm.). Collection of Mr. and Mrs. Ralph F. Colin, New York.

**René Magritte**

Belgian, 1898-1967

**47** *The Empire of Light, II
(L'Empire des Lumières, II),* 1950
Oil on canvas, 31 x 39 inches (78.7 x 99 cm.). The Museum of Modern Art, New York, Gift of D. and J. de Menil, 1951.

**48** *Force de l'Habitude (Force of Habit)*
(altered by Max Ernst), 1960
Oil on canvas, 23⅜ x 19⅛ inches (59.4 x 48.6 cm.). Mr. and Mrs. Jimmy Ernst, New York.

**46** *La Loi de la Pesanteur (The Law of
Gravity),* 1929
Oil on canvas, 21⅝ x 15⅛ inches (54.9 x 38.4 cm.). Private collection, USA.

**45** *The Menaced Assassin (L'Assassin
Menacé),* 1926
Oil on canvas, 59¼ x 76⅞ inches (150.5 x 195.3 cm.). The Museum of Modern Art, New York, Kay Sage Tanguy Fund, 1966.

**44** *La Trahison des Images
(Ceci n'est pas une Pipe),* 1928-29
Oil on canvas, 25⅜ x 37 inches (64.5 x 94 cm.). Los Angeles County Museum of Art — Purchased with funds provided by the Mr. and Mrs. William Preston Harrison Collection.

**Man Ray**

American, 1890-1976

**4** *L'Homme Nouveau, (The New
Man),* 1964
Wood box, 8 x 8 x 16½ inches (20.3 x 20.3 x 41.9 cm.). Mr. and Mrs. Frank H. Porter.

**3** *The Rope Dancer Accompanies Her-
self with Her Shadow,* 1916
Oil on canvas, 52 x 73⅜ inches (132.1 x 186.4 cm.). The Museum of Modern Art, New York, Gift of G. David Thompson, 1954.

**André Masson**

French, b. 1896

**41** *In the Tower of Sleep
(Dans la Tour du Sommeil),* 1938
Oil on canvas, 32 x 39½ inches (81.2 x 100.3 cm.). The Baltimore Museum of Art, Bequest of Mrs. Saidie A. May.

**42** *Meditation on an Oak Leaf,* 1942
Tempera, pastel, and sand on canvas, 40 x 33 inches (101.6 x 83.8 cm.). The Museum of Modern Art, New York, Given anonymously, 1950.

**43** *Pasiphaë,* 1943
Oil and tempera on canvas, 39¾ x 50 inches (101 x 127 cm.). Dr. and Mrs. Jerome H. Hirschmann.

**Matta (Roberto Sebastian
Antonio Echaurren)**

Chilean, b. 1911

**78** *Morphologie Psychologique,* ca.
1939
Oil on canvas, 28³/₈ x 36³/₁₆ inches (72 x 91 cm.). Mr. and Mrs. Jimmy Ernst, New York.

**80** *Prince of the Blood,* 1943
Oil on canvas, 30 x 72½ inches (76.2 x 184.2 cm.). Pierre Matisse Gallery.

**79** *The Prisoner of Light,* 1943
Oil on canvas, 77 x 99 inches (195.6 x 251.4 cm.). Harold Diamond, Harriet Griffin Gallery, and B. C. Holland, Inc.

**81** *Splitting of the Ergo,* 1945-46
Oil on canvas, 77½ x 96 inches (196.8 x 243.8 cm.). Mr. and Mrs. Burton Tremaine.

**Joan Miró**

Spanish, b. 1893

**28** *Horse at the Seashore,* 1926
Oil on canvas, 28¾ x 36¼ inches (73 x 92 cm.). William R. Acquavella, New York.

**25** *The Hunter (Catalan Landscape),*
1923-24
Oil on canvas, 25½ x 39½ inches (64.8 x 100.3 cm.). The Museum of Modern Art, New York, Purchase, 1936.

**27** *Landscape (The Hare),* 1927
Oil on canvas, 51 x 76⅝ inches (129.5 x 193 cm.). The Solomon R. Guggenheim Museum, New York.

**29** *Nocturne,* 1935
Oil on copper, 16½ x 11½ inches (42 x 29.2 cm.). The Cleveland Museum of Art, Purchase, Mr. and Mrs. William H. Marlatt Fund, 78.61.

**26** *Painting,* 1925/1964
Oil on canvas, 35 x 45¾ inches (88.9 x 116.2 cm.). Rosamond Bernier.

CONSTELLATIONS

**40** *The Beautiful Bird Revealing the
Unknown to a Pair of Lovers,* 1941
Gouache and oil wash, 18 x 15 inches (45.7 x 38.1 cm.). The Museum of Modern Art, New York, Acquired through the Lillie P. Bliss Bequest.

**37** *Le Chant du Rossignol à Minuit et la
Pluie Matinale (The Nightingale's
Song at Midnight and Morning
Rain),* 1940
Gouache on paper, 15 x 18 inches (38.1 x 45.7 cm.). Perls Galleries, New York.

**36** *Femme dans la Nuit (Woman in the
Night),* 1940
Gouache and oil wash, 18⅛ x 15 inches (46 x 38.1 cm.). Art Advisory S.A.

**33** *The Ladder for Escape,* 1940
Gouache, water color, brush, and ink, 15 x 18 inches (38.1 x 45.7 cm.). The Museum of Modern Art, New York, Bequest of Helen Acheson.

**31** *L'Oiseau Migrateur (The Migratory Bird),* 1941
Gouache and oil wash on paper, 18⅛ x 15 inches (46 x 38.1 cm.). William R. Acquavella, New York.

**38** *La Poétesse (The Poetess),* 1940
Gouache on paper, 15 x 18 inches (38.1 x 45.7 cm.). Collection of Mr. and Mrs. Ralph F. Colin, New York.

**30** *Le Reveil au Petit Jour (Awakening at Dawn),* 1941
Gouache on paper, 18 x 15 inches (45.7 x 38.1 cm.). Collection of Mr. and Mrs. Ralph F. Colin, New York.

**32** *The 13th Ladder Brushed Against the Heavens,* 1940
Gouache and oil wash on paper, 18⅛ x 15 inches (46 x 38.1 cm.). Mrs. H. Gates Lloyd.

**39** *Woman at the Border of a Lake Irradiated by the Passage of a Swan,* 1941
Gouache and oil wash on paper, 18⅛ x 15 inches (46 x 38.1 cm.). Private collection, Switzerland.

**34** *Woman with Blond Armpit Combing Her Hair by the Light of the Stars,* 1940
Gouache and oil on paper, 15 x 18⅛ inches (38.1 x 46 cm.). Contemporary Collection of The Cleveland Museum of Art, 65.2.

**35** *Wounded Personage,* 1940
Gouache and oil wash on paper, 15 x 18⅛ inches (38.1 x 46 cm.). Mr. and Mrs. Robert Mosbacher.

**Robert Motherwell**
American, b. 1915

**91** *Figure in Black,* 1947
Collage and oil on panel, 24 x 19 inches (61 x 48.2 cm.). Private collection, Connecticut.

**92** *The Homely Protestant,* 1948
Oil on composition board, 96 x 48 inches (243.8 x 121.9 cm.). Private collection, Connecticut.

**89** *The Little Spanish Prison,* 1941
Oil on canvas, 27⅛ x 17 inches (68.9 x 43.2 cm.). Private collection, Connecticut.

**90** *Mallarmé's Swan,* 1944
Gouache, crayon, and paper on cardboard, 43½ x 35½ inches (110.5 x 90.2 cm.). Contemporary Collection of The Cleveland Museum of Art, 61.229.

**Francis Picabia**
French, 1879-1953

**2** *I See Again in Memory My Dear Udnie (Je Revois en Souvenir Ma Chère Udnie),* 1914
Oil on canvas, 98½ x 78¼ inches (250.1 x 198.7 cm.). The Museum of Modern Art, New York, Hillman Periodicals Fund, 1954.

**Pablo Picasso**
Spanish (French School), 1881-1973

**67A** *Bather with a Ball,* 1932
Oil on canvas, 57½ x 45 inches (146 x 114.3 cm.). Private collection, New York.

**70** *Goat Skull and Bottle,* 1951-52 (cast 1954)
Painted bronze, 31 x 37⅝ x 21½ inches (78.7 x 95.5 x 54.6 cm.). The Museum of Modern Art, New York, Mrs. Simon Guggenheim Fund, 1956.

**66** *Harlequin,* 1927
Oil on canvas, 31¾ x 25½ inches (80.7 x 64.8 cm.). Perls Galleries, New York.

**69** *Monkey and Her Baby,* 1951
Bronze, 21½ x 13⅛ x 24 inches (54.6 x 33.3 x 61 cm.). Lent by The Minneapolis Institute of Arts, Gift of Mr. and Mrs. John Cowles.

**67** *Seated Bather,* 1930
Oil on canvas, 64¼ x 51 inches (163.2 x 129.5 cm.). The Museum of Modern Art, New York, Mrs. Simon Guggenheim Fund, 1950.

**65** *Seated Woman (Femme Assise),* 1926-27
Oil on canvas, 51½ x 38½ inches (130.8 x 97.8 cm.). Collection, Art Gallery of Ontario, Purchase, 1964.

**68** *Woman in a Garden,* 1938
Oil on canvas, 51 x 38 inches (129.5 x 96.5 cm.). Mr. and Mrs. Daniel Saidenberg, New York.

**Jackson Pollock**
American, 1912-1956

**95** *Collage and Oil,* 1951
Oil and paper collage on canvas, 50 x 35 inches (127 x 88.9 cm.). The Phillips Collection, Washington.

**93** *Guardians of the Secret,* 1943
Oil on canvas, 48¾ x 75 inches (123.8 x 190.5 cm.). San Francisco Museum of Modern Art, Albert M. Bender Bequest Fund Purchase.

**94** *Number 5,* 1950
Oil on canvas, 53¾ x 39 inches (136.5 x 99.1 cm.). The Museum of Modern Art, New York, Gift of Mr. and Mrs. Walter Bareiss, 1957.

**96** *Portrait and a Dream,* 1953
Oil on canvas, 58⅛ x 134½ inches (147.6 x 341.6 cm.). Dallas Museum of Fine Arts, gift of Mr. and Mrs. Algur H. Meadows and the Meadows Foundation, Incorporated.

**Kurt Schwitters**

German, 1887-1948

**11** *Little Dance (Kleiner Tanz),* 1920
Collage, 5¼ x 4⅛ inches (13.3 x 10.5
cm.). Contemporary Collection of The
Cleveland Museum of Art, 63.1.

**10** *Radiating World,* 1920
Oil and paper collage on composition
board, 37½ x 26¾ inches (95.2 x 68
cm.). The Phillips Collection, Washing-
ton (Katherine S. Dreier Bequest).

**12** *Untitled,* 1923
Paper collage, 10¼ x 8 inches (26 x 20.3
cm.). Private collection.

**Yves Tanguy**

American (born in France), 1900-1955

**53** *The Five Strangers,* 1941
Oil on canvas, 38⅝ x 32 inches (98.1 x
81.3 cm.). Wadsworth Atheneum, Hart-
ford, The Ella Gallup Sumner and Mary
Catlin Sumner Collection.

**50** *Mama, Papa Is Wounded! (Maman,*
   *Papa est Blessé),* 1927
Oil on canvas, 36¼ x 28¾ inches (92 x
73 cm.). The Museum of Modern Art,
New York, Purchase, 1936.

**52** *Movements and Acts,* 1937
Oil on canvas, 25½ x 30¾ inches (64.8 x
52.7 cm.). Smith College Museum of Art,
Northhampton, Massachusetts, Gift of
the Kay Sage Tanguy Estate, 1964.

**51** *Passage of a Smile,* 1935
Oil on canvas, 25⅝ x 21¼ inches (65.1 x
54 cm.). The Toledo Museum of Art, Gift
of Edward Drummond Libbey.

**49** *The Storm,* 1926
Oil on canvas, 32 x 25¾ inches (81.3 x
65.4 cm.). Philadelphia Museum of Art,
The Louise and Walter Arensberg Col-
lection.

# Bibliography

## Selected General Bibliography

*Abstract and Surrealist Art in the United States.* San Francisco: San Francisco Museum of Art, 1978. Works of art selected by Sidney Janis.

*Abstract Expressionism: The Formative Years.* Ithaca: Cornell University, Herbert F. Johnson Museum of Art, 1978. Catalog by Robert Carleton Hobbs and Gail Levin.

Alexandrian, Sarane. *Surrealist Art.* Translated from the French by Gordon Clough. New York and Washington: Praeger, 1970.

Alquié, Ferdinand. *The Philosophy of Surrealism.* Translated from the French by Bernard Waldrop. Ann Arbor: University of Michigan Press, 1965.

*American Art at Mid-Century: The Subjects of the Artists.* Washington: National Gallery of Art, 1976. Catalog by E. A. Carmean, Jr. and Eliza E. Rathbone, with Thomas B. Hess.

*Artforum* 5 (September 1966). Special issue devoted to Surrealism. Essays by Max Kozloff, Lucy R. Lippard, Ronald Hunt, Robert Rosenblum, Toby Mussman, Roger Shattuck, William Rubin, Whitney Halstead, Kurt von Meier, Sidney Tillim, Annette Michelson, Nicolas Slonimsky, Nicolas Calas, and Jerrold Lanes.

Balakian, Anna. *Surrealism: The Road to the Absolute.* New York: Noonday Press, 1959.

Baur, John I. H. "Revolution in Subject: The Machine and the Subconscious." In *Revolution and Tradition in Modern American Art.* Cambridge, Mass.: Harvard University Press, 1951.

Breton, André. *Manifestoes of Surrealism.* Translated from the French by Richard Seaver and Helen R. Lane. Ann Arbor: University of Michigan Press, 1969. Includes "Preface for a Reprint of the Manifesto" (1929); "Manifesto of Surrealism" (1924); "Soluble Fish" (1924); "Preface for the New Edition of the Second Manifesto" (1946); "Second Manifesto of Surrealism" (1930); "A Letter to the Seers" (1925); "Political Position of Surrealism" (extracts); "Preface 1935"; "Political Position of Today's Art" (1935); "Speech to the Congress of Writers" (1935); "On the Time When the Surrealists were Right" (1935); "Surrealist Situation of the Object" (1935); "Prolegomena to a Third Surrealist Manifesto or Not" (1942); "On Surrealism in Its Living Works" (1953).

————. *Surrealism and Painting.* Translated from the French by Simon Watson Taylor. New York: Harper & Row, 1973. Includes "Surrealism and Painting" (1928); "Fragments" (1933-61); "Environs" (1936-62); "Further Affluences and Approaches" (1963-65).

————. *What Is Surrealism? Selected Writings.* Edited by Franklin Rosemont. New York: Monad Press, 1978. Introduction also by Rosemont.

*Cahiers d'Art* 11 (1936). Issues 1-2 contain articles by André Breton, Paul Eluard, Salvador Dali, and others; issues 6-7, articles by Max Ernst and Paul Eluard; issues 8-10, articles on Dada and Joan Miró.

Calas, Nicolas. "Surrealist Intentions," *Trans/formation* 1 (1950): 48-52.

*Dada and Surrealism Reviewed.* London: The Arts Council of Great Britain, 1978. Exhibition at the Hayward Gallery. Catalog by Dawn Ades; introduction by David Sylvester; supplementary essay by Elizabeth Cowling.

*Dada, Surrealism, and Their Heritage.* New York: The Museum of Modern Art, 1968. Catalog by William S. Rubin.

*The Disquieting Muse: Surrealism.* Houston: Contemporary Arts Museum, 1958. Contains excerpts from Herbert Read, *Surrealism and the Romantic Principle;* Jermayne MacAgy, "History Is Made at Night"; Julien Levy, "The Disquieting Muse."

*Exposition Internationale du Surréalisme.* Paris: Galerie Beaux-Arts, 1938. Exhibition organized by André Breton and Paul Eluard. Catalog contains "Dictionnaire abrégé du surréalisme" compiled by Breton, Eluard, and others.

*Exposition Internationale du Surréalisme: Le Surréalisme en 1947.* Paris: Galerie Maeght, 1947. Exhibition organized by André Breton and Marcel Duchamp.

*Fantastic Art, Dada, Surrealism.* New York: The Museum of Modern Art, 1936. Reprint. New York: Arno Press, 1970. Catalog edited by Alfred H. Barr, Jr.; 2nd ed., 1937, includes essays by Georges Hugnet.

*The Fifty-Eighth Annual Exhibition of American Painting and Sculpture: Abstract and Surrealist Art.* Chicago: The Art Institute of Chicago, 1947. Essays by Katherine Kuh and Frederick A. Sweet.

*First Papers of Surrealism.* New York: Coordinating Council of French Relief Societies, 1942. Exhibition at Reid Mansion; hanging by André Breton; webbing installation by Marcel Duchamp.

Fowlie, Wallace. *Age of Surrealism.* Bloomington: Indiana University Press, 1960.

Gascoyne, David. *A Short Survey of Surrealism.* London: Cobden-Sanderson, 1935.

Gauss, Charles E. "The Theoretical Backgrounds of Surrealism." *Journal of Aesthetics and Art Criticism* 2 (Fall 1943): 37-44.

Gershman, Herbert S. *The Surrealist Revolution in France.* Ann Arbor: University of Michigan Press, 1969.

———. *A Bibliography of The Surrealist Revolution in France.* Ann Arbor: University of Michigan Press, 1969.

Guggenheim, Peggy, ed. *Art of This Century: Objects, Drawings, Photographs, Paintings, Sculpture, Collages, 1910 to 1942.* New York: Art of This Century, 1942. Includes André Breton, "Genesis and Perspective of Surrealism"; Jean Arp, "Abstract Art, Concrete Art."

Haslam, Malcolm. *The Real World of the Surrealists.* London: Weidenfeld and Nicolson, 1978.

*The International Surrealist Exhibition.* Translated by David Gascoyne. London: New Burlington Galleries, 1936. Preface by André Breton; introduction by Herbert Read.

Janis, Sidney. *Abstract and Surrealist Art in America.* New York: Reynal & Hitchcock, 1944.

Jean, Marcel. *The History of Surrealist Painting.* Translated from the French by Simon Watson Taylor. New York: Grove Press, 1960.

Josephson, Matthew. *Life Among the Surrealists.* New York: Holt, Rinehart, and Winston, 1962.

Levy, Julien. *Surrealism.* New York: The Black Sun Press, 1936. Excerpts from the writings of twentieth-century Surrealists and precursors of Surrealism.

Lippard, Lucy, ed. *Dadas on Art.* Englewood Cliffs, N.J.: Prentice-Hall, 1971.

———. *Surrealists on Art.* Englewood Cliffs, N.J.: Prentice-Hall, 1970.

Motherwell, Robert, ed. *The Dada Painters and Poets: An Anthology.* New York: Wittenborn, Schultz, 1951. Critical bibliography by Bernard Karpel.

Nadeau, Maurice. *The History of Surrealism.* Translated from the French by Richard Howard. London: Jonathan Cape, 1965. Introduction by Roger Shattuck.

Peyre, Henri. "The Significance of Surrealism." *Yale French Studies* 1 (Fall-Winter 1948): 34-49.

Raymond, Marcel. *From Baudelaire to Surrealism.* New York: Wittenborn, Schultz, 1950.

Read, Herbert, ed. *Surrealism.* London: Faber & Faber, 1936. Contributions by André Breton, Hugh Sykes Davies, Paul Eluard, Georges Hugnet.

Richter, Hans. *Dada: Art and Anti-Art.* London: Thames and Hudson, 1965.

Rubin, William S. *Dada and Surrealist Art.* New York: Harry N. Abrams, 1968.

Schneede, Uwe M. *Surrealism.* Translated from the German by Maria Pelikan. New York: Harry N. Abrams, 1974.

Simon, Sidney. "Concerning the Beginnings of the New York School: 1939-1943." *Art International* 11 (Summer 1967): 17-23. Interviews with Peter Busa, Matta, and Robert Motherwell.

Soby, James Thrall. *After Picasso.* New York: Dodd, Mead & Company, 1935.

*Surrealism and Its Affinities: The Mary Reynolds Collection, A Bibliography Compiled by Hugh Edwards.* Chicago: The Art Institute of Chicago, 1956.

*Surrealism Then and Now.* Chicago: The Arts Club of Chicago, 1958.

*Surrealist Objects & Poems.* London: London Gallery, 1937. Foreword by Herbert Read.

Sweeney, James Johnson, ed. "Eleven Europeans in America." *The Museum of Modern Art Bulletin* 13 (September 1946): 1-39.

Verkauf, Willy, ed. *Dada: Monograph of a Movement.* New York: George Wittenborn, 1957. Texts in English, German, and French.

Waldberg, Patrick. *Surrealism.* London: Thames and Hudson, 1965.

Wechsler, Jeffrey. *Surrealism and American Art 1931-1947.* New Brunswick: Rutgers, The State University, 1976.

## Philosophy and Psychoanalysis

Barzun, Jacques. *Darwin, Marx, Wagner.* Garden City, N.Y.: Doubleday Anchor, 1958.

Beck, Lewis W. *A Commentary on Kant's Critique of Practical Reason.* Chicago: University of Chicago Press, 1960.

Brill, Abraham A. *Basic Principles of Psychoanalysis.* Garden City, N.Y.: Doubleday, 1949.

Fordham, Frieda. *An Introduction to Jung's Psychology.* London: Penguin, Pelican, 1953.

Freud, Sigmund. *Basic Writings of Sigmund Freud.* Translated and edited by Abraham A. Brill. New York: Modern Library, 1938.

———. *A General Introduction to Psychoanalysis.* Translated from the German by Joan Riviere, with authorized revisions. Garden City, N.Y.: Doubleday, Permabooks, 1953.

———. *On Creativity and the Unconscious.* New York: Harper and Brothers, 1958. Originally published as *Papers on Applied Psychoanalysis.* London: Hogarth Press, 1925. Translation supervised by Joan Riviere.

Hall, Calvin. *A Primer of Freudian Psychoanalysis.* Cleveland: World Publishing, 1954.

Hook, Sidney. *From Hegel to Marx: Studies in the Intellectual Development of Karl Marx.* New York: Humanities Press, 1950.

———. *Toward an Understanding of Karl Marx.* New York: John Day Company, 1933.

Jones, Ernest. *The Life and Work of Sigmund Freud.* 3 vols. New York: Basic Books, 1953-57.

Jung, Carl Gustav. *Psyche and Symbol.* Edited by Violet S. de Laszlo. Garden City, N.Y.: Doubleday Anchor, 1958.

*Kant on the Foundation of Morality.* Translated with commentary by E. A. Liddell. Bloomington and London: Indiana University Press, 1970. A modern version of the *Grundlegung.*

Körner, Stephan. *Kant.* Baltimore: Penguin, 1955.

Laski, Harold Joseph, ed. *The Communist Manifesto: Socialist Landmark.* London: G. Allen and Unwin, 1948.

Leontiev, Alekei. *Marx's Capital: An Aid to the Study of Political Economy.* New York: International Publishers, 1946.

Marcuse, Herbert. *Reason and Revolution: Hegel and the Rise of Social Theory.* London: Routledge & Kegan Paul, 1954.

————. *Soviet Marxism: A Critical Analysis.* New York: Columbia University Press, 1958.

Marx, Karl, and Engels, Friedrich. *Basic Writings on Politics and Philosophy.* Edited by Lewis S. Feuer. Garden City, N.Y.: Doubleday, 1959.

Marx, Karl. *Capital: A Critique of Political Economy.* Edited by Friedrich Engels. New York: Modern Library, 1906.

Mueller, Gustave E. "The Hegel Legend of 'Thesis — Antithesis — Synthesis.'" *Journal of the History of Ideas* 19 (1958): 411-414.

Mure, Geoffrey Reginald Gilchrist. *An Introduction to Hegel.* Oxford: Clarendon Press, 1940.

*An Outline of Psychoanalysis.* New York: Random House, Modern Library, 1925. Edited by James Samuel van Teslaar; contributions by Sigmund Freud, Abraham A. Brill, Carl Gustav Jung, James Samuel van Teslaar, and others.

Plamenatz, John. "The Social and Political Philosophy of Hegel." In *Man and Society,* vol. 2. New York and San Francisco: McGraw-Hill, 1963.

Ricoeur, Paul. *Freud and Philosophy.* Translated by Denis Savage. New Haven and London: Yale University Press, 1970. The Terry Lectures.

Strachey, James, ed. *The Standard Edition of the Complete Psychological Works of Sigmund Freud.* 24 vols. London: Hogarth Press, 1953-66.

Tucker, Robert. *Philosophy and Myth in Karl Marx.* Cambridge: At the University Press, 1961.

Wolff, Robert P., ed. *Kant: A Collection of Critical Essays.* Garden City, N.Y.: Doubleday, 1967.

## Literary Origins of Surrealism

Balakian, Anna. *Literary Origins of Surrealism: A New Mysticism in French Poetry.* New York: King's Crown Press, 1947.

Benedikt, Michael, ed. *The Poetry of Surrealism: An Anthology.* Boston and Toronto: Little, Brown & Co., 1974. Introduction, critical notes, and new translation by Benedikt. Includes poems by Guillaume Apollinaire, Pierre Reverdy, Tristan Tzara, Philippe Soupault, André Breton, Louis Aragon, Paul Eluard, Jean (Hans) Arp, Benjamin Péret, Robert Desnos, Antonin Artaud, René Daumal, Jacques Prévert, and Aimé Césaire.

Esslin, Martin. *The Theatre of the Absurd.* Woodstock, N.Y.: Overlook Press, 1973.

Jarry, Alfred. *Ubu Roi.* Translated from the French by Barbara Wright. Norfolk, Conn., and New York: New Directions, 1961.

Lautréamont, Le Comte de (Isidore Ducasse). *Les Chants de Maldoror.* Translated from the French by Guy Wernham. New York: New Directions, 1965. Also includes a translation of Lautréamont's *Poésies.*

*Lautréamont's Maldoror.* Translated from the French by Alexis Lykiard. New York: Thomas Y. Crowell, 1972.

Marx, Karl, and Engels, Friedrich. *Literature and Art: Selections from Their Writings.* New York: International Publishers, 1947.

Matthews, J. H. *Surrealism and the Novel.* Ann Arbor: University of Michigan Press, 1966.

————. *Theatre in Dada and Surrealism.* Syracuse: Syracuse University Press, 1974.

Raymond, Marcel. *From Baudelaire to Surrealism.* New York: Wittenborn, Schultz, 1950.

Rimbaud, Arthur. *Les Illuminations.* Paris: La Vogue, 1886. Reprinted in *Mercure de France,* 1936.

————. *Une Saison en Enfer.* Brussels: Alliance Typographique, Poot & Cie., 1872. Reprinted in *Mercure de France,* 1937.

## Political Background

Burnham, James. *The Managerial Revolution: What Is Happening in the World.* New York: John Day Company, 1941.

Howe, Irving. *Leon Trotsky.* New York: Viking, 1978.

Kennan, George F. *Russia and the West under Lenin and Stalin.* Boston and Toronto: Little, Brown and Company, 1961.

Trotsky, Leon. *The Bolsheviki and World Peace.* New York: Boni and Liveright, 1918. Introduction by Lincoln Steffens.

————. *The Revolution Betrayed: What Is the Soviet Union and Where Is It Going?* Garden City, N.Y.: Doubleday, Doran & Company, 1937.

Zeldin, Theodore. *France 1848-1945.* Vol. 1: *Ambition, Love and Politics.* Oxford: Clarendon Press, 1973.

# The Artists

## JEAN (HANS) ARP

Arp, Jean (Hans). *On My Way: Poetry and Essays, 1912-1947.* Documents of Modern Art. New York: Wittenborn, Schultz, 1948.

Giedion-Welcker, Carola. *Jean Arp.* Translated from the German by Norbert Guterman. New York: Harry N. Abrams, 1957.

Jean, Marcel, ed. *Arp on Arp: Poems, Essays, Memories.* Translated from the French by Joachim Neugroschel. New York: Viking, 1972.

Read, Herbert. *The Art of Jean Arp.* New York: Harry N. Abrams, 1968.

Seuphor, Michel. *Arp.* New York: Universe Books, 1961.

Soby, James Thrall, ed. *Arp.* New York: The Museum of Modern Art, 1958. Articles by Jean (Hans) Arp, Richard Huelsenbeck, Robert Melville, and Carola Giedion-Welcker.

## WILLIAM BAZIOTES

Cavaliere, Barbara. "An Introduction to the Method of William Baziotes." *Arts Magazine* 51 (April 1977): 124-131.

Franks, Paula, and White, Marion, eds. "An Interview with William Baziotes." *Perspectives* 2 (1956-57): 27, 29-30.

Hadler, Mona. "Willaim Baziotes: A Contemporary Poet-Painter." *Arts Magazine* 51 (June 1977): 102-110.

Hare, David. "William Baziotes, 1912-63." *Location* 1 (Summer 1964): 85-86.

Hess, Thomas B. "William Baziotes, 1912-63." *Location* 1 (Summer 1964): 83-84.

Sandler, Irving H. "Baziotes: Modern Mythologist." *Art News* 63 (February 1965): 28-30, 65-66.

Still, Clyfford. *William Baziotes: Late Work 1946-1962.* New York: Marlborough Gallery, 1971.

*William Baziotes, A Memorial Exhibition.* New York: The Solomon R. Guggenheim Museum, 1965. Introduction by Lawrence Alloway.

*William Baziotes: A Retrospective Exhibition.* Newport Beach: Newport Harbor Art Museum, 1978. Introduction by Michael Preble; essays by Barbara Cavaliere and Mona Hadler.

## GIORGIO DE CHIRICO

de Chirico, Giorgio. *Hebdomeros.* Paris: Carréfour, 1929.

———. "Sur le silence." *Minotaure* 5 (May 1934): 31-32.

Far, Isabella, ed. *Giorgio de Chirico.* Translated from the French by Joseph M. Bernstein. New York: Harry N. Abrams, 1968.

*Giorgio de Chirico.* New York: The Museum of Modern Art, 1955. Reprint. New York: Arno Press, 1966. Catalog by James Thrall Soby.

Goodrich, Lloyd. "Giorgio de Chirico." *Littérature* 2 (January 1920): 28.

Motherwell, Robert. "Notes on Mondrian and de Chirico." *VVV* 5 (June 1942): 59-61.

Sakraischik, Claudio Bruni. *Catalogo Generale dell'Opera di Giorgio de Chirico.* 5 vols. Milan: Electa Editrice, 1972.

———. *Giorgio de Chirico.* Translated by Helen Barnes. Rome: Edizioni La Medusa, 1976.

Soby, James Thrall. *The Early Chirico.* New York: Dodd, Mead, 1941.

## JOSEPH CORNELL

Ashton, Dore. *A Joseph Cornell Album.* New York: Viking Press, 1974. Special contributions by John Ashbery, Peter Bazeley, Elizabeth Bishop, Denise Hare, Richard Howard, Stanley Kunitz, Jonas Mekas, Duane Michals, John Bernard Myers, Octavio Paz, and Terry Schutté.

*Joseph Cornell.* New York: The Solomon R. Guggenheim Museum, 1967. Catalog text by Diane Waldman.

*Joseph Cornell.* Turin: Galleria Galatea, 1971. Catalog text by Luigi Carluccio.

*Joseph Cornell.* New York: ACA Galleries, 1975. Catalog text by John Bernard Myers.

*Joseph Cornell.* New York: Leo Castelli Gallery, 1976. Catalog edited by Sandra Leonard Starr; contributions by Donald Barthelme, Bill Copley, Tony Curtis, Howard Hussey, Allegra Kent, Julien Levy, Jonas Mekas, Robert Motherwell, and Hans Namuth.

*An Exhibition of Works by Joseph Cornell.* Pasadena: Pasadena Art Museum, 1966. Catalog text by Fairfield Porter.

Hussey, Howard. "Joseph Cornell (Towards a Memoir)." *Prose* 9 (Fall 1974): 73-85.

Johnson, Ellen H. "A Loan Exhibition of Cornell Boxes." *Allen Memorial Art Museum Bulletin* 23 (Spring 1966): 127-31.

Waldman, Diane. *Joseph Cornell.* New York: George Braziller, 1977.

## SALVADOR DALI

Bosquet, Alain. *Conversations with Dali.* Translated from the French by Joachim Neugroschel. New York: E. P. Dutton, 1969.

Dali, Salvador. *Conquest of the Irrational.* Translated from the French by David Gascoyne. New York: Julien Levy, 1935.

———. "The Stinking Ass." *This Quarter* (Summer 1932): 49-54. Translation of "L'Ane pourri." *Le Surréalisme au Service de la Révolution* (July 1930): 9-12.

Descharnes, Robert. *Salvador Dali.* Translated from the French by Eleanor Morse. New York: Harry N. Abrams, 1976.

———. *The World of Salvador Dali.* Translated from the French by Albert Field. New York: Viking, 1972.

Gerard, Max, ed. *Salvador Dali.* New York: Harry N. Abrams, 1968.

Morse, A. Reynolds. *Dali: A Study of His Life and Work.* Greenwich, Conn.: New York Graphic Society, 1958. With a special appreciation by Michel Tapié and descriptive captions for the color plates written especially for this volume by Salvador Dali.

*Salvador Dali: Paintings, Drawings, Prints.* New York: The Museum of Modern Art, 1941. Catalog by James Thrall Soby.

*Salvador Dali, 1910-1965, with the Reynolds Morse Collection.* New York: Gallery of Modern Art, 1966.

## PAUL DELVAUX

Butor, Michel; Clair, Jean; and Houbart-Wilkin, Suzanne. *Delvaux.* Brussels: Cosmos, 1975. Catalog raisonné.

de Bock, Paul-Aloise. *Paul Delvaux. L'Homme. Le Peintre. Psychologie d'un Art.* Brussels: Laconti, 1967.

Gaffé, René. *Paul Delvaux ou Les Rêves Eveillés.* Brussels: La Boétie, 1945.

Langui, Emile. *Paul Delvaux.* Venice: Alfieri, 1949.

Meuris, Jacques. *7 Dialogues avec Paul Delvaux accompagnés de 7 lettres imaginaires.* Paris: Le Soleil noir, 1971.

Spaak, Claude. *Paul Delvaux.* Monographies Art Belge. Anvers: De Sikkel, 1948.

Terrasse, Antoine. *Paul Delvaux (La septième face du Dé).* Paris: Filipacchi, 1972.

## MARCEL DUCHAMP

*The Almost Complete Works of Marcel Duchamp.* London: The Arts Council of Great Britain, 1966. Exhibition at the Tate Gallery.

Breton, André. "Phare de la Mariée." *Minotaure* 6 (Winter 1935): 45-49.

Cabanne, Pierre. *Dialogues with Marcel Duchamp.* New York: Viking, 1971.

Duchamp, Marcel. *Salt Seller; the Writings of Marcel Duchamp.* Edited by Michel Sanouillet and Elmer Peterson. London: Thames and Hudson, 1975.

Golding, John. *Duchamp: The Bride Stripped Bare by Her Bachelors, Even.* London: Penguin, 1973.

Hamilton, Richard, ed. *The Bride Stripped Bare by Her Bachelors, Even; A Typographic Version.* New York: George Wittenborn, 1960.

Lebel, Robert. *Marcel Duchamp.* Translated from the French by George Heard Hamilton. New York: Grove Press, 1959. Catalog raisonné; chapters by Marcel Duchamp, André Breton, and H. P. Roché.

*Marcel Duchamp.* New York: The Museum of Modern Art, 1973. Exhibition also at the Philadelphia Museum of Art. Catalog edited by Anne d'Harnoncourt and Kynaston McShine; contributors: Anne d'Harnoncourt, Michel Sanouillet, Richard Hamilton, Lawrence D. Steefel, Jr., Arturo Schwarz, davidantin, Lucy R. Lippard, Kynaston McShine, Robert Lebel, Octavio Paz, John Tancock; bibliography by Bernard Karpel.

*Marcel Duchamp. Ready-mades, etc. (1913-1964).* Milan: Galleria Schwarz, 1964. Catalog text by Walter Hopps, Ulf Linde, and Arturo Schwarz.

*Marcel Duchamp, A Retrospective Exhibition.* Pasadena: Pasadena Art Museum, 1963.

*L'Oeuvre de Marcel Duchamp.* 4 volx. Paris: Centre National d'Art et de Culture Georges Pompidou, Musée National d'Art Moderne, 1977.

Paz, Octavio. *Marcel Duchamp: Or the Castle of Purity.* London: Cape Goliard Press, 1970.

Rubin, William. "Reflections on Marcel Duchamp," *Art International* 4 (December 1960): 49-53.

Schwarz, Arturo. *The Complete Works of Marcel Duchamp.* New York: Harry N. Abrams, 1969.

Tomkins, Calvin. *The Bride and the Bachelors; the Heretical Courtship in Modern Art.* New York: Viking, 1965.

## MAX ERNST

Ernst, Max. *Une semaine de bonté: A Surrealistic Novel in Collage.* New York: Dover, 1976.

*Max Ernst.* New York: The Museum of Modern Art, 1961. Catalog edited by William S. Lieberman.

*Max Ernst: Inside the Sight.* Houston: Rice University, Institute for the Arts, 1973. Essays by Werner Hofmann, Wieland Schmeid, and Werner Spies.

*Max Ernst: A Retrospective.* New York: The Solomon R. Guggenheim Museum, 1975. Catalog by Diane Waldman.

*Max Ernst: Retrospektive 1979.* Munich: Prestel-Verlag, 1979. Exhibition at Haus der Kunst. Catalog edited by Werner Spies.

*Max Ernst: Sculpture and Recent Painting.* New York: The Jewish Museum, 1966. Catalog edited by Sam Hunter; includes sections by Lucy R. Lippard and John Russell; with a statement by the artist.

Motherwell, Robert, ed. *Max Ernst: Beyond Painting and Other Writings by the Artist and His Friends.* Documents of Modern Art. New York: Wittenborn, Schultz, 1948.

Quinn, Edward. *Max Ernst.* Translated from the French by Kenneth Lyons. Boston: New York Graphic Society, 1977. Contributors: Max Ernst, Uwe M. Schneede, Patrick Waldberg, and Diane Waldman.

Rubin, William. "Max Ernst." *Art International* 5 (May 1961): 31-37.

Russell, John. *Max Ernst: Life and Work.* New York: Harry N. Abrams, 1967.

Schneede, Uwe M. *Max Ernst.* Translated by R. W. Last. New York: Praeger, 1973.

Spies, Werner. *Max Ernst – Collagen: Inventar und Widerspruch.* Cologne: Verlag M. DuMont Schauberg, 1974.

———. *The Return of La Belle Jardinière: Max Ernst, 1950-1970.* Translated from the German by Robert Allen. New York: Harry N. Abrams, 1971.

———, ed. *Max Ernst: Oeuvre-Katalog.* 3 vols. Houston: Menil Foundation, and Cologne: Verlag M. DuMont Schauberg, 1975-76.

Waldberg, Patrick. *Max Ernst.* Paris: Jean-Jacques Pauvert, 1958.

## ALBERTO GIACOMETTI

*Alberto Giacometti.* New York: The Museum of Modern Art, 1965. Introduction by Peter Selz.

*Alberto Giacometti: A Retrospective Exhibition.* New York: The Solomon R. Guggenheim Museum, 1974. Catalog text by Reinhold Hohl.

*Alberto Giacometti, Sculptor and Draftsman.* New York: American Federation of Arts, 1977. Catalog by Louise Averill Svendsen.

*Alberto Giacometti: Sculpture, Paintings, Drawings 1913-1965.* London: The Arts Council of Great Britain, 1964. Exhibition at the Tate Gallery. Catalog text by David Sylvester.

Dupin, Jacques. *Alberto Giacometti.* Paris: Maeght, 1962.

Giacometti, Alberto. "1 + 1 = 3." *Trans/formations* 1 (1952): 165-66. Originally published in *Minotaure* 3-4 (December 1933): 46.

Hohl, Reinhold. *Alberto Giacometti: Sculpture, Painting, Drawing.* London: Thames and Hudson, 1972.

Huber, Carlo. *Alberto Giacometti.* Lausanne: Editions Rencontre, 1970.

Lord, James. *A Giacometti Portrait.* New York: The Museum of Modern Art, 1965.

Moulin, Raoul. *Giacometti: Sculpture.* Translated by Bettina Wadia. New York: Tudor, 1964.

## ARSHILE GORKY

*Arshile Gorky.* New York: Julien Levy Gallery, 1945. Foreword by André Breton.

*Arshile Gorky: Drawings to Paintings.* Austin: The University of Texas at Austin Art Museum, 1975. Essays by Isobel Grossman, Karlen Mooradian, Jim M. Jordan, and others.

*Arshile Gorky: Paintings and Drawings.* London: The Arts Council of Great Britain, 1965. Exhibition at the Tate Gallery.

*Arshile Gorky: Paintings, Drawings, Studies.* New York: The Museum of Modern Art in collaboration with the Washington Gallery of Art, 1962. Catalog by William C. Seitz; foreword by Julien Levy.

*The Drawings of Arshile Gorky.* College Park: University of Maryland Art Department and Art Gallery, J. Millard Tawes Fine Arts Center, 1969. Catalog by Brooks Joyner; preface by George Levitine; foreword by William H. Gerdts.

Levy, Julien. *Gorky.* New York: Harry N. Abrams, 1966.

Mooradian, Karlen. *Arshile Gorky Adoian.* Chicago: Gilgamesh Press, 1978.

————. "A Special Issue on Arshile Gorky." *Ararat* 12 (Fall 1971). Edited by David Kherdian.

Reiff, Robert F. *A Stylistic Analysis of Arshile Gorky's Art from 1943-1948.* New York: Garland Publishers, 1977.

Rosenberg, Harold. *Arshile Gorky: The Man, the Time, the Idea.* New York: Horizon Press, 1962.

Rubin, William. "Arshile Gorky, Surrealism, and the New American Painting." *Art International* 7 (February 1963): 27-38.

Schwabacher, Ethel K. *Arshile Gorky.* New York: Macmillan Co. for the Whitney Museum of American Art, 1957. Preface by Lloyd Goodrich; introduction by Meyer Schapiro.

Seitz, William C. "Arshile Gorky's 'The Plow and the Song.'" *Allen Memorial Art Museum Bulletin* 12 (Fall 1954): 4-15.

## PAUL KLEE

Armitage, Merle. *5 Essays on Klee.* New York: Duell, Sloan, and Pearce, 1950.

Cooper, Douglas. *Paul Klee.* Harmondsworth, Middlesex, England: Penguin Books, 1949.

Geelhaar, Christian. *Paul Klee and the Bauhaus.* New York: New York Graphic Society, 1973.

Grohmann, Will. *Paul Klee.* London: Lund Humphries, 1954.

Haftmann, Werner. *The Mind and Work of Paul Klee.* London: Faber and Faber, 1954.

Hulton, Nika. *An Approach to Paul Klee.* London: Phoenix House, 1956.

Kagan, Andrew. "Paul Klee's Influence on American Painting." *Arts Magazine* 50 (September 1975): 84-90.

Klee, Felix. *Paul Klee.* Translated from the German by Richard and Clara Winston. New York: George Braziller, 1962.

Klee, Paul. *The Diaries of Paul Klee 1898-1918.* Berkeley and Los Angeles: University of California Press, 1964.

————. *Pädagogisches Skizzenbuch.* Munich: Langen, 1925. English edition, *Pedagogical Sketchbook.* Translated by Sibyl Moholy-Nagy. New York: F. A. Praeger, 1953.

————. *The Thinking Eye.* Edited by Jürg Spiller. London: Lund Humphries, 1961.

Miller, Margaret, ed. *Paul Klee.* New York: The Museum of Modern Art, 1945. Revised and enlarged edition of 1941 catalog of Paul Klee Memorial Exhibition at The Museum of Modern Art. Includes statements by the artist; articles by Alfred H. Barr, Jr., Julia and Lyonel Feininger, and James Johnson Sweeney.

*Paul Klee, 1879-1940, in the Collection of The Solomon R. Guggenheim Museum.* New York: The Solomon R. Guggenheim Museum, 1977. Essay by Louise Averill Svendsen.

Read, Herbert. *Klee 1879-1940.* London: Faber and Faber, 1948.

## RENE MAGRITTE

Calas, Elena. "Magritte's Inaccessible Woman." *Artes* 30 (December 1976): 24-31.

Clureman, Irene. *Surrealism and the Painting of Matta and Magritte.* Stanford: Stanford University Humanities Honors Program, 1970.

Gablik, Suzi. *Magritte.* London: Thames and Hudson, 1970

Hammacher, Abraham Marie. *René Magritte.* Translated by James Brockway. New York: Harry N. Abrams, 1973.

Larkin, David, ed. *Magritte.* New York: Ballantine Books, 1972. Introduction by Eddie Wolfram.

*Magritte.* London: The Arts Council of Great Britain, 1969. Exhibition at the Tate Gallery. Catalog by David Sylvester.

Magritte, René. *Ecrits complets.* Paris: Flammarion, 1979.

*René Magritte.* New York: The Museum of Modern Art, 1965. Catalog by James Thrall Soby.

*Retrospective Magritte.* Brussels: Musées Royaux des Beaux-Arts de Belgique, 1978. Exhibition at the Palais des Beaux-Arts. Essays by Jean Clair, Louis Scutenaire, and David Sylvester.

Scutenaire, Louis. *Avec Magritte.* Brussels: Le Fil Rouge, Editions Lebeer Hossmann, 1977.

*Secret Affinities: Words and Images by René Magritte.* Houston: Rice University, Institute for the Arts, 1976. Essay by André Breton.

Torczyner, Harry. *Magritte, Ideas and Images.* Translated from the French by Richard Miller. New York: Harry N. Abrams, 1977.

Waldberg, Patrick. *René Magritte.* Translated from the French by Austryn Wainhouse. Brussels: André De Rache, 1965.

## MAN RAY

Alexandriane, Sarane. *Man Ray.* Paris: Filipacchi, 1973.

Belz, Carl I. "Man Ray and New York Dada." *Art Journal* 23 (Spring 1964): 207-13.

*An Exhibition Retrospective and Prospective of the Work of Man Ray.* London: Institute of Contemporary Arts, 1959.

*Man Ray.* Los Angeles: Los Angeles County Museum of Art, 1966. Catalog texts by Jules Langsner and Man Ray; writings by Paul Eluard, Marcel Duchamp, André Breton, Tristan Tzara, and Hans Richter.

*Man Ray.* Rotterdam: Museum Boymans-van Beuningen, 1972. Introduction by Alain Jouffroy.

*Man Ray: The Dada of Us All.* New York: The New York Cultural Center, 1974. Catalog text by William Copley.

*Man Ray, L'Oeuvre photographique.* Paris: Bibliothèque Nationale, 1962. Catalog by Jean Adhémar and Evelyne Pasquet; text by Jean Adhémar.

Penrose, Roland. *Man Ray.* London: Thames and Hudson; Boston: New York Graphic Society, 1975.

Schwarz, Arturo. *Man Ray: The Rigour of Imagination.* London: Thames and Hudson, 1977.

————. "This is not for America." *Arts Magazine* 51 (May 1977): 116-21. An interview with Man Ray.

————, ed. *Man Ray: 60 Years of Liberties.* Milan: Galleria Schwarz, 1971. Preface and anthology: Louis Aragon, Jean Arp, Carl Belz, Pierre Bost, André Breton, Marcel Duchamp, Paul Eluard, Max Ernst, Patrick J. Kelleher, Adon Lacroix, Man Ray, Francis Picabia, Georges Ribemond-Dessaignes, Philippe Soupault, Tristan Tzara, and Patrick Waldberg.

## ANDRE MASSON

*André Masson*. New York: The Museum of Modern Art, 1976. Catalog by William S. Rubin and Carolyn Lancher.

Hahn, Otto. *Masson*. Translated from the French by Robert Erich Wolf. New York: Harry N. Abrams, 1965.

Leiris, Michel, and Limbour, Georges. *André Masson and His Universe*. Geneva and Paris: Editions des Trois Collines; London: Horizon, 1947. Texts in French; some translated into English by Douglas Cooper.

Masson, André. *Entretiens avec Georges Charbonnier*. Paris: René Juillard, 1958.

————. *Le rebelle du surréalisme: Ecrits, Edition etablie par François Will-Levaillant*. Paris: Collection Savoir Hermann, 1976.

Rubin, William. "Notes on Masson and Pollock." *Arts* 34 (November 1959): 36-43.

## MATTA (ROBERTO SEBASTIAN ANTONIO ECHAURREN)

Calas, Nicolas. "The Totemic World of Matta." *Colóquio Artes* 23 (June 1975): 25-31.

Clureman, Irene. *Surrealism and the Painting of Matta and Magritte*. Stanford: Stanford University Humanities Honors Program, 1970.

Frost, Rosamund. "Matta's Third Surrealist Manifesto." *Art News* 43 (February 1944): 18.

Haglund, Elisabeth. "The Morphologies of Matta." *ARIS* 2 (1969): 9-32.

Kozloff, Max. "An Interview with Matta." *Artforum* 4 (September 1965): 23-26.

*Matta*. New York: The Museum of Modern Art, 1957. Catalog by William Rubin.

*Matta Coïgitum*. London: The Arts Council of Great Britain, 1977. Exhibition at the Hayward Gallery. Includes interview with Peter de Francia and text by André Breton.

*Matta: Opere dal 1939 al 1975*. Rome: Galleria dell'Oca, 1976. Text in Italian and English by Luisa Laureati.

Matta (Roberto Sebastian Antonio Echaurren). "Hellucinations." In *Max Ernst: Beyond Paintings and Other Writings by the Artist and His Friends*. Documents of Modern Art. New York: Wittenborn, Schultz, 1948.

*Sebastian Matta*. Stockholm: Moderna Museet, 1959. Text in Swedish and English by Ingemar Gustafson.

Soby, James Thrall. "Matta Echaurren." *Magazine of Art* 40 (March 1947): 102-6.

## JOAN MIRO

Breton, André. "Constellations de Joan Miró." *L'Oeil* 4 (December 1958): 50-55.

Dupin, Jacques. *Joan Miró: Life and Work* Translated from the French by Norbert Gutetman. New York: Harry N. Abrams, 1962. Catalog raisonné.

Greenberg, Clement. *Joan Miró*. New York: Quadrangle Press, 1948.

*Joan Miró*. New York: The Museum of Modern Art, 1941. Essay by James J. Sweeney.

*Joan Miró*. New York: The Museum of Modern Art, 1959. Essay by James T. Soby.

*Joan Miró: pintura*. Madrid: Museo español de arte contemporaneo, 1978. Essays by Julio Gallego, Jacques Dupin, James J. Sweeney, and others.

Kramer, Hilton. "Miró." *Arts* 33 (May 1959): 48-50.

Lassaigne, Jacques. *Miró: Biographical and Critical Study*. Translated from the French by Stuart Gilbert. Geneva: Skira, 1963.

*Miró*. London: The Arts Council of Great Britain, 1964. Exhibition at the Tate Gallery. Catalog text by Roland Penrose.

*Miró*. Paris: Réunion des Musées Nationaux, 1974. Exhibition at the Grand Palais. Preface by Jean Laymarie.

Motherwell, Robert. "The Significance of Miró." *Art News* 58 (May 1959): 32-33.

Sweeney, James Johnson. "Miró." *Art News Annual* 23 (1954): 58-81.

Zervos, Christian. "L'Oeuvre de Joan Miró, de 1917 à 1933," *Cahiers d'Art* 9 (1934): 11-58.

————. "Joan Miró: Oeuvre 1944-1946." *Cahiers d'Art* 20-21 (1945-46): 269-300.

## ROBERT MOTHERWELL

Arnason, Hjorvardur Harvard. "On Robert Motherwell and His Early Works." *Art International* 10 (January 1966): 17-35.

————. *Robert Motherwell*. New York: Harry N. Abrams, 1974. Preface by Bryan Robertson.

————. "Robert Motherwell: The Years 1948 to 1965." *Art International* 10 (May 1966): 19-45.

————. "Robert Motherwell: 1966-1976." *Art International* 20 (October-November 1976): 9-25, 55-56.

*The Collages of Robert Motherwell: A Retrospective Exhibition*. Houston: The Museum of Fine Arts, 1972. Catalog text by E. A. Carmean, Jr.

Krauss, Rosalind. "Robert Motherwell's New Paintings." *Artforum* 7 (May 1969): 26-28.

Motherwell, Robert. "Painter's Objects." *Partisan Review* 11 (Winter 1944): 93-97.

————. "The Painter and the Audience." In "The Creative Artist and His Audience: A Symposium." *Perspectives USA* 9 (Autumn 1954): 107-12.

————. "The Creative Use of the Unconscious by the Artist and by the Psychotherapist." *Annals of Psychotherapy: Journal of the American Academy of Psychotherapists* 8 (1964): 47-49. Edited by Jules Barron and Renee Nell.

————. Documents of Modern Art Series. New York: Wittenborn, Schultz, 1945-. Director, prefaces, and introductions.

Motherwell, Robert, and Reinhardt, Ad, eds. Modern Artists in America, First Series. New York: Wittenborn, Schultz, 1952.

*Robert Motherwell*. New York: The Museum of Modern Art, 1965. Edited by William Berkson; introduction by Frank O'Hara; selections from the writings of Robert Motherwell.

*Robet Motherwell: A Retrospective Exhibition*. Pasadena: Pasadena Art Museum, 1962. Catalog texts by T. W. Leavitt, Frank O'Hara, and Sam Hunter.

## FRANCIS PICABIA

Camfield, William. *Francis Picabia: His Art, Life and Times*. Princeton: Princeton University Press, 1979.

————. "The Machinist Style of Francis Picabia." *Art Bulletin* 48 (September-December 1966): 309-322.

*Francis Picabia*. Newcastle: University of Newcastle-upon-Tyne, Hatton Gallery, 1964. Introduction by Ronald Hunt.

*Francis Picabia*. New York: The Solomon R. Guggenheim Museum, 1970. Catalog by William Camfield.

*Francis Picabia*. Paris: Centre National d'Art et de Culture Georges Pompidou, Musée National d'Art Moderne, 1976. Exhibition at the Grand Palais.

Pearlstein, Philip. "The Symbolic Language of Francis Picabia." *Arts* 30 (January 1956): 37-43.

Picabia, Francis. "Francis Picabia et Dada." *L'Esprit Nouveau* 9 (June 1921): 1059-60.

————. *Poèmes et dessins de la fille née sans mère*. Lausanne: Imprimeries Réunis, 1918.

————, ed. *391*. Barcelona, New York, Zurich, Paris: 1917-23.

## PABLO PICASSO

Ashton, Dore. *Picasso on Art.* Documents of Twentieth-Century Art. New York: Viking, 1972. Edited by Robert Motherwell.

Boeck, William, and Sabartés, Jaime. *Picasso.* New York: Harry N. Abrams, 1955.

Cabanne, Pierre. *Pablo Picasso: His Life and Times.* Translated from the French by Harold J. Salemson. New York: William Morrow, 1977.

Kibley, Ray Anne. *Picasso: A Comprehensive Bibliography.* New York and London: Garland Publishing, 1977.

Lipton, Eunice. *Picasso Criticism 1901-1939: The Making of an Artist-Hero.* New York and London: Garland Publishing, 1976.

Malraux, André. *Picasso's Mask.* Translated from the French by Jacques Guicharnaud. New York: Holt, Rinehart, and Winston, 1976.

Penrose, Roland. *Picasso: His Life and Works.* New York: Harper & Row, 1958.

Penrose, Roland, and Golding, John, eds. *Picasso: in Retrospect.* New York: Praeger, 1973. Articles by Daniel Henry Kahnweiler, Theodore Reff, Robert Rosenblum, John Golding, Alan Bowness, Roland Penrose, Jean Sutherland Boggs, and Michel Leiris.

*Picasso: 50 Years of His Art.* New York: The Museum of Modern Art, 1946. Catalog by Alfred H. Barr, Jr.; bibliography by Dorothy Simmons.

*Picasso in the Collection of The Museum of Modern Art.* New York: The Museum of Modern Art, 1972. Catalog by William Rubin; additional texts by Elaine L. Johnson and Riva Castleman.

Picasso, Pablo. *Desire Caught by the Tail.* Translated from the French by Bernard Frechtman. New York: Citadel Press, 1962.

Rosenblum, Robert. "Picasso as a Surrealist." *Picasso and Man.* Toronto: The Art Gallery of Toronto, 1964. Catalog by Jean Sutherland Boggs.

## JACKSON POLLOCK

Busignani, Alberto. *Pollock.* London: Hamlyn, 1971.

Friedman, Bernard Harper. *Jackson Pollock: Energy Made Visible.* New York: McGraw-Hill, 1972.

*Jackson Pollock.* New York: The Museum of Modern Art, 1956. Catalog by Sam Hunter.

*Jackson Pollock.* New York: The Museum of Modern Art, 1967. Catalog by Francis V. O'Connor.

*Jackson Pollock: Paintings, Drawings, and Watercolours from the Collection of Lee Krasner Pollock.* London: Marlborough Fine Art Ltd., 1961. Catalog by Lawrence Alloway.

*Jackson Pollock: Works on Paper.* New York: The Museum of Modern Art, 1969. Catalog by Bernice Rose. Published in association with The Drawing Society, Inc.

O'Connor, Francis Valentine, and Thaw, Eugene Victor, eds. *Jackson Pollock: A Catalogue Raisonné of Paintings, Drawings, and Other Works.* 4 vols. New Haven and London: Yale University Press, 1978.

O'Hara, Frank. *Jackson Pollock.* New York: George Braziller, 1959.

Robertson, Bryan. *Jackson Pollock.* New York: Harry N. Abrams, 1960.

## KURT SCHWITTERS

Danieli, Fidel A. "Kurt Schwitters." *Artforum* 3 (May 1965): 26-30.

Giedion-Welcker, Carola. "Schwitters: Or the Allusions of the Imagination." *Magazine of Art* 41 (October 1948): 218-21.

*Kurt Schwitters.* London: Marlborough Fine Art Ltd., 1972. Introduction by Carola Giedion-Welcker.

*Kurt Schwitters Retrospective.* New York: Marlborough-Gerson Gallery, 1965. Introduction by Werner Schmalenbach; essay by Kate T. Steinitz.

Schmalenbach, Werner. *Kurt Schwitters.* London: Thames and Hudson, 1970.

——. "Kurt Schwitters." *Art International* 4 (September 1960): 58-62.

Schwitters, Kurt. *Die Kathedrale.* Hanover: Paul Steegemann, 1920.

——. *Anna Blume. Dichtungen.* Hanover: Paul Steegemann, 1922.

——. *Die Märchen vom Paradies.* Hanover: Apossverlag, 1924.

——. *Die Scheuche Märchen.* Hanover: Apossverlag, 1925.

Steinitz, Kate. *Kurt Schwitters: A Portrait from Life.* Berkeley and Los Angeles: University of California Press, 1968.

Themerson, Stefan. *Kurt Schwitters in England.* London: Gaberbocchus Press, 1958.

## YVES TANGUY

Breton, André. *Yves Tanguy.* Translated from the French by Bravig Imbs. New York: Pierre Matisse Editions, 1946. Text in French and English.

Jean, Marcel. "Tanguy in the Good Old Days." *Art News* 54 (September 1955): 30, 55-56.

Levy, Julien. "Tanguy, Connecticut Sage." *Art News* 53 (September 1954): 24-27.

Soby, James Thrall. "Inland in the Subconscious: Yves Tanguy." *Magazine of Art* 41-42 (January 1949): 2-7.

Tanguy, Kay Sage, ed. *Yves Tanguy: A Summary of His Work.* New York: Pierre Matisse, 1963.

*Yves Tanguy.* New York: The Museum of Modern Art, 1955. Catalog by James Thrall Soby.

*Yves Tanguy.* New York: Acquavella Galleries, 1947. Essay by John Ashbery, "Yves Tanguy, Geometer of Dreams."

*Yves Tanguy: Das Druckgraphische Werk.* Düsseldorf: Kunsthalle, 1976. Catalog by Wolfgang Wittrock; essays by Wittrock and Stanley W. Hayter (in German, French, and English).

# Comparative Illustrations

Figure 1. Marcel Duchamp. *The Chocolate Grinder No. 2,* 1914, oil, thread, and pencil on canvas, 26 x 21 inches (65 x 54 cm.). Philadelphia Museum of Art, The Louise and Walter Arensberg Collection.

Figure 2. Marcel Duchamp. *The Bride Stripped Bare by Her Bachelors, Even (The Large Glass),* 1915-23, oil, varnish, lead foil, lead wire, and dust on two glass panels (cracked), each mounted between two glass panels, with five glass strips, aluminum foil, and a wood and steel frame, 109¼ x 69¼ inches (277.5 x 176 cm.). Philadelphia Museum of Art, Bequest of Katherine S. Dreier.

Figure 3. Gustave Moreau. *L'Apparition,* ca. 1876, oil on canvas, 55⅞ x 40½ inches (142 x 103 cm.). Musée Gustave Moreau, Paris.

Figure 4. Odilon Redon. *Orpheus,* painted after 1913, pastel, 27½ x 22¼ inches (69.8 x 56.5 cm.). The Cleveland Museum of Art, Gift from J. H. Wade.

Figure 5. Paul Gauguin. *L'Appel (The Call),* 1902, oil on canvas, 51¼ x 35½ inches (130.1 x 90.1 cm.). The Cleveland Museum of Art, Gift of Hanna Fund and Leonard C. Hanna, Jr.

Figure 6. Georges Seurat. *La Parade,* 1888, oil on canvas, 39¾ x 59⅛ inches (101 x 150.2 cm.). Metropolitan Museum of Art, Bequest of Stephen C. Clark, 1960.

Figure 7. Henri Rousseau. *The Dream,* 1910, oil on canvas, 80½ x 117½ inches (204.5 x 298.5 cm.). Collection, The Museum of Modern Art, New York, Gift of Nelson A. Rockefeller.

Figure 8. Henri Rousseau. *The Jungle: Tiger Attacking a Buffalo,* 1908, oil on canvas, 67¾ x 75⅜ inches (172.1 x 191.5 cm.). The Cleveland Museum of Art, Gift of Hanna Fund.

Figure 9. Joan Miró. *Carnival of Harlequin,* 1924-25, oil on canvas, 26 x 36⅝ inches (66 x 93 cm.). Albright-Knox Art Gallery, Buffalo, New York, Room of Contemporary Art Fund.

Figure 10. Jackson Pollock. *Totem I,* 1944, oil on canvas, 70 x 44 inches (177 x 111.5 cm.). Private collection.

Figure 11. Pablo Picasso. *Les Demoiselles d'Avignon,* 1907, oil on canvas, 96 x 92 inches (243.8 x 233.7 cm.). The Museum of Modern Art, New York, Lillie P. Bliss Bequest.

Figure 12. Pablo Picasso. *Three Dancers,* 1925, oil on canvas, 85½ x 56½ inches (216.5 x 143.5 cm.). Tate Gallery, London.

Figure 13. Pablo Picasso. *Girl Before a Mirror,* 1932, oil on canvas, 63¾ x 51¼ inches (162 x 130.2 cm.). The Museum of Modern Art, New York, Gift of Mrs. Simon Guggenheim.

Figure 14. Pablo Picasso. *Bull's Head,* 1943, bronze, after bicycle seat and handlebars, 16½ x 16⅛ x 5⅞ inches (41.9 x 41 x 14.9 cm.). Picasso estate.

Figure 15. Matta. *To Escape the Absolute,* 1944, oil on canvas, 38 x 50 inches (96.5 x 127 cm.). Collection, Mr. and Mrs. Joseph Slifka, New York.

*Library of Congress Cataloging in Publication Data*

Henning, Edward B.
   The spirit of surrealism.

   Catalog of an exhibition held at the Cleveland Museum of Art Oct. 3-Nov. 25, 1979.
   Bibliography: p. 177.
   1. Surrealism — Exhibitions. 2. Arts, Modern — 20th century — Exhibitions. I. Cleveland Museum of Art. II. Title.
NX600.S9H46      709'.04      79-63387
ISBN 0-910386-52-8

## Lenders to the Exhibition

William R. Acquavella, New York
Albright-Knox Art Gallery, Buffalo
Allen Memorial Art Museum,
 Oberlin College, Oberlin, Ohio
Art Advisory S. A., London
The Baltimore Museum of Art
Mr. and Mrs. Edwin A. Bergman,
 Chicago
Rosamond Bernier, New York
Centre Georges Pompidou, Musée
 National d'Art Moderne, Paris
Mr. and Mrs. Ralph F. Colin,
 New York
Dallas Museum of Fine Arts
The Detroit Institute of Arts
Harold Diamond, New York
Mr. and Mrs. Victor W. Ganz,
 New York
Mr. and Mrs. Jimmy Ernst, New York
Mr. and Mrs. Jacques Gelman,
 Mexico City
Harriet Griffin Gallery, New York
The Solomon R. Guggenheim Museum,
 New York
Dr. and Mrs. Jerome H. Hirschmann,
 Winnetka, Illinois
Hirshhorn Museum and Sculpture
 Garden, Washington
B. C. Holland, Inc., Chicago
Krannert Art Museum, University of
 Illinois, Champaign, Illinois
Mr. and Mrs. Julien Levy,
 Bridgewater, Connecticut
Mrs. H. Gates Lloyd, Haverford,
 Pennsylvania
Los Angeles County Museum of Art
Pierre Matisse Gallery, New York
The Metropolitan Museum of Art,
 New York
The Minneapolis Institute of Arts
Mr. and Mrs. Robert Mosbacher,
 Houston
Munson-Williams-Proctor Institute,
 Utica, New York
The Museum of Modern Art, New York
National Gallery of Art, Washington
Art Gallery of Ontario, Toronto
Perls Galleries, New York
Philadelphia Museum of Art
The Phillips Collection, Washington

Mr. and Mrs. Frank H. Porter,
 Chagrin Falls, Ohio
Private Collection, Switzerland
Private Collections, USA
Mr. and Mrs. Daniel Saidenberg,
 New York
The St. Louis Art Museum
San Francisco Museum of Modern Art
Dr. and Mrs. Howard D. Sirak,
 Columbus
Smith College Museum of Art,
 Northampton, Massachusetts
Thyssen-Bornemisza Collection,
 Lugano, Switzerland
The Toledo Museum of Art
Mr. and Mrs. Burton Tremaine,
 Meriden, Connecticut
Vassar College Art Gallery,
 Poughkeepsie, New York
Wadsworth Atheneum, Hartford
Yale University Art Gallery,
 New Haven
Richard S. Zeisler, New York